*"Does your heart hold the magic of the holidays?
Is it filled with warm memories just waiting to be
discovered again? Well, now is the time to open your
heart, believe in that magic, and remember those
treasured moments. Oh, they're still there, deep within
you, waiting to touch you once more. So come along,
as the magic of the season leads the way."*

Believe . . . in Holiday Magic fireworks spectacular
Disneyland

Copyright © 2020 Disney Enterprises, Inc.

The following are copyrights or trademarks of their respective owners: *Adventureland®* Area; *Audio-Animatronics®* Figure; *Aulani, A Disney Resort & Spa*; *Club 33®*; *Discoveryland®* Area; *Disney California Adventure®* Park; *Disney Cruise Line®* Ships; *Disney Dream®* Cruise Ship; *Disney Explorers Lodge®*; *Disney Fantasy®* Cruise Ship; *Disney Magic®* Cruise Ship; *Disney Springs™*; *Disney Vacation Club®*; *Disney Village®*; *Disney Wonder®* Cruise Ship; *Disney's Hollywood Hotel®*; *Disneyland®* Hotel; *Disneyland®* Paris; *Disneyland®* Park; *Disneyland®* Resort; *Disney's All-Star Movies Resort*; *Disney's All-Star Music Resort*; *Disney's All-Star Sports Resort*; *Disney's Animal Kingdom®* Lodge; *Disney's Animal Kingdom®* Villas—Kidani Village; *Disney's Animal Kingdom®* Theme Park; *Disney's Art of Animation Resort*; *Disney's Beach Club Resort and Villas*; *Disney's BoardWalk Inn and Villas*; *Disney's Caribbean Beach Resort*; *Disney's Contemporary Resort*; *Disney's Coronado Springs Resort*; *Disney's Fort Wilderness Resort*; *Disney's Grand Californian Hotel®* & Spa; *Disney's Grand Floridian Resort & Spa*; *Disney's Hilton Head Island Resort*; *Disney's Hollywood Studios®*; *Disney's Hotel Cheyenne®*; *Disney's Hotel New York®*; *Disney's Hotel Santa Fe®*; *Disney's Newport Bay Club®*; *Disney's Old Key West Resort*; *Disney's Paradise Pier®* Hotel; *Disney's Polynesian Village Resort*; *Disney's Pop Century Resort*; *Disney's Port Orleans Resort—French Quarter*; *Disney's Port Orleans Resort—Riverside*; *Disney's Saratoga Springs Resort & Spa*; *Disney's Sequoia Lodge®*; *Disney's Vero Beach Resort*; *Disney's Wilderness Lodge*; *Disney's Winter Summerland Miniature Golf Course*; *Disney's Yacht Club Resort*; *Downtown Disney®* District; *EPCOT®*; *Fantasyland®* Area; *Frontierland®* Area; *Hong Kong Disneyland®* Hotel; *Hong Kong Disneyland®* Park; *Hong Kong Disneyland®* Resort; Imagineering; Imagineers; *It's A Small World®* Attraction; *Magic Kingdom®* Park; *Main Street, U.S.A.®* Area; Mickey's Not-So-Scary Halloween Party; Mickey's Very Merry Christmas Party; *Parc Disneyland®*; *Pirates of the Caribbean®* Attraction; *Primeval Whirl®* Attraction; *Production Courtyard®*, *Space Mountain®* Attraction; *Splash Mountain®* Attraction; *Tokyo Disney®* Resort; *Tokyo Disneyland®* Park; *Tokyo DisneySea®* Park; *Tomorrowland®* Area; *Tomorrowland®* Stage; *Videopolis®*; *Walt Disney Studios®* Park; *Walt Disney World®* Railroad; *Walt Disney World®* Resort; *Wishes™* Nighttime Spectacular; and World Showcase.

All rights reserved.

Avatar characters and artwork ©Twentieth Century Fox Film Corporation. JAMES CAMERON'S *AVATAR* is a trademark of Twentieth Century Fox Film Corporation. All rights reserved.

Cars Land background inspired by the Cadillac Ranch by Ant Farm (Lord, Michels and Marquez) © 1974.

Cirque du Soleil® Entertainment Group Copyright © Cirque du Soleil.

Haunted Mansion Holiday and certain characters, visuals, decorations, and food items inspired by *Tim Burton's The Nightmare Before Christmas*. The movie *Tim Burton's The Nightmare Before Christmas* story and characters by Tim Burton. Copyright © 1993 Disney Enterprises, Inc.

Marvel characters and artwork © Marvel.

Mr. Potato Head®, *Mrs. Potato Head®*, and *Tinkertoys®* are registered trademarks of Hasbro, Inc. Used with permission. © Hasbro, Inc.

Pixar characters and artwork © Disney Enterprises, Inc., and Pixar Animation Studios.

Roger Rabbit's Car Toon Spin and *Roger Rabbit* characters and artwork © Walt Disney Pictures/Amblin Entertainment, Inc.

Slinky Dog © POOF Slinky LLC.

Star Wars © & TM Lucasfilm Ltd. All Rights Reserved.

The Twilight Zone® is a registered trademark of CBS, Inc., and is used with permission pursuant to a license from CBS, Inc.

Published by Disney Editions, an imprint of Buena Vista Books, Inc. No part of this book may be reproduced or transmitted in any form or by any means, electronic or mechanical, including photocopying, recording, or by any information storage and retrieval system, without written permission from the publisher.

For information address Disney Editions, 1200 Grand Central Avenue, Glendale, California 91201.

Editorial Director: Wendy Lefkon
Senior Editor: Jennifer Eastwood
Senior Designer: Lindsay Broderick
Production: Kate Milford, Karen Romano, and Marybeth Tregarthen
Book design: Graham Allan

Photography and art: Graham Allan, Rebecca Cline, Charlie Price, Ty Popko, Todd Anderson, Thierry Arensma, Mark Ashman, Andrea Barnett, Pascal Baudrier, Vincent Begon, Alain Boniec, Scott Brinegar, Sylvain Cambon, David Caranci, Tonia Carlisle, Jean-Claude Coutausse, Steven Davison, Jimmy DeFlippo, Valentin Desjardins, Bob Desmond, Gene Duncan, Alexandar Dunlap, Hugh Gentry, Bertrand Guay, Charlene Guilliams, Larry Hack, David Hartmann, Paul Hiffmeyer, Brad Kaye, Hannah Loflin, Sheri Lundberg, Preston Mack, Lauren Marshall, Suzan Najjar, Ali Nasser, Donald Newell, Gregg Newton, Jeff Nickel, Larry Nikolai, Kaitlyn Patterson, Kent Phillips, Jerome Picoche, Brad Ringhausen, David Roark, Brian Sandahl, Cary Severn, Chris Sista, Matt Stroshane, Joshua Sudock, Garth Vaughan, Marc Veillard, Stacy Wieckowicz, Tim Wollweber, Ian Yater, Diana Zalucky, and others, particularly from the early years, whose great work lives on in Disney's photo archives but whose names we were unable to identify.

This book's producers would like to thank Alicia Chinatomby, Alison Giordano, Andrew Sansone, Dania Kurtz, Danny Saeva, David Jefferson, David Stern, Debra Kohls, Denise Brown, Ed Ovalle, Elke Villa, Fanny Sheffield, Jeffrey Epstein, Jennifer Black, Jennifer Chan, Jessie Ward, Juleen Woods, Ken Shue, Kevin Kern, Kori Neal, Lia Murphy, Lynn Waggoner, Mary Ann Zissimos, Matt Moryc, Megan Speer, Meredith Lisbin, Michael Freeman, Michael Jusko, Mike Buckhoff, Monique Diman, Nancy Hickman, Nicole Carroll, Pat Van Note, Rachel Rivera, Rudy Zamora, Sara Liebling, Scott Piehl, Seale Ballenger, Terry Downes, Tim Retzlaff, Vanessa Hunt, Vicki Korlishin, Warren Meislin, Winnie Ho, and Zan Schneider.

ISBN 978-1-4847-4701-8
FAC-039745-21137
Printed in South Korea
Reinforced binding
First Hardcover Edition, October 2020
10 9 8 7 6 5 4

Visit www.disneybooks.com

THE OFFICIAL DISNEP FAN CLUB

Holiday Magic

at the Disney Parks

Graham Allan • Rebecca Cline • Charlie Price

Disney's Hollywood Studios
2017

EDITIONS

Los Angeles • New York

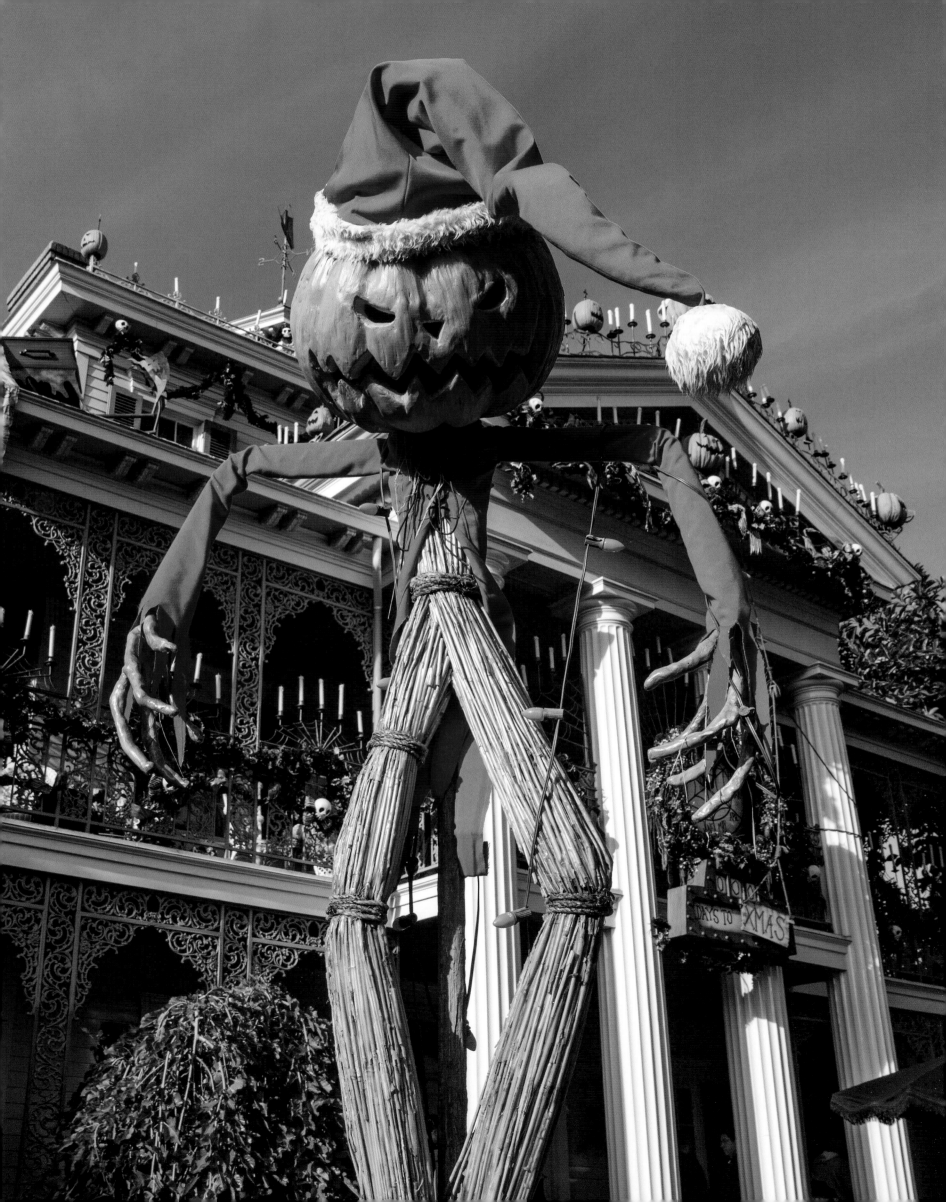

Contents

Disneyland
2018

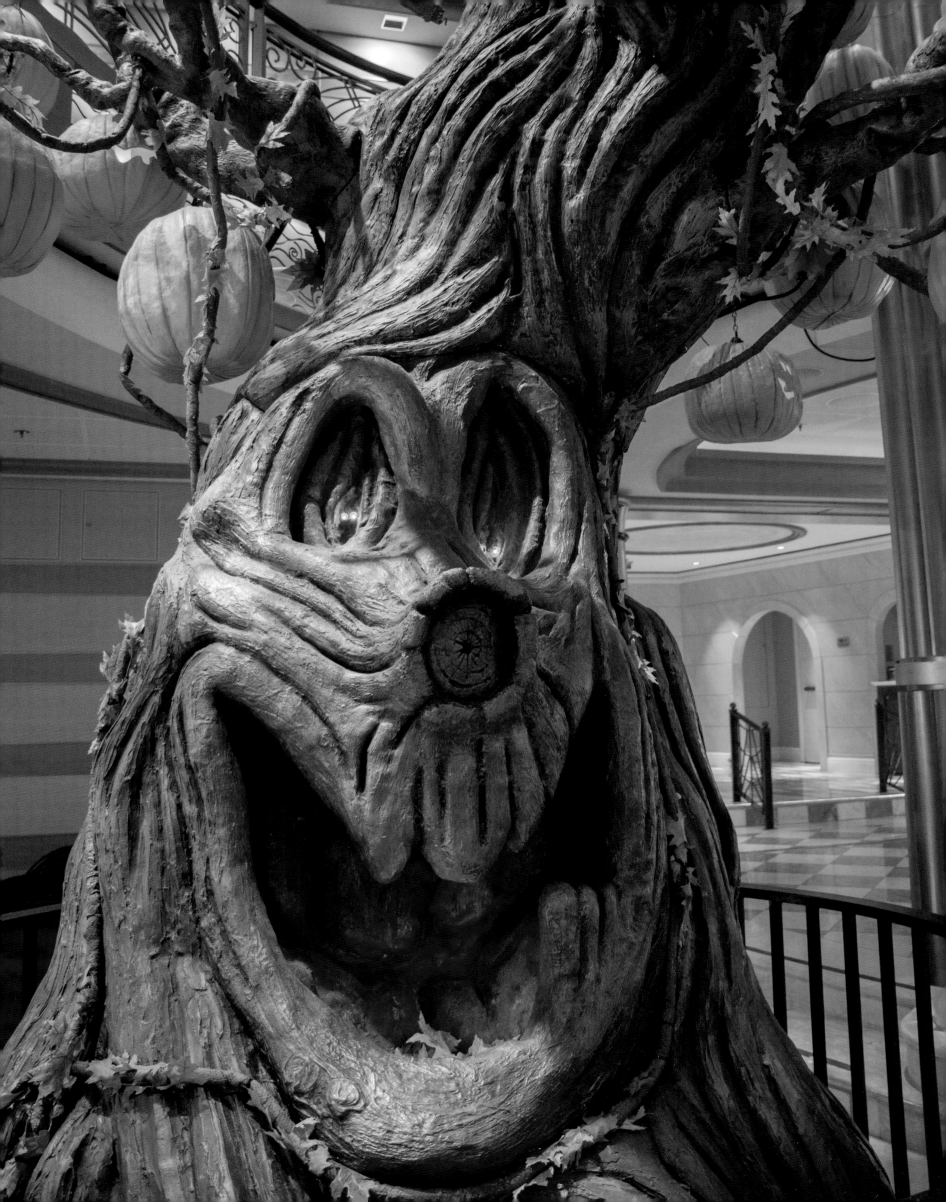

Introduction

"Does your heart hold the magic of the holidays? Is it filled with warm memories just waiting to be discovered again? Well, now is the time to open your heart, believe in that magic, and remember those treasured moments. Oh, they're still there, deep within you, waiting to touch you once more. So come along, as the magic of the season leads the way."

Those words open the Believe . . . in Holiday Magic fireworks spectacular show in Disneyland, and encapsulate the vision for this book rather nicely, too. The fall and winter holiday seasons are, somehow, more than the individual feasts we celebrate—they are an exceptional concoction of feelings, dreams, hopes, reawakened memories, and (perhaps more than at any other time of year) the renewal of traditions. Sounds a bit like the Disney park experience already, doesn't it? Disney magic and holiday enchantment blend very smoothly—and the resulting cocktail has been delighting Guests for decades.

With twelve theme parks and dozens of resort hotels, plus numerous cruise ships, dining venues, and shopping districts, and more than six decades of holiday experiences to look back on, it has been quite a challenge deciding what to include. That's a lot of pumpkins to cover, and hundreds of Christmas trees to reflect upon, too—from the smallest, at just four inches, to the very tallest at a Disney property (at seventy feet). We have packed in as much as we could: all of the locations; the most significant historical holiday events; the biggest parades, stage productions, and nighttime spectacles; and special holiday menu offerings. Only a few of our own favorites eluded us; we could not find a good photograph of the unique Christmas tree from the opening year in Disney's Animal Kingdom Theme Park, for example.

Like us, you will have your special memories from past holiday visits—and traditions you return to Disney for each year! We certainly hope you will find many of those favorites covered in the pages that follow. So, to evoke those treasured memories most effectively, we have made a conscious decision to use pictures more often than words. The amazing artists and designers who have and continue to create Disney's decorating magic are telling their holiday stories visually, so we have done the same here as well, retelling those tales with as many photographs as we could squeeze in—almost 1,900 of them between the covers.

We are greatly indebted to the photo librarians and archivists all around The Walt Disney Company who allowed us to explore their vaults and pluck the tastiest images in their respective collections for inclusion here. We spent many pleasant hours thumbing through literally thousands of historical slides (most of which have not been looked at in years); as we were mining those wonderful treasure troves of bygone times, we have tried to pick an array of images not seen before—or at least not seen in quite a long time.

Almost two thirds of the photographs here, though, were taken just for this book. We have visited every Disney park and resort around the world to see their holiday presentations firsthand, to snap many, *many* pictures, and, wherever possible, meet the talent behind it all. We flew more than 180,000 miles and took eighty thousand photographs on behalf of this worthy endeavor. A rather pleasant excuse to be globe-trotting, even we must say, although we found ourselves wishing the Halloween and Christmas seasons could last a little bit longer!

Whether from an archive or from our own photo shoot, the visuals we have chosen illustrate, as much as possible, the decor, parades, and performances from a Guest's perspective during operating park hours, to make this as close as possible to your own experiences. Only in a handful of cases did we need to sneak in after hours—mostly for attraction interiors, which would have been difficult to photograph during the day without impeding operations. For some parades and fireworks shows, we were fortunate to get help from the entertainment and media relations teams, too; they let us set up our cameras in just the right spot. Otherwise, what you see here is pretty much the perspective any park Guest would have.

Disney Cruise Line ship, Disney Dream 2018

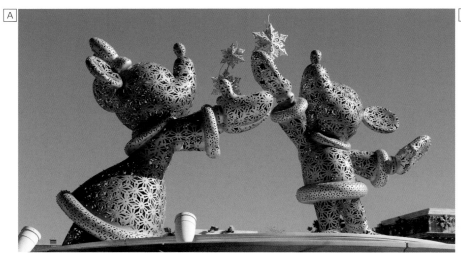

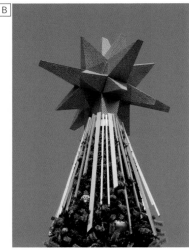

A *Tokyo DisneySea*
Waterfront Park
2017

B *Hong Kong Disneyland*
Town Square Christmas
tree
2018

C *Disneyland*
It's a Small World
Holiday
2018

D *Shanghai Disneyland*
Gardens of Imagination
2017

E *Disney Springs,*
Walt Disney World
Christmas Tree Trail
2018

F *Disneyland Paris*
Fantasyland courtyard
2018

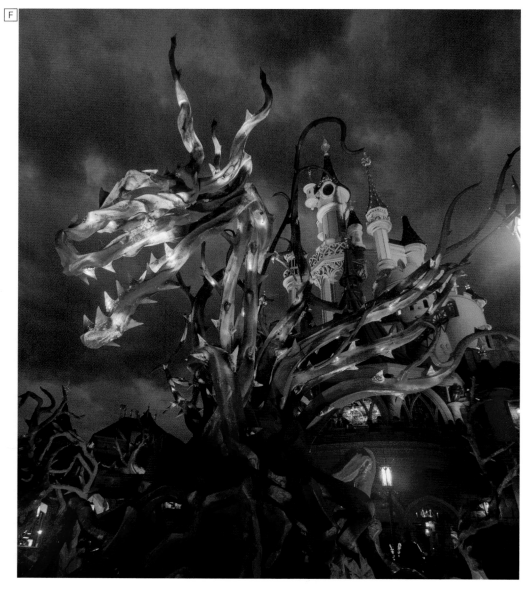

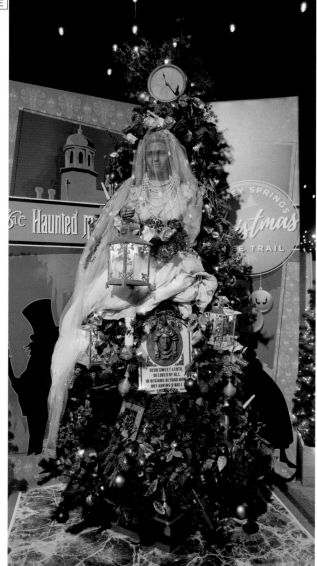

Try as we might, though, it's impossible to create a book like this without being a little bit out of date by the time the presses roll—and it's published. Disney parks are always changing, and the current holiday celebrations are no exception. As you leaf through these pages, much of what you will see is already history, even the pictures taken quite recently—the decor at that location having been refreshed or the parade updated. A show that we talk about as current may, by now, have closed. We have noted the year each photograph was taken; and where we have found good images of the same setting through the years, we have included them so you can see how it has changed.

One final thought before we scan our tickets and head through the turnstiles: we want to acknowledge the many, many people involved in bringing Disney's seasonal magic to life. Every parade or show requires dozens—sometimes hundreds—of creative magicians both onstage and off. And each decoration is chosen carefully to fit the theme and story of a location, placed on its tree or garland by craftspeople backstage; installed onstage, maintained, and, yes, disassembled, by small armies of technicians (usually at hours of the night few of us want to acknowledge people are working hard); and then cleaned, prepared, and stored for next year in vast warehouses out of sight by unsung employees. We were privileged to meet many of them. All are gifted, talented people, endlessly passionate about the holiday magic they create. It has to be said that they also seem to be having an awfully good time—for those who love the holidays, working on them all year long might be a dream job! We would usually ask if the novelty of Christmas . . . or New Year's . . . or Hanukkah ever wore off? And the answer was invariably "definitely not."

"During this glorious time of year, there is one message that rings out around the world in every language. 'Peace on earth, goodwill to men' is a wish to hold in our hearts throughout each passing year. A gift of immeasurable value. A treasure to be handed down with care from generation to generation. And so, our holiday wish is that everyone, everywhere, share in the spirit of the season. Peace on earth, goodwill to men."

Walter Cronkite as the narrator of Holiday IllumiNations, EPCOT, 1994

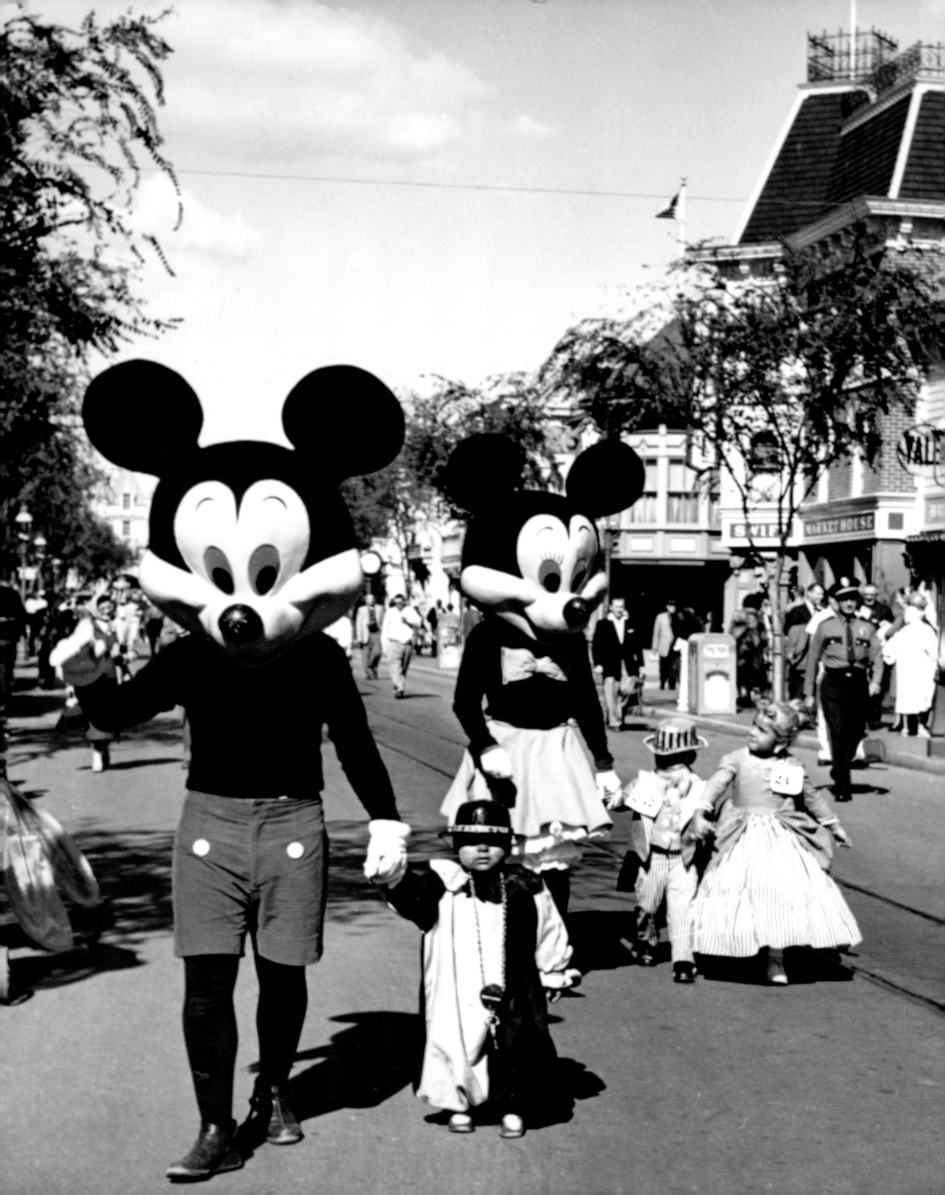

Bygone Fall Traditions

Pumpkins, pigskin, pilgrims, and jazz from the early years of Disney parks

Today at Disney parks around the world, the fall holiday spirit abounds with a swirl of autumn colors, spicy scents, warm, comforting foods, and (perhaps most excitingly) the spooky thrills of family-friendly Halloween chills. Walt Disney dreamed up special Halloween treats for his audience even in the years *preceding* the opening of Disneyland in 1955.

In a piece of marketing serendipity, the Anaheim Chamber of Commerce reached out to Walt Disney Productions in 1953, inviting the studio to participate in their highly popular annual Anaheim Halloween Parade. Unbeknownst to the Anaheim committee, Walt had recently identified the city as the location for his brand-new theme park, and he jumped on the opportunity to share some Disney magic with the people of that community—even prior to the public reveal of the project (we know today as Disneyland). The committee was thrilled when Walt offered the talents of his studio artists to design six floats based on classic Disney stories; he also committed to sending performers, including fabulous Disney characters.

Approximately one year later (shortly after plans to build Disneyland had been announced), Walt, on April 2, 1954, again offered to participate in what would be the thirty-first annual Anaheim Halloween Parade. This time he asked Imagineer and Disney Legend Yale Gracey to design six new floats based on attractions that were under development for the park, including Sleeping Beauty Castle, the *Mark Twain* Riverboat, the Casey Jr. Circus Train, a Tomorrowland rocket, and even a float inspired by the True-Life Adventure nature film series.

In October 1955, with the park having opened a few months earlier, Disneyland participated in a very big way by having the newly organized Disneyland Band, under conductor Vesey Walker, march in the parade, followed by the brand-new Mouseketeer stars of the *Mickey Mouse Club*, who rode in a restored antique circus wagon. Disneyland continued to be involved in the annual celebration in various ways for many years afterward, including major participation in a 1973 special golden

version of the Halloween festivities that celebrated both the beginnings of Anaheim's parade and The Walt Disney Company itself in 1923.

It wasn't until four years after Disneyland opened that it hosted a Halloween event. That event was the charmingly homegrown Parade of the Pumpkins, held October 31, 1959. "There'll be pumpkins, pumpkins everywhere this Saturday morning in Holidayland at Disneyland. 1,000 pumpkins and 1,000 official entry blanks for Disneyland's first Parade of the Pumpkins will be given away free to youngsters under 12 accompanied by a parent," *News from Disneyland* described in October 1959.

The momentum began on October 23, 1959, with the delivery of one thousand pumpkins, piled up near the Holidayland gate. On Saturday morning, October 24, the gates were thrown open for registration, pumpkin selection, and contest information. The following week, on Saturday, October 31, the celebration began with a hand-carved and decorated pumpkin contest in the large candy-striped Holidayland tent. Only real pumpkins were accepted, and the judging was based on the originality of design as well as the entrant's Halloween costume. The celebrity judges were actor Henry Calvin, who portrayed the comic Sgt. Garcia in Disney's hugely popular television series *Zorro*; Disney animator and "Big Mooseketeer" Roy Williams, co-host of the *Mickey Mouse Club*; and television personality Don Lamond, the host of a local Three Stooges program airing daily in the Los Angeles area at the time.

Following the pumpkin judging, the contestants carried their entries into the park, where they lined up in three age groups—ages nine to eleven, six to eight, and those who were under six. Then the kids excitedly paraded with their pumpkin creations down Main Street, U.S.A. to the thrilling sounds of the Disneyland Band. Each group was led by one of the Three Little Pigs carrying a sign. Chip and Dale followed carrying signs announcing the judges, who were riding behind in a Disneyland vehicle. For the grand finale, Mickey and Minnie Mouse also joined the fun.

Disneyland Parade of the Pumpkins 1959

The parade ended in Fantasyland at the Mickey Mouse Club Theater, where the prizes were awarded. A sweepstakes winner in each age category was announced and the top prizes were a Gym-Dandy surrey (a child-sized two-seater canopied pedal car), an electric train, and a bike. Runners-up in all three groups received, respectively, cameras, watches, and board games. After the prizes were awarded, each contestant and a chaperone were admitted to Disneyland for the day without charge. They also received free admission to the Mickey Mouse Club Theater for any showing of the Disney shorts *The Legend of Sleepy Hollow* and *Trick or Treat*, which were screened all day to celebrate the holiday.

As charming as the 1959 "kiddie parade" must have been, Walt and the Disneyland event planners found that the city of Anaheim celebration, which attracted over 250,000 attendees by 1960, covered their needs when it came to hosting a local Halloween event. So, Disneyland did not celebrate Halloween again at the park until it featured a Halloween Festival Parade in 1968.

The next Disney park Halloween events were in Florida and part of the Magic Kingdom, as early as 1972, when a Halloween Weekend of activities (including a show and parade) was presented. The Halloween Spooktacular Party, held in 1973, and a Halloween Weekend & Ghostly Characters Parade, in 1974, followed. Specific Halloween celebrations did not return to Disneyland, however, until 1995, when Mickey's Halloween Treat debuted at the park.

But there were many other classic autumn celebrations in Disneyland during its infancy. Those special annual "fall" events included Horseless Carriage Days (from 1955 to 1960) and a special Steamer Car Meet and Parade that was held in 1958. Patriotic events were held at the park almost from the beginning, starting with a Veterans Day remembrance in November 1956 that featured an American Legion Activities and Parade event. This was followed in 1957 with a special Veterans Day Show with Spin and Marty featuring actors Tim Considine (as Spin Evans) and David Stollery (as Marty Markham) of the *Mickey Mouse Club* serial *The Adventures of Spin and Marty*. The three-day event saw the young actors board a Disneyland horse-drawn streetcar each day in Town Square and follow the Disneyland Band down Main Street, U.S.A. to the Plaza Gardens (now home to Fantasy Faire), where they signed autographs.

Through the following years, Disneyland offered special salutes to US veterans with its evening Flag Retreat Ceremonies, which were often coordinated with concerts by the Disneyland Band. In 1968, an inspirational flag-raising ceremony was held at the Town Square with a color guard composed of military personnel and veterans. The highlight of the rite was a "winged salute" of two hundred trained pigeons that flew down Main Street, U.S.A. to spiral the flag standard before retracing their route. This special ceremony was followed by the first Disneyland parade held to salute the nation's former servicemen. The pageantry of the Red, White and Blue parade included troops of the Orange County (California) Boy Scouts carrying American flags, several drum and bugle corps, the Disneyland Marching Band, the Delta Ramblers Dixieland band, and twenty-eight of Disney's most famous characters, led by Mickey Mouse.

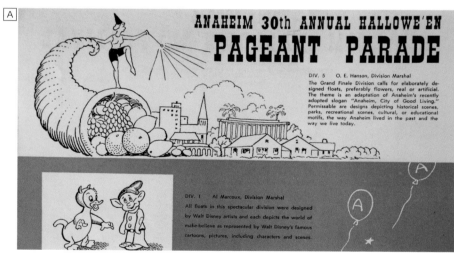

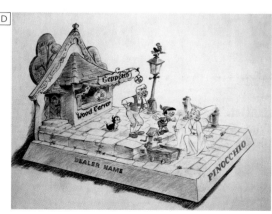

Anaheim Halloween Parade

A *Flyer*
1953

B *Peter Pan float*
1953

C *Pinocchio float*
1953

D *Concept artwork*
1953

E F *Yale Gracey concept artwork*
1954

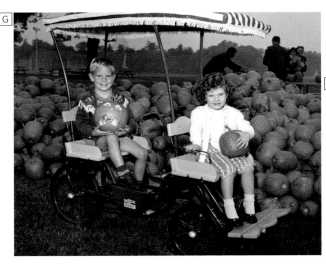

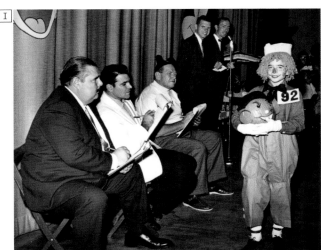

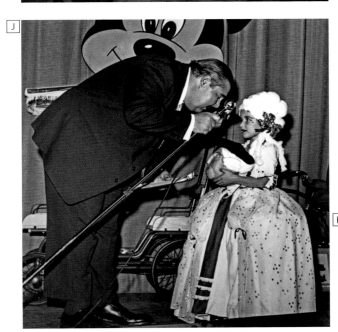

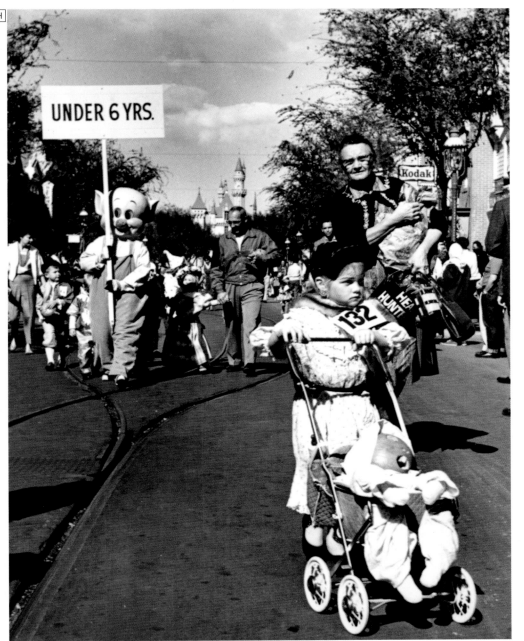

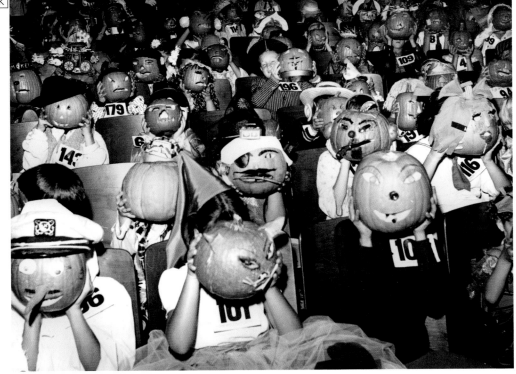

Parade of the Pumpkins,
Disneyland, 1959

G Pumpkins ready for Guests to select, along with first prize "Gym-Dandy Surrey"

H Parade on Main Street, U.S.A.

I Pumpkin and costume contest at the Mickey Mouse Club Theater, with judges Henry Calvin, Don Lamond, and Roy Williams

J Henry Calvin interviews a contestant

K Contestants seated in the Mickey Mouse Club Theater

The fall celebrations also included music-based events such as the charmingly odd Piano Teachers Day event and parade in 1959 and notable offerings for country music fans, with 1967's Country Music Jubilee and 1971's Country Spectacular. An autumn favorite with teens, Sadie Hawkins Day, was celebrated at the park with Date Nite dancing.

But probably the most fondly remembered musical events were the incredible jazz concerts that floated down the Rivers of America in Disneyland every September and October. In 1960, for example, the park presented its First Annual Dixieland at Disneyland. This special ticketed event featured six of the world's best Dixieland bands in a one-hour Salute to Dixieland production. The show celebrated the full range of jazz, from New Orleans and Chicago styles to the Blues and Big Dixie, and even to the more modern sounds of the 1960s that were starting to emerge. Rafts floated gently by, carrying renowned bands such as the Elliott Brothers Orchestra, the Teddy Buckner Band, Dick Cathcart, and Pete Kelly's Big Seven, Disneyland's own Strawhatters, and Bob Crosby and the Bob Cats, with each group playing three numbers.

The highlight of the show was the Young Men of New Orleans, who were on the final raft. This special ensemble was comprised of eight legendary musicians all over the age of sixty, including Alton Purnell, one of the greatest rhythm pianists ever to come out of New Orleans, and seventy-year-old Johnny St. Cyr, considered by many to be one of the world's best rhythm-section guitarists and banjo players. Blues singer Monette Moore also performed with the band on Tom Sawyer Island. Following the bands, the *Mark Twain* Riverboat sailed in for a finale with fireworks and a rousing rendition of "When the Saints Go Marching In."

The event was such a success that it was repeated in 1961 with appearances by the Firehouse Five Plus Two (a Disney employee group that included animators Ward Kimball and Frank Thomas), legendary trombonist Kid Ory, and the "King of Jazz" himself, Louis Armstrong.

Dixieland at Disneyland continued for eight more years. In 1963, the event reached its pinnacle with a six-act Mardi Gras on the river gathering, presided over by the great New Orleans trumpet player Al Hirt as "Rex, King of the Mardi Gras." From 1965 until 1970, the main event left the river and was staged on Main Street, U.S.A. as a traditional Tailgate Ramble, with the bands playing aboard wagons in a torch-lit parade through the park to various sites, where each act would perform throughout the evening.

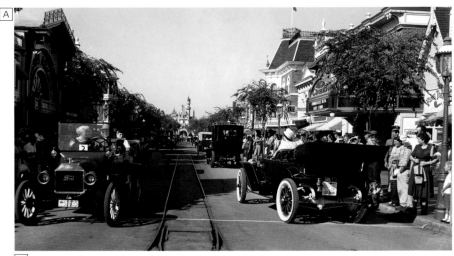

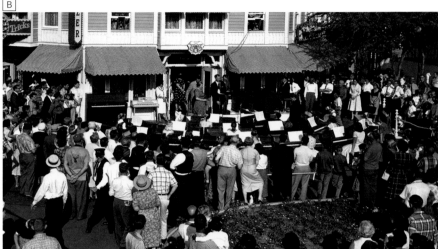

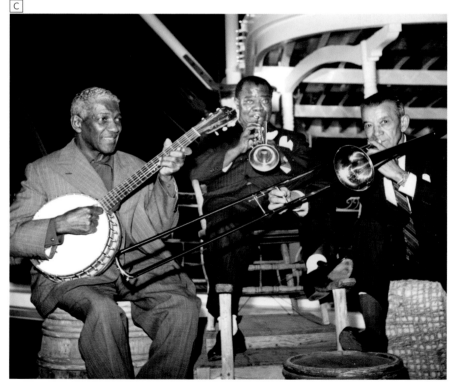

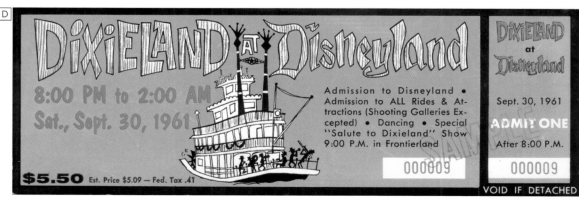

Disneyland

A *3rd Annual Horseless Carriage Parade 1957*

B *Piano Teachers Day 1959*

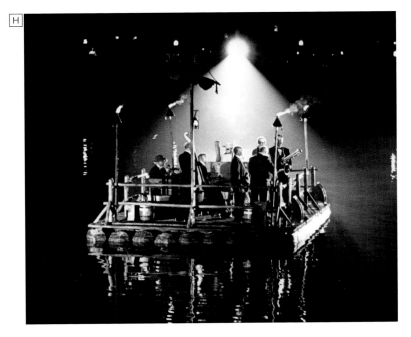

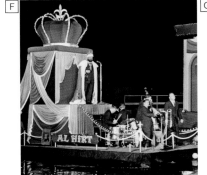

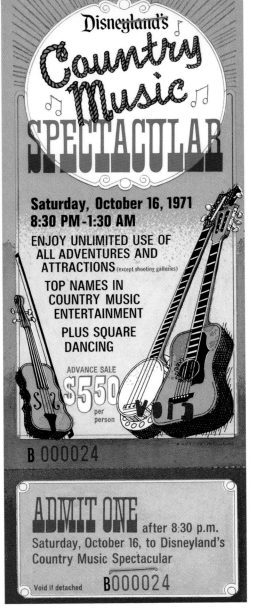

Dixieland at Disneyland

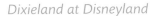

C Johnny St. Cyr, Louis
Armstrong, and Kid Ory
1961

D Event ticket
1961

E Grand Finale
1963

F Al Hirt as "Rex, King
of the Mardi Gras"
1963

G Young Men of New
Orleans
1962

H Matty Matlock's All Stars
1961

Country Music Spectacular,
Disneyland

I Event ticket
1971

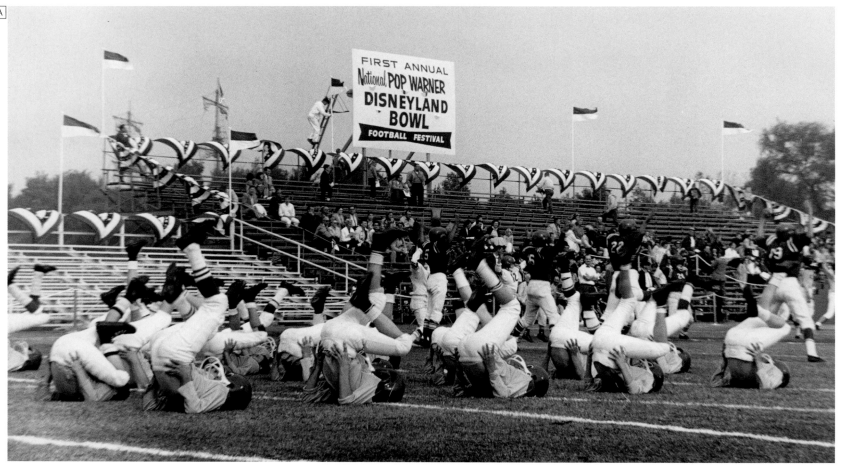

As the weather turned cooler in Southern California, people's thoughts and attention turned more toward football—but Disneyland was not to be left behind. From September 27 to November 8, 1958, Football Rallies were held in the park, mostly for younger fans, though it wasn't just high school football that was celebrated. In 1959, Walt Disney became interested in the national Pop Warner Football program and what it contributed to the youth of our nation. Pop Warner Little Scholars, better known as Pop Warner, was then (and remains) a nonprofit organization that provides structured activities in academics and in sports, such as football, to over 400,000 youths ranging in age from five to sixteen both inside and outside the United States, with an emphasis on the importance of academic success. And as in 1959, the group strives to inspire youth, regardless of race, creed, or national origin, to practice the ideals of sportsmanship, scholarship, and physical fitness as reflected in the life of the late player and coach, Glenn Scobie "Pop" Warner.

On December 19, 1959, Disneyland held its first National Pop Warner–Disneyland Football Festival in Holidayland with what the Disneyland public relations department dubbed "two hundred and forty of Southern California's outstanding young 'football stars of the future." Four twenty-minute games were held with local teams participating in the tournament: the Camp Pendleton Scrappers vs. the Redondo Beach Yellowjackets in the Pee Wee class; the Reseda Rams vs. the San Bernardino Grid Kids in the Midget class; the La Mirada Vikings vs. the Fullerton Falcons in the Bantam class; and the El Monte Meteors vs. the Westchester Giants, also in the Bantam class. A special fifteen-minute "halftime" spectacle featuring pom-pom girls, Anaheim's Western High School Band and "Silhouette" drill team, and the crowning of the Queen, thirteen-year-old Karen Beth Smukler. The official Football Festival hostess of this wonderful new sporting

event was "America's Sweetheart": Mouseketeer Annette Funicello, already a very popular recording and movie star.

The tournament was quite successful and inspired Walt to create *Moochie of Pop Warner Football* (1960)—a two-part series of the *Disneyland* television show that featured little Moochie joining a Pop Warner Football team and having trouble with the son of the town's mayor. When the two boys make amends, they help their team win the "Disneyland Bowl" and are awarded a fabulous trip to Disneyland. The show starred one of the favorite child actors of the Disney studios, Kevin Corcoran. Kevin played several different (but very similar) characters for Disney, each under the nickname "Moochie," including the three *Mickey Mouse Club* serials: *Adventure in Dairyland* (1956), *The Further Adventures of Spin and Marty* (1956), and *The New Adventures of Spin and Marty* (1957). He also appeared as Moochie Daniels in the feature *The Shaggy Dog* (1959) and as Moochie Morgan in the *Disneyland* two-part series *Moochie of the Little League* (1959).

The real-life National Pop Warner–Disneyland Football Festival was held for another two years, in 1960 and 1961, at Anaheim's nearby La Palma Park stadium. In 1960, the event was again hosted by Annette Funicello, and the main draw was a battle between the Eastern and Western regional championship teams in a game consisting of four ten-minute quarters. The halftime show was even more elaborate with additional bands, drill teams, and a boys' choir performing, and the addition of princesses to the crowning ceremony. For the 1961 tourney, the participants included local teams competing against others that traveled in from as far away as Hawaii and New York. For the festive halftime event, Disneyland arranged for twenty-two Southern California youth bands to perform A Salute to Broadway, which featured more than 1,200 musicians and four hundred drum majors and majorettes.

First Annual National Pop Warner Disneyland Bowl Football Festival, 1959

A Pre-game drills by the Redondo Beach Yellowjackets and the San Bernardino Grid Kids

B Walt cheers on the teams

C Players from the winning Redondo Beach Yellowjackets with festival hostess Annette Funicello

D Event ticket

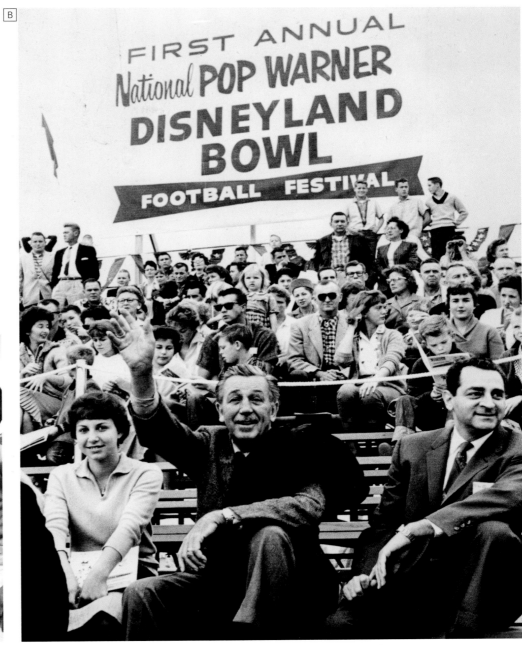

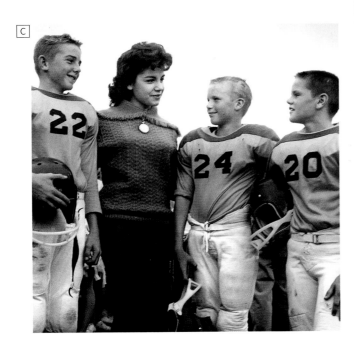

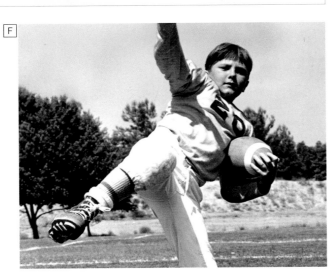

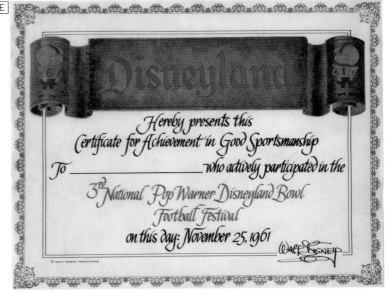

National Pop Warner Disneyland Bowl Football Festival

E Certificate of Participation 1961

F Kevin Corcoran as Moochie Morgan in Moochie of Pop Warner Football 1960

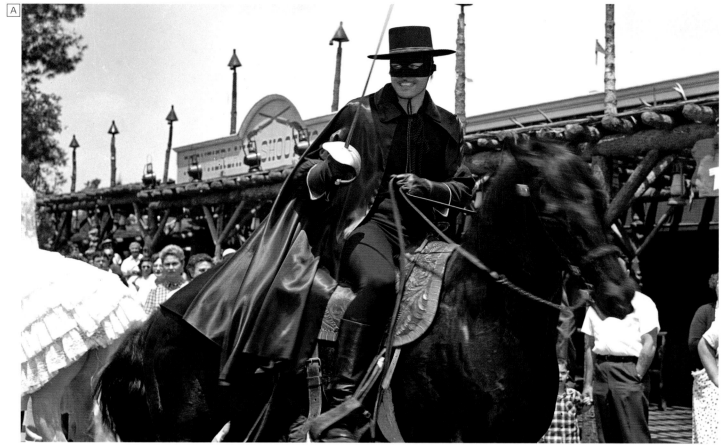

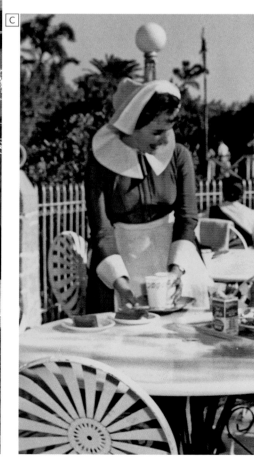

Zorro Days, Disneyland

A B *Guy Williams as Zorro*
1958

C D *Thanksgiving dinner,*
Chicken Plantation Restaurant,
Frontierland
1959

One of the most interesting autumn events in Disneyland occurred the weekend of November 27–30, 1958, as Zorro Days. The *Zorro* television series enjoyed enormous success when it launched on ABC in the fall of 1957, and with the second season, the bold renegade lead, along with his friends and foes, was invited down to the park to interact with Disneyland Guests. While there were also two prior sets of Zorro Days in 1958 (on April 26–27 and again on May 30), the November event filled three days, three times each day, with excitement. Zorro clashed in stunt duels with other skilled swordsmen and lancers, battling from the rooftops of Frontierland buildings and even chasing his adversaries overboard from the top of the *Mark Twain* Riverboat into the Rivers of America.

After vanquishing his foes, Zorro would race from the riverboat and enter The Golden Horseshoe Revue. Shortly afterward, he would join the Disneyland Band and the rest of the *Zorro* cast riding horseback in a parade from Frontierland to Main Street, U.S.A. And once each day, following the parade, there would be a stage show in Frontierland's Magnolia Park, featuring the hilarious Sgt. Garcia (Henry Calvin), Zorro's friend and companion Bernardo (Gene Sheldon), and the villainous Capt. Monastario (Britt Lomond). In the stage show, young Guests—many of whom came to the park in their own black capes and masks—had the rare opportunity to cross swords with Zorro himself (Guy Williams).

Disneyland staged the Zorro-themed event again in 1959, adding an additional gala show for Guests who wished to enjoy their Thanksgiving turkey dinner in a frontier-country atmosphere. The entire area of Frontierland bordering the river was decorated as a Native American settlement and featured seventy-five Native American performers who shared the traditional feast dances of fifteen different tribes. Complete turkey dinners were served with waitresses garbed in Pilgrim-style outfits. In 1960, Zorro Days featured the same action shows, but this time with an "Old California" fiesta theme instead of the Pilgrim feast promoted previously—with the Corina Valdez and Lilly Aguilar dance companies, equestrians, and marching bands from the Los Angeles area.

That same year, the tradition of Thanksgiving musical weekends also began at the park, with special shows featuring Annette and the Elliott Brothers rhythm band.

Two special Disneyland Date Nites for Thanksgiving weekend followed in 1964 and were dubbed the Turkey Trot. Musical performers included the Elliott Brothers playing at the Plaza Gardens, Kay Bell and the Spacemen in Tomorrowland, the South Sea Islanders in the Tahitian Terrace, and Gary Lewis and the Playboys at a dance area adjoining the *20,000 Leagues Under the Sea* Exhibit, also in Tomorrowland. This tradition of musical Date Nite entertainment for the holiday continued through 1967 and became the Thanksgiving Musical Feast in 1968, when a traditional Thanksgiving turkey dinner was added to the menus of the three major restaurants residing in the park: the Plaza Inn, Blue Bayou Restaurant, and the French Market restaurant.

Disneyland continued offering a Thanksgiving Musical Revue weekend with entertainment in various musical styles until 1984, and with the opening of Walt Disney World, the Magic Kingdom followed suit, hosting Thanksgiving revues in its earliest years, from 1971 through 1974. Shortly thereafter, Thanksgiving feasting dining opportunities became more of an option at various resort hotels. Autumnal Thanksgiving holiday activities themselves again became, as it was in the earliest days of Disneyland, the kickoff to the joys of the winter holiday season—with all of its sparkle, merriment, and delight.

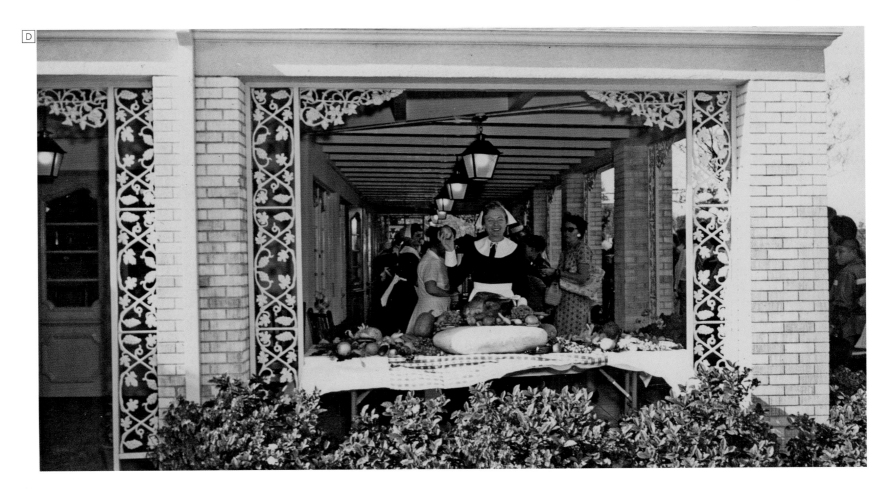

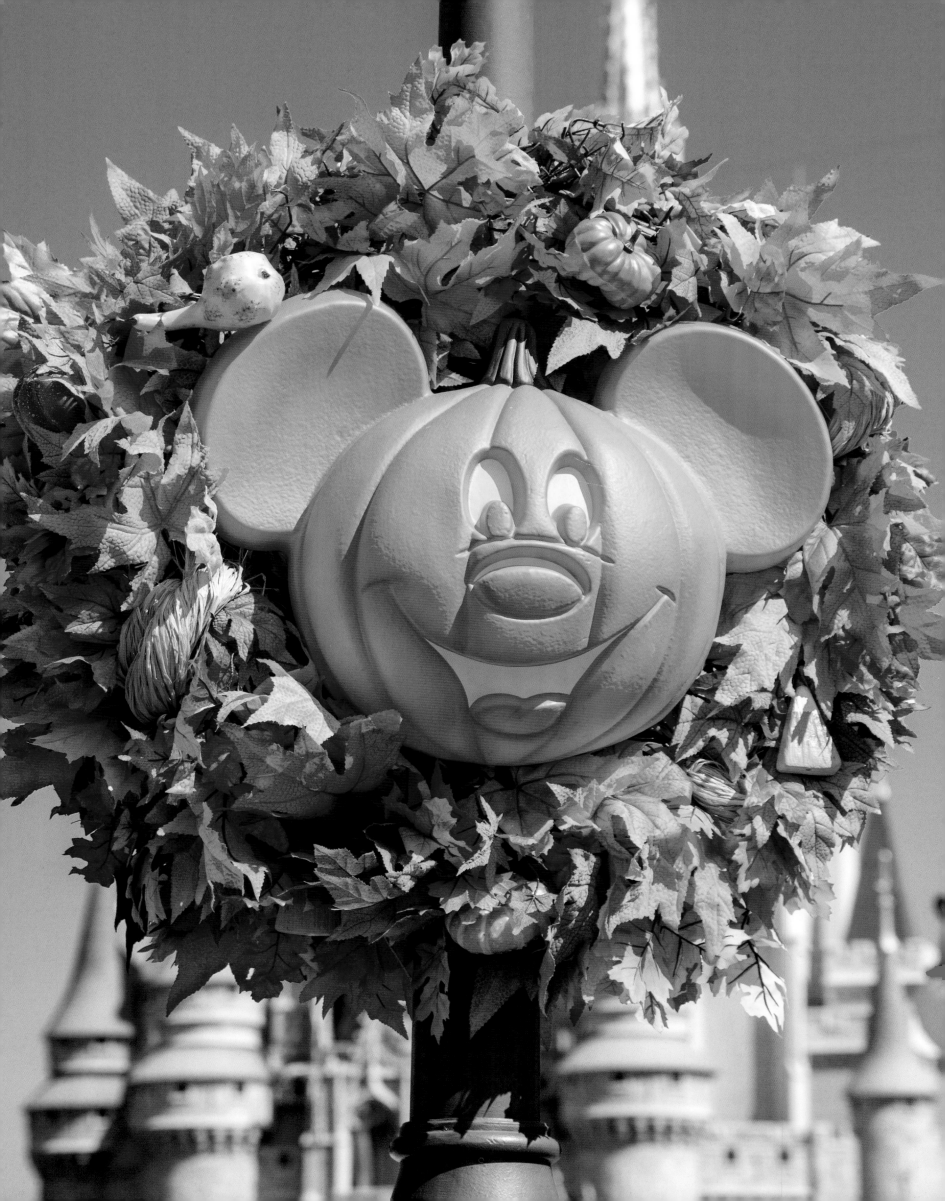

Devilish Decor

Bewitching and batty, Disney parks usher in the season of spooks and spells

There are numerous ways to celebrate Halloween, each with enticing and different aspects of mood-creating splendor and tradition. Enhance those traditions on a much grander scale and see how decorating a Disney park is a momentous task with many variables to consider: overarching themes, story, Guest preferences, and functionality play vital roles in the types of decor, food, and atmospheric entertainment that become Halloween's symphony of the senses.

With all that in mind, the creative teams at the Disney parks always start with one simple question: What does a Disney Halloween mean to *you*? Given the broad range of options, the teams then define that within the confines of a particular area to keep a cohesive feel in the parks.

What better way to start our journey into the world of things that go bump in the night than at the main gates of each park. Halloween takes on a very different feel when celebrated under the autumn sun, as opposed to a full moon, and nowhere is this more evident than at the respective entrances to Disneyland and Disney California Adventure. In Disneyland, a bountiful autumn pumpkin patch with warm fall colors featuring fabricated overgrown pumpkin renderings of Mickey Mouse and friends looms large over the main gate; it's an introduction to the Main Street Pumpkin Festival.

Across the promenade, Disney California Adventure takes a darker—yet still family friendly—tone with the ominous spell-casting silhouette of Oogie Boogie from *Tim Burton's The Nightmare Before Christmas* (1993), releasing a bevy of black bats out into the sky, shrouding it in darkness.

The iconic Floral Mickey that greets Disneyland Guests inside the front gate is one of the most photographed locations for good reason: each year the horticulture team installs a new color palette, striving to create a different look. For Halloween 2017, Mickey's face was created with Sweetunia Black Satin Petunia and Alyssum Clear Crystals that were complemented by the orange and yellow Marigold Zenith Mix scrolls. During Halloween

Magic Kingdom 2018

times, Mickey has worn a floral mask, changed his color to orange and purple, and even featured real pumpkins and gourds (which, it turns out, don't hold up so well in the hot California sun).

At Main Street, U.S.A. in Disneyland and other Magic Kingdom–style parks around the globe, there are autumn floral garlands and wreaths festooning the buildings, miniature Mickey head pumpkins adorning vintage light poles, and vibrant Spicy Cheryl Orange Mum flowers infusing optimism and energy into Town Square. Decor is constantly maintained, refurbished, and given a fresh coat of paint to keep everything looking pristine. Typically, decor is switched out every few years due to everyday usage and the sun's intense presence, which leads to a major fade factor. Window displays feature nods to goblins and ghoulies from past Halloweens, while characters adorned in festively fall attire and merchandise (and whimsical pumpkins) represent a store's proprietor.

Not to be left out, the windows along Buena Vista Street in Disney California Adventure have their own surprises. Those with a keen eye can even find a haunted gingerbread house at the bottom of the Rock Candy Mountain window. For the Resort Enhancement team, a satisfying end of the day is "a good window that has a lot of fingerprints and nose marks."

Main Street, U.S.A. decor must feel harmonious to its surroundings, but can often present its own anachronistic Halloween challenge. In a turn of the century–era setup, Halloween decor had an ephemeral quality and was arranged for onetime usage. And a delicate decoration is not feasible for six to eight weeks of everyday usage. The Resort Enhancement team finds a delicate balance of representing the essence of that era while using durable modern-day materials. This delicate balance is achieved through blending color and style. Bunting, a decorative mainstay on Main Street, U.S.A., combined with the natural colors associated with autumn and Halloween (orange, yellows, scarlets, blacks) gives a familiarity to the celebration at hand.

In Disneyland, the Main Street Pumpkin Festival is on full display with a sixteen-foot-tall Mickey Pumpkin, along with over one hundred themed playful jack-o'-lanterns lining the buildings. Be on the lookout for the Elvis-inspired pumpkin above the 20th Century Music Company. At the Central Plaza at the end of Main Street, U.S.A., character pumpkins representing the themed lands surround the *Partners* statue. Buena Vista Street trees in Disney California Adventure twinkle with purple lights and lead to the Headless Horseman, who's holding his glowing pumpkin head, atop his midnight black steed with fiery eyes and smoke-filled nostrils.

At the Magic Kingdom, the decor features the "Town Square-crows," a good-natured *contest* decorated by the proprietors of Main Street, U.S.A. The square-crow band members are dressed in iconic costumes from the Main Street Philharmonic marching band. The Halloween art director found a creative way to infuse a personal touch into the story line: the Pumpkin Mayor and the Socialite are a tribute to his parents, and the band members represent the art director and a significant other. This is one of many personal touches throughout the parks.

World Bazaar in Tokyo Disneyland routinely alters the overall theme, which is reflective throughout the land's illuminated pumpkins, window-shop dressing, signage, and tasty treats. Festive character sculptures (depicting spooky scenes with fun-filled fright) are set up near the enclosed Bazaar in the Plaza. Main Street, U.S.A. in Hong Kong Disneyland celebrates Halloween in a playful manner. Just beyond the jovial scarecrows and pumpkins are the desolate ruins of the villains lair—crumbled columns exposing a golden Jafar-ish snake with blood-red eyes, an old, discarded magic mirror that's been overtaken by nature, and a bubbling black cauldron.

Toontown in Tokyo Disneyland easily sports the most animated decor at the resort. Toontown scarecrows, vintage-inspired spooky-kitsch scalloped banners, kooky-faced pumpkins, black cats, and mischievous ghosts abound throughout the place. Westernland has a harvest hoedown outside the Country Bear Theater, with ghost musicians and pumpkins galore, while down by the railroad, cowboy ghosts and train-worker scarecrows are ready to treat Guests to a haunting good time.

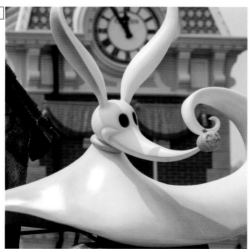

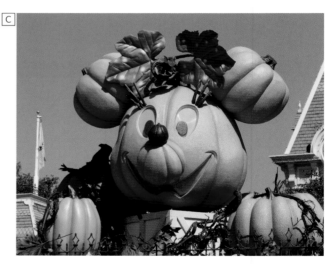

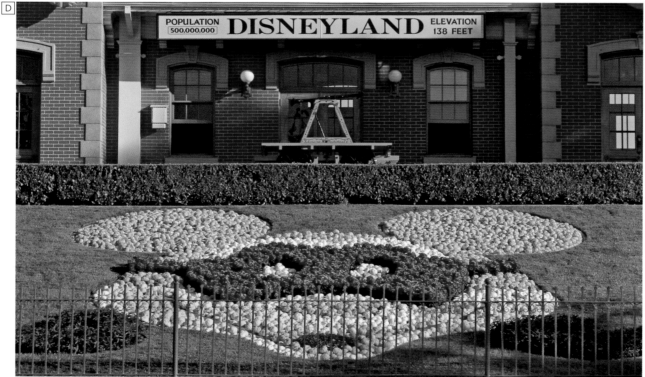

Main entrance areas

A Disneyland
2018

B Hong Kong
Disneyland
2019

C Disneyland
2018

D Disneyland
2007

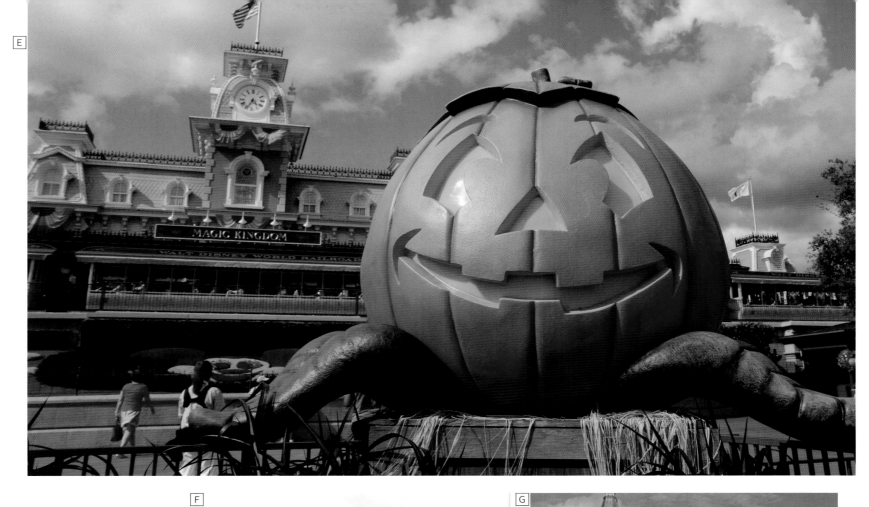

Main entrance areas

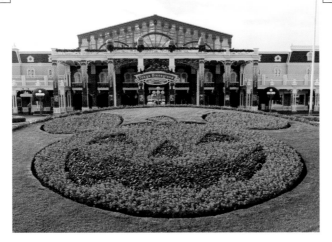

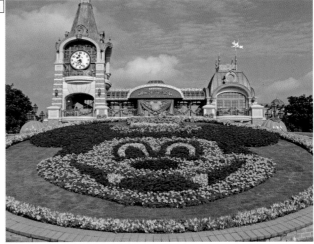

E Magic Kingdom
2018

F Tokyo Disneyland
2016

G Shanghai
Disneyland
2019

H Hong Kong
Disneyland
2017

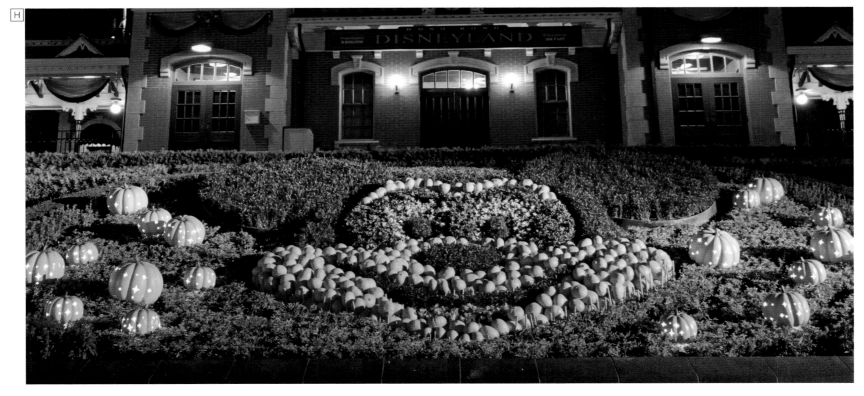

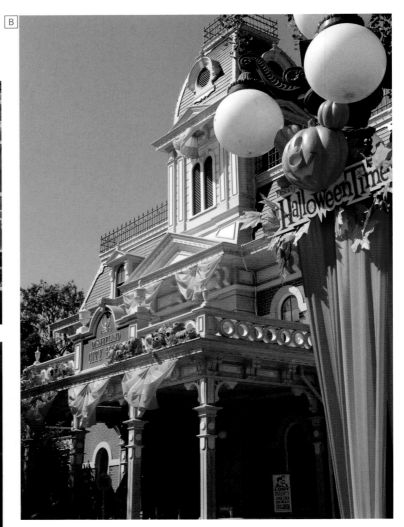

Town Square, Disneyland

A *City Hall 2017*

B *City Hall 2018*

C D *Gardens 2018*

E *Gardens 2017*

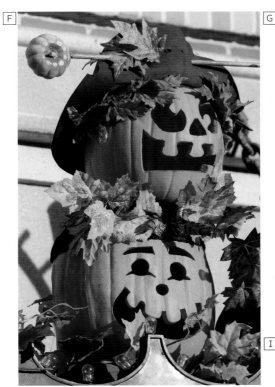

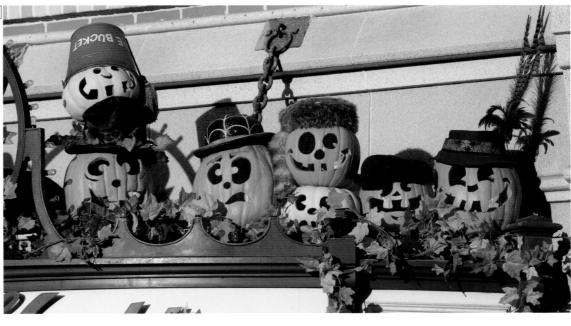

Town Square, Disneyland

F G *The Mad Hatter*
2018

H I *Opera House*
2018

J *Opera House window display*
2018

K *Disney Showcase*
2018

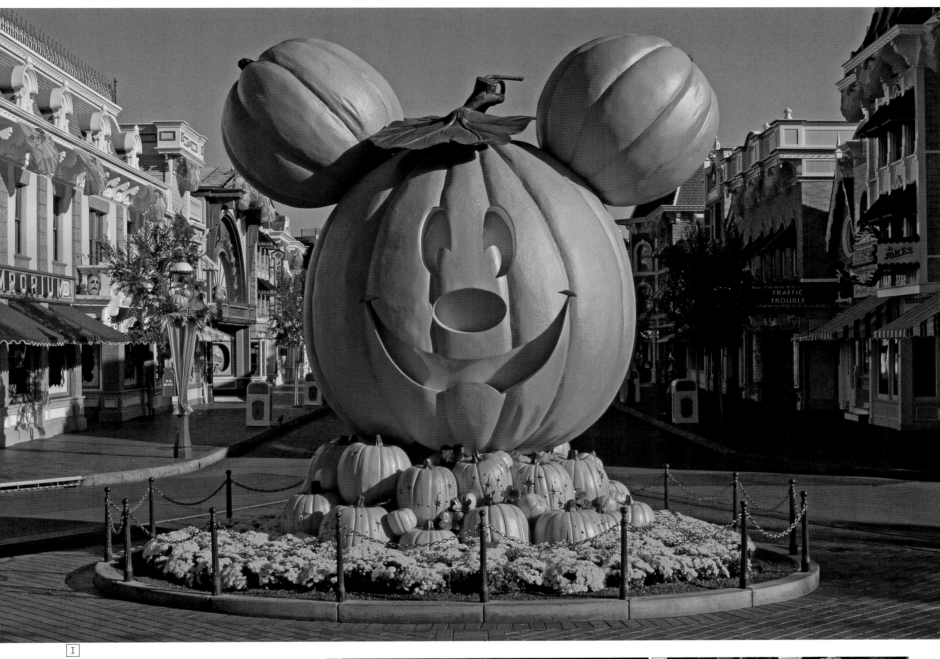

I

J

K

L

Main Street, U.S.A., Disneyland

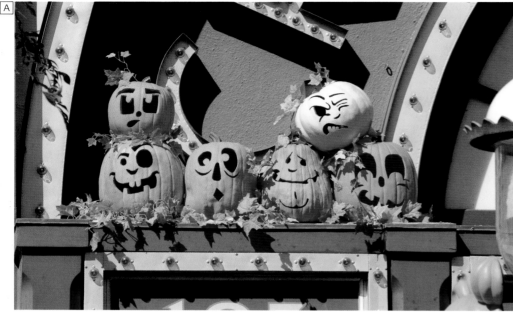

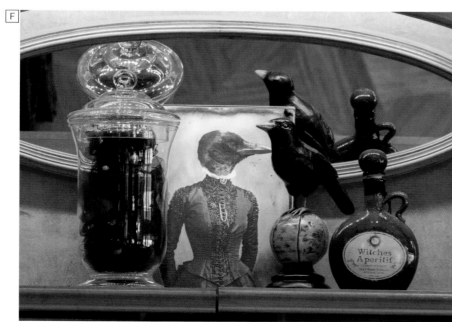

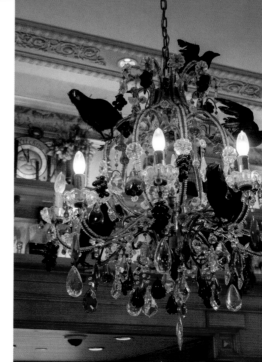

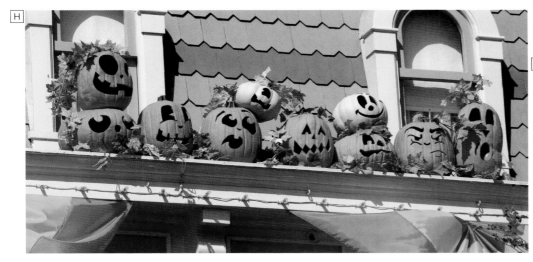

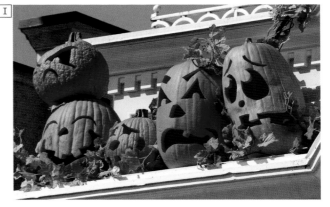

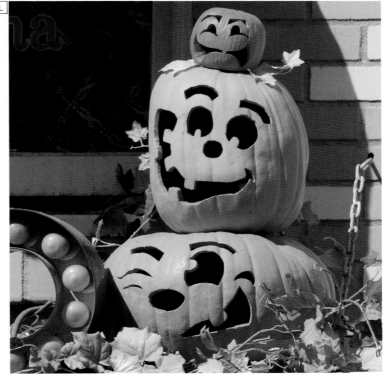

Main Street, U.S.A., Disneyland

A B *Crystal Arcade 2018*

C *20th Century Music Company 2018*

D *Carnation Cafe 2018*

E F G *Fortuosity Shop interior decor 2018*

H *Refreshment Corner 2018*

I *Candy Palace 2018*

J K *Candy Palace interior decor 2018*

L *Gibson Girl Ice Cream Parlor 2018*

M *Candy Palace 2018*

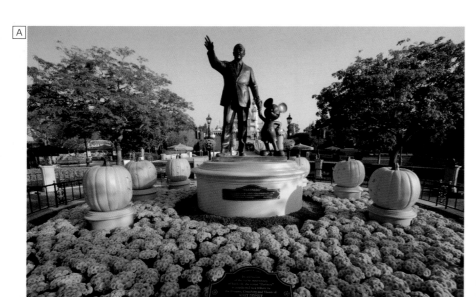

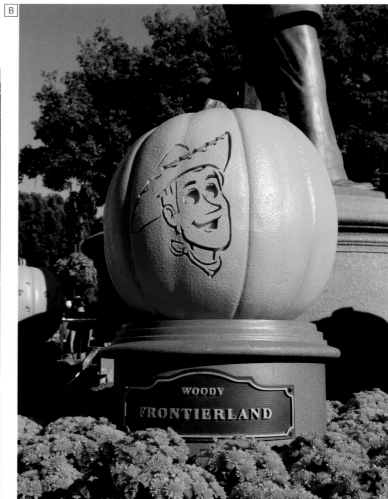

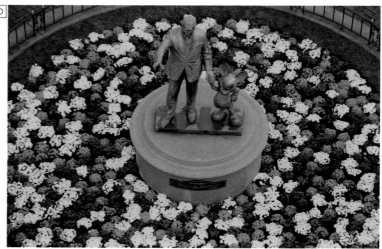

Disneyland

A Partners *statue*
2006

B Partners *statue*
2018

C *Decor detail*
2017

D *After Halloween and before Christmas*
2016

E *Sixtieth anniversary decor*
2015

F *Central Plaza*
2018

Partners *statue* ▶
2018

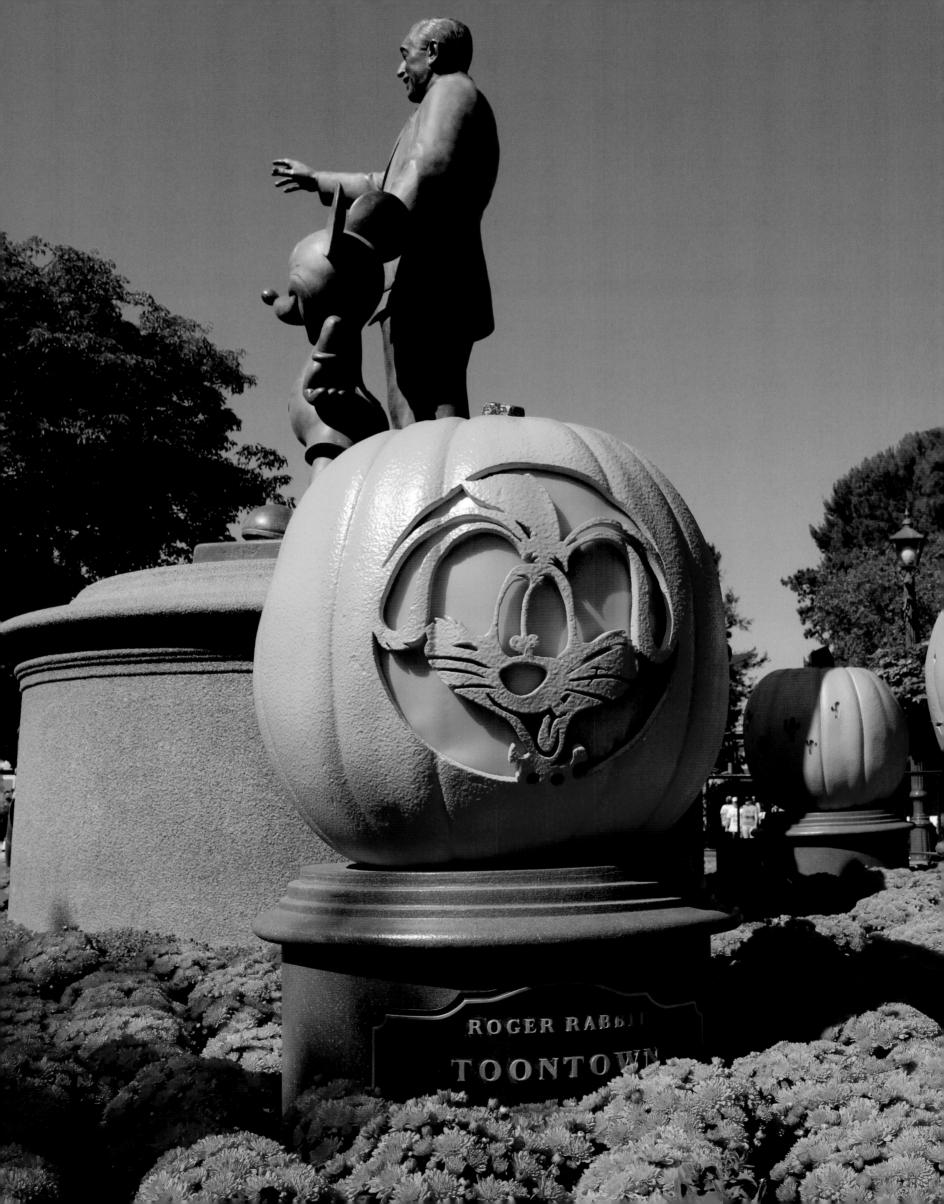

ROGER RABBIT
TOONTOWN

In Disneyland, a ghost of Halloween's past, Big Thunder Ranch's Halloween Carnival Roundup (2010–2015), once featured an array of treats and tricks. The festive fair was the perfect place to sit a spell. Inside the Scare-dy-crow Shack log cabin, old-timey 1930s decor lined the walls and cowboy pumpkin people, inspired by the look of Jack Pumpkinhead from 1985's *Return to Oz*, were ready for the hoedown. One card-playin' cowboy held the unlucky "deadman's hand." Even the petting zoo animals dressed for the occasion with Halloween bandanas. Beyond the log cabin, the autumn carnival featured magicians and the hilarious and harmonious Billy Hill and the Haunted Hillbillies, plus a creepy sideshow tent loosely based on a place in the 1983 film *Something Wicked This Way Comes*. Inside the tent, the magical expression "Higitus Figitus" conjured up a villain. While pumpkin carving was first featured on Main Street, U.S.A., one could argue that it truly found a home at the carnival when a group of parade sculptors became the Incredible Pumpkin Carvers and captured the imagination of Guests with their attention to Disney details.

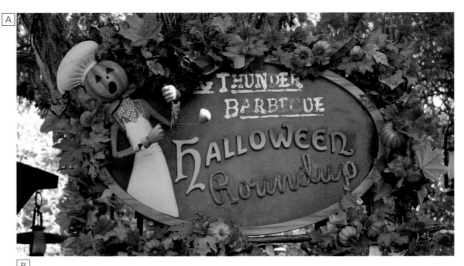

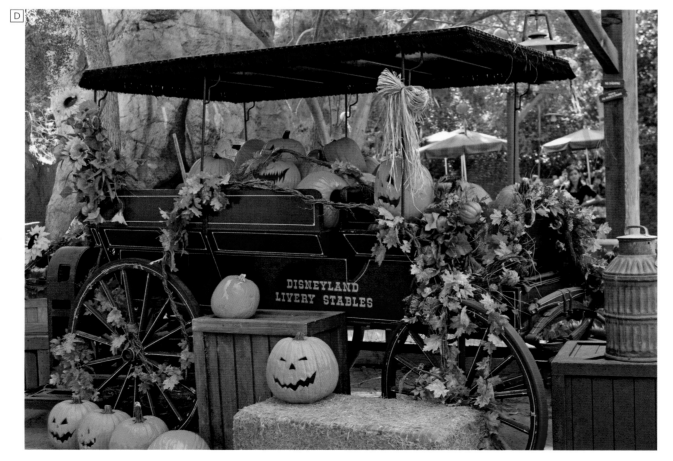

Big Thunder Barbecue Halloween Roundup, Disneyland

A 2015

B 2007

C 2015

D 2008

E F G 2014

H 2015

I 2012

Disneyland Resort

J Paradise Pier Hotel
2019

K L Grand Californian Hotel & Spa
2018

M Main esplanade
2018

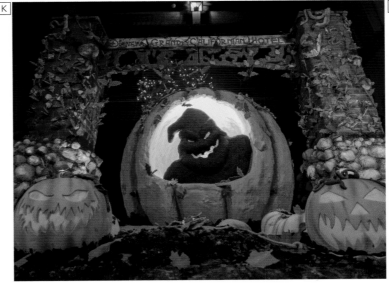

Hong Kong Disneyland

A *Main Street, U.S.A.*
2019

B *Town Square*
2019

C *Main Street Corner Cafe*
2019

D *Main Street Sweets*
2019

E F *Halloweentime*
Festival Gardens,
Fantasyland
2019

G *Main Street Bakery*
2019

H *Main entrance area*
2019

Hong Kong Disneyland Hotel

I *Main lobby*
2019

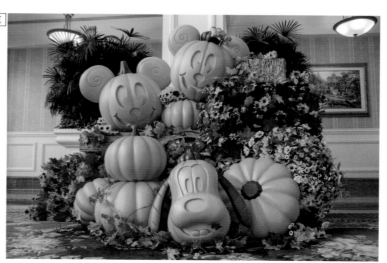

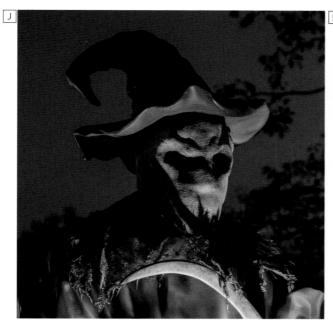

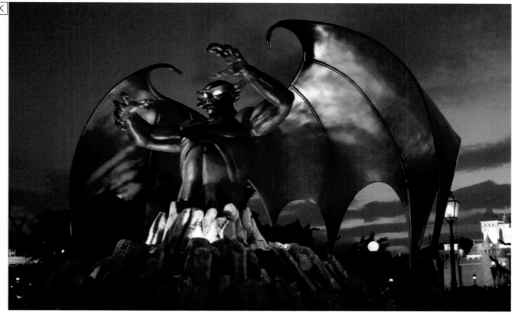

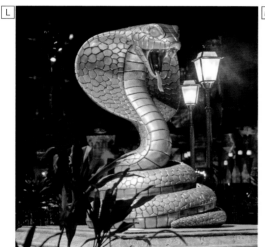

L Central Plaza
2017

M Town Square
2019

N Main Street, U.S.A.
2019

O Halloweentime
Festival Gardens,
Fantasyland
2019

Hong Kong Disneyland

J Central Plaza
2019

K Central Plaza
2017

P Toy Story Land
2019

Q Main Street, U.S.A.
2017

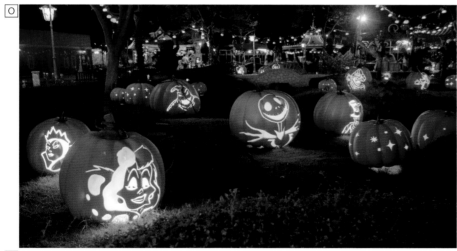

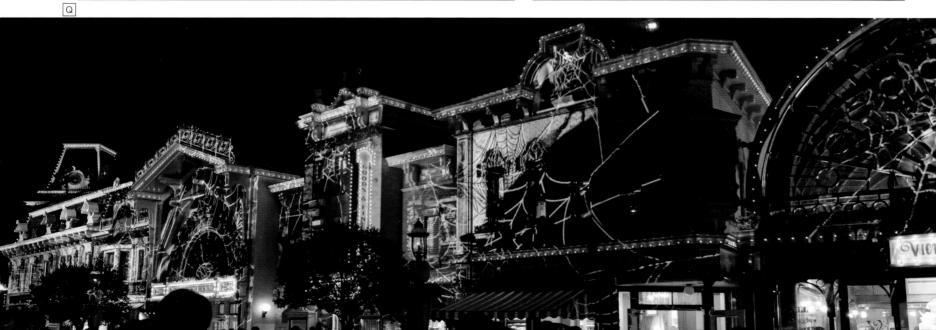

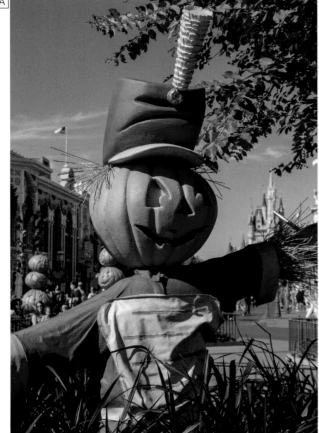

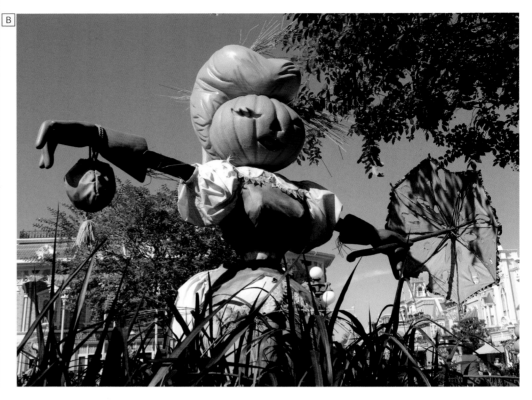

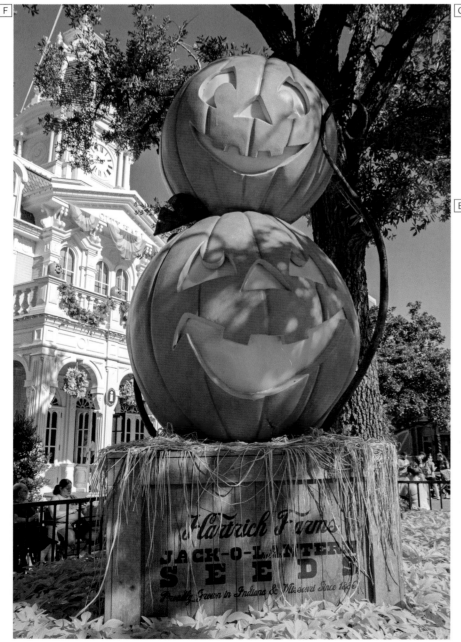

Town Square, Magic Kingdom

A B Square-crows
2018

F G Stacked pumpkins
2018

C D E City Hall
2018

H — K Square-crows
2018

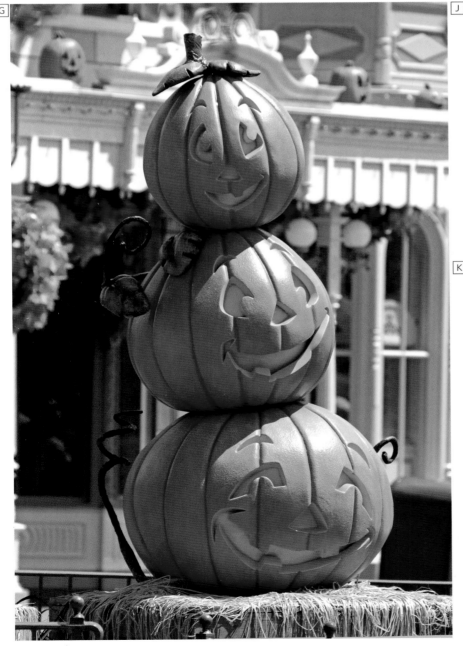

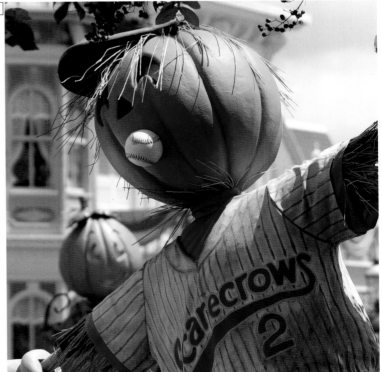

A

B

C

D
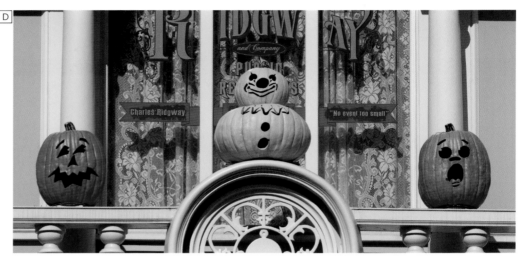

E

F

G

Main Street, U.S.A., Magic Kingdom

A — D *Emporium*
2018

E *House of Magic*
2018

F G *Casey's Corner*
2018

H *Main Street*
Confectionery
2018

I *Main Street*
Cinema
2018

J K *Center Street*
2018

L *Crystal Arts*
2018

M *Plaza Ice*
Cream Parlor
2016

N *Plaza Ice*
Cream Parlor
2018

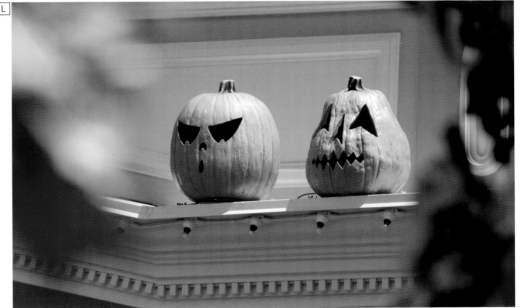

*Main Street, U.S.A.,
Magic Kingdom*

A *Emporium entrance
2017*

B *Crystal Arts
2017*

C *Emporium entrance
2017*

D *Emporium entrance
2018*

Main Street, U.S.A., Magic Kingdom

E Emporium interior
2018

F Train station
2018

G Uptown Jewelers
2018

H I Main Street
Confectionery
2018

J Uptown Jewelers
2018

K Disney
Clothiers
2018

L Main Street
Chamber of
Commerce
2018

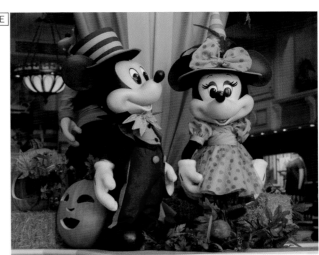

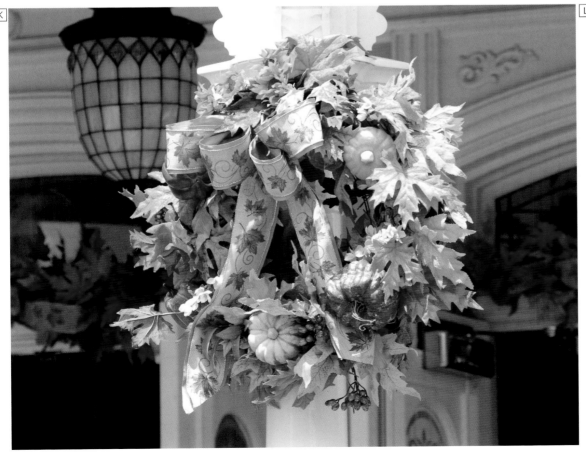

Magic Kingdom

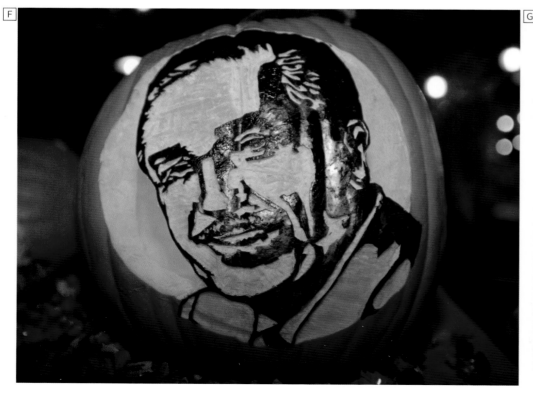

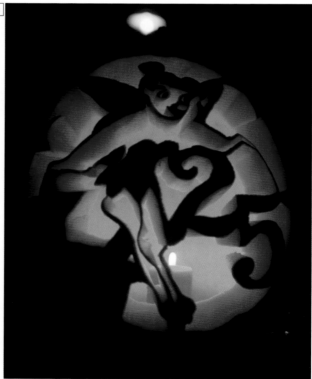

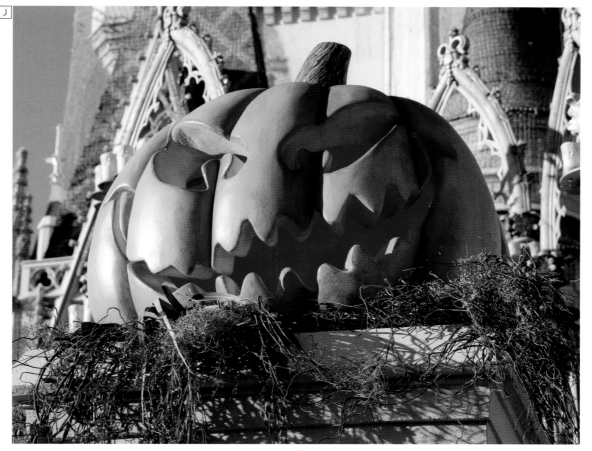

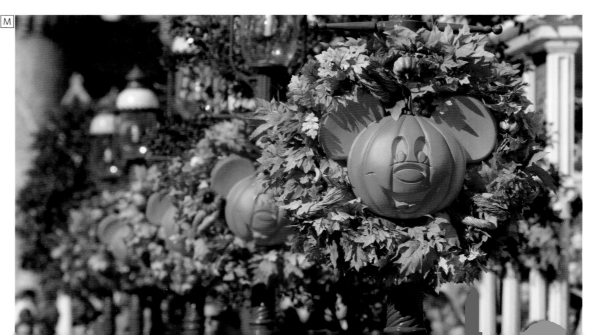

Magic Kingdom

Devilish Decor

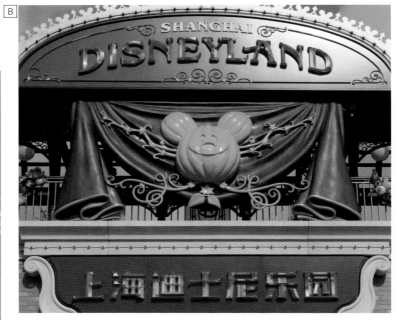

Shanghai Disneyland

A B *Main entrance area*
2019

C D *Gardens of*
Imagination
2019

E F G *Mickey Avenue*
2019

H I *Avenue M Arcade*
2019

J *Sweetheart's*
Confectionery
2019

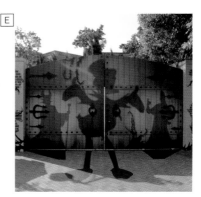

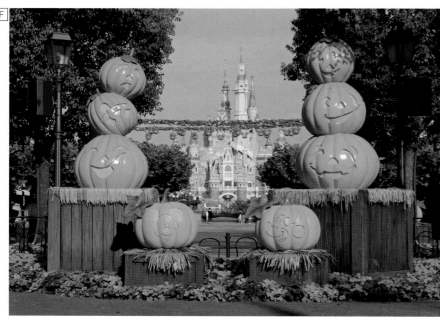

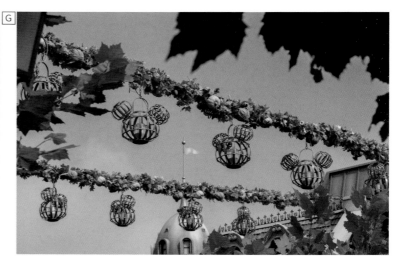

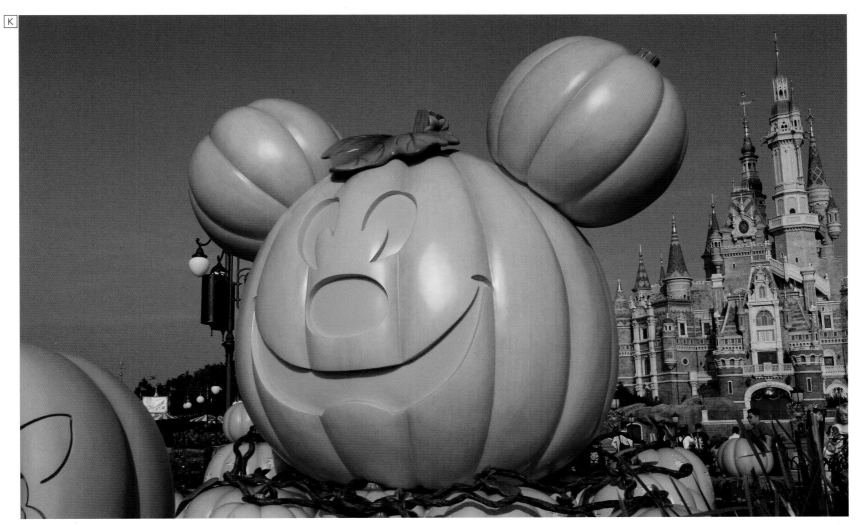

Shanghai Disneyland

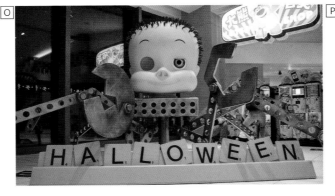

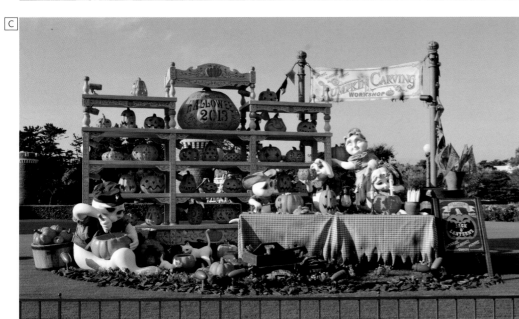

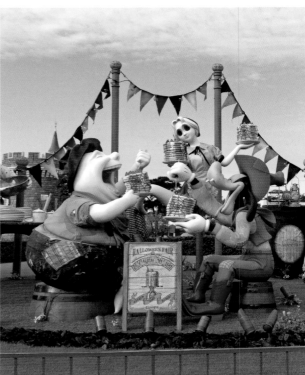

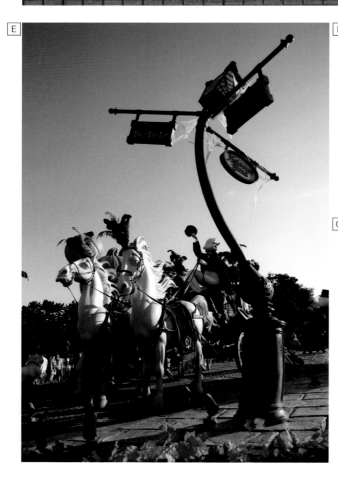

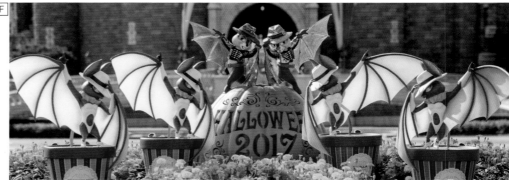

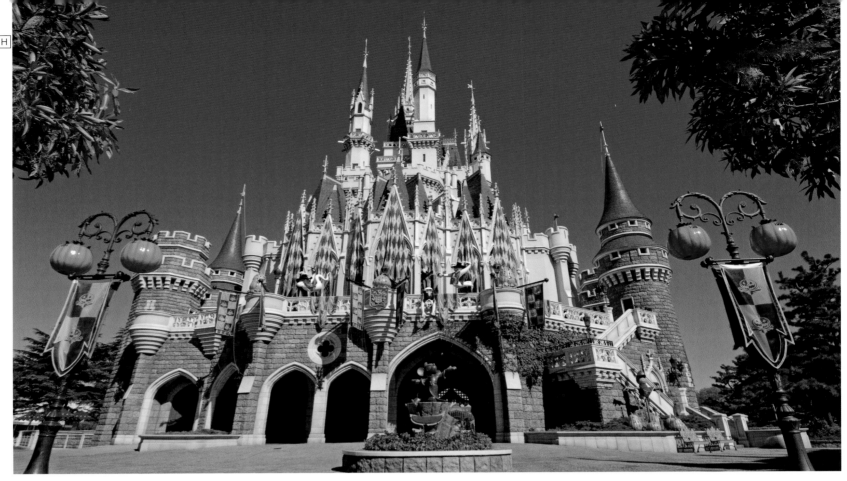

Tokyo Disneyland

A Main entrance area
2014

B World Bazaar
2017

C Plaza
2013

D Plaza
2015

E Plaza
2010

F G Plaza
2017

H Fantasyland
Courtyard
2009

I J Omnibus
2019

K Fantasyland
2009

L Dumbo the
Flying Elephant
2009

M Fantasyland
2018

N O Plaza
2019

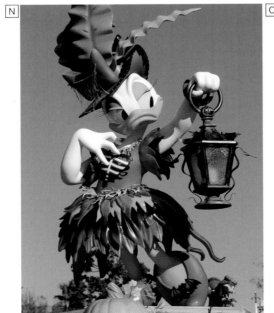

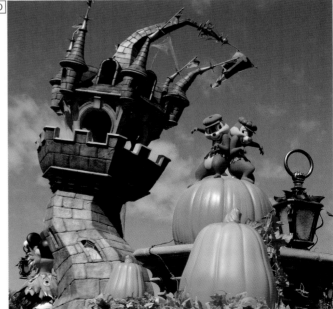

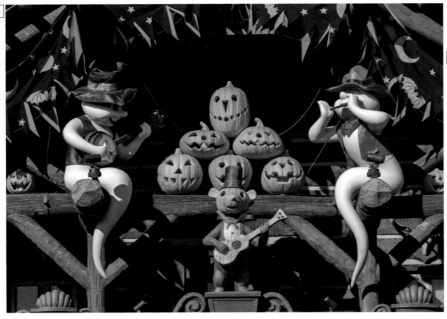

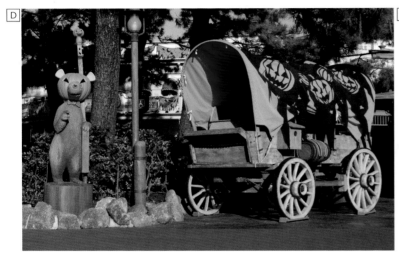

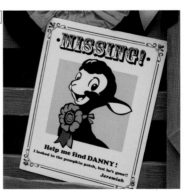

Westernland, Tokyo Disneyland

A	*Trading Post* 2013	F	*Riverboat Landing* 2019
B	*Country Bear Theater* 2019	G	*Westernland area* 2009
C	*Trading Post* 2013	H	*Western Wear* 2019
D	*Westernland area* 2010	I	*Picture Parlour* 2015
E	*Western Wear* 2017	J K	*Westernland area* 2019

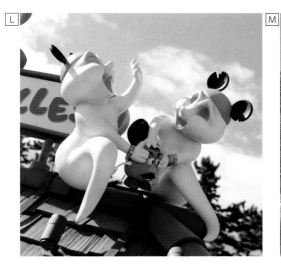

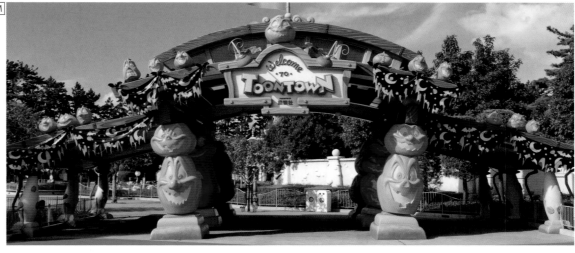

Toontown,
Tokyo Disneyland

L Jolly Trolley
 2017

M Toontown entrance
 2011

N Mickey's House
 2010

O Minnie's House
 2011

P Donald's Boat
 2019

Q Toontown
 2017

R Mickey's House
 2017

S Goofy's Paint 'n' Play
 House
 2017

T Trash cans
 2010

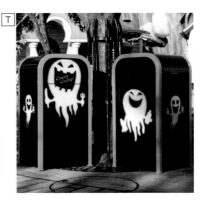

For some more vintage present-day kitsch, head over at night for a neon-filled Haul-O-Ween at Cars Land in Disney California Adventure. Displays include an old car graveyard, a mummy tractor, *Cars*-inspired movie posters (*Hocus Spokus*), a gingerbread Brakes Motel, a spider-shaped car, an *ofrenda* altar honoring the memory of Doc Hudson, and the Horn-O-Plenty harvest.

This, however, is hardly the first harvest that ever existed in Disney California Adventure: Candy Corn Acres in Sunshine Plaza (Now Buena Vista Street) featured hundreds of oversized candy corns decorating the area around Goofy's unusual candy corn farm, which featured the world's largest candy corn. At various times of the day, Heimlich, from *A Bug's Life*, could be seen munching on his favorite candy, filled with sweetness and sunshine in every bite. *Golden Dreams* became *Golden Screams*, an attraction starring the crafty, scheming, nefarious villains, where the loudest screamer, after taking the "Honorary Villains" oath, would win a Chernabog statuette.

On the outskirts of what was once The Hollywood Tower Hotel, spooky stained glass displays and a bat arch set the scene for terrifying ghost stories. Inside, a celebration of the witching hour at a thirteenth-floor Halloween Gala (2006–2008)—with 1930s stylized skulls, witches, and pumpkins—adorned the lobby that later hosted the Silverlake Sisters, who serenaded Guests into complete darkness with "Late Check-Out" (2016).

The sundown shenanigans continued even after the attraction became Guardians of the Galaxy—Mission: BREAKOUT!, with its Halloween-themed Monsters After Dark (which has provided chills and thrills since 2017). Lighting surges, shadowy creatures lurking about, and a harrowing encounter with an accidentally released fire dragon all had to be boldly taken on in order to save Baby Groot. Since music was a vital component to the attraction, the seventies punk rock music machinations from Tyler Bates were designed to work with the motion of the ride.

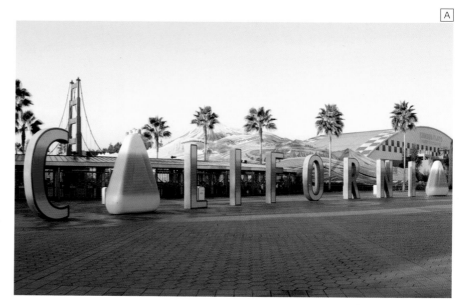

A

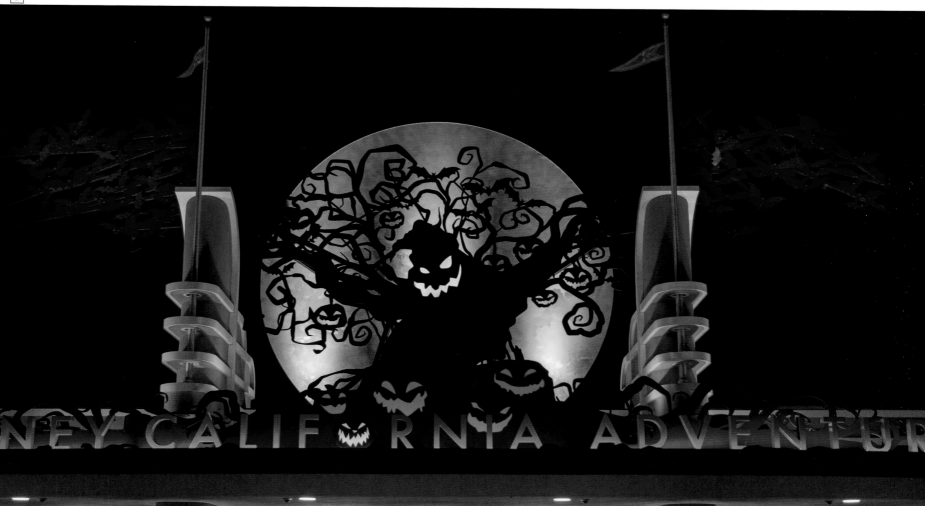

B

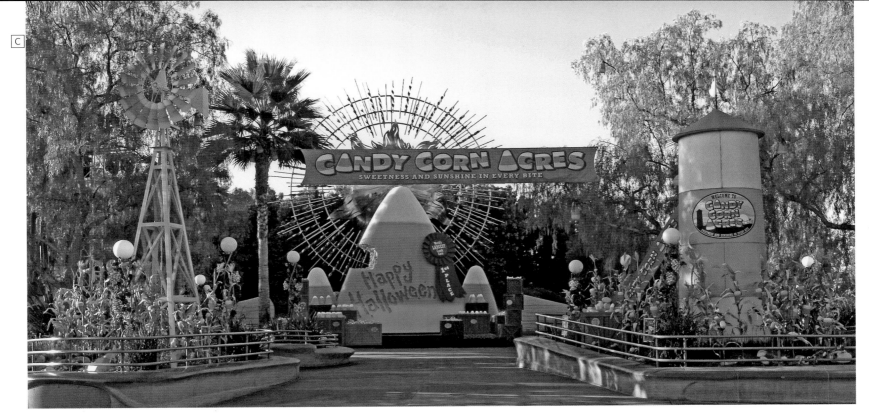

Disney California Adventure

| A | Main entrance area 2006 | C | Sunshine Plaza 2007 | E | Carthay Circle 2018 |
| B | Main entrance area 2017 | D | Buena Vista Street 2018 | F | Buena Vista Street 2017 |

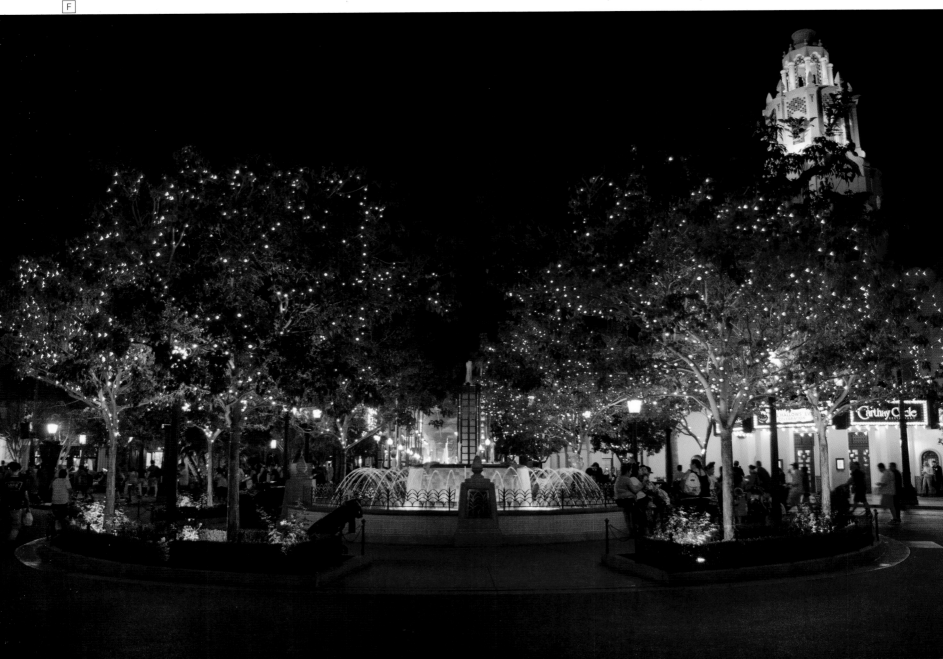

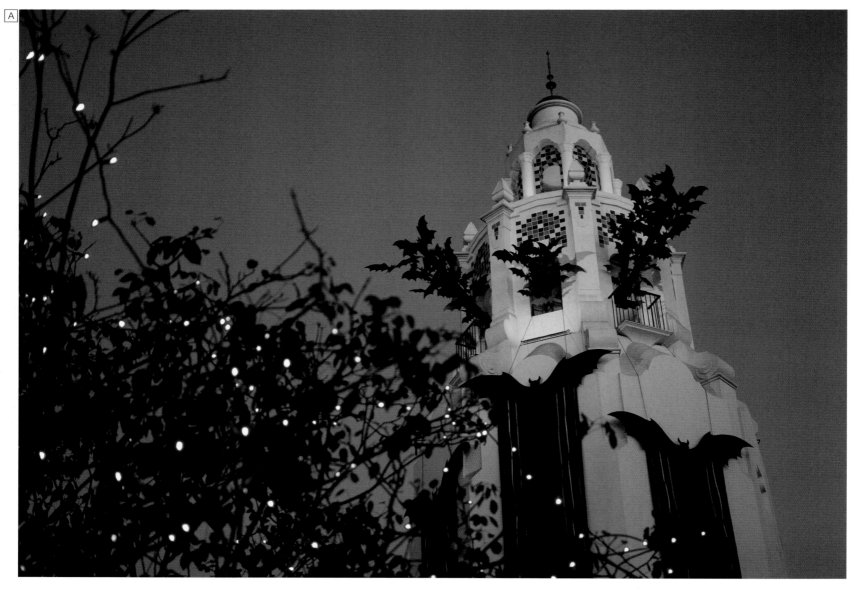

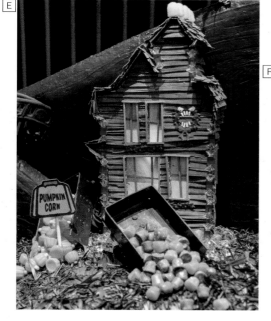

Buena Vista Street,
Disney California Adventure

A Carthay Circle
2017

B C D Los Feliz Five & Dime
2018

E F Trolley Treats
2018

G Atwater Ink & Paint
2018

Headless Horseman ▶
2018

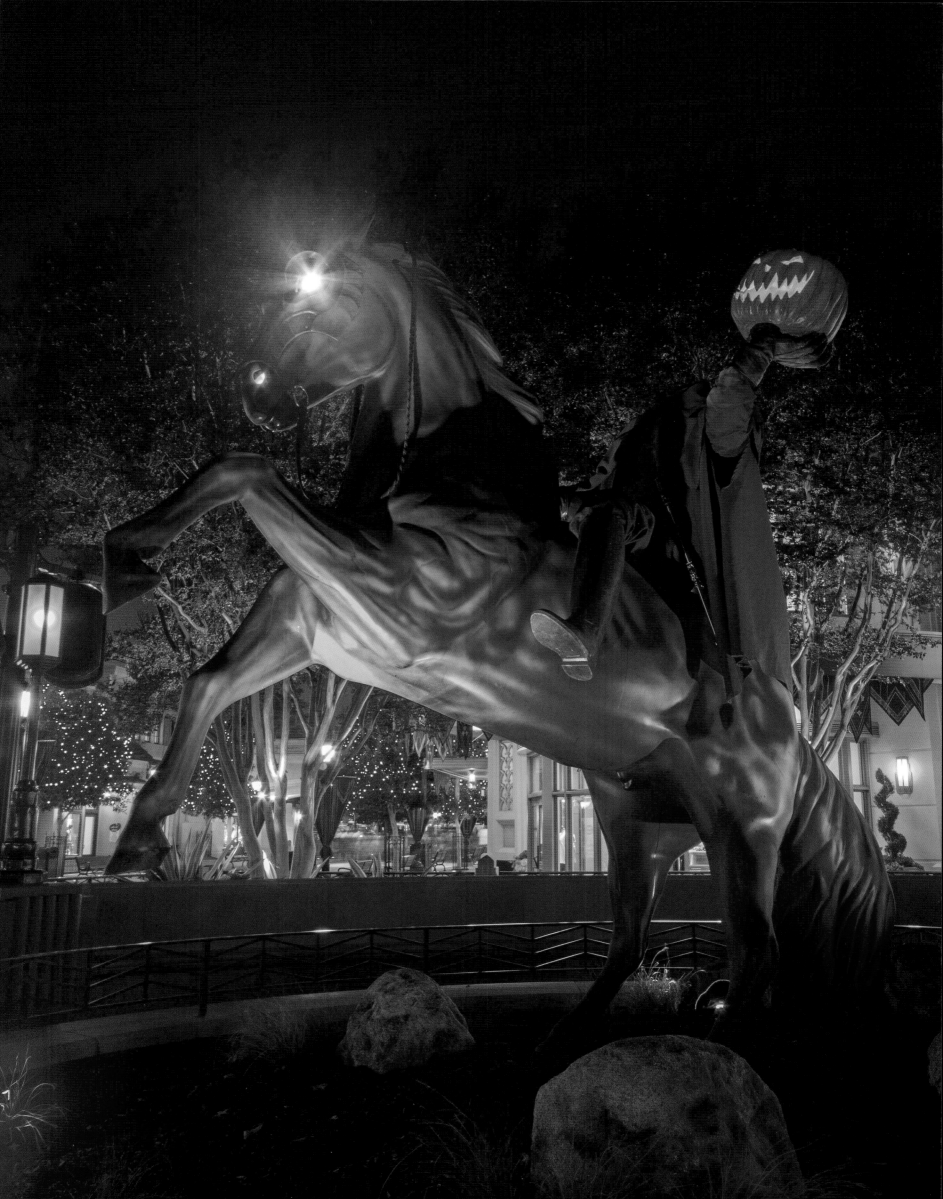

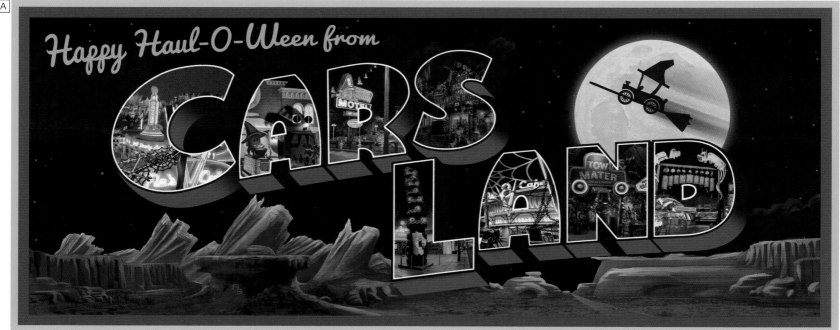

Cars Land,
Disney California Adventure

A Cars Land entrance sign,
 original artwork
 2017

B Cars Land entrance sign
 2017

C Horn-o-plenty
 2017

D Luigi's Casa Della Tires
 2018

E Mater's Junkyard
 Jamboree
 2017

F G Fillmore's Taste-In
 2019

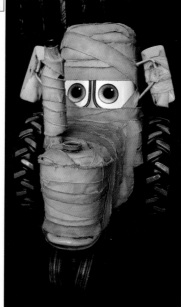

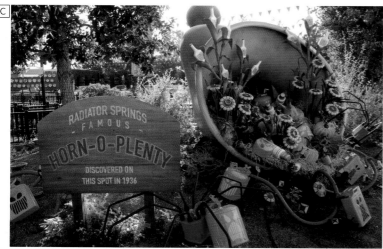

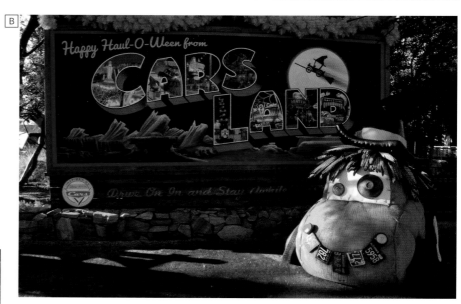

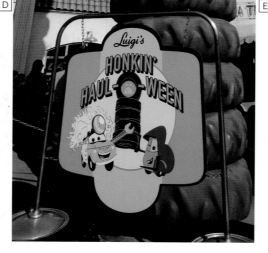

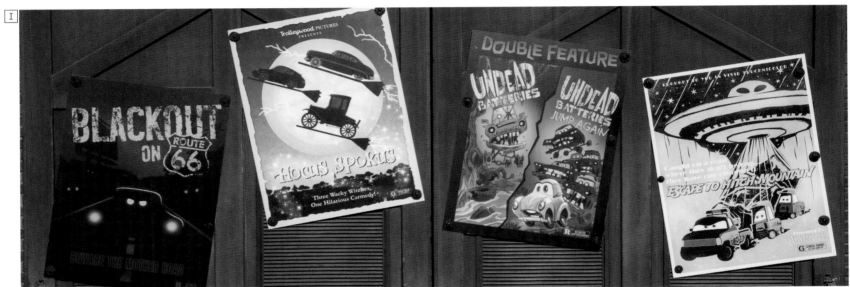

Grizzly Peak,
Disney California Adventure

L Grizzly River Run
2018

Cars Land,
Disney California Adventure

H Radiator Springs decor
2017

I Radiator Springs decor
2018

J Radiator Springs Curios
2017

K Mater's Junkyard
Jamboree
2018

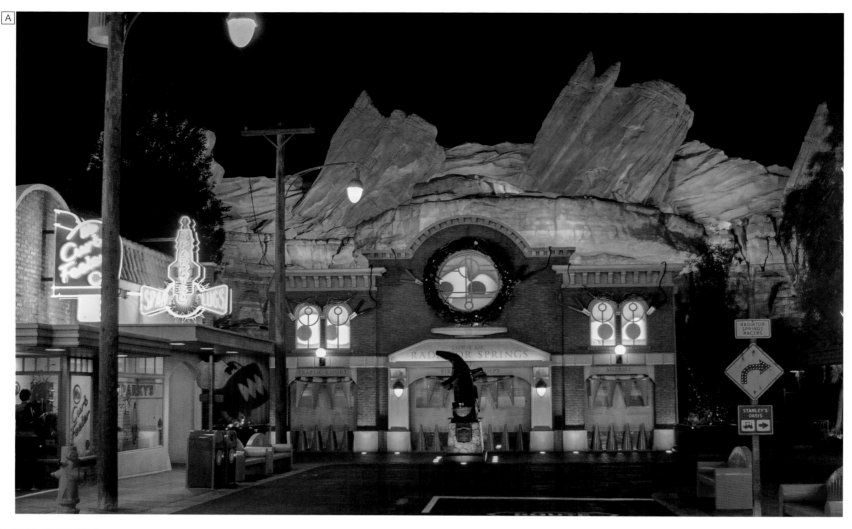

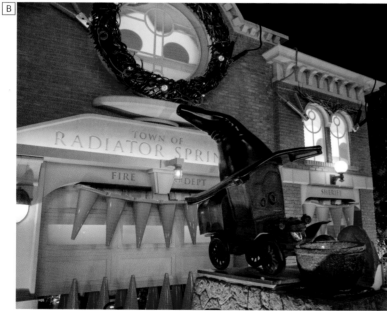

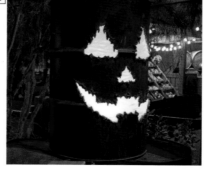

Cars Land,
Disney California Adventure

D *Radiator Springs decor*
 2018

E *Fillmore's Taste-in*
 2017

F G *Radiator Springs Curios*
 2017

A *Radiator Springs*
 2018

H *Mater's Junkyard Jamboree*
 2017

B *Radiator Springs Courthouse*
 2017

I *Flo's V8 Cafe*
 2018

C *Radiator Springs decor*
 2017

J *Sarge's Surplus Hut*
 2018

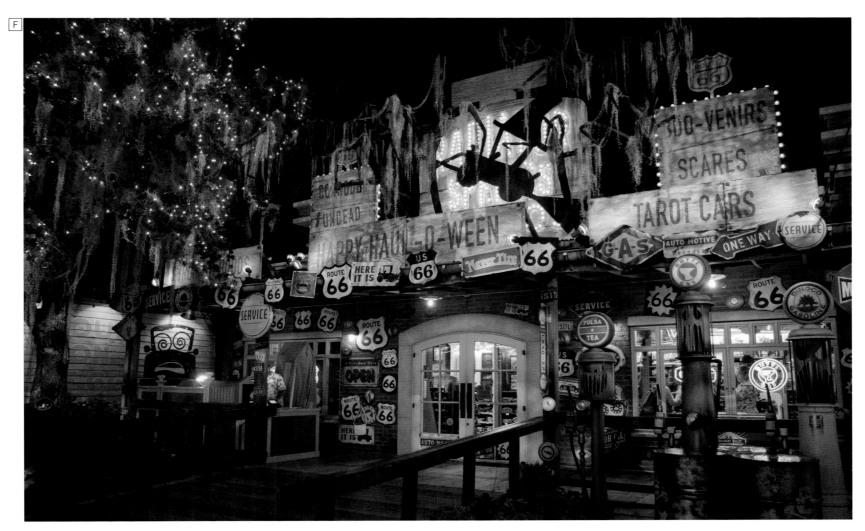

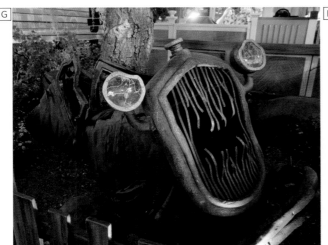

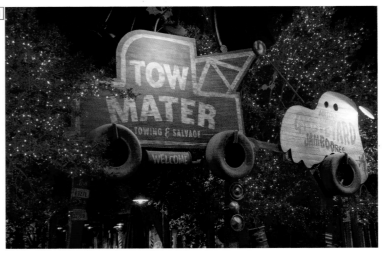

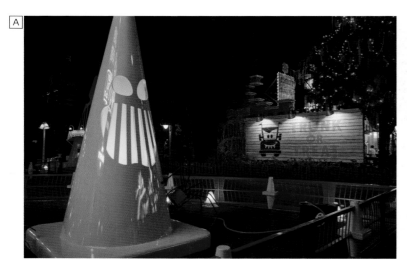

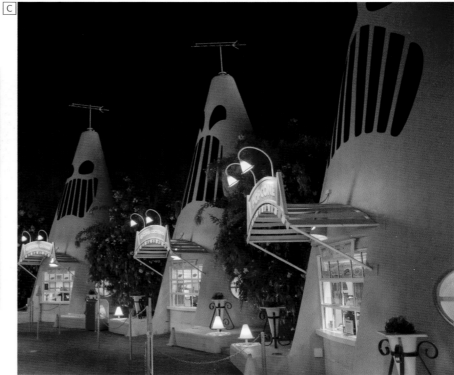

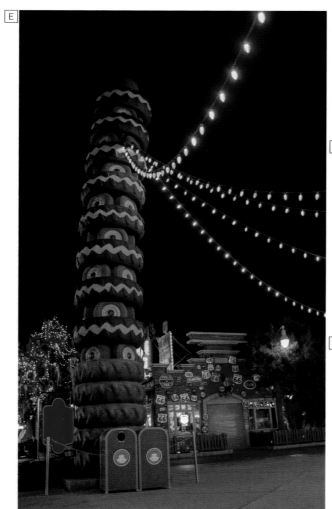

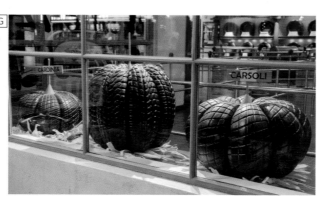

Cars Land,
Disney California Adventure

A B *Cozy Cone Motel*
2017

C D *Cozy Cone Motel*
2018

E *Luigi's Casa Della*
Tires
2018

F *Cozy Cone Motel,*
lobby display
2018

G *Luigi's Casa Della*
Tires
2018

Cars Land,
Disney California Adventure

H Cars Land decor
2018

I Cars Land entrance
2018

J Ramone's House of Body Art, decorated
for Día de los Muertos
2018

K Ramone's House of Body Art, interior
ofrenda honoring Doc Hudson
2018

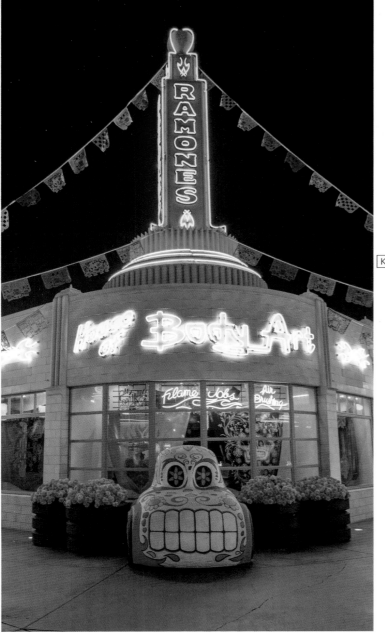

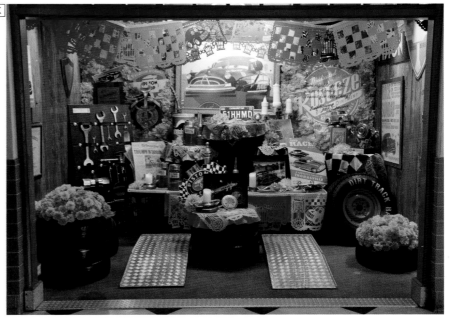

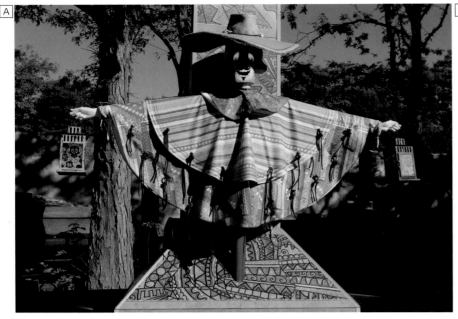

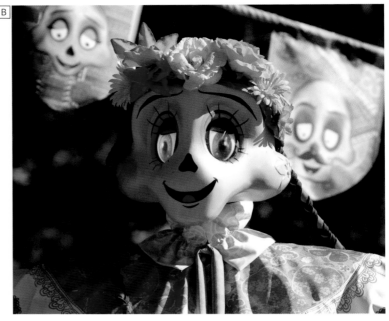

Over in the Old West in Frontierland in Disneyland Paris, the Día de los Muertos theme is on full display with stylized skeletons sporting vibrant traditional Mexican folklore dance costumes, multicolored cacti, paintings, and unfurled banners along with brightly colored mythical Mexican folk art sculptures called *alebrijes*. A more traditional Día de los Muertos honoring the dearly departed and celebrating life can be found at El Zócolo Park in Frontierland in Disneyland. Traditional altars with *ofrendas* (offerings) to lost loved ones include sugar skulls, marigolds, *pan de muerto* (bread of the dead), *papel picado* (paper art flags) strewn overhead, an homage to the elegant *La Calavera Catrina* sculpture, and a musical trio of joyous skeletons.

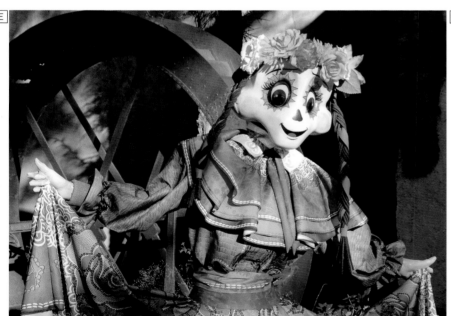

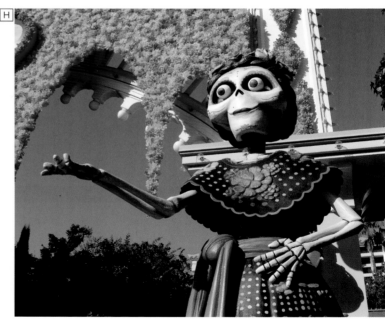

Disneyland Paris

A — G *Frontierland 2018*

Disney California Adventure

H I *Plaza de la Familia, Paradise Gardens Park 2018*

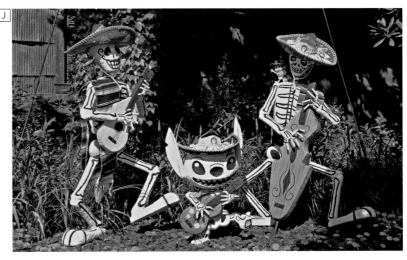

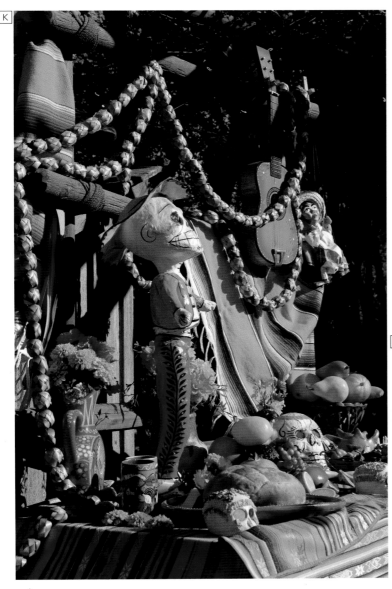

Tokyo DisneySea

J Fiesta de los Esqueletos,
 Lost River Delta
 2013

Disneyland

K L M El Zócalo Park, Frontierland
 2018

N El Zócalo Park, Frontierland
 2015

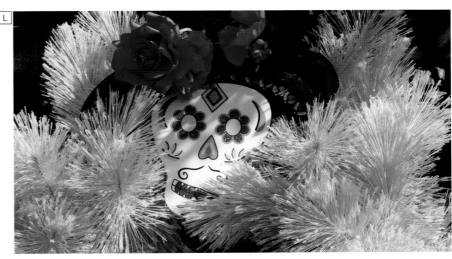

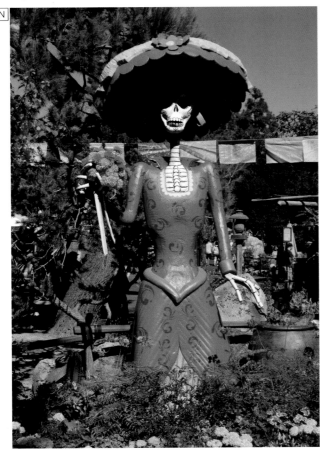

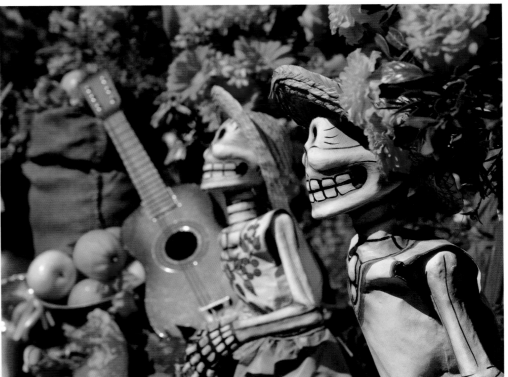

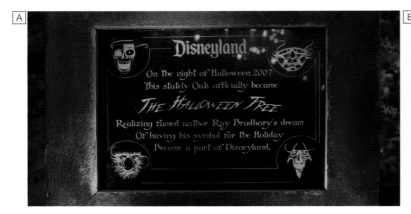

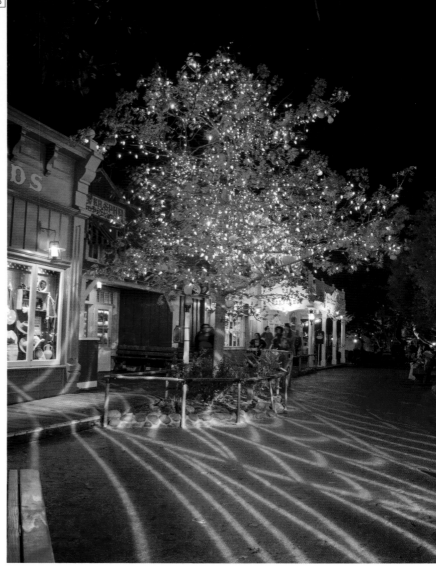

A quartet of dancing skeletons from the 1929 Silly Symphony short *The Skeleton Dance* began Ray Bradbury's deep-rooted fascination with Halloween and Disney that eventually sprouted into the Halloween Tree in Disneyland. The author of novels such as *Fahrenheit 451* and *Something Wicked This Way Comes* became friends with Walt Disney in 1964 and helped develop several projects at EPCOT. In 1972 Ray wrote the classic Halloween novel *The Halloween Tree* about a group of trick-or-treaters, who while searching for a friend, discover the origins of Halloween. Ray always dreamed the Halloween Tree, a symbol of his favorite holiday, would one day find a home in Disneyland.

Thirty-five years later, on Halloween night 2007, Ray thought he was giving a talk about the re-release of *The Halloween Tree* to a group of Guests at Club 33 in Disneyland. Little did he know, however, what awaited the second part of the gathering that very night. Imagineers Tony Baxter and Kim Irvine, along with Brad Kaye, Creative Entertainment's art director, had secretly decorated The Halloween Tree the night before. They strung orange lights around an oak tree, scattered autumn leaves on the ground, and created pumpkin faces of all sorts with magic . . . markers.

During the surprise tree ceremony, Ray did the honors of flipping a switch, "lighting" the Halloween Tree in an October orange and yellow glow against the hand-painted jack-o'-lanterns. As Ray gazed up in wonderment, a tear rolled down his cheek. "I belong here in Disneyland, ever since I came here fifty years ago," Ray remarked. "I'm glad I'm going to be a permanent part of the spirit of Halloween here at Disneyland."

Disneyland

The Halloween Tree, Frontierland

Ⓐ — Ⓕ *2018*

Ⓖ *2017*

The Halloween Tree has inspired the Haunted Tree in Hong Kong and the Pumpkin Trees on each of the four Disney Cruise Line ships. The Pumpkin Trees—named Grim, Muckelbones, Bog, and Reap—represent different characteristics of the Pumpkin King. Blossoming only once a year in the main atrium of their respective ships during Halloween on the High Seas cruises, the morbid trees transform, as their barren, gnarled branches—with the recitation of an enchantment (and some late-night Cast Member magic)—sprout jovial jack-o'-lanterns, bringing the spirit of Halloween to life once again. The life of the party continues with Mickey's Mouse-querade Party, where Vampire Mickey and Witch Minnie dance alongside costumed families, and there's a spine-tingling interactive event called A Nightmare Before Christmas Sing and Scream sing-along, plus the campfire-style Haunted Stories of the Seas gathering.

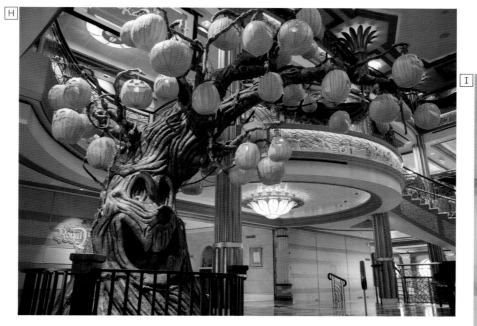

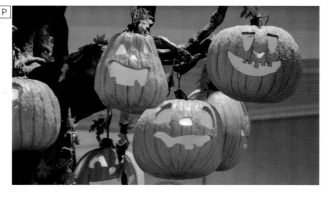

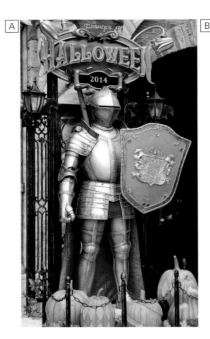

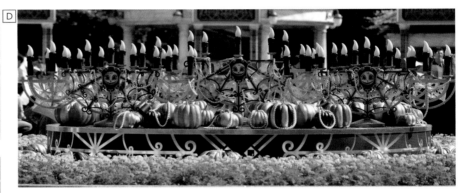

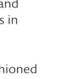

Newer parks have also gotten into the Halloween spirit. At the American Waterfront in Tokyo DisneySea, a Villains Haven area featured sinister stained-glass portraits and spooky silhouettes, while pumpkin-head scarecrows in autumn attire give the Cape Cod area a classic feel.

Back in Frontierland in Disneyland Paris, foliage-fashioned Pumpkin Men celebrate the autumn harvest. The Pumpkin Men's storied history began in the mystical and mischievous Halloweenland inside the magical Pumpkinwood Forest, where twisted trees produced pumpkins that became Pumpkin Men—passionate painters whose favorite color is, naturally, orange. And their favorite place to paint was good ol' Main Street, U.S.A. But the Pumpkin Men faced an infamous battle against the Pink Witches for the right to decorate the area in their chosen color. The Pumpkin Men won the battle in 2008, and the head witch, Gruzella, and her Pink Witches flew off on a permanent Witch Cruise. For another dose of Disney dragon lore, travel to Fantasyland in Disneyland Paris, where the imposing dragon-shaped bramble patch overtakes Maleficent's Court.

Tokyo DisneySea

A *Main entrance area 2014*

B *Mediterranean Harbor 2019*

C *Mediterranean Harbor 2010*

D *Waterfront Park 2014*

American Waterfront

E *2013*

F *2009*

G *2019*

H *2017*

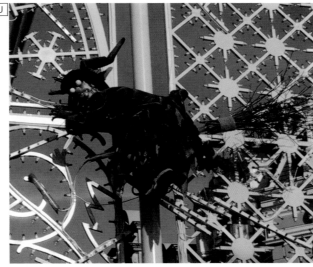

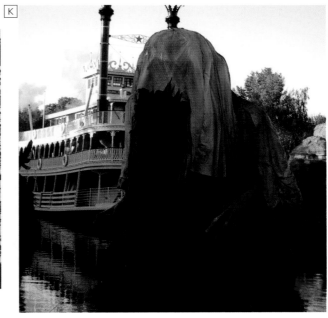

Disneyland Paris

I *Pumpkin Man,
 Emporium entrance
 2003*

J *Main Street, U.S.A.
 2003*

K *Phantom Cruise Line,
 Rivers of the Far West
 2003*

L *Main entrance area
 2018*

M *Town Square
 2018*

N O P *Bandstand decor
 detail, Town Square
 2018*

Q *Central Plaza
 2018*

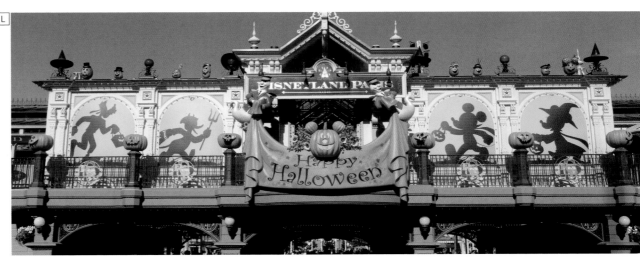

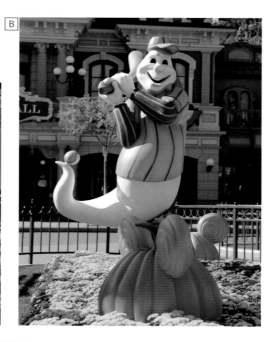
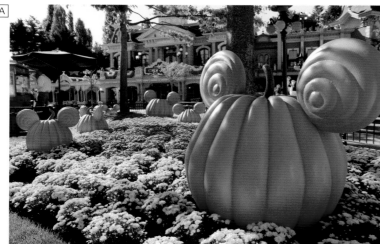

Disneyland Paris

A B C *Town Square*
2018

D *The Storybook Store*
2018

E *Town Square*
2018

F *Main Street*
Transportation Co.
2018

G — J *Town Square decor*
details
2018

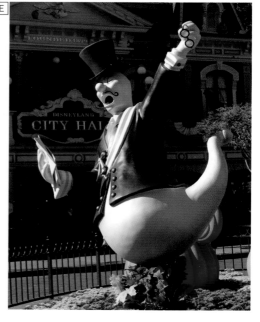

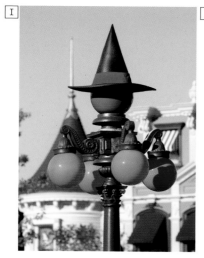
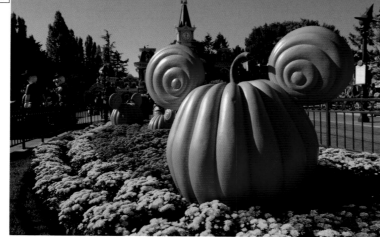

Main Street, U.S.A., Disneyland Paris

K Garlands
2018

L M N Garland details
2018

O Disney Clothiers Ltd.
2018

P Main Street Limousine
2018

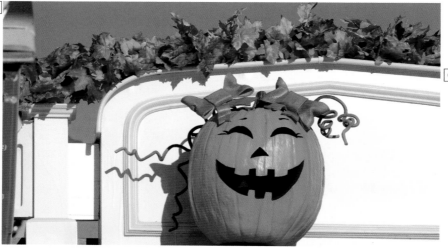

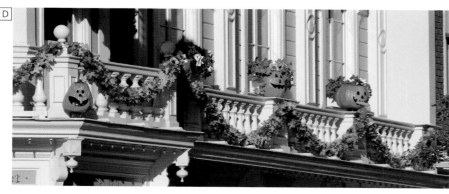

Main Street, U.S.A.,
Disneyland Paris

A *Walt's—an American*
restaurant
2018

B *Casey's Corner*
2018

C D *Walt's—an American*
restaurant
2018

E F *Bixby Brothers*
2018

G H *Disney & Co.*
2018

I *Bixby Brothers*
2018

J *Casey's Corner*
2018

K *Emporium*
2018

Holiday Magic at the Disney Parks

*Main Street, U.S.A.,
Disneyland Paris*

L M **New Century Notions**
2018

N **Main Street Motors**
2018

O **Candy Palace**
2018

P Q **New Century Notions**
2018

R **Disney Clothiers Ltd.**
2018

S **Harrington's Fine
China & Porcelains**
2018

T **Market House Deli**
2018

U **Main Street Motors**
2018

V **Candy Palace**
2018

W **Cable Car Bake Shop**
2018

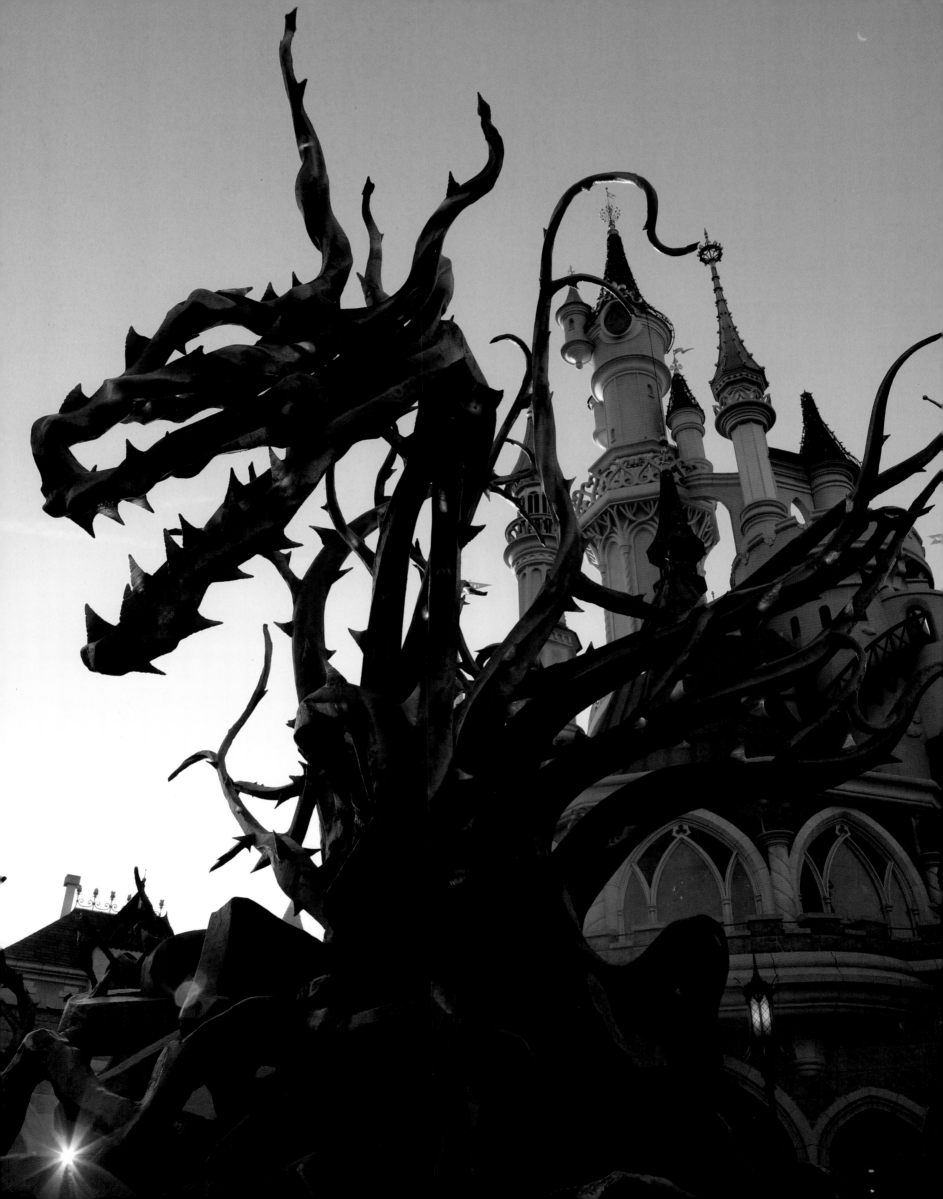

Fantasyland,
Disneyland Paris

◄ Castle courtyard
2018

Frontierland,
Disneyland Paris

[A] Cowboy Cookout
Barbecue
2018

[B]—[F] Thunder Mesa
decor details
2018

[G] Silver Spur
Steakhouse
2018

[H] The Lucky
Nugget Saloon
2018

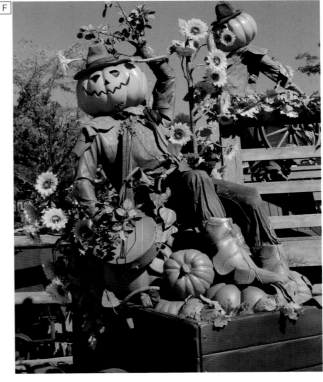

Inspired by the Haunted Mansion, which was originally designed as a walk-through attraction, seasonal haunted houses in Hong Kong Disneyland have a flair for the scare. Main Street Haunted Hotel (2007–2011) hides a tragic past: Over one hundred years ago, a dark force took out hotel owner Victoria Maxwell. Her ghostly soul and other unhappy souls ended up haunting the halls of the hotel, searching for new permanent residences. The dark world also moved on to an outpost built on a burial ground in the Demon Jungle (2008–2010) in Adventureland, and a mysterious spaceship that crash-landed in Tomorrowland, setting off an Alien Invasion (2009).

Creative forces were on full display as well with The Revenge of the Headless Horseman (2011–2014), which blended the character of the Headless Horseman with the saga of one with a nefarious background who drops into the Adventurers' Club: he's a con man, who brings his carnival to Adventureland, claiming to have the head of the Headless Horseman. Angered by these false claims, the Horseman comes seeking revenge, and whoever gets in his way . . . well, it's off with their heads!

What can be scarier than a Headless Horseman? How about a strict disciplinarian looking for new enrollment to breed the future of evil through fear at the demented Graves Academy (2012–2014). Now step through the door and into a dreamscape journey through nightmarish worlds where images elicit screams: The Nightmare Experiment (2016) and the Maze of Madness: The Nightmare Experiment Continues (2017), a twisted take on Disney tales.

When darkness falls, Jungle River Cruise in Hong Kong Disneyland becomes a perilous quest with a navigator and skipper guiding Guests through the Adventureland Jungle in search of voodoo emerald stones. As the legend goes, "Immortality is the reward for escaping the jungle with one stone." However, the search for the Curse of the Emerald Trinity (2015) stones brings with it disaster: vines arise from the ground, attacking those who dare to tempt fate. As Guests delve deeper within the unknown, one explorer in the group does not heed the warnings, leading to his "eternal reward." One wrong turn brings the boat into the legendary Canyon of the Gods, where Guests stare into the cold, unforgiving emerald eyes of a rock monster. A fire rages all around as green smoke bellows from the monster's mouth. Leaving the stone behind, Guests escape, only to face the most chilling challenge of all: a return to civilization.

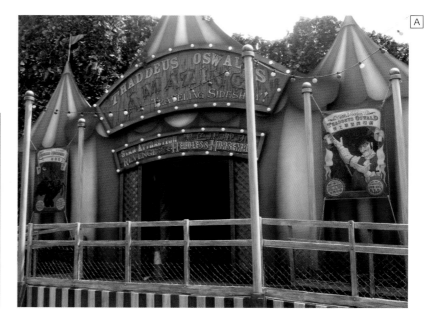

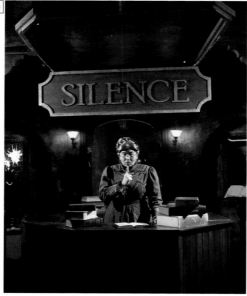

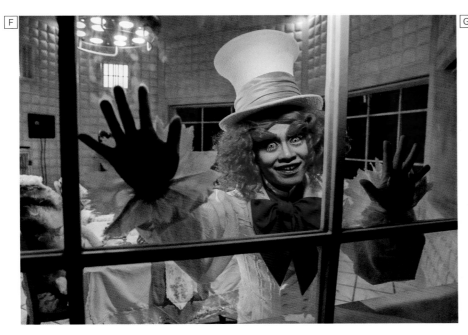

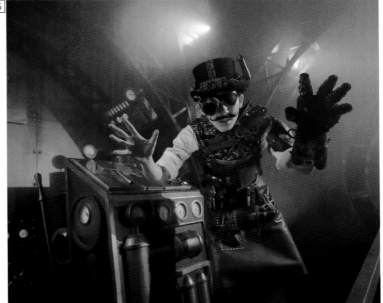

Hong Kong Disneyland

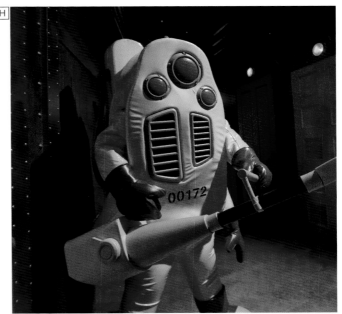

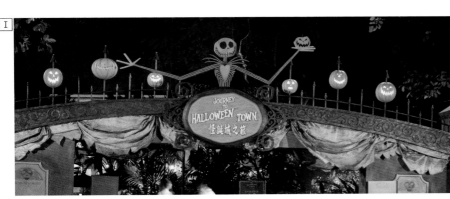

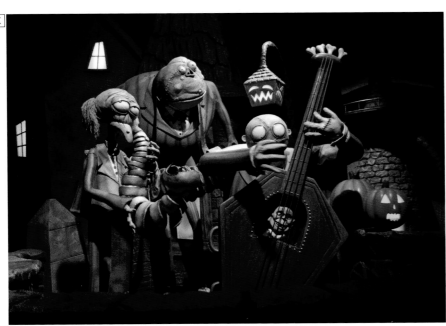

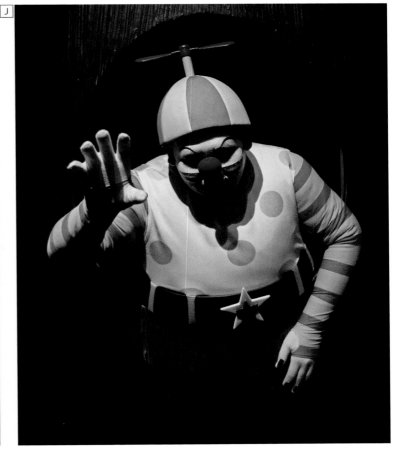

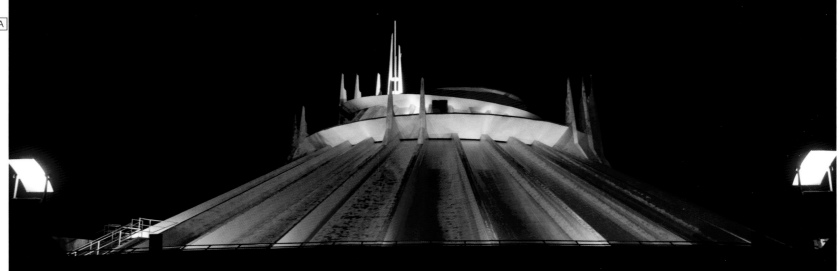

In October of 2007, Space Mountain Ghost Galaxy premiered in Hong Kong Disneyland, while over in Anaheim, the Cast Member-exclusive Space Mountain Nightmare Nebula debuted. Nightmare Nebula was set in complete darkness with villainous cackling and screaming as riders spiraled down the mountain. It disappeared from Disneyland after 2007 and was replaced by Space Mountain Ghost Galaxy in 2009.

Space Mountain Ghost Galaxy in Anaheim gave the Imagineers an opportunity to enhance the sense of arrival with suspense, using projections and audio on the building's exterior. Primal screams screeched out into the night, a fiery hand clawed at the structure, and ominous sounds shook and rumbled the building. Something was aghast in the mountain.

Inside Space Station 77, the scouting team had been exploring deeper unknown regions of space, and they were seeking volunteers to aid them. As Guests approached the liftoff, darkness surrounded them—much darker than usual. They continued onwards, and suddenly lightning exploded all around. They radioed for help. A blue screen appeared—"Loss of Signal"—and that's when it materialized. A nightmarish nebula with a ghostly face and galaxy eyes taunting, each moment growing angrier and angrier as Guests launched into space—the final frontier, the ghost's home.

Ghost Galaxy in Hong Kong had its final departure in 2013 and continued to haunt the galaxy at Disneyland through the 2018 Halloween season.

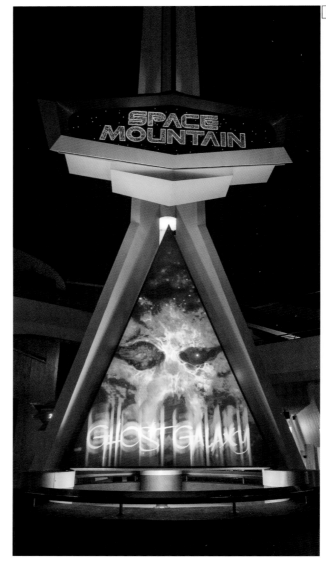

Space Mountain Ghost Galaxy, Disneyland

A *Exterior lighting and projection 2018*

B *Attraction entrance 2018*

C *It was a dark and stormy night . . . 2018*

Disney's Hollywood Studios

D *"Fearful Tower" 1994*

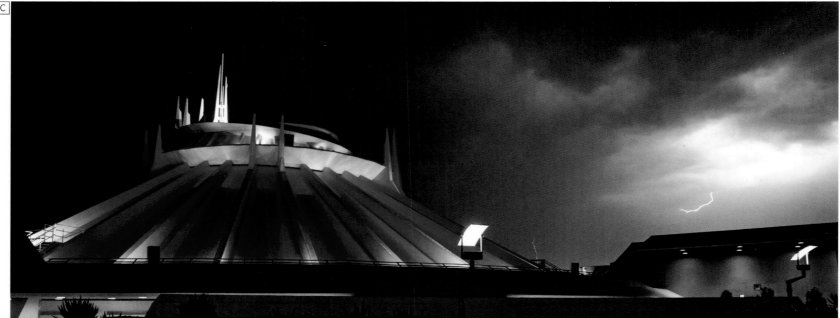

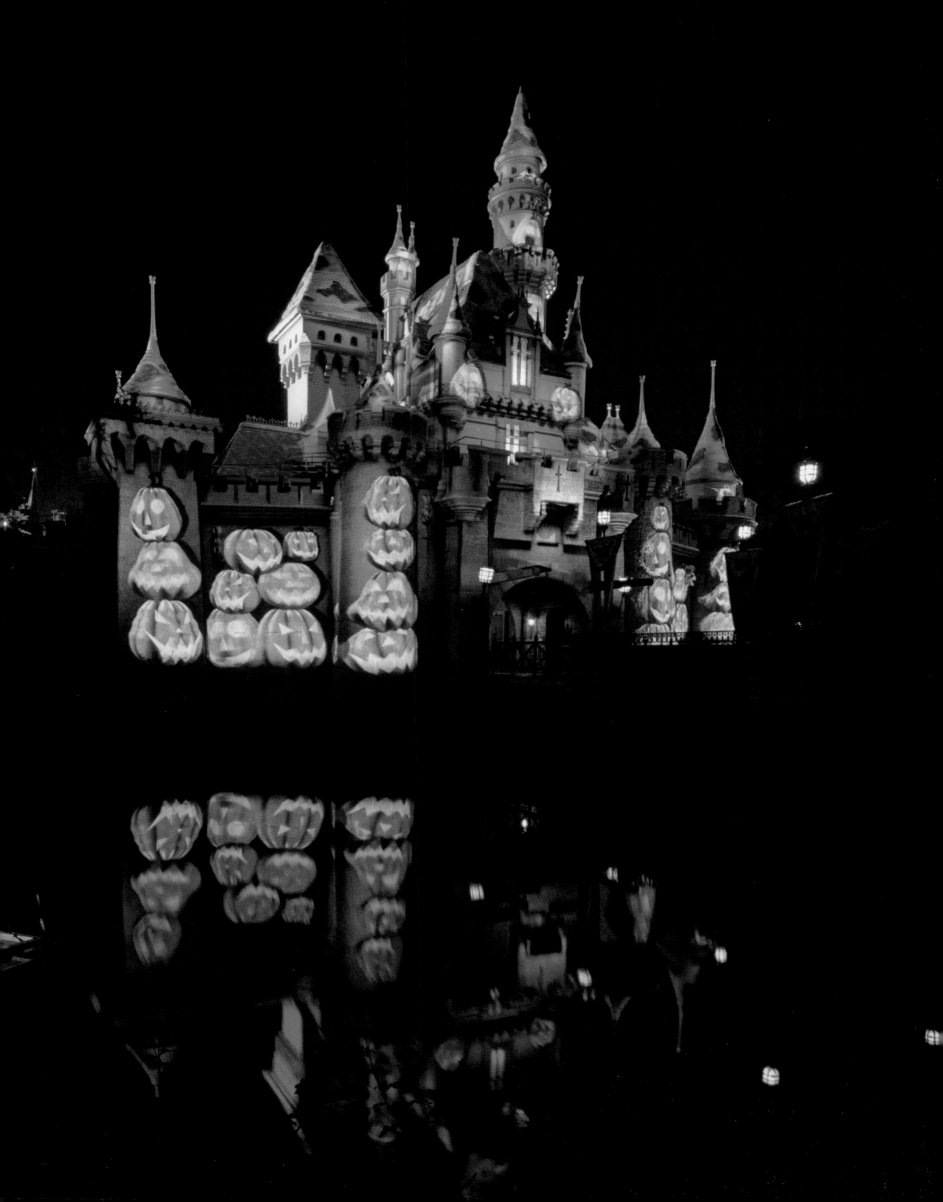

Tricks, Treats, and Spooktaculars

More fun than fright: the pageants and parties of the fall season

Autumn- and Halloween-themed special events at the Disney parks are meant to offer a unique experience beyond the everyday magic Guests have come to expect when visiting. Sometimes they're vast in scale, taking place throughout an entire park; other times they're set in a more intimate setting, inside a restaurant or section of a particular land. Halloween, once viewed as a singular celebration, has had numerous one-off or weekend Disney events throughout the years.

Halloween events focusing on the scary side of the holiday had grown in popularity since the 1970s at other parks in California and Florida. Known for family-friendly entertainment, though, Disney had no interest in creating a scary party at this time and figured Halloween was an event best left to others. But that perspective all changed on Monday, October 31, 1994, at 6 a.m.

A local Los Angeles radio station promoted free admission to Disneyland from 6:00 a.m.–8:30 a.m. for anyone dressed in a Halloween costume. The excitement and buzz created by this seemingly spontaneous promotion, however, soon sparked nightmarish results, as Disneyland quickly reached full capacity. The promotion also created a four-hour freeway traffic jam in the surrounding area (whoops!). One thing was for sure: A Disney Halloween was here to stay.

Disney realized it *could* be that family-friendly place for children of all ages to dress up and play together in a magical environment—and *the* place to trick or treat. The next year large-scale Halloween parties premiered in Disneyland and the Magic Kingdom. Jumping ahead, Disney's largest Halloween celebration event today is Mickey's Not-So-Scary Halloween Party, held at the Magic Kingdom. What had started out as a one-night-only event on Halloween night has expanded to over thirty nights beginning in mid-August! Guests eagerly await their opportunity to dress in themed group costumes and grab the highly touted and sought-after tickets—at a separate admission—as soon as they go on sale six months in advance.

Today, party planning takes place year-round, with weeks of decorating and show-quality testing, but back when it began in 1995, it was quite a different story. The first Mickey's Not-So-Scary event was held with what today would be looked upon as minimal decor, placed onstage in a very limited time frame. Not wanting to offend daytime Guests who didn't celebrate Halloween, autumn and Halloween decor was practically nonexistent during regular park hours. Once the park was cleared of Guests (at the posted closing times), however, the decorating team feverishly set out for the farthest lands at 6:00 p.m. and progressed all the way to the front of the park on Main Street, U.S.A. before Guests celebrating Halloween arrived at 7:00 p.m.

Nowadays Mickey's Not-So-Scary Halloween Party has customized music, atmospheric lighting, huge projections, dance parties, shows, a parade, and fireworks. Familiar Disney characters get into the spirit of the season in their Halloween costumes, while villains, rarely seen as walk-around characters during daytime park hours, appear and enhance the *streetmospheric* entertainment—and are always a real treat. Haunted Mansion Cast Members are covered in spiderwebs and ghoulish makeup, while ghosts make appearances on the lawn, and green and purple lighting provide an unearthly ambience. But perhaps the biggest treat of all is discovering the many "treat trails," and feeling the delight of trick-or-treating—for some, for the first time in what's probably been several years. The fright-time Happy HalloWishes: A Grim Grinning Ghosts Spooktacular in the Sky (2005 – 2018) combined spooky-style Disney tunes, haunted castle projections, and a mixture of fast- and slow-burning pyrotechnics (and sometimes lightning, courtesy of the Florida weather) with a spectacular 180-degree perimeter fireworks finale.

Different Disney parks have offered their own unique take on Halloween fireworks through the years, such as Halloween Soirée fireworks (2005 and 2006) in Disneyland Paris, Nightmare in the Skies (2010) in Hong Kong Disneyland, and Night High Halloween (from 2012) at the Tokyo Disney Resort.

Disneyland Mickey's Halloween Party 2018

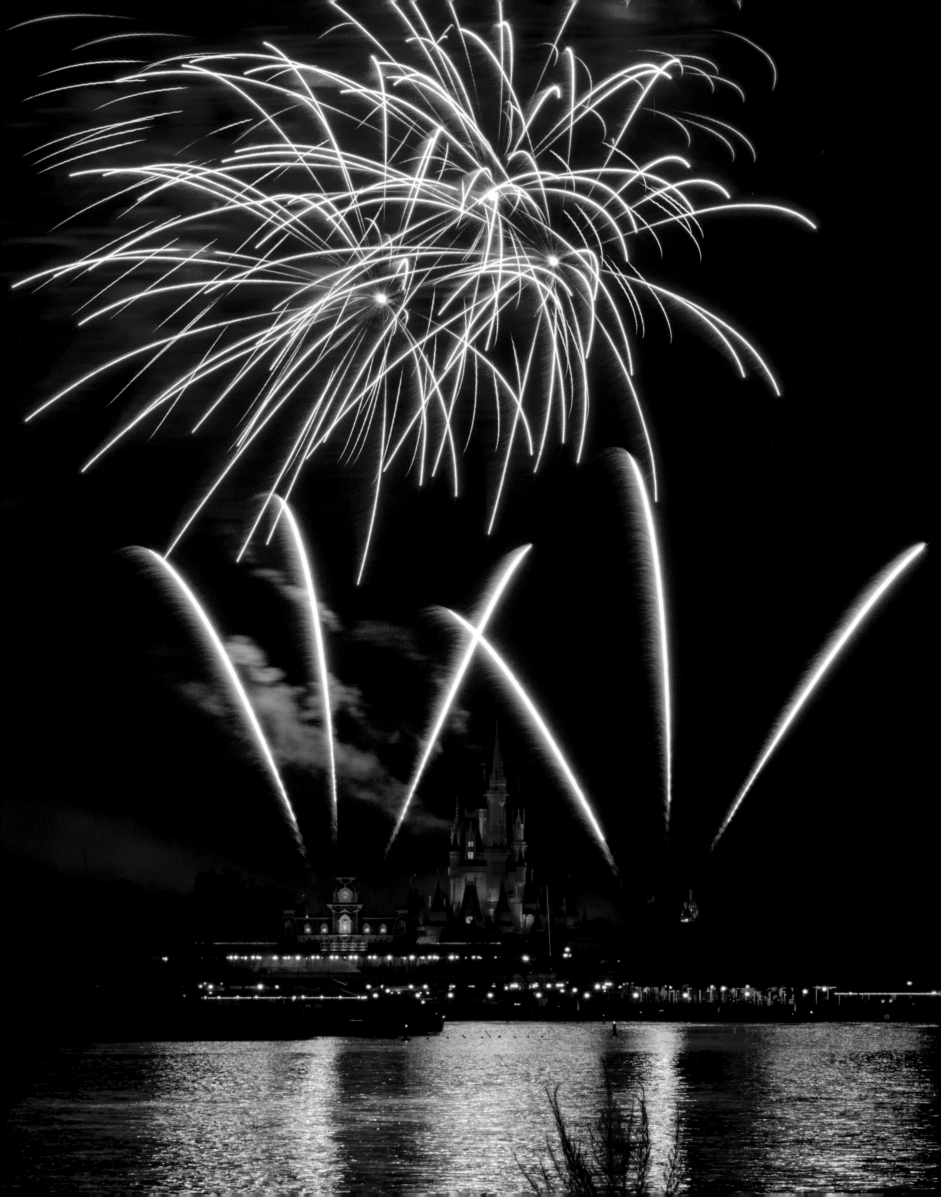

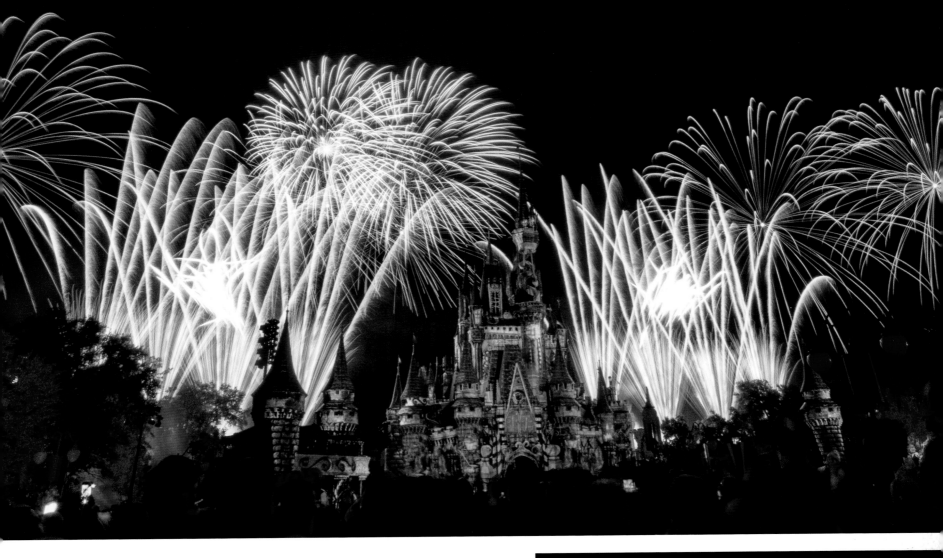

Magic Kingdom

◄ *Happy HalloWishes*
2017

▲ *Disney's Not So Spooky Spectacular*
2019

Disneyland Paris

▼ *Disney's Halloween Party*
2016

Tokyo Disneyland

► *Night High Halloween*
2019

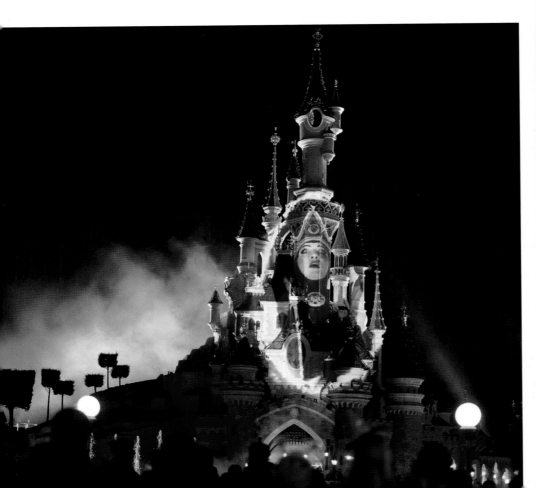

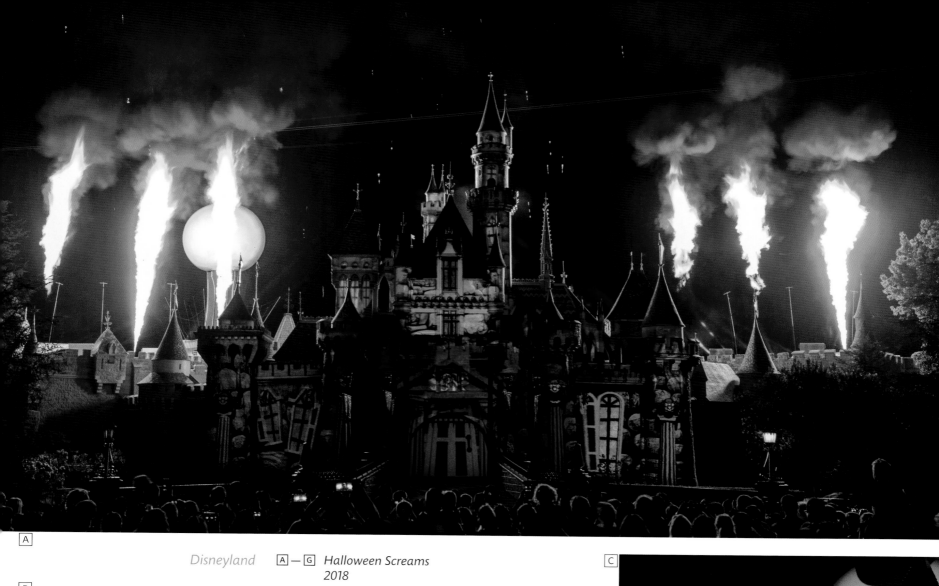

Disneyland [A] — [G] *Halloween Screams*
2018

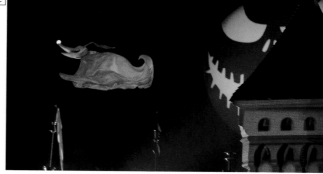

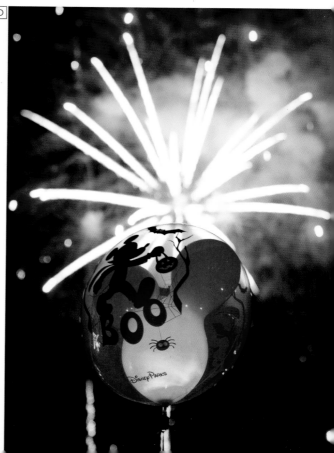

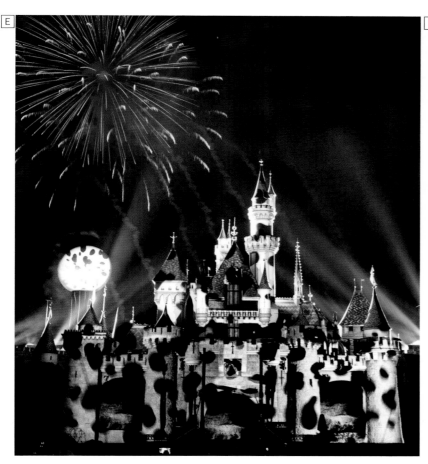

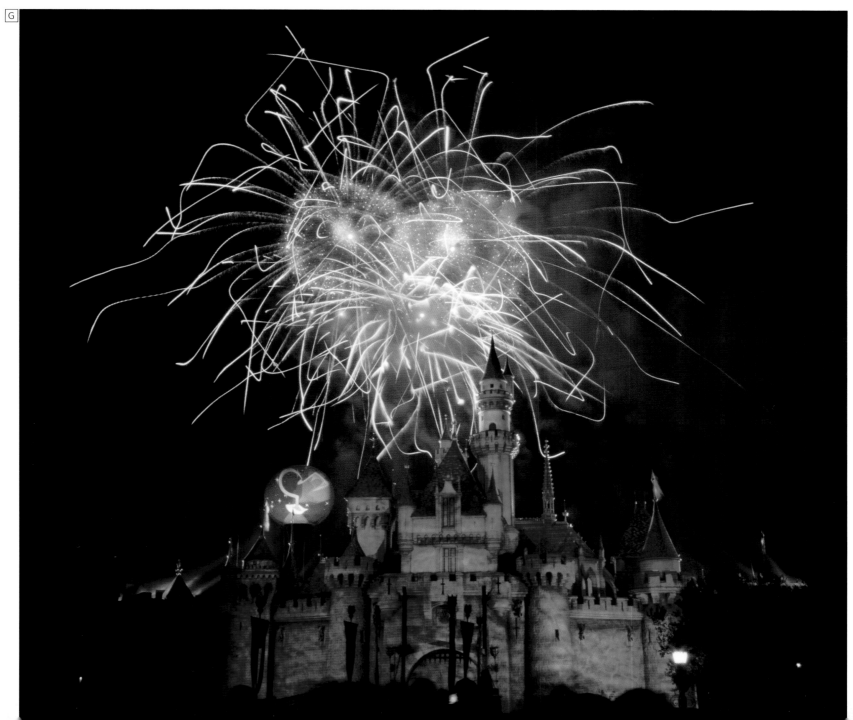

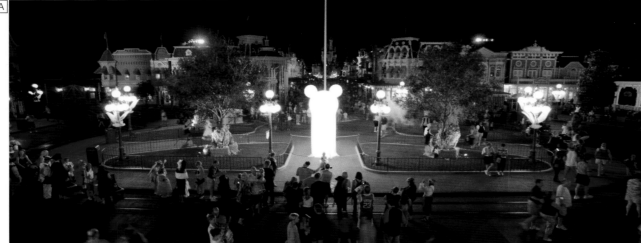

Mickey's Not-So-Scary Halloween Party

Don't miss **Mickey's Not-So-Scary Halloween Party**
October 31, from 7:00pm to 12 midnight.
Trick-or-treat throughout the Magic Kingdom for lots of
free treats. Delight to dazzling presentations of
"SpectroMagic" and "Fantasy in the Sky" fireworks.
Let your little ghosts and goblins star in a special
Halloween costume parade.
Enjoy free hayrides on Main Street, U.S.A., fortunetelling,
magic, and your favorite Disney characters in costume.
It's the perfect Halloween party for little ghouls and boys.
Tickets are available at Walt Disney World ticket locations
for $16.95 in advance or $18.50 on the day of the event.

Entertainment Highlights

Legend of the Lion King
Located west of Cinderella's Golden Carrousel
7:40, 8:40, 9:40, 10:40 & 11:40pm

"Every Day's a Holiday"
Performed on the Castle Forecourt Stage.
7:30, 10:05 & 11:00pm

"SpectroMagic"
You'll find viewing locations for this parade from Town
Square on Main Street, U.S.A., to the front of Cinderella
Castle, through Liberty Square, Frontierland and up to the
Splash Mountain/Pecos Bill Cafe area.

9:00pm

"Fantasy in the Sky" fireworks
Above Cinderella Castle
10:00pm

Entertainment subject to change without notice.

Mickey's Not-So-Scary Halloween Party, Magic Kingdom

A B *Town Square*
2006

C *First party guidemap*
1995

D *Main Street, U.S.A.*
2013

E F *Adventureland*
2018

G H *Tomorrowland*
2017

I *Mad Tea Party Halloween*
2018

J *Main Street, U.S.A.*
2018

K L *Haunted Mansion*
2018

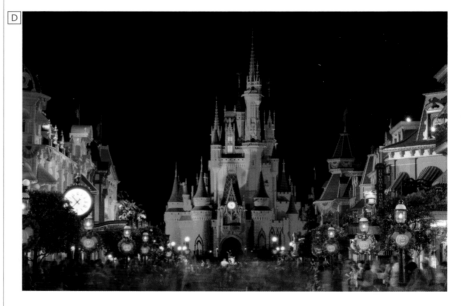

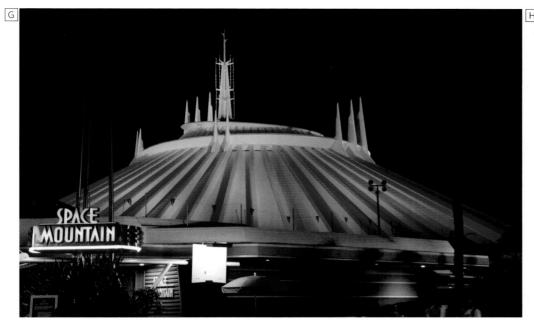

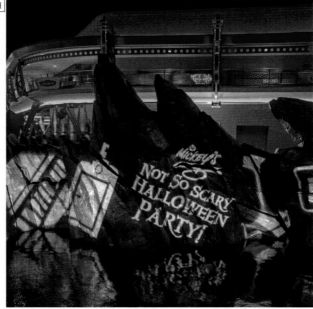

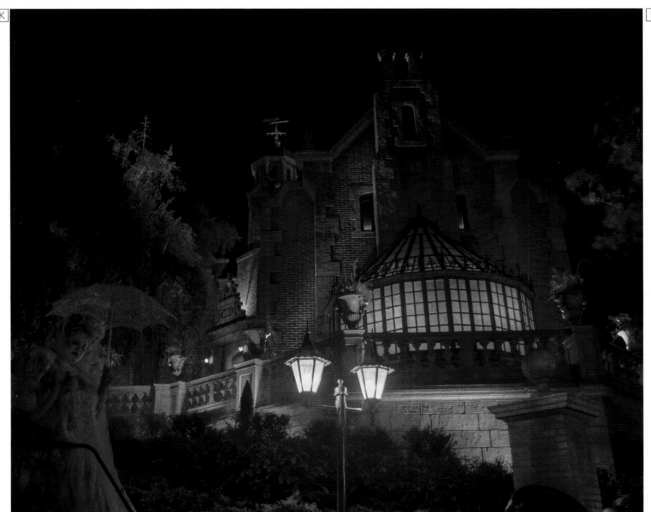

Mickey's Halloween Party debuted in Disneyland as Mickey's Halloween Treat in 1995. On Main Street, U.S.A., one would find appealing autumn decor and horse-drawn hayrides with singing, storytellin' Hayride Hank. A massive 516-pound pumpkin was carved next to the Plaza Inn, and pumpkin seed packets were handed out to Guests. Live actors were placed inside two popular attractions: Haunted Mansion saw the return of 1985's "Mr. Scary Knight," and comedic pirates inhabited Pirates of the Caribbean. At the end of the regular park day, crows routinely gathered on Main Street, U.S.A. to scavenge popcorn scraps and other dropped goodies. On the first night of Mickey's Halloween Party, when the music was turned back on and Guests returned for the party, Main Street, U.S.A. was full of confused crows that flew around for ten minutes taking in this unexpected event—for them at least—before flying away.

Mickey's Halloween Party has risen in both a spook-tacular way and in its presentation. The Cadaver Dans, singing spooky songs as they float over a fog covered Rivers of America, are a Guest favorite. There are numerous treat stations and rare character interactions (including some wisecracking scarecrows that show up in Frontierland). The fireworks show, Halloween Screams: A Villainous Surprise in the Skies (which debuted in 2005), can be experienced in front of the castle, where Jack's ghost dog, Zero, flies overhead, toward the exterior of It's a Small World with uniquely fitted projections, or through Fantasmic-style water projections on the Rivers of America.

Nothing sets the mood better than the ominous Headless Horseman. Over time, this fearsome character has become a more prominent figure, leading Halloween parades at the parks in Hong Kong, Anaheim, and Orlando, wielding a sword in Paris Terrorific Nights and giving Guests the heebie-jeebies in the dense woods of Disney's Fort Wilderness Resort and Campground at Walt Disney World on the Haunted Carriage Ride.

For the Horseman's appearances, preparation is a vital element to make the many moving parts flow effortlessly. The role presents a challenge for any skilled costumed performer: the character holds a pumpkin while riding one-handed down a long path at night with a limited range of vision. Consider the process of acclimating the Horseman's horses for an on-stage performance. Training at Circle D Corral, the horse ranch at Disneyland, begins months in advance: each horse is introduced to music and needs to get used to different surroundings. (Horses aren't normally accustomed to seeing a pumpkin that is larger than they are.) They will also get used to spending time working around Guests and Cast Members, plus have numerous nighttime park rehearsals to become ready to take on their role.

Across the promenade, a popular character from *Tim Burton's The Nightmare Before Christmas* headlines the festivities at Disney California Adventure. Oogie Boogie Bash—A Disney Halloween Party is promoted as a "howliday spellebration." These special event nights launched in September 2019 with unique shows, dance parties, and mysterious walk-through experiences.

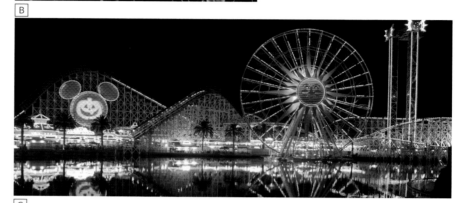

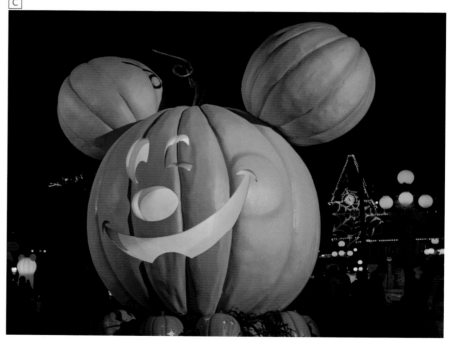

Disney California Adventure

A B *Mickey's Trick or Treat Party*
2008

Disneyland

C *Mickey's Halloween Party*
2018

The Halloween Soirée in Disneyland Paris offers an energetic Halloween parade filled with costumed characters and villains (it's Bowler Hat Guy's time to shine), an up-tempo tune playing, and a massive fire-breathing mechanical Maleficent dragon. Along with dance parties and a parade, there's a themed castle show with nifty villains projections and water displays synchronized with the Halloween music.

Perhaps the darkest take of the Halloween season came at Terrorific Nights at Walt Disney Studios Park at Disneyland Paris. It just felt more macabre than Mickey's Not-So-Scary; the air was filled with mist and mischief: demons, dragons, and deranged characters invaded the tram tour. A brave soul might encounter the Freaky Circus, Scream Monastery, and Horror Market around the park, or find a whole new Crime Scene storyline at Rock 'n' Roller Coaster.

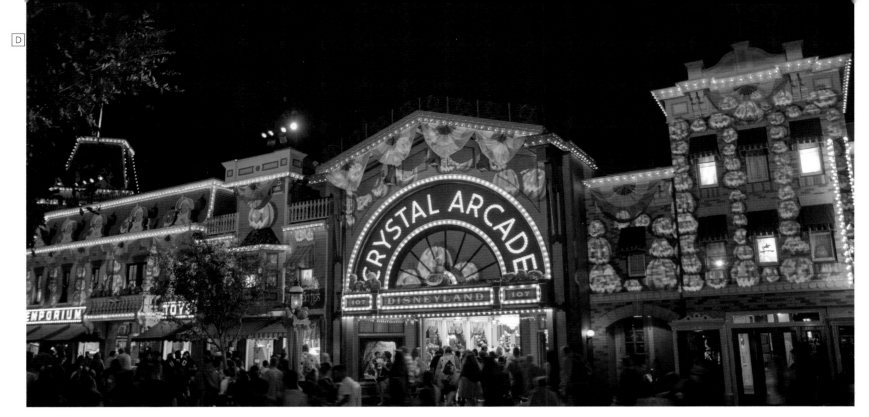

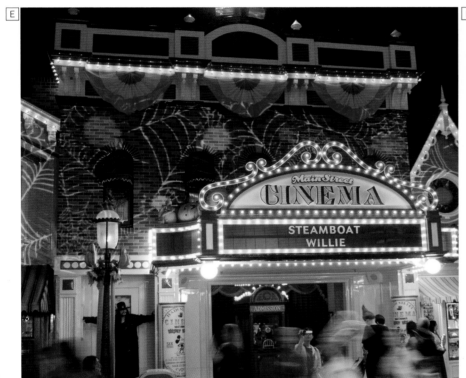

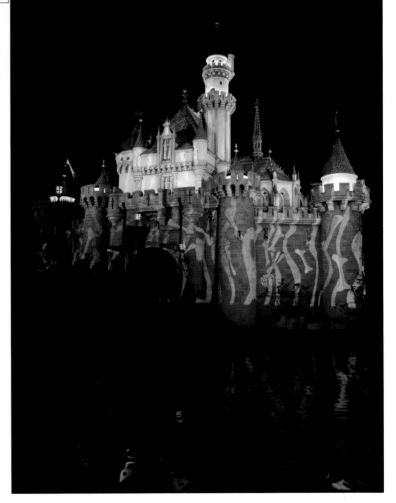

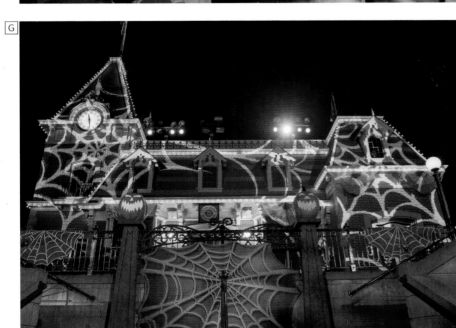

Mickey's Halloween Party, Disneyland

D — H *2018*

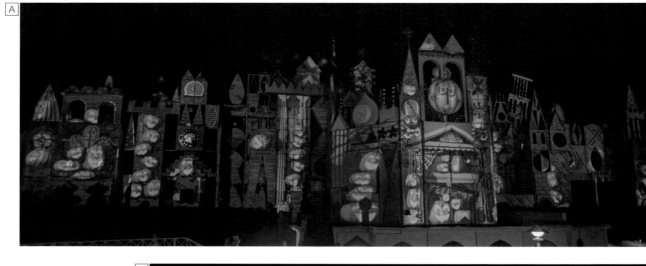

Mickey's Halloween Party, Disneyland

A *It's a Small World*
2018

B *Frontierland*
2018

C *Headless Horseman*
2018

D E *The Golden Horseshoe*
2018

F *Haunted Mansion character greeting, French Market*
2018

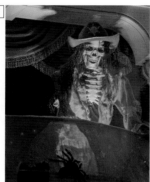

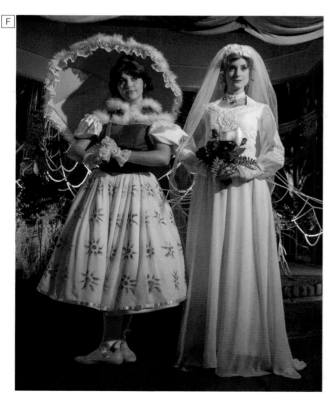

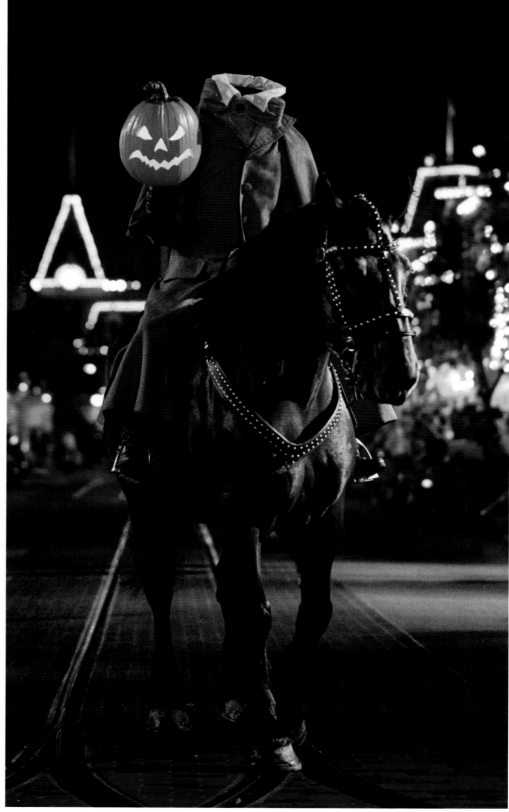

Mickey's Halloween Party,
Disneyland

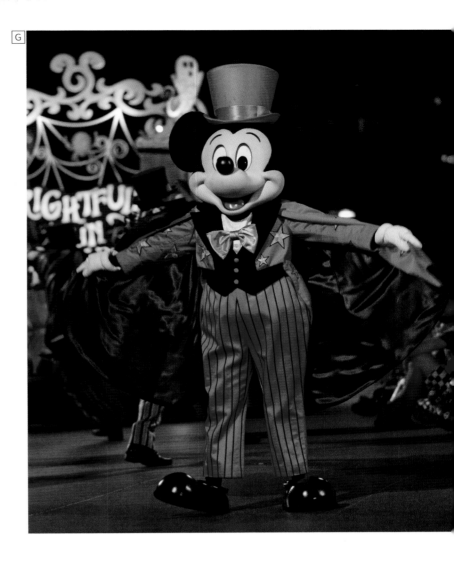

G *Frightfully Fun Parade*
 2018

With new technologies come new, innovative ways to tell tales beyond the grave. Haunted Mansion's sister attractions—Mystic Manor in the Hong Kong park and Phantom Manor at the Paris locale—provide settings already themed for the occasion. Mystic Manor Cycle of Spirits (2015) in Hong Kong Disneyland lured unsuspecting Guests into watching the spirits relive one hour of their lives in an endless loop of time. Phantom Manor in Disneyland Paris, covered in a ghostly white fabric scrim, was the scene for The Phantom Wedding (2004) projected onto the building's exterior. A tale of nuptial doom: a ravishing bride . . . and a vanishing groom.

At the Disney parks around the world, Halloween parades developed from humble beginnings: Happy Halloween Twilight Parade (1998 and 1999) in Tokyo Disneyland featured costumed characters leading Guests—many of whom were also dressed up—to the song "This Is Halloween." Appealing to the comfort level Europeans seem to have with the macabre, the Disney Villains Parade (2000) in Disneyland Paris featured Vampire Mickey and Minnie leading the procession, while riding in the eye sockets of a cracked skull, driven by a motorcycle-riding skeleton.

Back at Walt Disney Word, one parade that still exudes a homegrown feel is at the Fort Wilderness Resort and Campground: the Halloween Golf Cart Parade, which started in 2010. The handmade Halloween-themed golf carts are created by Guests who are perhaps the equal measure of those who create the Disney park parades, at least when it comes to turning cardboard into unique art.

Typically, fall daytime parades and happenings at the parks have focused more on autumnal themes such as the harvest, pumpkins, autumn-inspired character costumes—like Mickey's Halloween Time Street Party (debuted 2017) in Hong Kong Disneyland—or are just slightly on the spooky side. Participants in the latter want Mickey and his friends to join them in their wonderful, wondrous world of dreams and *screams*, a theme in the Spooky Boo! Parade (2018 and 2019) at Tokyo Disneyland.

But when night falls, villains take center stage at the Disney parks, including at events like Villains Night Out (2016–2018) in Hong Kong Disneyland. In Halloweens past, villains have typically "invaded" parade floats, adding their own devious decor—and presence. In the wake of this increasing popularity, the Parades team now focuses on creating more Halloween-centric floats—and adding those with a more nefarious reputation. In Disneyland Paris, the Disney Villains' Halloween Celebration (2014) finale float featured a lunging snakelike Jafar, *Fantasia's* Chernabog exploding out from his Bald Mountain home, and a twisted, tentacled Ursula; Glow in the Park Parade (2007–2013) in Hong Kong Disneyland featured a larger-than-life Audio-Animatronics figure of Jack Skellington atop a jack-o'-lantern that was a sight to see.

The crowning ghoul of the Halloween nighttime parades is at the Magic Kingdom: Mickey's Boo to You Halloween Parade (performed since 2003). Beyond the costumed characters and villains, the characters brought out from the attractions for this event are a welcomed addition. There's a nice blend of pirates from Pirates of the Caribbean and Peter Pan, who sing "a Pirates Life" (it sure beats 1999's rappin' Captain Hook). Haunted Mansion characters are a Guest favorite. The Gravediggers' sparking shovels were a hit (an aspect to the show only added when it was discovered that shovels dragged against the ground cause sparks to fly, believe it or not) and the ashen-faced Dead Waltzers were given backstories to give dimension to their demise: electrocution, poisoning . . . digesting of too many churros (is that even possible?).

The Halloween parade in Disneyland has evolved from the "simple" Mickey's Trick or Treat on the Street (2005–2009) and transformed into the more elaborate Mickey's Costume Party Cavalcade (2010–2015) with a larger range of characters and floats. The finale staircase float, once featured in the Parade of Dreams, was revamped with Halloween accessories: pumpkins, autumn foliage, Mickey bats, and featured Vampire Mickey and Witch Minnie (and friends). The Frightfully Fun Parade (presented variously at Disneyland and Disney California Adventure since 2016) features characters from *Tim Burton's The Nightmare Before Christmas* and various attractions, plus Dr. Facilier (from *The Princess and the Frog*), providing a balance of fright and fun. The staircase float was also reimagined in a dark, dungeon-esque way, decked out with bats, skulls, gargoyles, spiderwebs, a smoking cauldron and numerous Disney villains, including the Maleficent dragon, which towers menacingly over the castle.

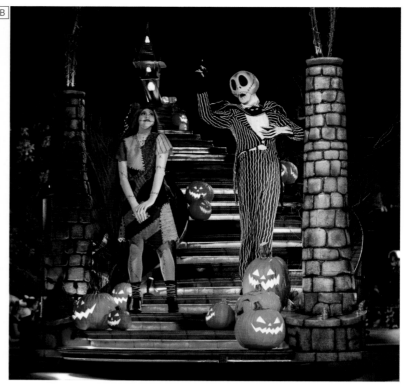

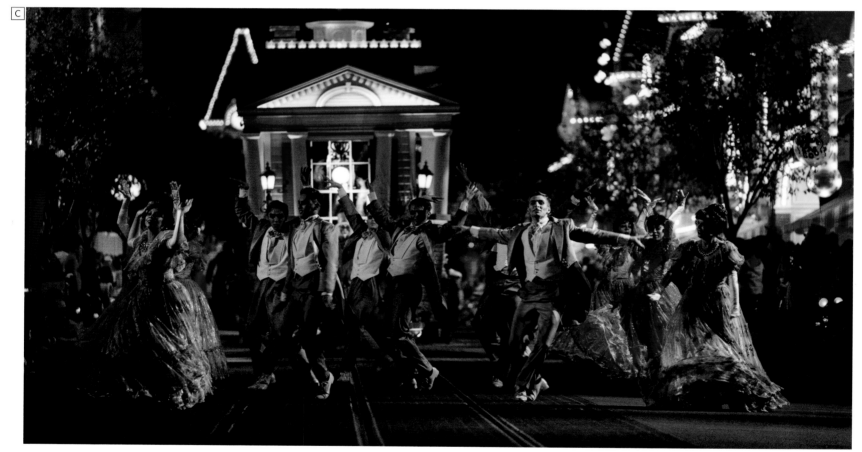

Mickey's Halloween Party,
Disneyland

A — F *Frightfully Fun Parade*
2018

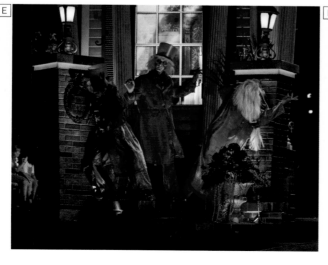

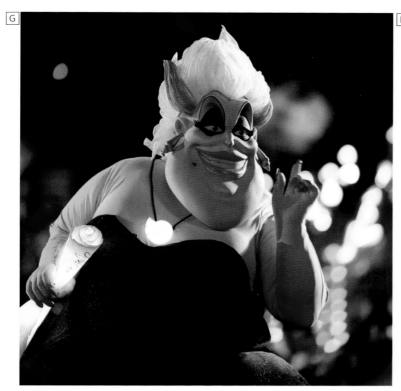

*Mickey's Halloween Party,
Disneyland*

G H I *Frightfully Fun Parade
2018*

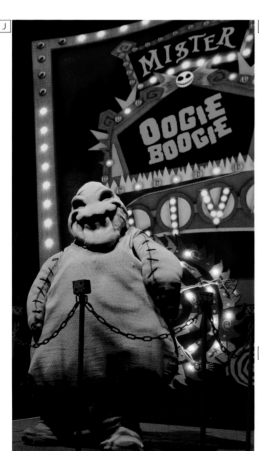

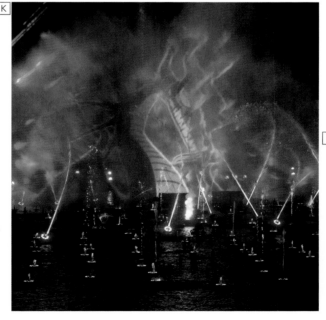

*Oogie Boogie Bash—
A Disney Halloween Party,
Disney California Adventure*

J *Oogie Boogie immersive treat
trail inside Disney Animation
2019*

K *Villainous! World of Color
2019*

L *Carthay Circle Restaurant
2019*

M *Villains Grove, Redwood
Creek Challenge Trail
2019*

Magic Kingdom

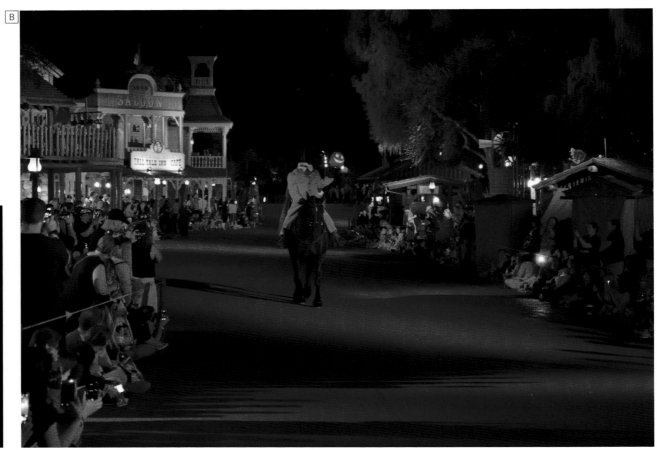

A *Mickey's Not-So-Scary Halloween Parade
1997*

B *Headless Horseman
2018*

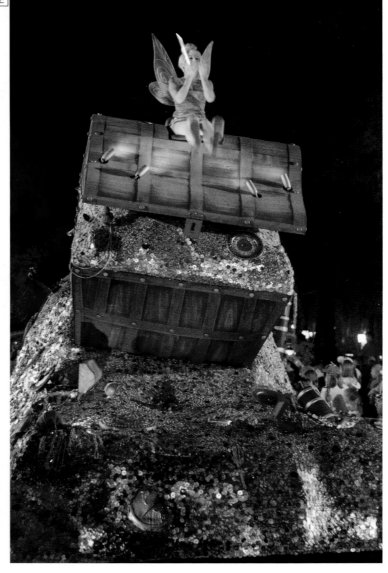

*Mickey's Boo to You
Halloween Parade,
Magic Kingdom*

C *2017*

D E *2018*

F *2013*

G H *2018*

I *2017*

J *2013*

K *2017*

L *2018*

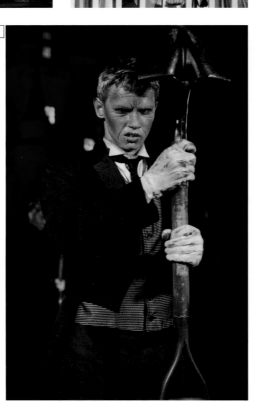

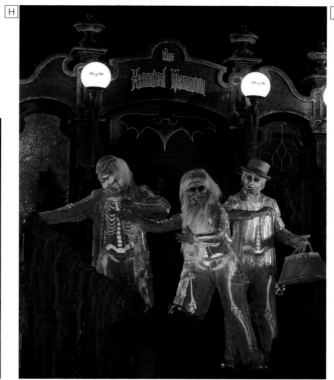

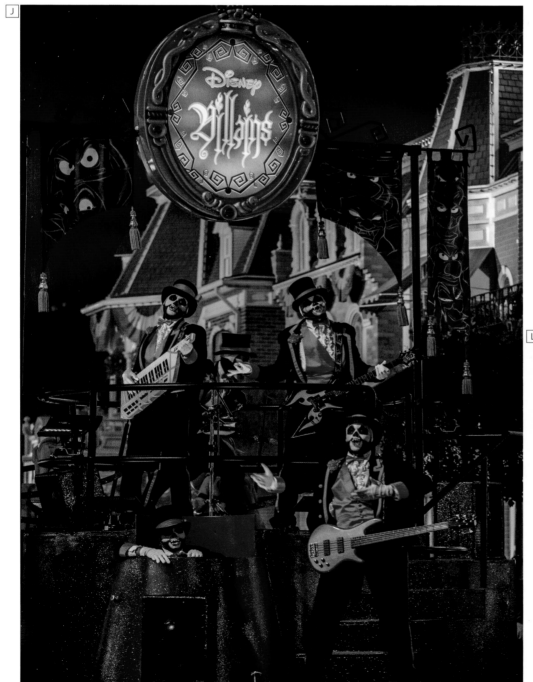

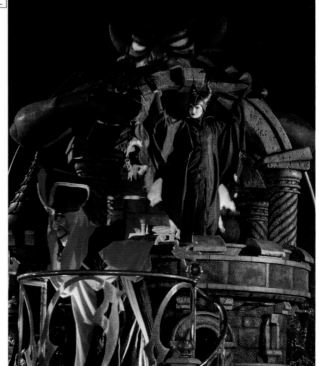

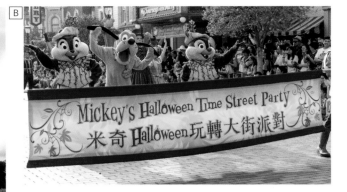

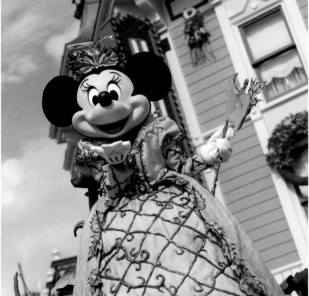

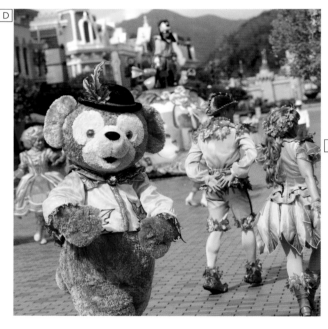

Hong Kong Disneyland

A — D *Mickey's Halloween Time Street Party 2017*

E — I *Villains Night Out 2017*

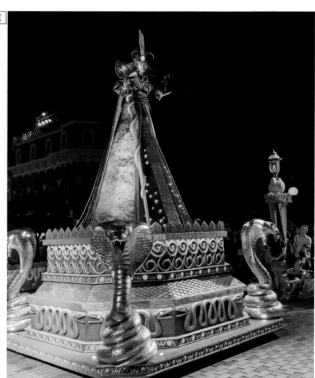

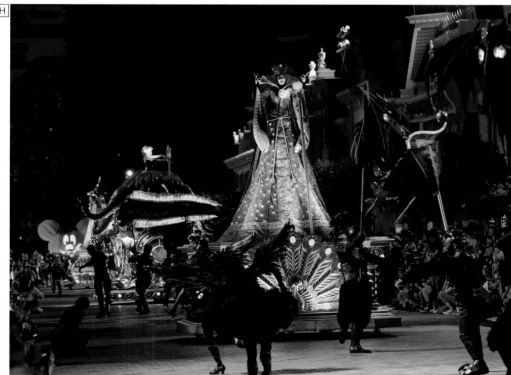

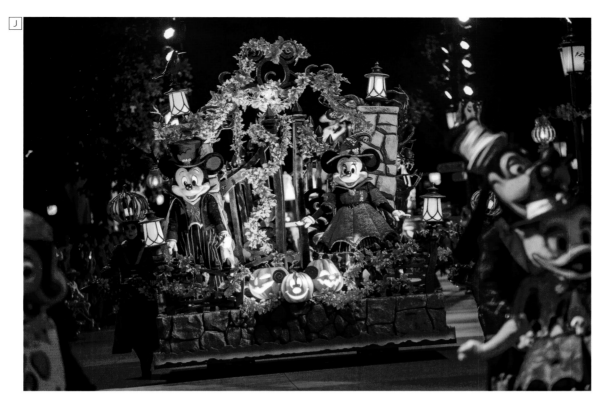

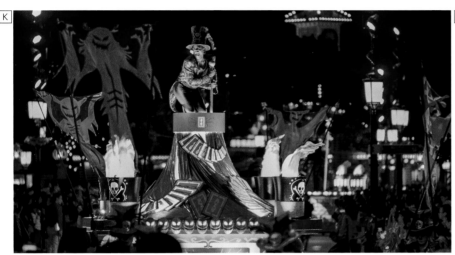

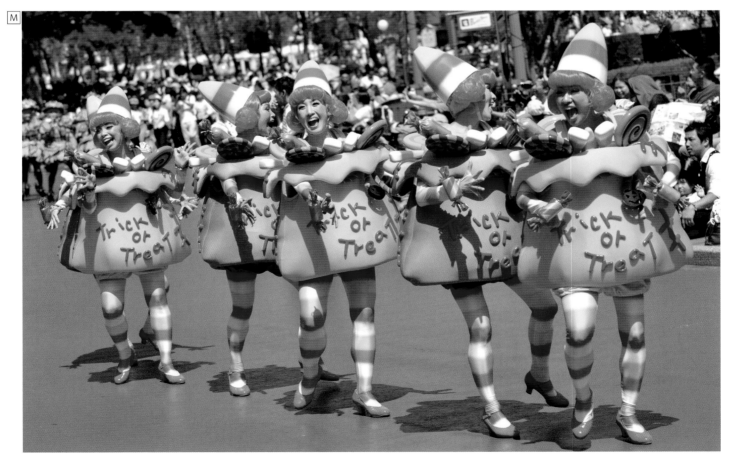

Shanghai Disneyland

J K Mickey's Halloween
Treat Cavalcade
2018

Tokyo Disneyland

L Welcome to
Spookyville Parade
2010

M Happy Halloween
Harvest Parade
2015

Mickey's Halloween Celebration, Disneyland Paris

A 2015

B C 2018

D 2015

E — H 2018

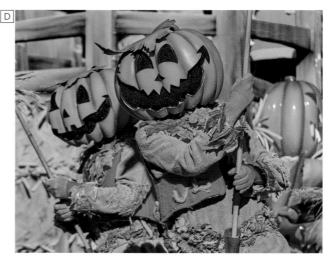

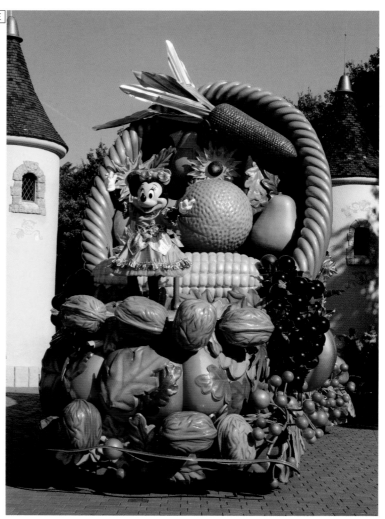

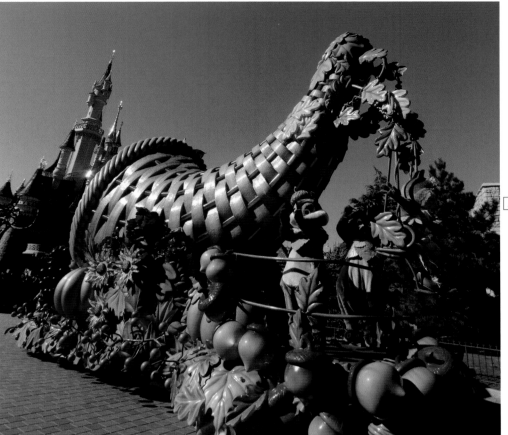

Mickey's Halloween Celebration,
Disneyland Paris

I — M *2018*

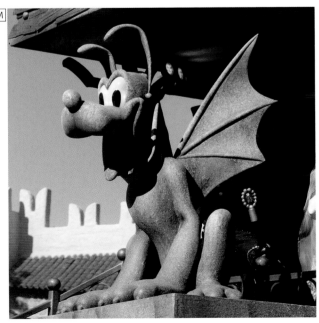

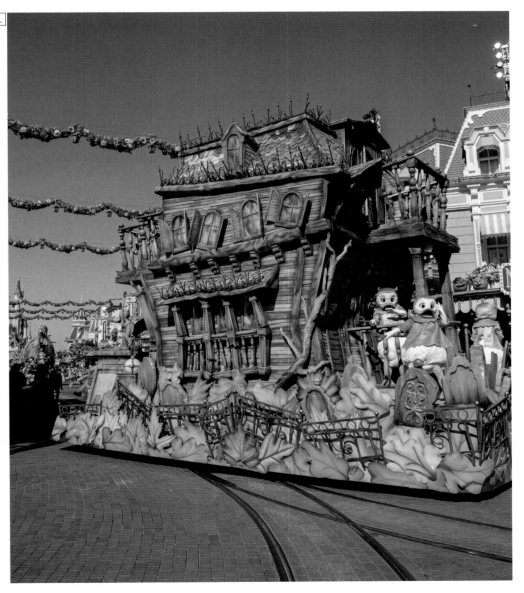

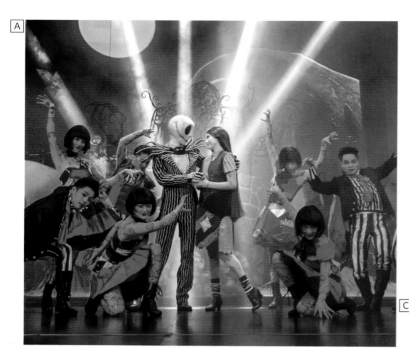

Halloween shows are a great way to celebrate the season. If ye seeks tall tales, head to the fog-filled Rivers of America in Disneyland, where a skittish, superstitious pirate on the Sailing Ship *Columbia* first warned of "ghosts" in 1996. In a humorous and corny twist, the ghosts turned out to be animatronic animals wearing ghostly white cloth. For tales of yore, venture to Liberty Square in the Magic Kingdom, where a cadaverous and tattered Mr. Knickerbocker, keeper of the legends, told the tale of Sleepy Hollow (and the Headless Horseman) in 2005. Adventure seekers discovered Horrors of the Amazon in Hong Kong Disneyland (2014), where a Jungle River Cruise skipper showcased his illustrious artifacts and creature collection in an attempt to join the Society of Explorers and Adventurers. Unfortunately, the creatures escaped! The skipper—and those being "entertained"—faced a grave encounter with an ancient cursed masked spirit as a result.

Halloween castle shows require a more elaborate combination of villainous choreographed dancing and singing, sophisticated projection, along with fire, water, or fireworks. At It's Good to Be Bad in Disneyland Paris in 2015, a dozen and one baddies rocked the fright away. But beware when the evil Queen transforms into the wicked Witch. At the Magic Kingdom, the long-running Villains Mix and Mingle (2005–2014) villainous Halloween party united evil forces for their favorite fright night.

In 2015, three unexpected guests, the cult favorite Sanderson sisters, crashed the party for the *Hocus Pocus* Villain Spelltacular. In a new story line, the sisters create a sinister party potion spell over the Magic Kingdom with the help of some dastardly villains, leading to some humorous interactions, snazzy song numbers, and magical mischief in the process. Keep an eye on the sisters' costumes, which are precisely re-created replicas of their movie attire (with help from the Walt Disney Archives).

Special spooky events give Guests the opportunity to partake in intimate evenings in a unique setting: Mr. Toad's Enchanted Evening (1999) transformed Fantasyland in Disneyland into a 1790-circa Halloween

celebration. The Mahaloween Luau at the Disneyland Hotel was a tropical-themed twist on the holiday, with a show and the ever-popular collectible Halloween tiki mugs in use, a must-have for Disney tiki collectors. The food and beverage team not only designed the tiki mugs, but have since expanded their creative collectible contributions to include Halloween-themed popcorn buckets, steins, and straw clips.

Mystical Spirits of the Blue Bayou (2015) in Disneyland was a séance soiree hosted by Dr. Facilier. The Shadow Man also hosted an eerie evening of mystical mayhem with the Divas of Darkness in Disney's Hollywood Studios at Walt Disney World called Club Villain (2016 and 2017). At Magic Kingdom, Lady Tremaine took over Cinderella's Royal Table for a Villains' Sinister Soiree (2014). While villain-themed desserts and drinks were being served, Lady Tremaine sang some haunting solos, but by far the scariest part of the night was the wicked stepsisters' horrible attempts at harmonizing.

Holiday gatherings have been done for Disney's own, too. Evoking the small-town feel of Main Street, U.S.A., Little Monsters on Main Street (since 1990), a Cast Member–exclusive party, gives the children of Disneyland employees the opportunity to trick-or-treat in a unique and safe environment.

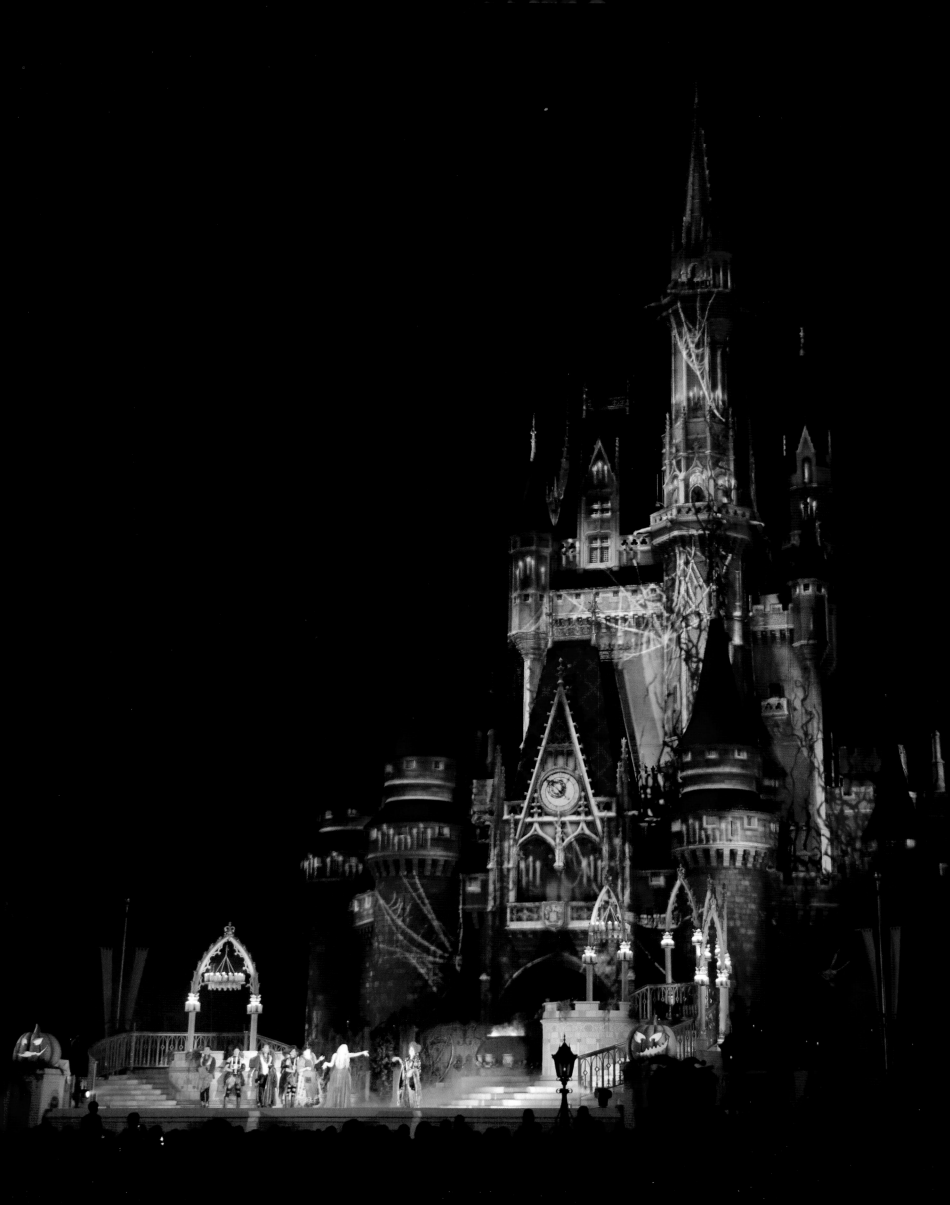

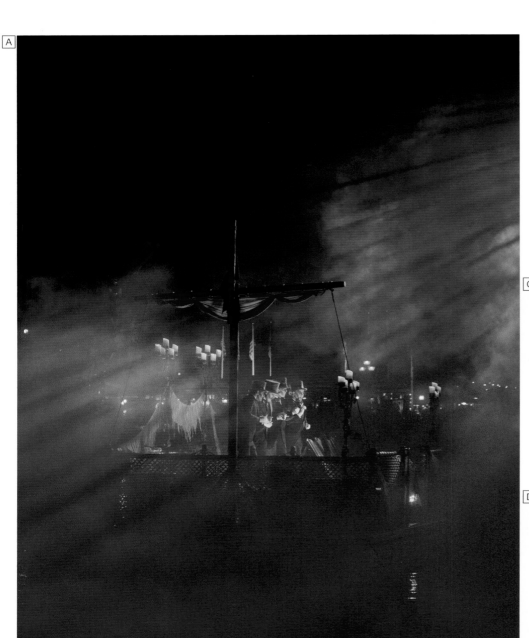

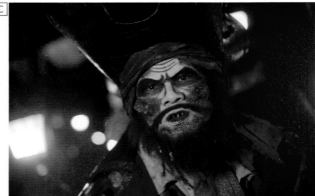

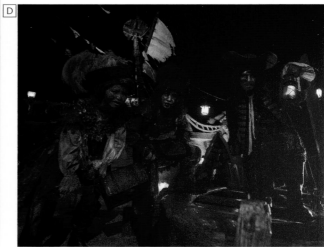

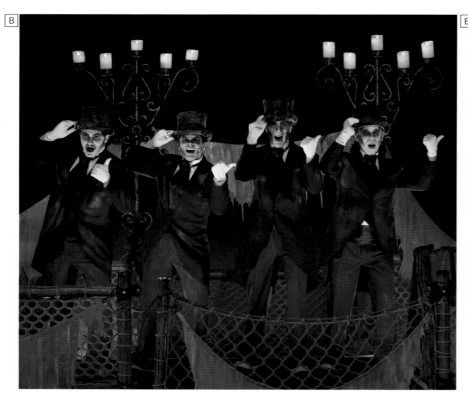

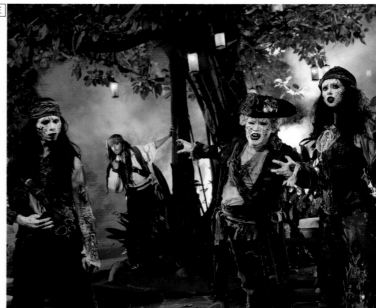

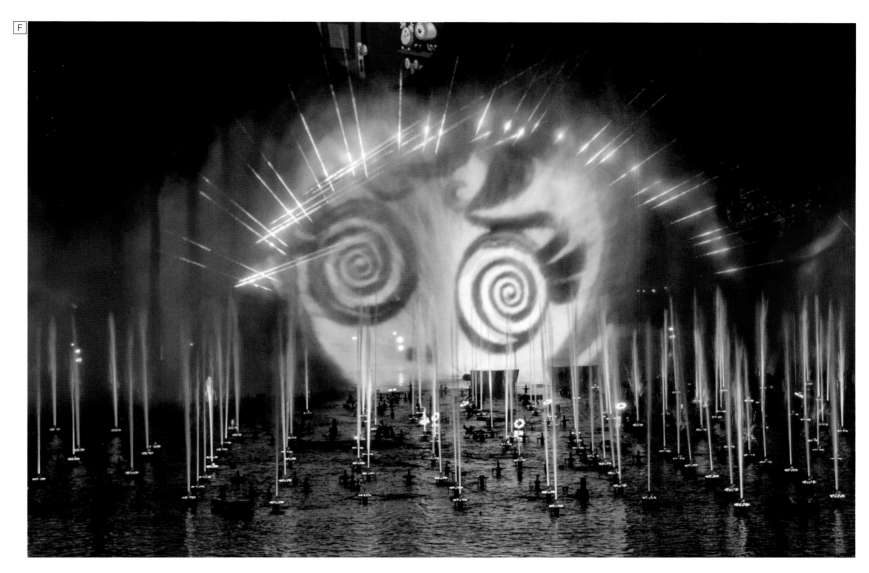

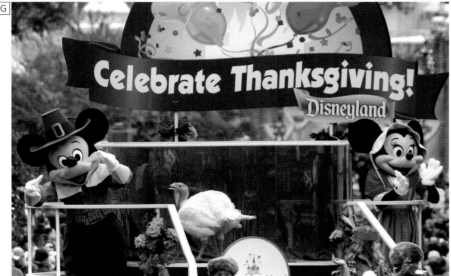

When discussing the Disney autumn holidays, one would be remiss not to mention Thanksgiving. The comfort of a nice, warm hearty Thanksgiving meal with loved ones at the Disney parks and hotels has been a draw for many Guests: roasted turkey, prime rib, homemade stuffing, mashed potatoes and gravy, cranberry sauce, and pumpkin pie are staples of the holiday feast. Traditionally, Thanksgiving has been a time when huge numbers show up at the Disney parks, though in the inaugural year of the Magic Kingdom there was below-average Guest attendance . . . till Thanksgiving. That day was the first day there was a massive spike in attendance, solidifying the season. Thanksgiving weekend celebrations in Disneyland and Magic Kingdom have since featured an array of popular musical acts of the era, special entertainment, festive fireworks, and parades.

From 2005 through 2009, the Thanksgiving parades featured a very special grand marshal who "flew in" for the occasion. Deemed the "Happiest Turkeys on Earth," these presidentially pardoned turkeys were placed on a special diet and flown in from Washington, D.C. on "Turkey 1" (in first class of course) to be the grand marshals in the Disneyland Thanksgiving Parade, before living out their days at the now-retired Big Thunder Ranch. Marshmallow and Yam became the first presidential pardons in 2005, followed by Flyer and Fryer (2006), May and Flower (who appeared at Walt Disney World in 2007), Pumpkin and Pecan (2008), and Courage and Carolina (2009). Courage was a very social, happy little bird, and a total ham, whereas Carolina's social interactions consisted of staring at the Circle D Cast Members with a "feed me" look on her face.

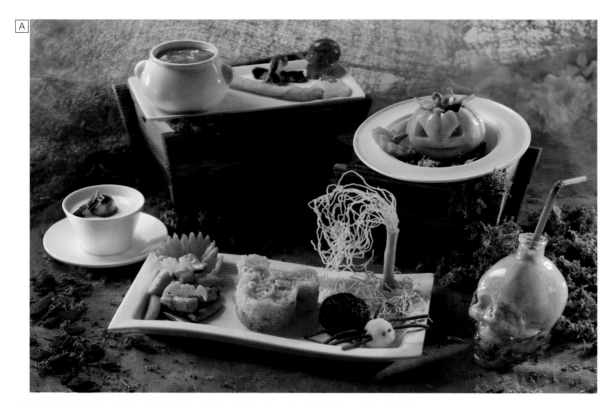

Hong Kong Disneyland

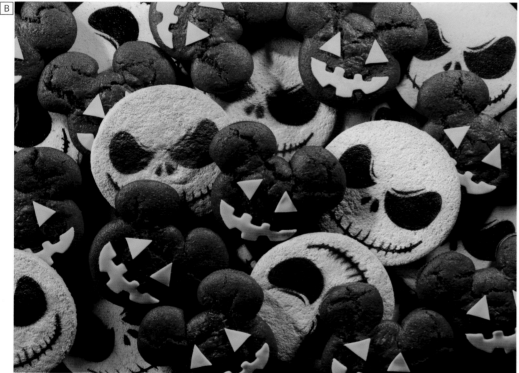

Hong Kong Disneyland Hotel

The sensational smells that surround those on Main Street, U.S.A. and throughout the parks and hotels are a source of pride and ownership for the food and beverage teams. Creating enticing new foods and desserts is an exciting challenge that typically takes two weeks of daily tweaks and presentations to the chefs team charged with setting up the proper balance. Pumpkin beignets, Mickey Bat cookies, Poison Carmel Apples, maple pumpkin churros, Black Tip torta (filled with cream cheese and warm blueberry), Jack Skellington–shaped curry bread, and a Cruella De Vil–inspired Gyoza Dog are just a select morsel of the *terror*-ific treats found throughout the parks during the various Halloween and autumn celebrations.

F *Hong Kong Disneyland*
Ghoul Mousse Cake,
World of Color Restaurant,
Disney Explorers Lodge
2017

*G**H**I* *Disneyland Paris*
Walt's—an American restaurant
2016

J *Shanghai Disneyland*
Black Magic Cheeseburger
2017

*Disney Cruise
Line ships*

K 2014

L 2013

A *Disney California Adventure*
Bat Wing Raspberry Sundae,
Clarabelle's Ice Cream
2017

B *Disney California Adventure*
Caramel Apple Smoothie
2018

C *Disneyland*
Cake Pops
2016

D *Aulani*
Thanksgiving Dessert
2014

E *Magic Kingdom*
HalloWishes Dessert Party,
Oogie Boogie Tarts
2017

F *Disneyland*
Halloween Apples
2010

G *Disney Springs*
Amorette's Patisserie desserts
2018

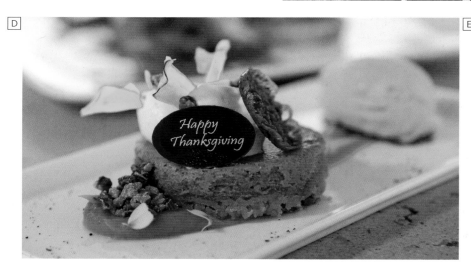

Magic Kingdom

H Madame Leota dessert, Liberty Tree Tavern
2018

I Hitchhiking Ghosts dessert, Aloha Isle
2018

J Zero Waffle Sundae, Sleepy Hollow
2018

Disney California Adventure

K Spoke-y Cone Macaron, Cozy Cone Motel
2017

L Vampire Mickey Sourdough, Pacific
Wharf Cafe
2018

M Pumpkin Spice Funnel Cake Fries,
Award Wieners
2018

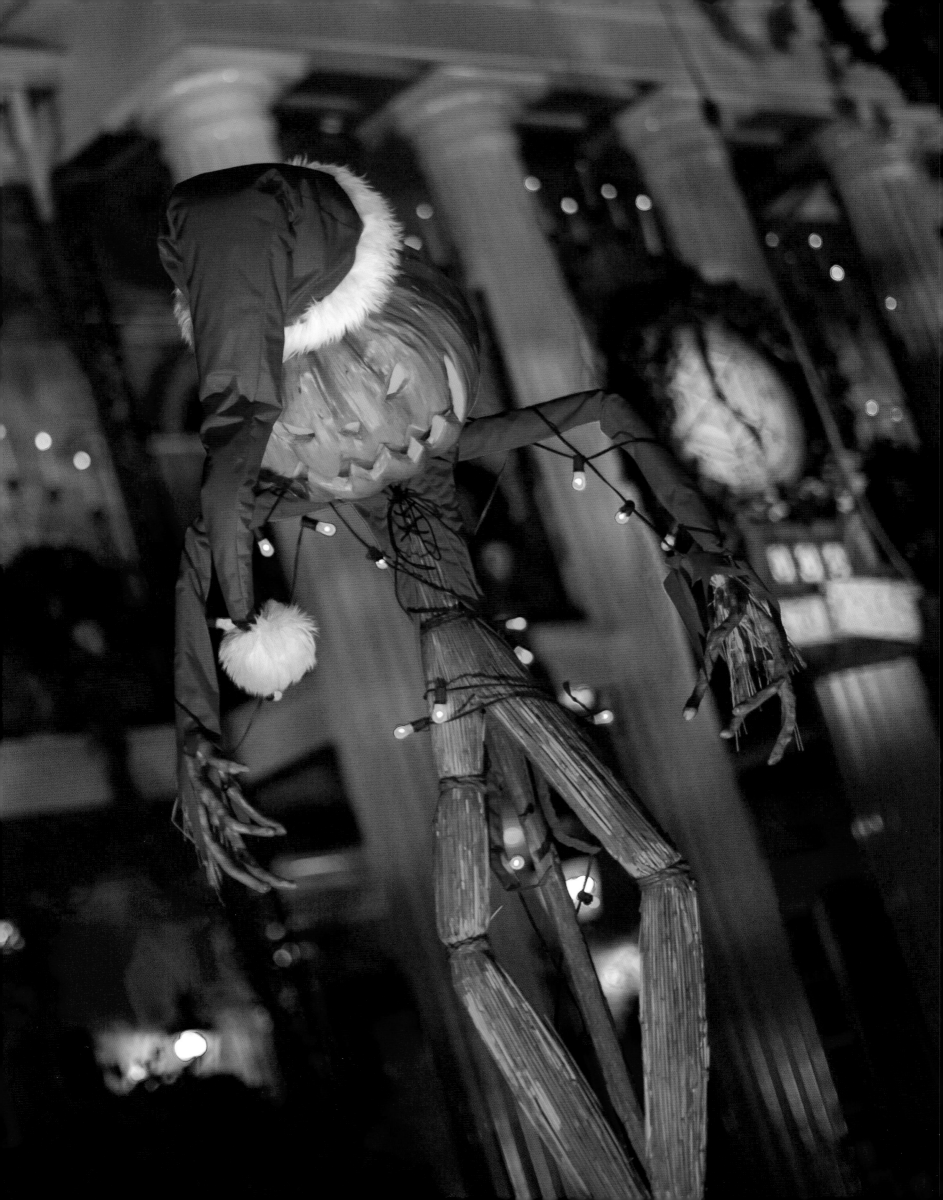

When Holidays Collide

Relax and reflect, feel free to take pause,
While we tell you a tale about dear Sandy Claws

'Twas a long time ago, longer now than it seems . . . when on October 5, 2001, Haunted Mansion Holiday opened in Disneyland, the first major Halloween-based attraction overlay at a Disney park. After creating the winter holiday overlay (aptly named It's a Small World Holiday) that debuted in 1997, Steven Davison, executive of Parades & Spectaculars, was looking to expand the holiday splendor in Disneyland. Disney Legend Tony Baxter had also been toying with the idea of *A Christmas Carol* at the Haunted Mansion.

One day, Davison and Baxter were brainstorming ideas while walking toward the attraction: "What if the ghosts of past, present, and future were there?" Or, "What if Santa landed at the wrong house and came down the chimney?" Santa and *A Christmas Carol* were not the exact right fit, but with the growing popularity of the stop-motion animated musical *Tim Burton's The Nightmare Before Christmas*, the team shifted their attention.

Davison had thoughts: *What if the first house Jack Skellington landed at while delivering presents on that faithful Christmas Eve was in fact the Haunted Mansion in Disneyland?* The story of Haunted Mansion Holiday took shape from there: *If Jack's transformation of the Haunted Mansion was such a success, naturally he believed he was an excellent Santa and would continue to deliver presents throughout the world.* Davison, Senior Art Director Brian Sandahl, Senior Graphic Designer Tim Wollweber, and the Disney Parks Live Entertainment team took months working on the style, making things bigger, bolder, and crazier. They were challenged artistically in meshing two opposing forces of a very classic Haunted Mansion design and the *Nightmare* style as caricatured in the movie.

During the development, Davison worked on selling the idea to management. He would print out scrolls of his "Haunted Mansion Holiday" poem with red licorice ties and pass them out at meetings to help create interest. The persistence paid off. After three years, the idea was

Disneyland
2008

approved. The team was excited but also terrified. They had never tried anything like it before and wanted to get it right. Eventually, they realized it's different—and that's why it works.

Jack Skellington views "Making Christmas" through his experiences in Halloween Town. Jack's Christmas decorations all have a frightful Halloween twist: black garlands, skulls and crossbones, candles and jack-o'-lanterns on spikes. When the Disney Parks Live Entertainment team started working on the exterior decor, their now-signature black garland didn't exist. Working alongside the Horticulture team for fireproofing purposes, the team ran black pine garland under bullet heaters, torched it, melted it, and twisted it into form. Then 480 feet of black ribbon was hand-painted with correction fluid, over a four-day period, to give the ribbon a homemade quality.

On opening day, Disney Imagineers were anxious to see how people would respond to the attraction overlay. A terrified Davison watched from the control room while Sandahl and Wollweber stood out front to gauge the reaction. Their collective fears began to dissipate when they saw Guests sprinting toward the entrance. An engineer told Davison to go inside the Portrait Chamber with Guests. Once there, he was thrilled to hear unbridled cheers for what was unfolding when Jack appeared.

There is a vibrant energy to the Haunted Mansion Halloween flair with four hundred flickering candles and one hundred jack-o'-lanterns, all with different expressions. The iconic Pumpkin King scarecrow in the queue originally debuted at a 2004 special event. Many other exterior elements were inspired by the movie, from the jack-o'-lanterns on spikes, the DAYS TO XMAS clock, Jack's sleigh and Jack's Christmas equation, which is leveraged directly from the movie. At night, look closely atop the exterior's cupola to see the eerie orange glow of ghost dog Zero's nose floating around.

Haunted Mansion Holiday

Inspired by
TIM BURTON'S NIGHTMARE BEFORE CHRISTMAS

A GHOSTLY HOLIDAY TALE

It was the nightmare before Christmas and all through the house
Not a creature was peaceful, not even a mouse
The stockings, all hung by the chimney with care
When opened that morning would cause such a scare!
The children nestled all snug in their beds
Would have nightmares of monsters and skeleton heads

Jack Skellington came here from HalloweenTown
You'll notice his handiwork scattered around
This year he's decided to play "Sandy Claws"
But when Halloween creates Christmas you might see some flaws
And now a dark carriage will take you away
Sit back, rest in peace in your black Christmas sleigh!

Yes, down through the chimney Jack flew like a bat
Clutching his magical "Sandy Claws" sack
He ripped open the sack and, in moments it seems,
Created a Christmas you have in bad dreams!
So hold on for your life, who knows what you'll find
In this Christmas created by Jack's ghoulish mind!

More rapid than vultures, the Mansion was changed
All was soon covered, adorned and deranged
Gravestones and coffins were "holiday-ized"
Showing us Christmas as seen through Jack's eyes
And what to your wondering eyes disappears
Is Jack's little friend Zero - the Ghost Dog Reindeer!

Each room, as you see, has Jack's own special flair
See the bow made of bats? No doubt Jack has been there!
Jack enjoyed being "Sandy" - he liked it so much
Every inch of this Mansion shows his unique touch!
Nothing here was forgotten, it all looks so pleasant
A coffin, Jack says, makes a fine Christmas present

He decked every hallway and trimmed every tree
It's his gift this Christmas to you and to me!
A man-eating plant makes a wonderful wreath…
As long as you don't get caught in its teeth
Jack's holiday vision was unlike no other
So ring out the bells, there's more cheer to uncover!

A holiday party reflects on its host
And whether you're living or "gave up the ghost"
With some treats and some games, you can make a scene merry
Why, even a gingerbread house could seem scary
All at once, Jack's true vision materialized
Like a nightmarish painting by Currier & Ives

All through the house with a true sense of joy
Jack happily strew little presents and toys
All the vampire teddy bears gave us a fright
And the shrunken doll heads made a horrible sight
A bag full of toys Jack had slung on his back
They were strange and bizarre - and on the attack!

"Sandy Claws" worked his magic, both outside and in
But one final touch made his bony face grin
"Now what better gift on my friends to bestow
Than a graveyard that's covered in ghostly white snow!"
And laying a finger aside of his nose
And giving a nod, the whole graveyard he froze!

As Jack sprang to his sleigh, three hitchhikers he spied
They said, "Sandy Claws, may we please have a ride?"
But Jack waved good-bye, for he just could not stay
He had much to deliver before Christmas Day!
And they heard him exclaim as he drove out of sight
"The world will not soon forget THIS Christmas Night!"

May Jack's "ghostly presents" now follow you home
And stay in your heart - where'er you may roam
But on some midnight clear if your skin feels a chill
Remember dear Jack was just spreading goodwill
For now you know what happens when holidays meet
You might get a trick… or a holiday treat!

We Wish You a Scary Christmas

-Sandy Claws

2. ALTERNATE COLOR SCHEMES FOR VARIETY IN THE FLOWERS

USE SAME EYES, LIPS, etc as LARGER FLOWER ALSO INCLUDE SAME LINEAR DETAILING ON POD HEAD AND PETALS

Blue Green Head with Darker Red petals

Yellowy Green Head with Finger Petals

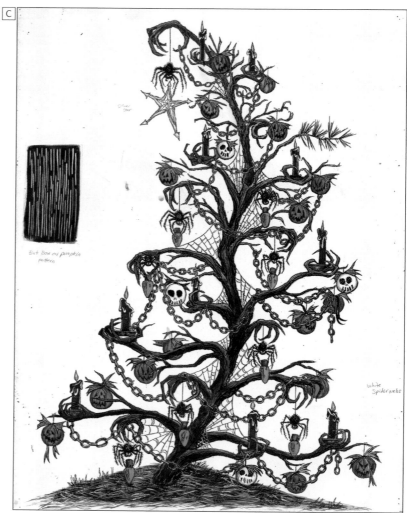

Silver Tree

Bat Bow on pumpkin pattern

White Spiderwebs

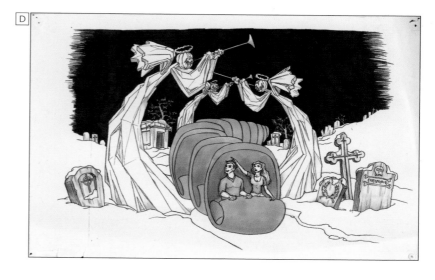

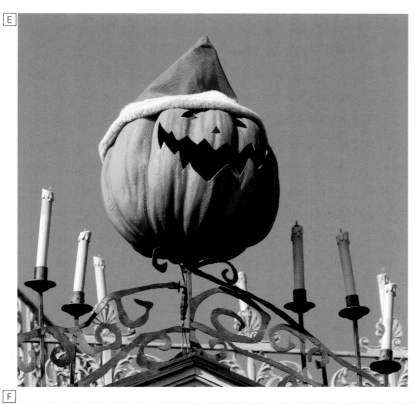

One of the unique elements of this attraction is the collaborative effort between multiple departments. The production team, which physically transforms the Haunted Mansion with set dressing and decor, is able to openly give creative suggestions. One particular suggestion, the cymbal monkeys, has managed to live on, even after their untimely demise. During the attraction's inaugural year, around fifty store-bought cymbal-playing monkeys were purchased and placed in the attic. But they couldn't hold up to the rigors of sixteen-hour days for three months, and literally died. By year two, most of the monkeys were gone (though a few found a new afterlife as static decorations inside the Haunted Mansion)! A loving tombstone tribute, however, was erected in their honor. In the queue area's pet cemetery, the cymbal monkeys have appeared over the years, along with an Oogie Boogie topiary (for Oogie's debut in 2003) and a Frankenweenie tombstone to coincide with the release of the 2012 movie *Frankenweenie*.

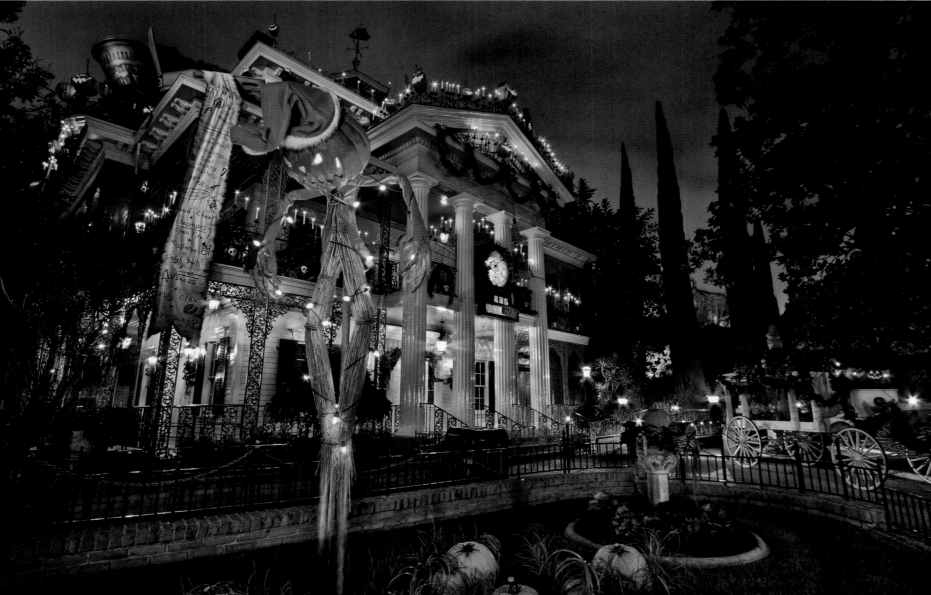

Concept development

A Concept pitch
2001

B C D Concept artwork
2000

Disneyland

E Exterior decor detail
2018

F Exterior
2012

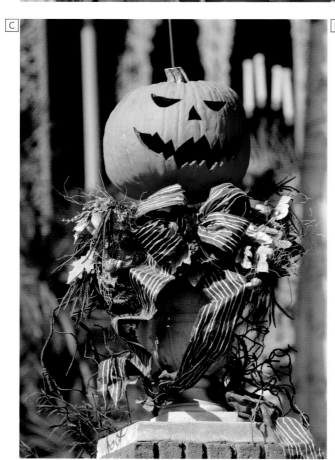

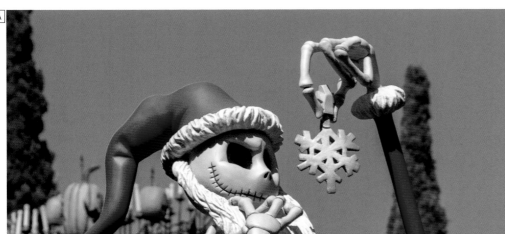

Disneyland

A *Attraction entrance 2019*

B *Queue area 2019*

C *Exterior 2018*

D *Attraction entrance 2018*

E *Attraction entrance 2019*

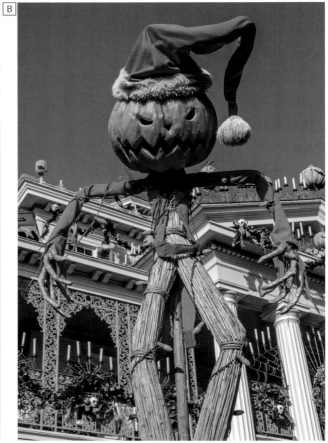

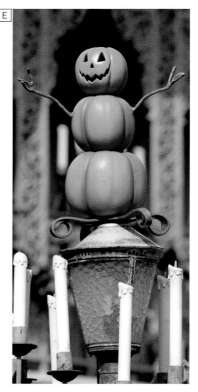

Disneyland

F G H *Exterior decor detail*
 2018

I *Exterior decor detail*
 2017

J *Cymbal-playing monkey,*
 queue area's pet cemetery
 2002

OLD MANSION TREE

O Old Mansion Tree
Old Mansion Tree
Your leaves are sharp and prickly!
Old Mansion Tree
Old Mansion Tree
You bring a gloom that's sickly!
Your branches droop
With moldy care
Your smell of mildew fills the air!
Old Mansion Tree
Old Mansion Tree
You clear the room so quickly

Old Mansion Tree
Old Mansion Tree
O how we decorate you!
Old Mansion Tree
Old Mansion Tree
With ornaments we weight you!
Your limbs are limp with bats and bows
Your tinsel tarnished years ago
Old Mansion Tree
Old Mansion Tree
Our fireplace awaits you!

"Scarols," tweaked classic carols, were added to the queue in 2002. Guests were encouraged to scream along to "Up on the Housetop," "Scary Bells," "Over the Graveyards," "Old Mansion Tree," "Wreck the Halls," "We Wish You a Scary Christmas," "The 13 Days of Christmas," and "God Rest You Merry Grinning Ghosts." A Porter baroque music box instrumental rendition of "Grim Grinning Ghosts," originally heard at Phantom Manor in Disneyland Paris, became the exterior music in 2003.

The Haunted Mansion Holiday transformation takes a little under two weeks, and this setup time is accelerated by storing ninety percent of the seasonal decor and Audio-Animatronics figures within the attraction itself. Closing an attraction for that amount of time each year requires patience and understanding from Guests visiting the park as well.

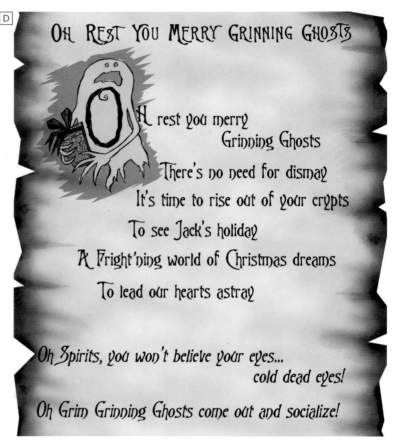

OH REST YOU MERRY GRINNING GHOSTS

O Oh rest you merry
Grinning Ghosts
There's no need for dismay
It's time to rise out of your crypts
To see Jack's holiday
A Fright'ning world of Christmas dreams
To lead our hearts astray

Oh Spirits, you won't believe your eyes...
cold dead eyes!

Oh Grim Grinning Ghosts come out and socialize!

Disneyland

A Scarol banner, original artwork 2002

B C Scarols, queue area 2002

D Scarol banner, original artwork 2002

E Hearse, queue area 2018

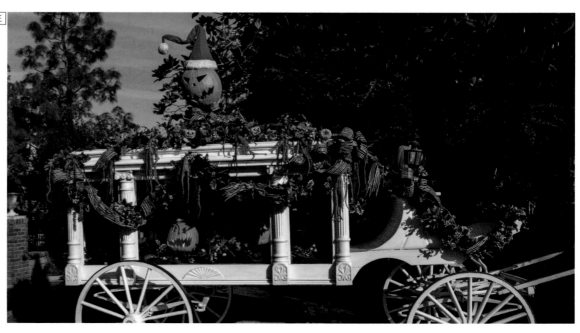

A counterpart to Haunted Mansion Holiday in Disneyland, Haunted Mansion Holiday Nightmare, debuted in Tokyo Disneyland in 2004. While similar in nature, there are some distinct differences. Anaheim's Haunted Mansion is a stately nineteenth-century antebellum manor, while the Haunted Mansion in Tokyo Disneyland is reminiscent of an eighteenth-century Dutch manor. Tokyo's exterior features a pumpkin tree wrapped in vines, Sally's graveyard garden, pumpkin snowmen, and the Pumpkin King.

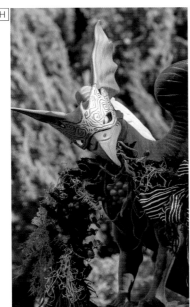

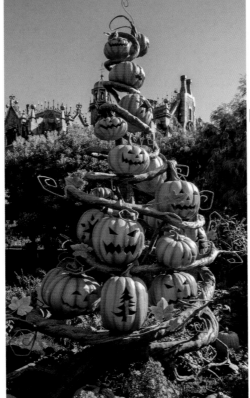

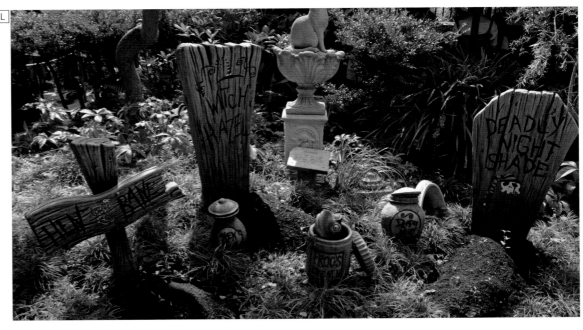

Tokyo Disneyland

F *Attraction entrance 2019*

G *Exterior decor detail 2017*

H *Attraction entrance 2018*

I *Queue area 2019*

J K L *Queue area 2017*

'Twas a long time ago, longer now than it seems
In a place that, perhaps, you have seen in your dreams
For the story that you are about to be told
Began in the holiday worlds of old
I know you're curious to see what's inside
It's what happens when two holidays collide!

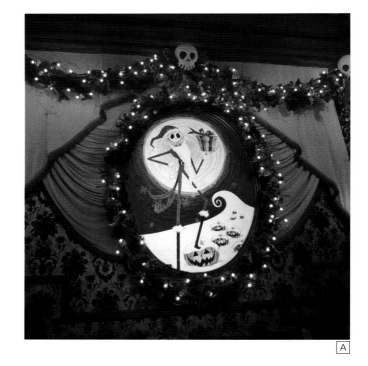

A

The music of *Tim Burton's The Nightmare Before Christmas* is an integral part of the storytelling splendor of that film, and there is no skimping on it at the Haunted Mansion Holiday attraction. The original score, composed by Gordon Goodwin, referenced the mood and compositional language of Disney Legend Danny Elfman's theatrical score. And in 2002, the music was altered to more closely reflect the more familiar Elfman score, composed by John Debney. Parts of Goodwin's score can still be heard in the Portrait Chamber and in the Exit.

The "Haunted Mansion Holiday" poem is the base and inspiration for the attraction's events. Steve Davison took inspiration from *Tim Burton's The Nightmare Before Christmas* movie, Tim Burton's "The Nightmare Before Christmas" poem, and Clement Clarke Moore's 1823 verse "A Visit from Saint Nicholas." The poem called for new narration, but the original voice of the Ghost Host, voice actor and Disney Legend Paul Frees, had since passed away. Longtime Frees admirer and voice actor Corey Burton stepped in to assist.

Burton grew up with a love of Disneyland and visited the Haunted Mansion as a child. He was enthralled by the voice of the Ghost Host, and by the time he finished riding through the place, he had discovered the passion that would become his life's work. For Burton, "The Ghost Host . . . was so much pure Paul Frees. The most remarkable piece of narration, I feel, ever recorded. It's everything: it's scary, it's funny, it's got authority, it's got weight to it, it has magic, it's just stunning," he says. "Without that narration, the Haunted Mansion is just a haunted house."

Over the years, Burton had been hesitant to touch and replicate Frees's characterization of the Ghost Host until he received a call from Disney Character Voices. As he remembers, "It was just a demo, a placeholder." At the recording session, there was an authentic old RCA ribbon microphone that could possibly have been the same microphone used for the original recording for Haunted Mansion narrative. Burton would listen to the original track and try to match the tonality and inflection to the best of his ability. He was set to leave after recording some stanzas, but Bruce Healey, musical director for Walt Disney Attractions, wanted him to keep going, and they ended up recording everything! The combination of Burton's performance and the sound and music editing (to get the same sonic flavor of the original) created the vocal illusion heard today at the attraction.

B

Tokyo Disneyland

A *Foyer*
 2018

Disneyland

B *Foyer*
 2018

Disneyland,
Portrait Chamber detail

C *2017*

D *2018*

E F *2017*

G *2016*

Welcome, my friends, to our Christmas delight
Come witness a ghoulishly glorious sight
It's time for our holiday tale to begin
There's no turning back now—
 please, come all the way in

Our holiday tale is a tale that's quite charming
But during this season, it's sometimes alarming
So relax and reflect, feel free to take pause
While we tell you a tale about dear Sandy Claws

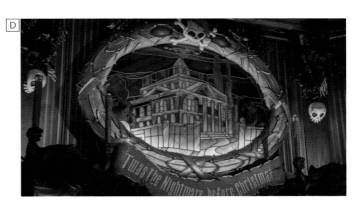

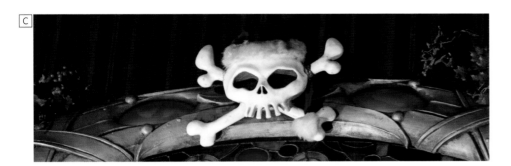

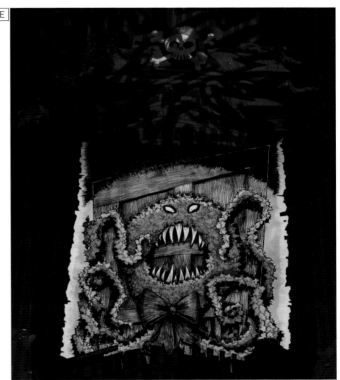

The Ghost Host narration takes Guests from the Foyer to the Portrait Chamber—a technical illusion originally created to solve a practical problem of getting Guests underground and under the Disneyland Railroad berm. When the creative team first started, they wanted to replace the Portrait Chamber paintings. This created another practical problem. While the existing portraits would take two weeks to take down, it would take months to get them back in perfect alignment if they were taken out. The team decided to put stained glass on top of the preexisting portraits, giving them a sense of freedom.

The *Nightmare*-inspired Portrait Chamber paintings and their woodblock style were created by Tim Wollweber, with Sherri Lundberg and Ian Yater designing the stained glass on top. Throughout the design process, the creative team would always keep this in mind: "How would Halloween make Christmas and how would the denizens of Halloween Town think?" The Portrait Chamber paintings are wood-block prints because that is how Halloween Town would have made their printing press. The stained glass images are beautifully colored renditions of the Haunted Mansion, a Christmas tree with presents underneath, stockings hung by the chimney, and children nestled snug in their beds. Once the stained glass shatters in half, the tone changes. This convincing effect was achieved by Lundberg's knowledge of cutting stained glass.

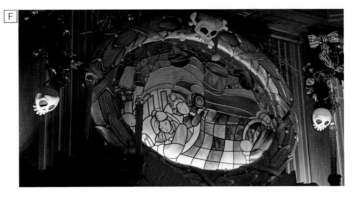

Some elements of the original portraits became stained glass. The children sleeping in their beds original concept artwork featured the girl holding a red-and-white candy cane. The portrait stretches down under the bed, however, to reveal a red-and-white snake, and the candy cane the girl is holding is actually the snake's tail. That is why the snake in the stretching portrait is red and white as opposed to the snake in the attic, which is blue and orange. As the stretching portraits emerge, Guests first sense the holidays colliding. The tension rises with a chorus of children's crescendos as a melodic motif of "Grim Grinning Ghosts" plays; the stained glass ceiling then cracks, actually appearing to resemble a pumpkin face, before completely shattering. Sandy Claws, Jack Skellington's misguided interpretation of Santa Claus, proclaims, "Happy Holidays Everyone" from the attic, along with his ghost dog, Zero. Sandy Claws mischievously laughs, and suddenly the Master of Fright disappears into the darkness of night—and all that is left are the screams.

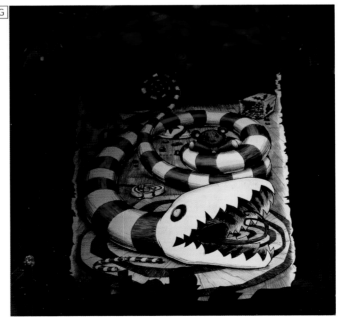

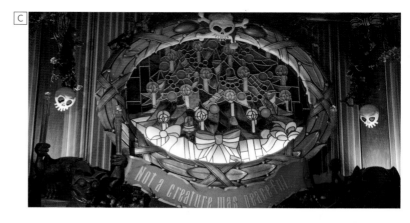

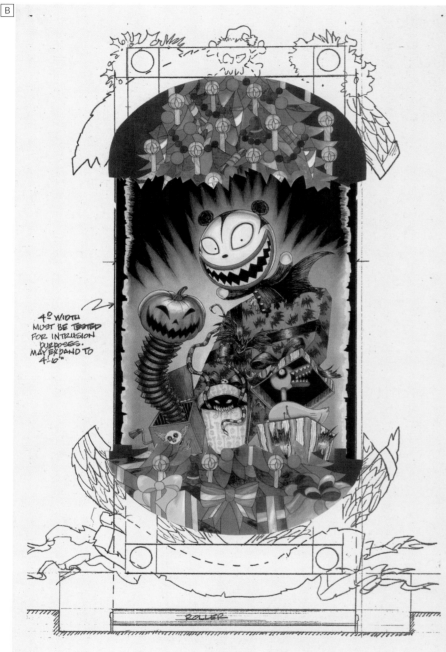

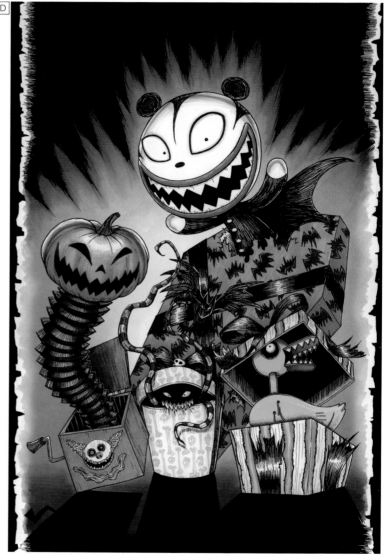

'Twas the nightmare before Christmas,
 and all through the house
Not a creature was peaceful, not even a mouse
The stockings, all hung by the chimney with care
When opened that morning would cause such a scare
The children, nestled all snug in their beds
Would have nightmares of monsters
 and skeleton heads

Disneyland, Portrait Chamber paintings

A B *Concept artwork 2000*

C *Stained glass detail 2017*

D *Original artwork 2000*

E *Fully expanded 2016*

F — I *Original artwork 2000*

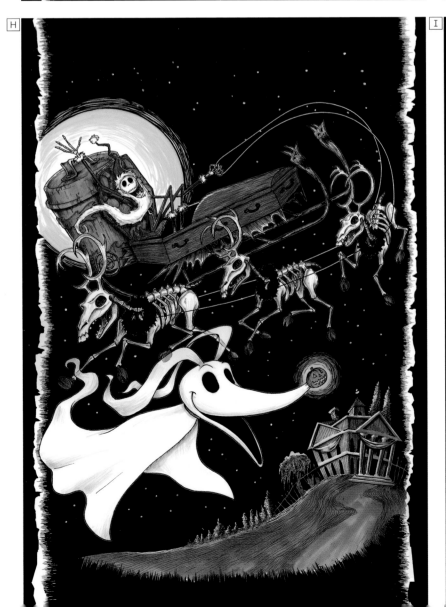

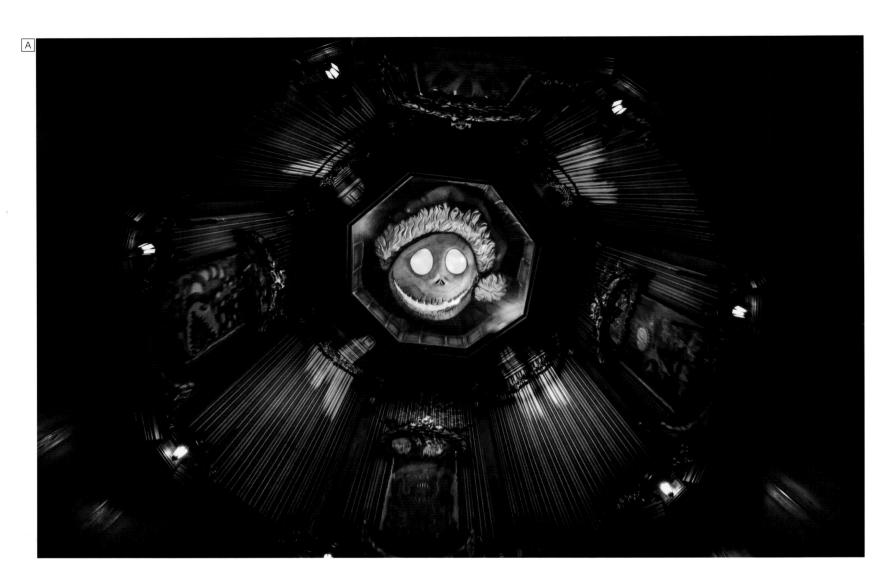

Moving now into the Portrait Corridor, find paintings transforming between the colliding holidays of Halloween and Christmas. The first four portraits reveal the pivotal moments of Jack's obsession with creating his Halloween-style Christmas: Santa on his sleigh transforms into Jack on his sleigh; a snowman transforms into a pumpkin man in snow; the Haunted Mansion morphs into the Haunted Mansion Holiday structure, with flickering lights and snow; and Jack Skellington "the Pumpkin King" turns into Sandy Claws. The final portrait depicts Sally's ominous premonition, a key movie moment: Sally admiring a small Christmas tree that then transforms into a concerned Sally holding the burnt remnants of the very same tree. An animated Zero floats throughout the portraits. (Take your time passing through the Portrait Corridor and you may spot the zombie band playing outside.)

Turning the corner to the Load Area, gaze up to the moving holiday card, which beckons Guests forward. The Disney Parks Live Entertainment team found their first opportunity to create a visual magnet—or as Walt Disney referred to them, a "weenie." Hosted by the mayor, the card features prominent *Nightmare* characters with presents "Making Christmas." When they first introduced the new characters in 2002, every week for thirteen weeks a new present would open up and a whole new character would appear; the giant advent card was born.

While boarding the "Black Christmas Sleigh" (Doom Buggy), look closely at the sign below: MERRY CHRISTMAS becomes SCARY CHRISTMAS. The word transformation came to Steve Davison as he was going between planning meetings.

Now hurry along,
as they say, look alive
This is one holiday
you will want to survive

Disneyland

A *Portrait Chamber*
2012

B *Portrait Corridor*
2018

*Jack Skellington came here
from Halloween Town
You'll notice his handiwork
scattered around
This year, he's decided to play
"Sandy Claws"
But when Halloween creates Christmas,
you might see a few flaws*

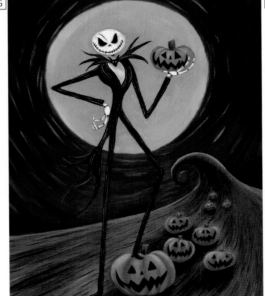

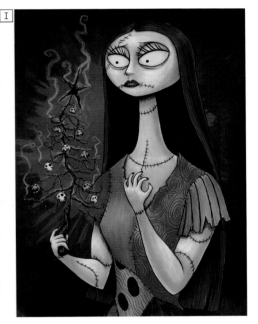

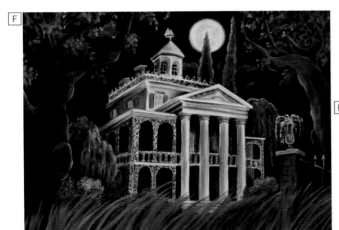

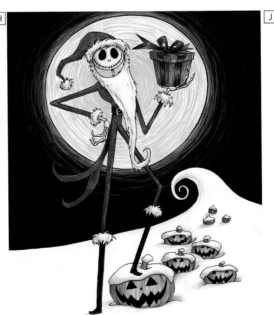

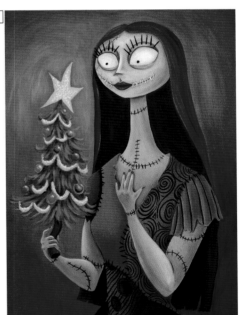

Disneyland

C — L *Changing pictures,
Portrait Corridor,
original artwork
2000*

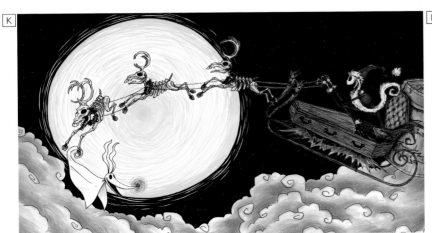

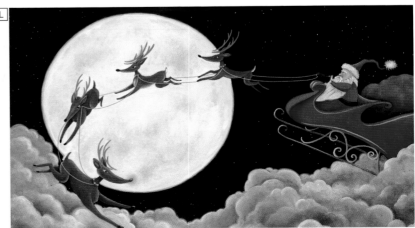

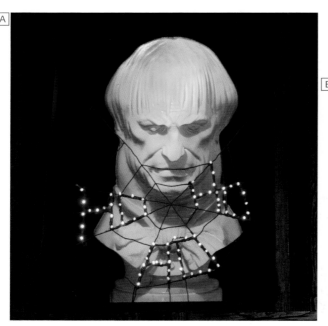

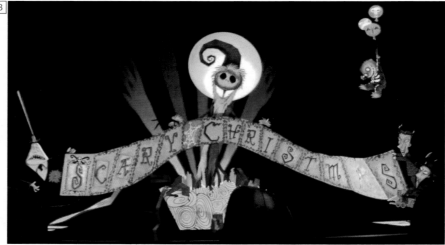

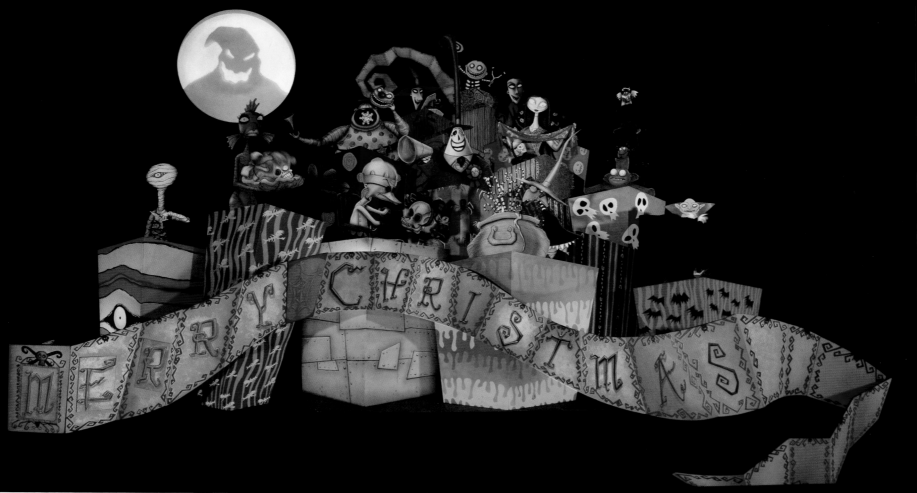

And now a dark carriage will take you away
Sit back, rest in peace in your black Christmas sleigh!
Your sleigh will accommodate one or two more
We hope you're prepared for what Jack has in store

Don't pull down the bar—it will float down with ease
And keep a close watch on all children, please
All good ghouls and boys must sit safe in their seats
And keep in their sleigh all hands, arms, legs, or feets

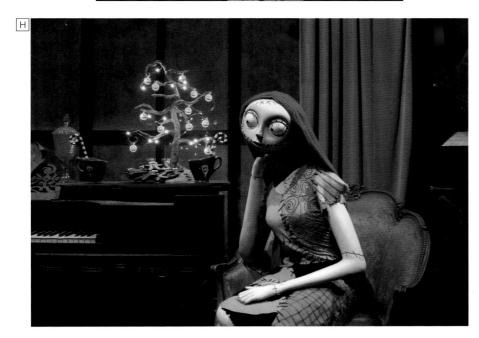

The unofficial guide aboard the "sleigh" is Scary Teddy, a beloved character in the film, though with minimal screen time. He takes over for the black raven, who is on "winter vacation." Scary Teddy greets Guests with scares as the attraction vehicle heads upward to the Endless Hallway. Jack's floating ghost dog, Zero, was the ideal way to add in a new character while emulating the floating candelabra theming of the room. When designing the hallway aesthetics, the team wondered, "What would Jack give Zero for Christmas?" Dog bones, of course! In fact, much of the hallway is decked out in dog bones.

Haunted Mansion Holiday Nightmare in Tokyo Disneyland has four additional rooms, sharing the same track layout as the Haunted Mansion in the Magic Kingdom. Directly after boarding a "sleigh," Guests pass through the stairway and Portrait Corridor. Sandy Claws, Sally, and Scary Teddy bid season's screamings as Guests pass below them, under the stairs.

Upon entering the Portrait Corridor, discover a breadth of residents of Halloween Town. There's also an old Library, dusty and dreary, decorated by Zero to make it more cheery. Zero puts his spin on the Halloween glee, wrapping a garland around floating books: it's a floating book tree. Once in the Music Room, feel free to pause as Sally listens to Scary Teddy's haunting refrain of "Kidnap the Sandy Claws." Ascending the Grand Staircase, Oogie Boogie maniacally laughs as he awaits his presents of trembling bugs in cages tied with Christmas bows.

Then, upon entering the Conservatory, notice Scary Teddy putting a nail in the coffin (a fine Christmas present!) and a joyful rant from some sinister snappy plants. Brian Sandahl, who came from the theater world, created the snappy flowers as an homage to Audrey II, a large man-eating plant from *Little Shop of Horrors*. This mansion's versions are in different colors and have poinsettia leaves emerging from behind to create a Christmas inspired Audrey II. A theater tribute is a natural fit, since the Haunted Mansion leverages many elements and tricks from the theater world. The production team, many of whom also have a technical theatrical background, is particularly thrilled each season when the time comes to deck the halls . . . and the cemetery.

The floral chorus continues to serenade as Guests travel down the Corridor of Doors among the garland vines that ultimately attach to a man-eating wreath, with glowing green eyes . . . and razor-sharp teeth. Although the killer wreath has very little screen time, the creative team found the humor and wondered how far they could take it. The original concept had Guests going toward its mouth as its arms would try to grab and pull them into it. While a great concept and a memorable visual, once designer Tim Wollweber noticed the sleigh went backward in that area, he changed the location to have the wreath above Guests, swinging a chandelier as they barely escape its clutches.

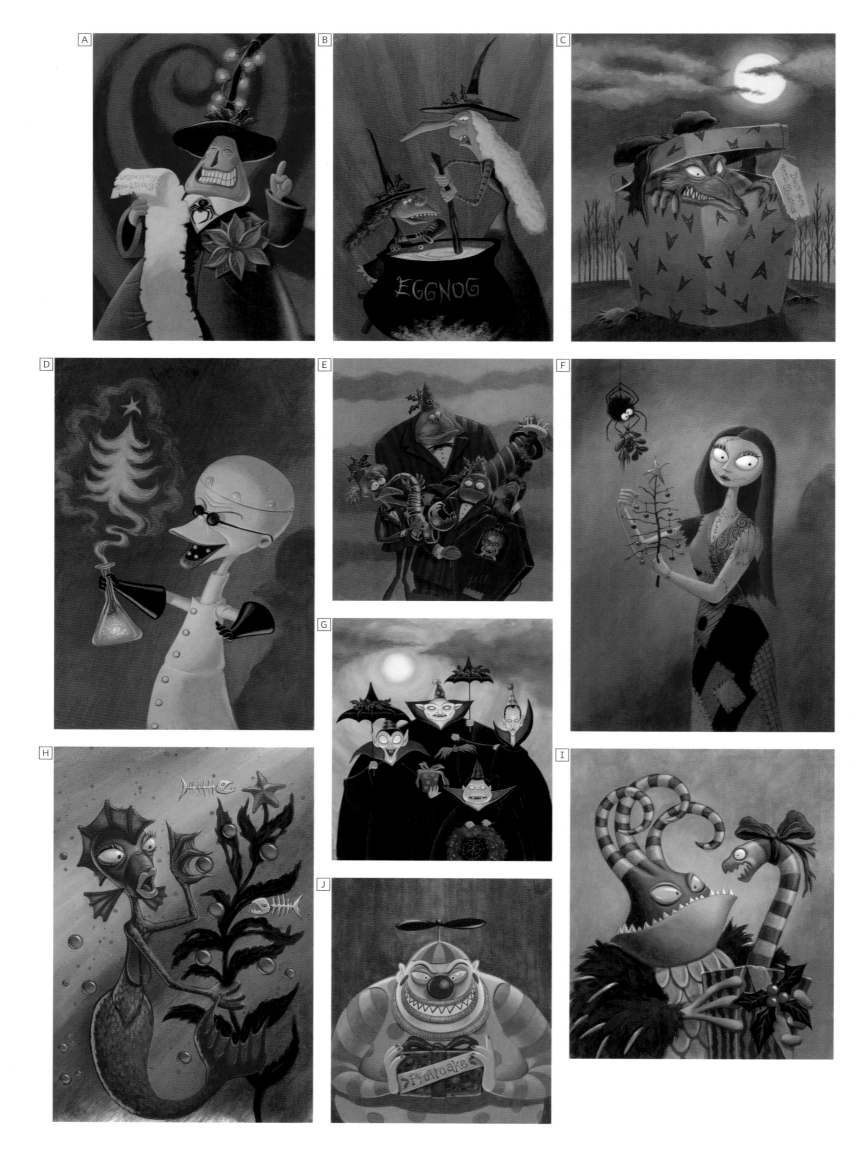

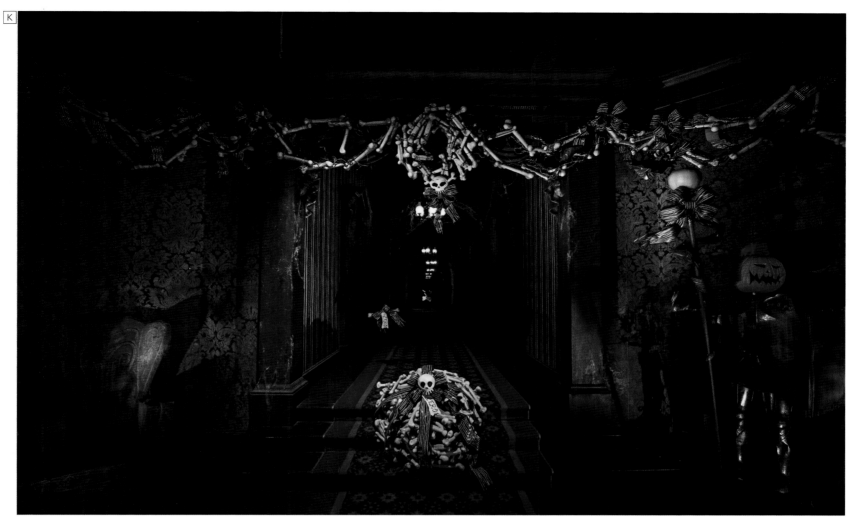

More rapid than vultures,
 the Mansion was changed
All was soon covered,
 adorned, and deranged
And what to your wondering eyes
 disappears
Is Jack's little friend Zero—
 the ghost dog reindeer!

Tokyo Disneyland

[A] — [J] *Portrait Corridor,*
 original artwork
 2004

Endless Hallway,
Disneyland

[K] *2012*

[L] *2016*

[M] *2003*

[N] *2017*

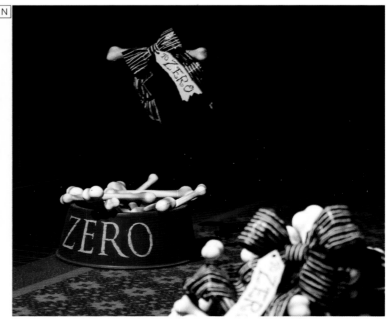

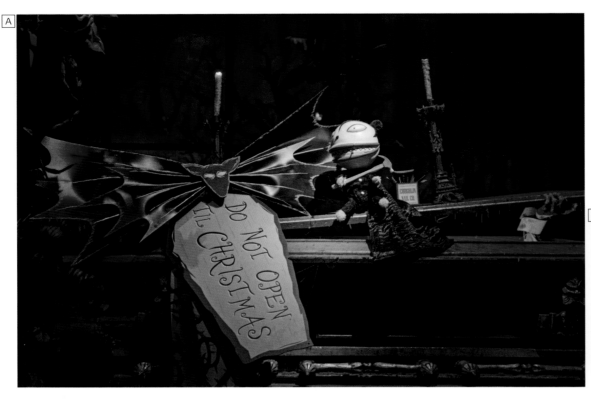

Nothing here was forgotten,
 it all looks so pleasant
A coffin, Jack says,
 makes a fine Christmas present
A man-eating plant
 makes a wonderful wreath . . .
As long as you don't
 get caught in its teeth
Jack's holiday vision
 was unlike no other
So ring out the bells,
 there's more cheer to uncover!

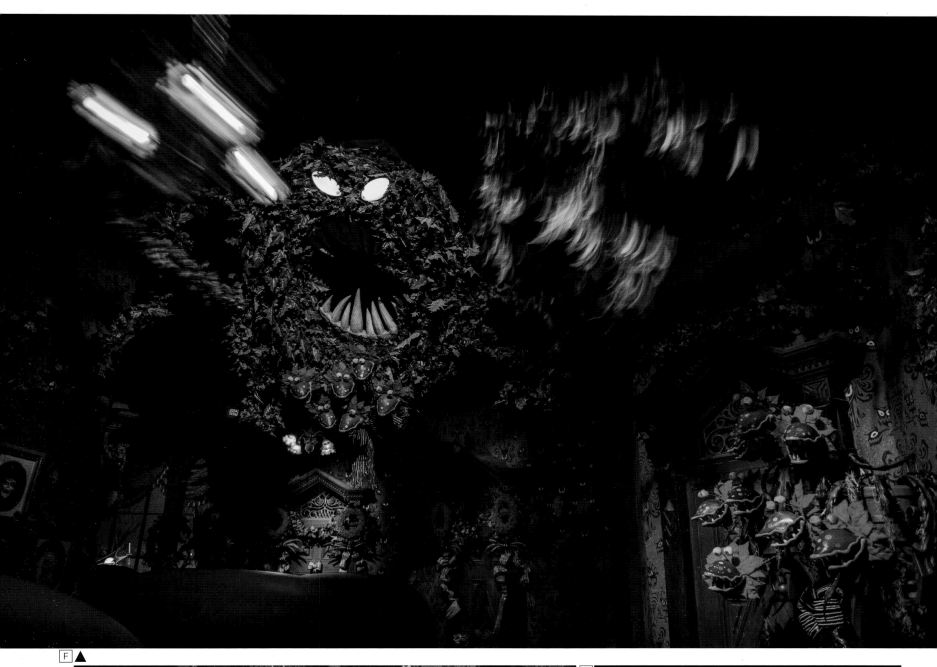

F ▲

G
▶

H

Disneyland

Conservatory

A *2016* D *2017*

B *2017* E *2016*

C *2016*

Corridor of Doors

F *2016*

G *2017*

H *2012*

This attraction is a testament to the collective skill and effort every team member has made, particularly when the transitions feel seamless. The Séance Circle proved to be one of the most difficult and the last room the creative team completed. What would Madame Leota want for Christmas? As fortune would have it, Jack gave her thirteen unlucky fortune cards. The cards represent the main characters of the movie, each one giving a present particular to that character. Originally the tarot cards had a very traditional design, but weren't "*Nightmare*"-ish enough.

Madame Leota, the ghostly character inside the crystal ball, is played by Disney Legend Leota "Lee" Toombs Thomas. Her Disney career began as one of the first women of the model shop at WED (later renamed Walt Disney Imagineering), where she worked on many classic attractions in Disneyland and in the Magic Kingdom. Fellow Imagineer and Disney Legend Yale Gracey had been working on the Haunted Mansion and came up with a neat effect and wanted someone to try it out on. Thomas volunteered. Her daughter, Kim Irvine, fondly recalls the experience of prepping for that role: "My mother would practice incantations at home for hours in front of the mirror."

Irvine followed in her mother's footsteps, becoming an Imagineer, working at Disneyland. The creative team wanted to honor Thomas when creating the overlay and thought what better way than to use her daughter's image inside the new crystal ball. Upon receiving the call from Steve Davison to record new incantations, the normally shy Irvine realized how much her mother would have appreciated her stepping in, and accepted the challenge. Irvine ended up going through the exact same process as her mother. Like her, she practiced incantations in front of the mirror for hours, which was imperative since she had to sit completely still and only act with her face. After a few years, the creative team realized Thomas and Irvine had similar facial structures, and they could keep one crystal ball year-round. Irvine sums it up perfectly: "We play a dual role. Mom would have liked that."

Séance Circle

[A] *Disneyland 2016*

[B] *Tokyo Disneyland 2004*

[C] *Disneyland 2016*

[D] *Disneyland Madame Leota 2016*

[E] — [Q] *Disneyland Tarot cards, original artwork 2000*

THIRTEEN RINGS OF POWER

TWELVE SIGNS OF THE ZODIAC

ELEVEN CANDLES FLOATING

TEN TELLING TEA LEAVES

NINE MAGIC CRYSTALS

EIGHT BALLS OF KNOWLEDGE

SEVEN PEARLS OF WISDOM

SIX MYSTIC MIRRORS

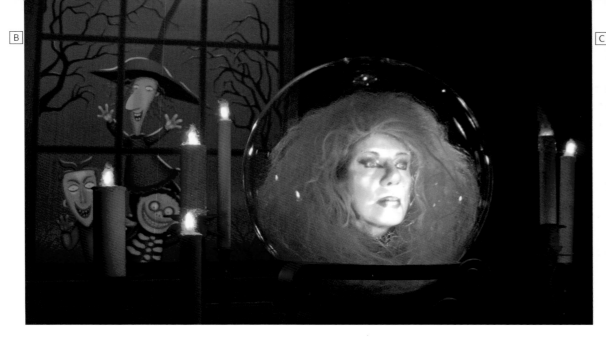

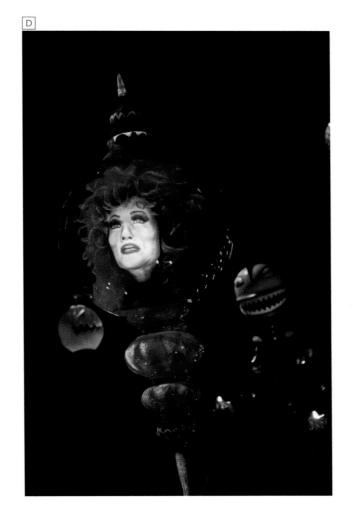

On the thirteenth day of Christmas, my ghoul love gave to me
Thirteen rings of power, embracing strength that never ends
Twelve signs of the zodiac that rule the future and transcend
Eleven candles floating, their scent of mystery in the air
Ten telling tea leaves that swirl with secrets yet to share

On the ninth day of Christmas, my ghoul love gave to me
Nine magic crystals that sparkle with a force that is pure
Eight balls of knowledge that answer with a truth that is sure
Seven pearls of wisdom to keep my love bewitched to me
Six mystic mirrors, reflecting futures yet to be

On the fifth day of Christmas, my ghoul love gave to me
Five lucky charms, to understand the right from wrong
Four wheels of fortune, to spin their rich and golden song
Three lifelines, extending help to those in need
Two passion potions, that love and romance may succeed

On the first day of Christmas, my ghoul love gave to me
A star, a brilliant star for my fortune card tree

FIVE LUCKY CHARMS

FOUR WHEELS OF FORTUNE

THREE LIFELINES

TWO PASSION POTIONS

A STAR FOR MY FORTUNE CARD TREE

The sweet smell of gingerbread wafts through the air as Jack's ultimate Christmas party inside the Grand Hall comes into view. Stockings hung by the chimney, ghosts carrying presents from Jack's sleigh, and glowing jack-o'-lanterns bring the party to death. During the design process of the hall, Tim Wollweber found a commonality with Halloween Town's residents. "'Making Christmas' was the most inspiring scene, because we were kinda doing the same thing," he says. "Going into a place that didn't really have Christmas in it and putting these tweaked ideas all into it." The Magical Spider Tree was created to give the Grand Hall a centerpiece. The twenty-five-foot-tall tree has pumpkin and skull ornaments with claw-shaped ends of branches. The dead tree has one lone live green branch toward the top.

An observant rider may notice the creative team even added a secret room above the staircase. Steve Davison recalls, "Riding it for years, you'd see the staircase go up and then there was this door. What's behind that door . . . what's there, what's there? So, one day, my childhood fantasy came through and I went through the door." What was behind that door? An alcove used as a maintenance shop. The alcove was then transformed into a secret library with a sea of magically suspended spinning books in the shape of a Christmas tree.

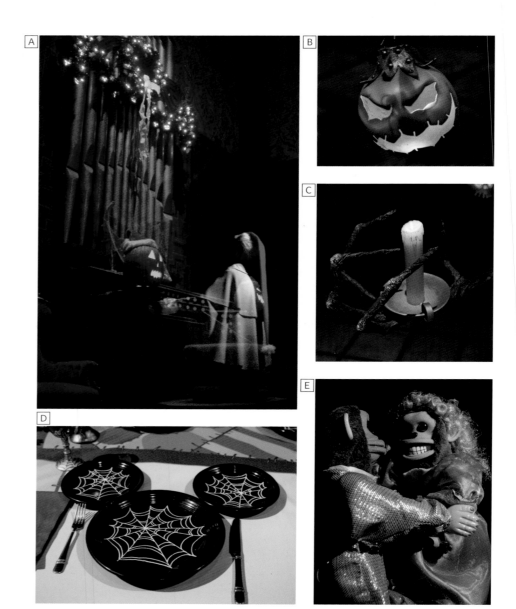

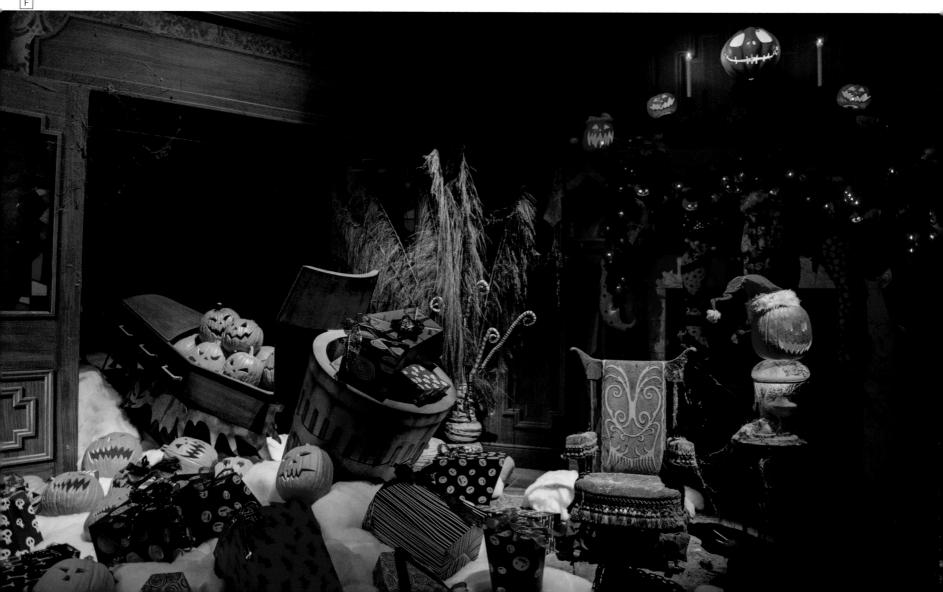

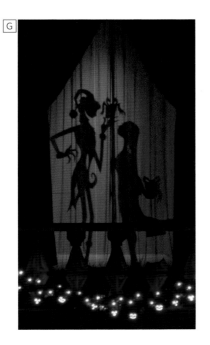

With some treats and some games,
	you can make a scene merry
Why, even a gingerbread house
	can seem scary!
All at once, happy haunts
	did materialize
Like a nightmarish painting
	by Currier and Ives

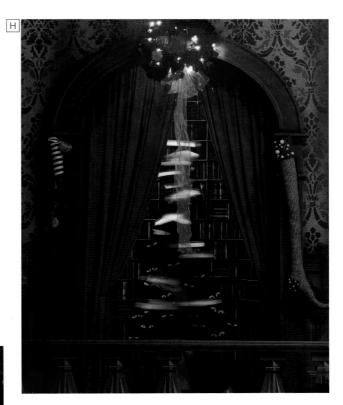

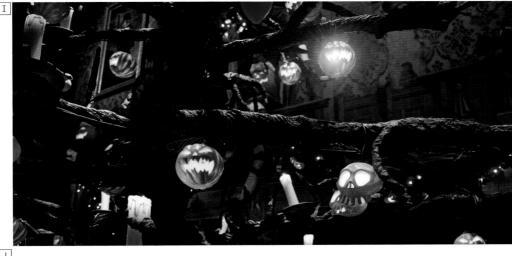

Grand Hall

A *Tokyo Disneyland
2004*

B C *Disneyland
2017*

D E F *Disneyland
2016*

G *Tokyo Disneyland
2004*

H *Disneyland
2018*

I J *Disneyland
2016*

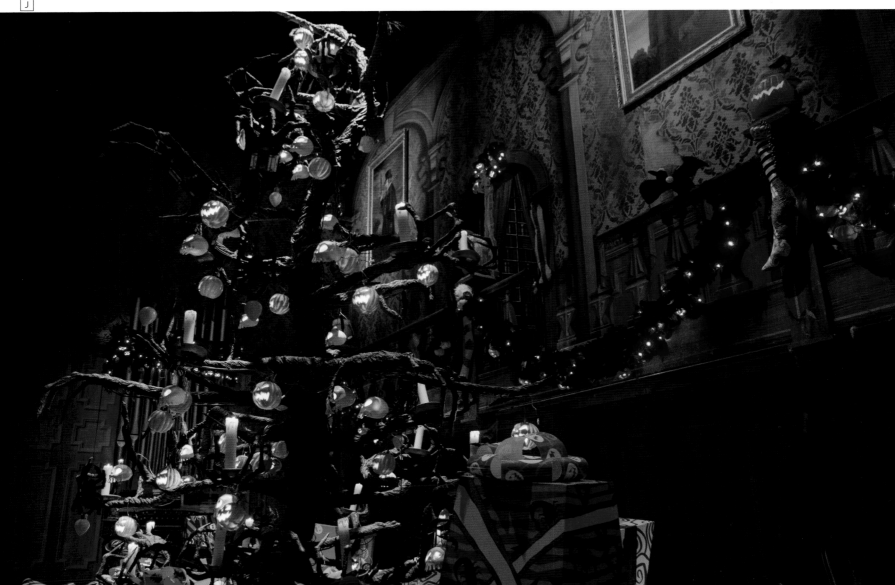

The yearly changing gingerbread house is a tradition Guests look forward to each season—a unique collaboration developed by the Disney Parks Live Entertainment and bakery teams. Brian Sandahl designed the first few gingerbread houses before Tim Wollweber took over this *grave* responsibility. Each gingerbread house is designed six to nine months in advance. Once the creative team provides the design, the bakery creates the first pass in two to three weeks. Two Disney veterans, Disneyland chef Jean-Marc Viallet and Karlos Siquerios, from Food Concept and Product Development, have been involved in the making of every gingerbread house since the inception of the tasty display.

For the first year, in order to get the gingerbread house into the Grand Hall, the bakery team had to take it down a small elevator. Unaware of the size of the elevator in relation to the gingerbread house, team members soon realized the house didn't fit the elevator's confines. The team ended up taking the house apart in order to get it to fit inside. From that year forward, the bakery team brings the gingerbread house down in pieces and assembles it on-site. Viallet remembers working in the Grand Hall the first year: "We were stuck in there for eight to ten hours a day for three days straight. There was a constant knocking on the door (from the Corridor of Doors) for three days and the music was on the entire time. It drove me crazy, dreaming about that door." Since 2001 the bakery team has partnered with CHOC (Children's Hospital of Orange County) in California, baking a gingerbread house and Mickey cookies to coincide with Walt Disney's birthday for some holiday cheer.

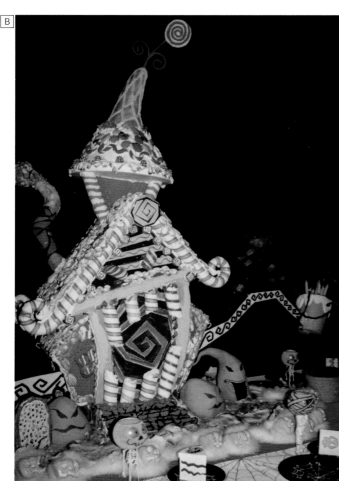

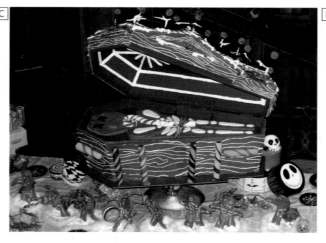

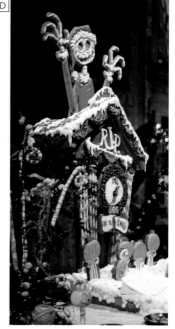

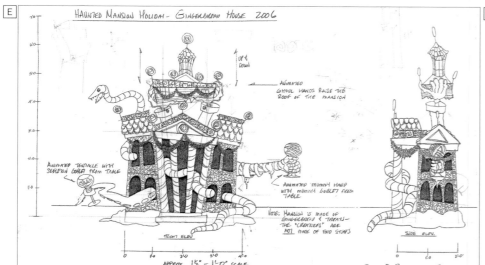

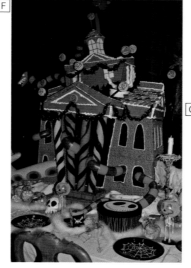

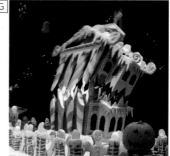

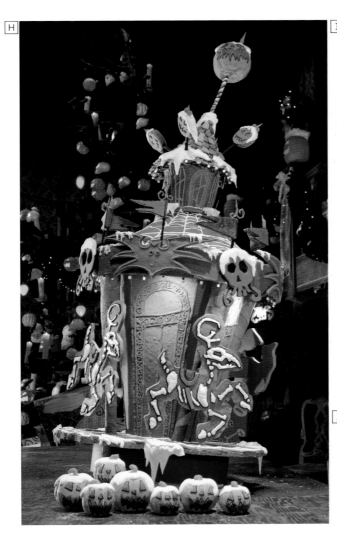

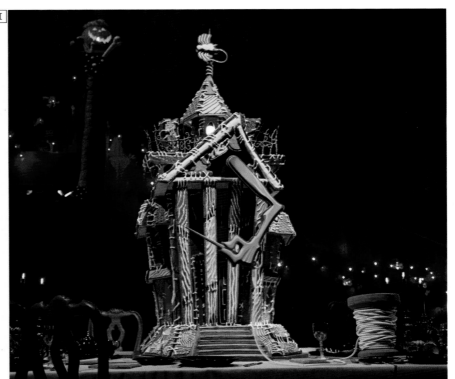

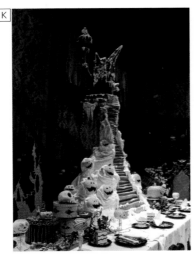

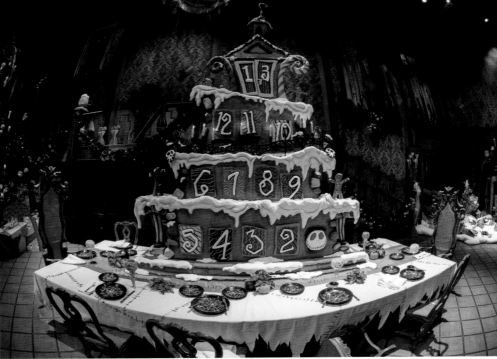

Disneyland

A *Concept artwork 2001*

B *Decor installed 2001*

C *2008*

D *2010*

E *Concept artwork 2006*

F *Decor installed 2006*

G *2011*

H *2009*

I *2017*

J *2013*

K *2012*

Tokyo Disneyland

L *Concept artwork 2004*

M *Decor installed 2018*

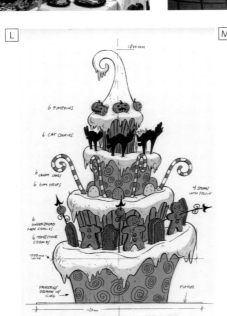

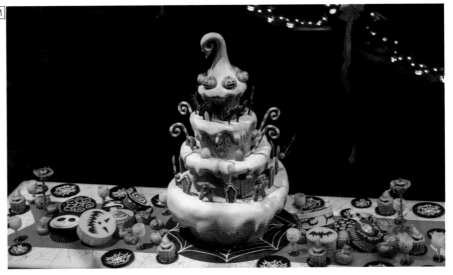

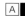

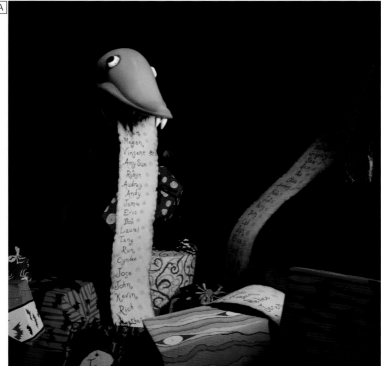

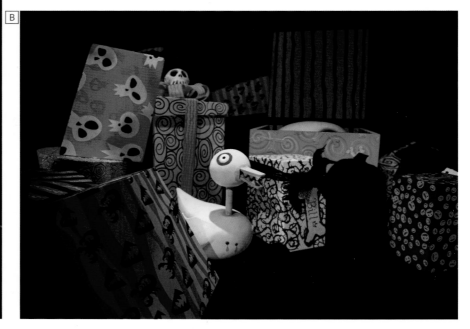

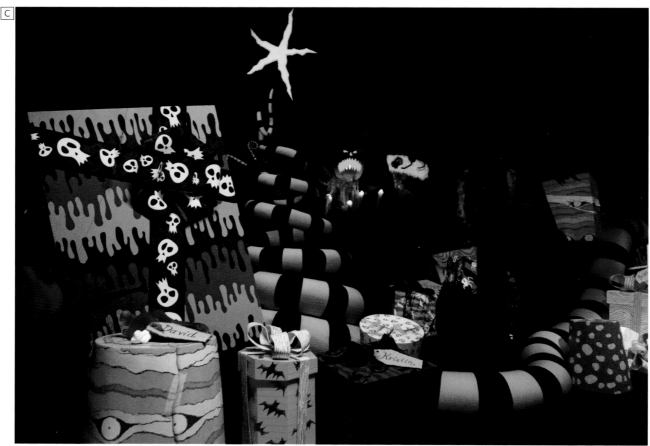

A bag full of toys
Jack had slung on his back
They were strange and bizarre—
and on the attack!

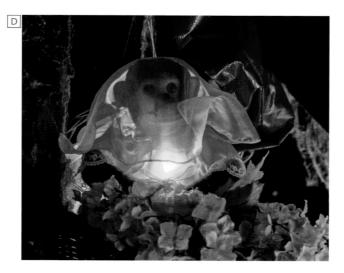

Attic,
Disneyland

A B C *2016*

D *2017*

E F *2016*

G *2015*

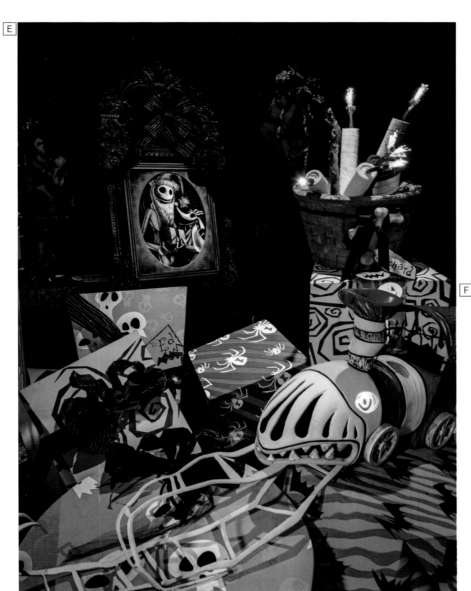

The attic is filled with presents and toys. With only two days left to open, that very first year, the creative team worked with their entire staff to wrap presents with glow-in-the-dark wrapping paper. This created a great camaraderie among the team as everyone participated in the creation of the overlay. A blue-and-orange snake now occupies the majority of the attic, weaving around presents and devouring a naughty or nice list. The list includes names of key Cast Members involved in the creation process. Keep an eye out for the list to see a sweet tribute to Brian Sandahl's parents, Harry and Betty.

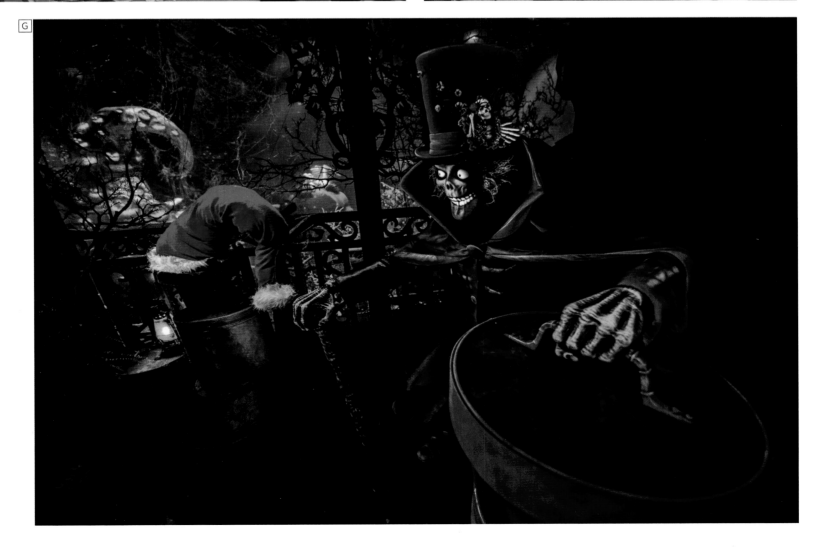

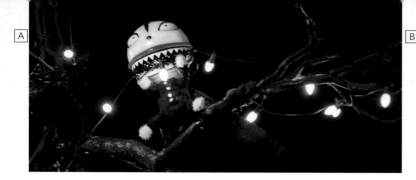

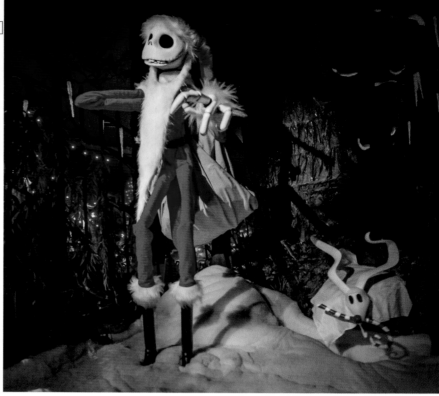

The giant snow mountain "weenie" immediately grabs attention after leaving the attic. This visual magnet is inspired by the spiral hill from *Tim Burton's The Nightmare Before Christmas*. Over twenty feet tall, the creative team incorporated sixty-nine pumpkins swirling to the top (a clever homage to the year the attraction originally opened—1969), and icicles hanging off the end. To incorporate the Singing Busts, they put pumpkins over their heads and converted them into singing pumpkins. Snow mountain is made up of five large pieces that are stored inside the Crypt during the off-season.

Paying tribute to the frightened Caretaker and his shivering dog, Sandy Claws (created by Garner Holt) and Zero now greet Guests entering the ghostly white snow-covered Graveyard. Sally has also been a welcome addition to the Graveyard since 2016, bringing an array of tasty treats for a picnic with Jack. The creative team is always looking to enhance scenes by adding storytelling details: a package for Jack from Sally at the Graveyard entrance, or giving "bone deer" tea out to the European ghosts inside the Graveyard for them to enjoy as well.

The Graveyard ghosts each celebrate Christmas with their own traditions. It all comes back to character. How would an ancient mummy create a Christmas tree? By wrapping it in bandages, decorating it with bugs, and adding a mummy mask topper. How would an executioner, who loves his job, celebrate Christmas? With an ax tree. And don't forget to look up and gaze at the marvelous snow angels throughout the Graveyard.

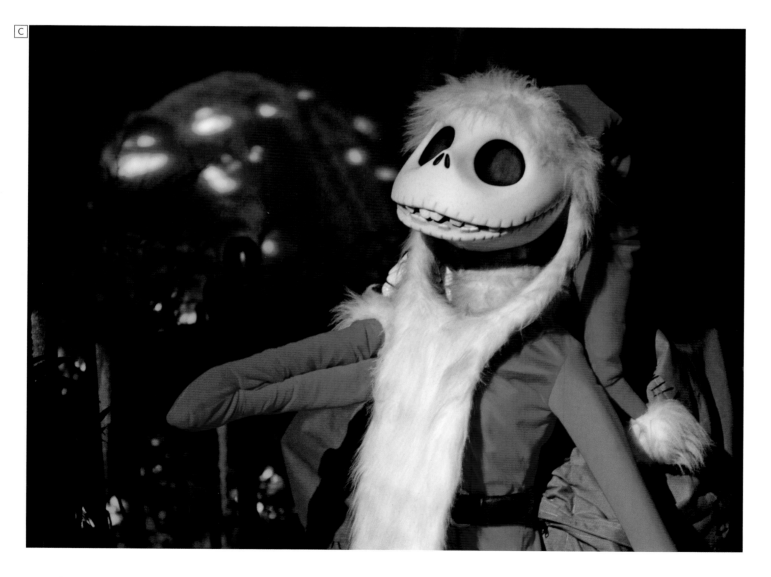

Graveyard, Disneyland

[A] *2016*

[B] *2012*

[C] *2015*

[D] *2016*

[E] *2017*

[F] *2016*

[G] *2017*

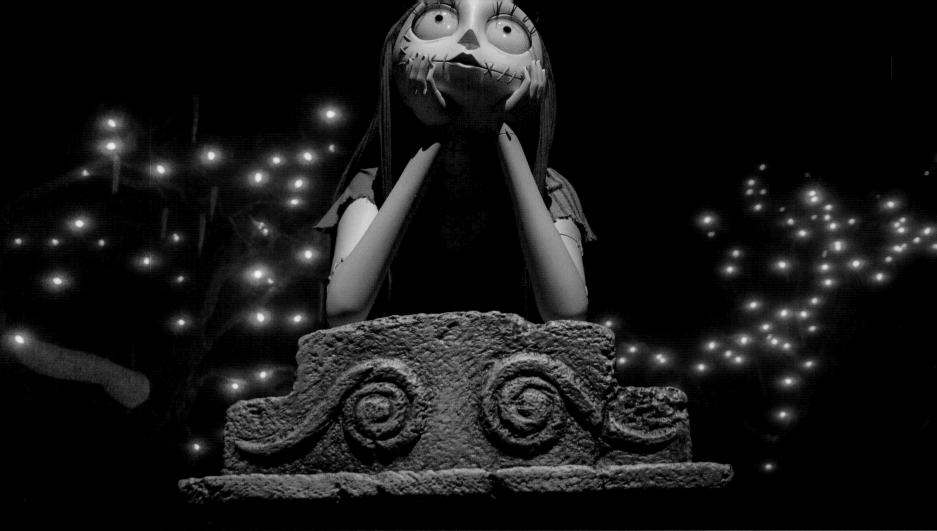

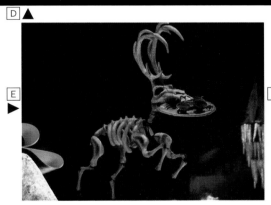

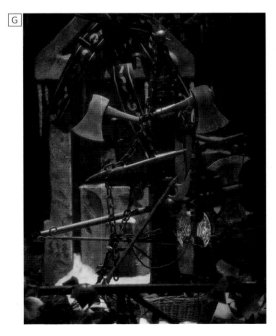

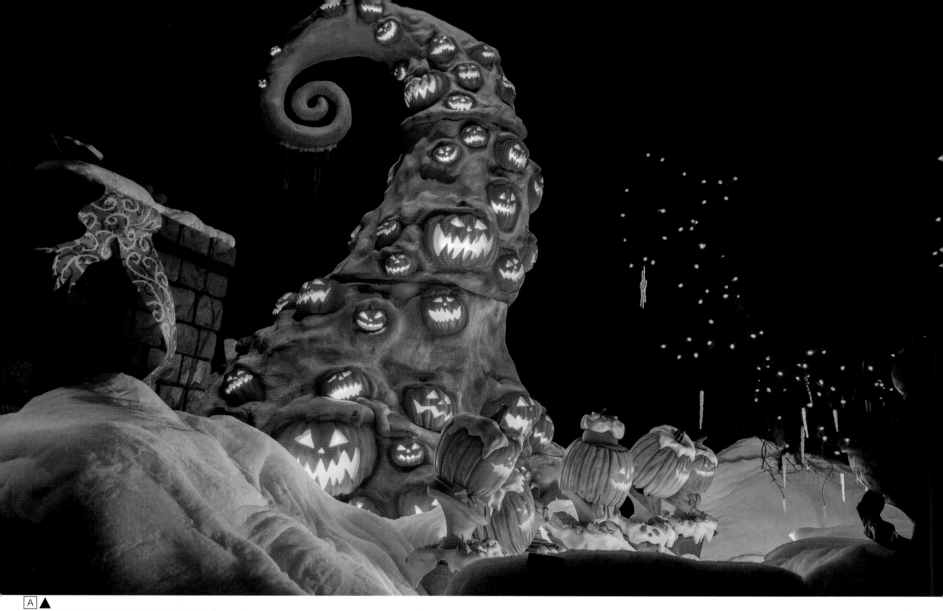

A ▲

B ▶

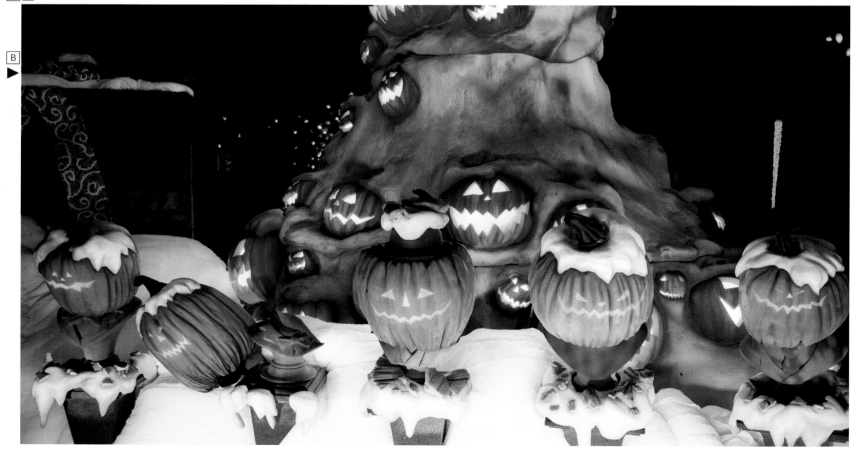

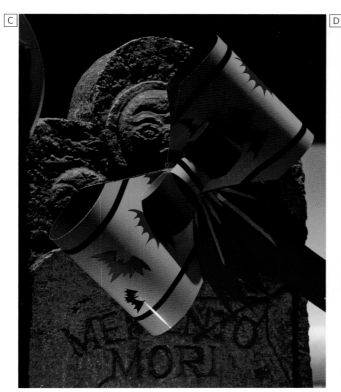

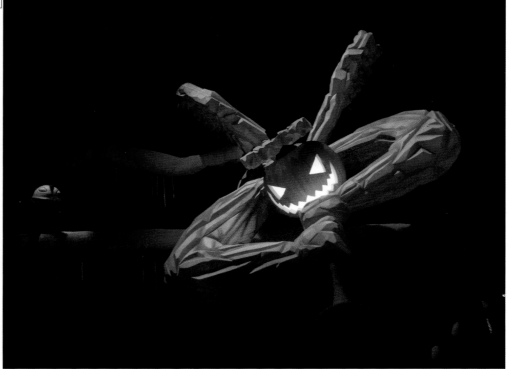

Sandy Claws worked his magic,
 both outside and in
But one final touch made his bony face grin
Now what better gift on my friends to bestow
Than a graveyard that's covered
 in ghostly white snow!

Graveyard

A B *Disneyland*
 2016

C *Disneyland*
 2017

D *Tokyo Disneyland*
 2017

E *Disneyland*
 2017

F *Disneyland*
 2009

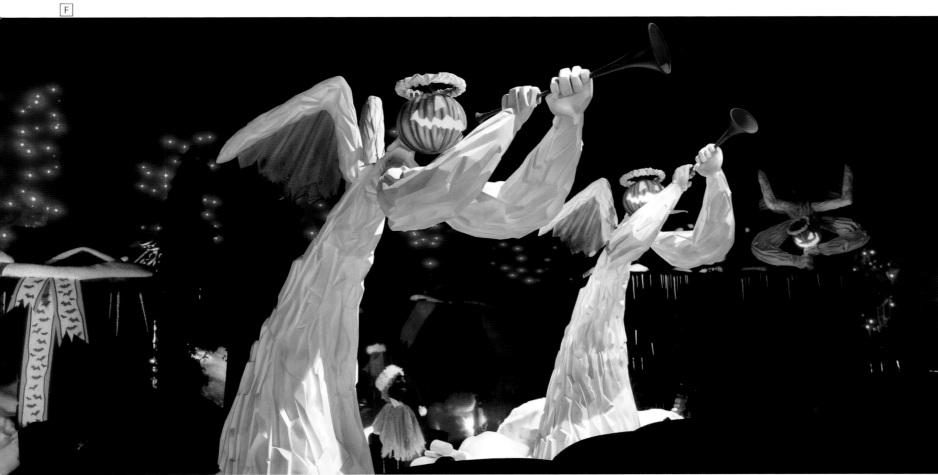

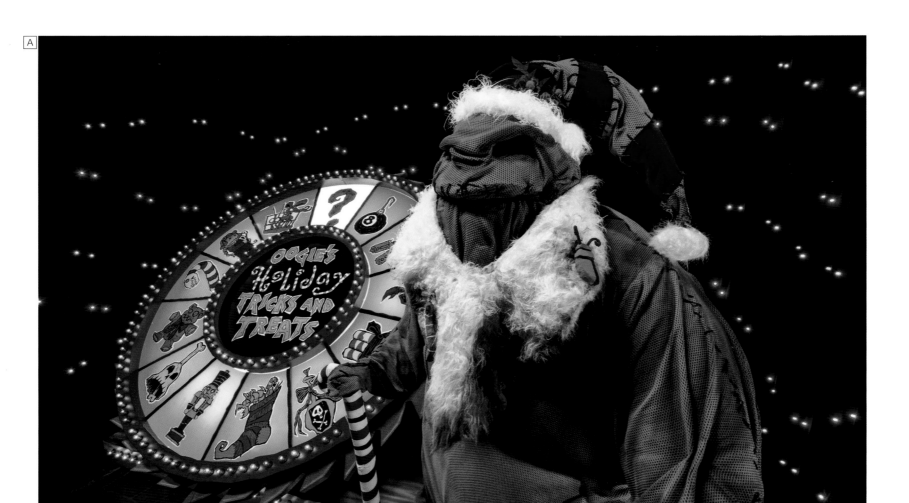

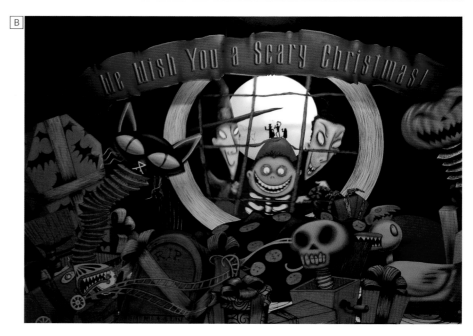

Inside the Crypt, Oogie Boogie's Holiday Tricks and Treats wheel is reminiscent of the saw blades in his lair that threaten Jack in the movie.

Round and round it goes, and where it stops only Oogie knows—and if the "lucky" Guest hits the question mark, then they're in for a surprise visit from Lock, Shock, and Barrel. In Tokyo Disneyland, playing tricks is a treat for the manic trio.

Back in Anaheim, at the Exit, Little Sally waves goodbye atop presents from Sandy Claws, who is riding in his Christmas sleigh against a full moon. He flies out of sight, but not before stating, "This world will not forget my Christmas night!"

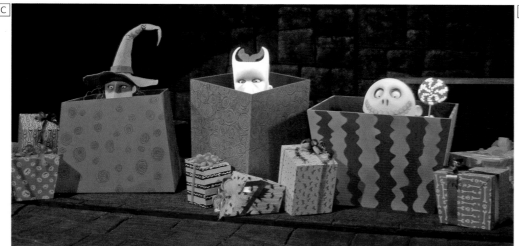

Crypt

A *Disneyland 2012*

B *Disneyland 2001*

C *Tokyo Disneyland 2004*

D *Disneyland Little Sally, Exit ramp 2018*

Disneyland
Special Oogie Boogie extras added to the overlay for the film's tenth anniversary in 2003

E *Portrait Corridor, original artwork*

F *Portrait Chamber painting, original artwork*

G *Séance Circle tarot card, original artwork*

H *Topiary, queue area's pet cemetery*

I *Oogie's Challenge scavenger hunt, original artwork*

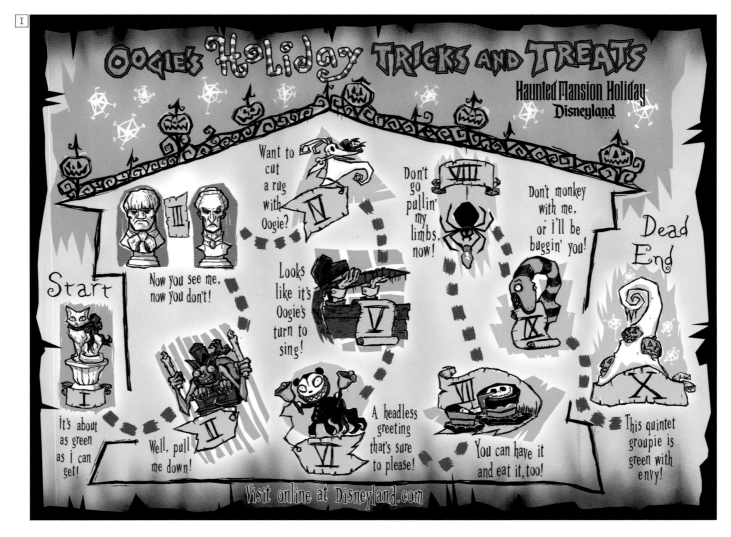

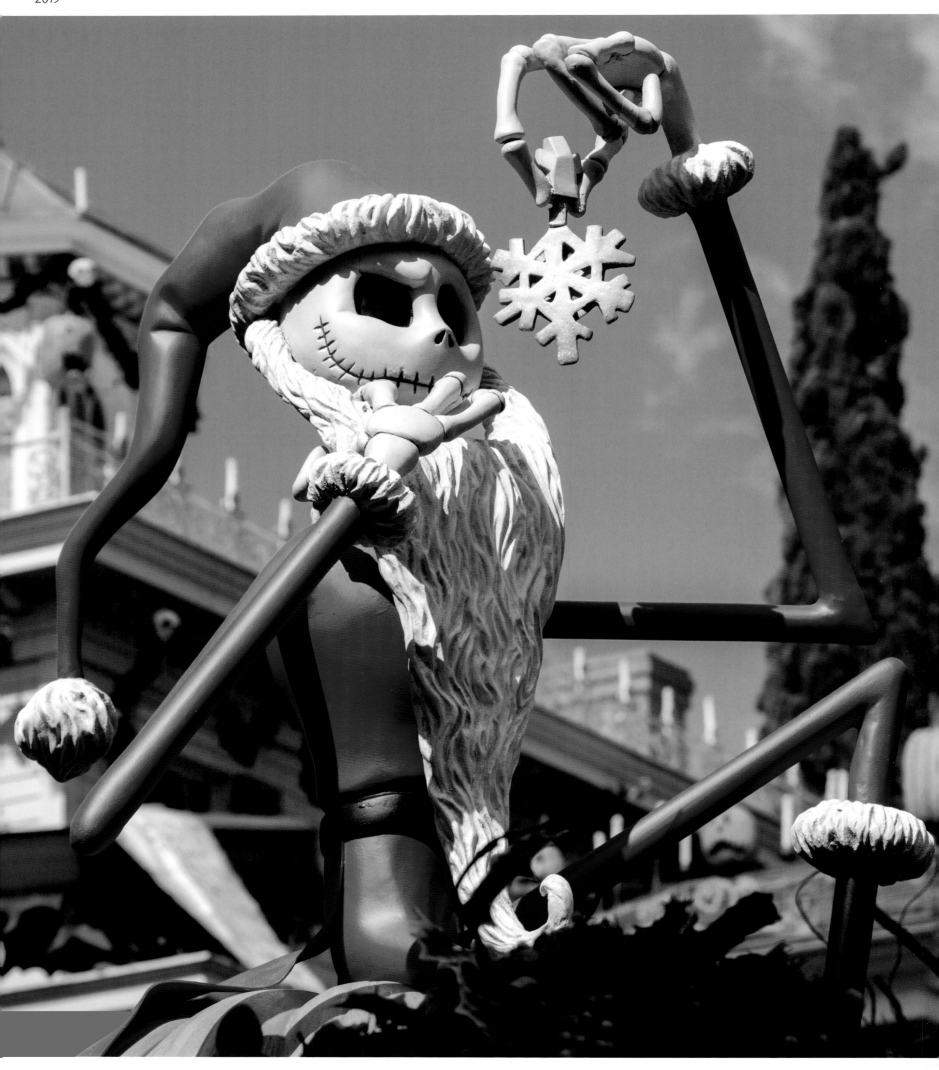

Holiday Magic at the Disney Parks

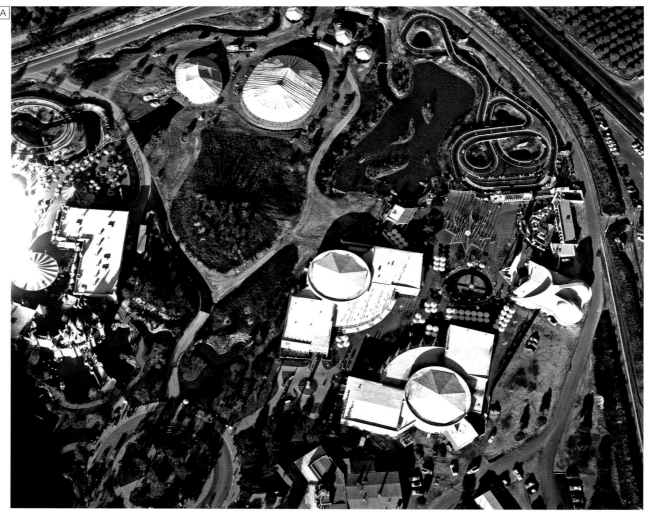

Mickey Mouse Club Circus, Disneyland, 1955

A Circus tent located behind Fantasyland and Tomorrowland

B Guest entrance, from Fantasyland

C Walt Disney and Fess Parker lead the parade through Disneyland

D E F The parade route from Town Square to the circus tent

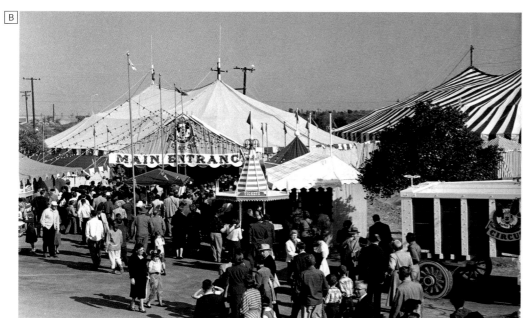

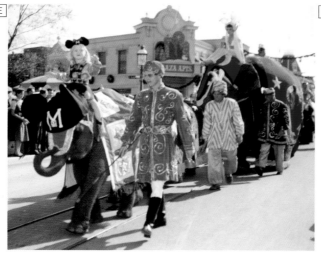

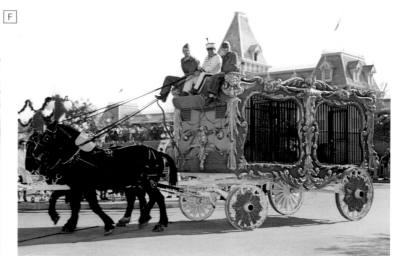

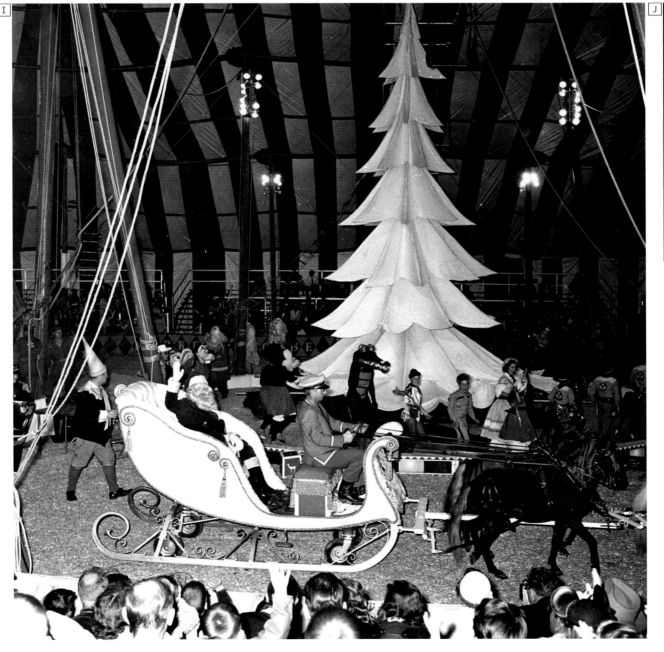

Mickey Mouse Club Circus,
Disneyland, 1955

G *Jimmie Dodd and the*
 Mouseketeers atop the
 Swan Bandwagon

H *Jimmie Dodd as the*
 Ringmaster

I *Christmas finale*

J *Professor George Keller*
 and his Feline Fantastics

Christmas Bowl, Disneyland

A *Christmas Bowl*
1955

B *Fresno Women's*
Chorus
1955

C *Anaheim High*
School Chorus
1956

D *Alpine Dance Group*
of Los Angeles
1956

E *Garden Grove Elementary*
School District
1958

F *Blue Danube Dancers*
1956

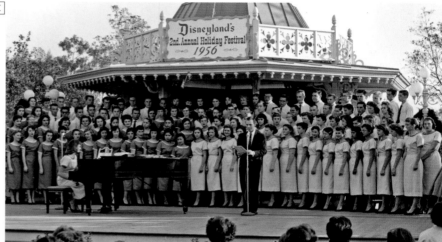

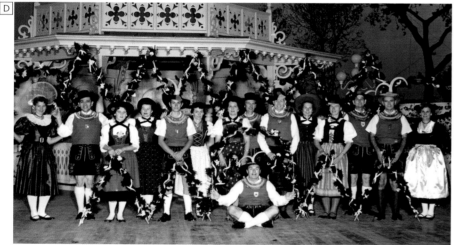

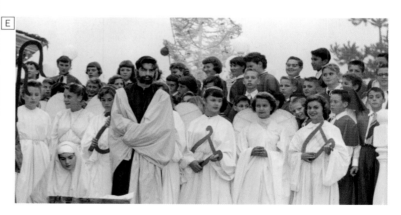

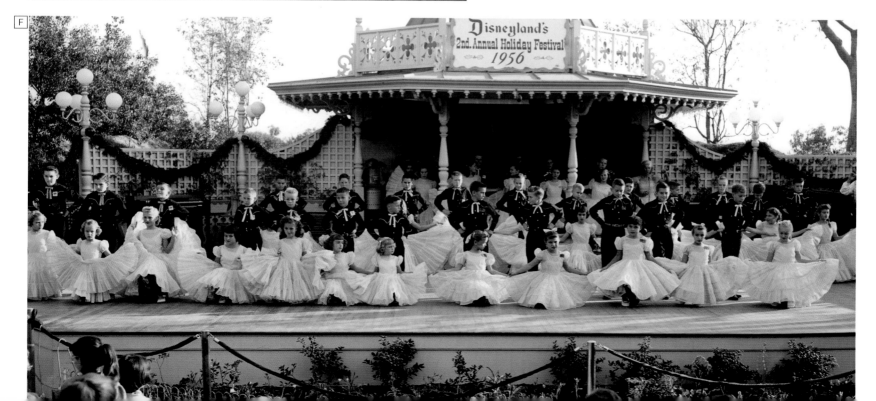

In his introduction to the 1965 television holiday episode *A Present for Donald*, Walt Disney said, "One of the nicest things about the holiday season is exchanging greetings with our many friends; for these messages, from all over the world, represent the true spirit of Christmas in many different ways." This sentiment spoken by Walt had a few years earlier inspired a new way—at least in the Disney sphere—to celebrate the season starting in 1957, when the annual Holiday Festival in Disneyland received an international overlay. The event was dubbed Christmas in Many Lands and featured a single-day Parade of All Nations as its exotic centerpiece. This practice of celebrating the traditions of various countries around the globe continued in Disneyland each season throughout the 1950s and early 1960s and is still at the heart of EPCOT holiday festivities today.

In 1960, to celebrate the upcoming release of the Disney live-action musical *Babes in Toyland*, a special Parade of Toys replaced the Parade of All Nations in the holiday festival. The parade featured oversized toys from the wondrous Toymaker's Shop sequences of the film and was so popular that it became a fixture of the holiday season for several years thereafter. The most enduring characters to march their way into the hearts of Disney fans everywhere were the gallant red toy soldiers, who are still drilling down Disney's streets each December.

Five years later, in 1965, Disneyland celebrated its tenth anniversary with an elaborate new event called Disneyland's Tencennial Holiday Festival, which featured a new Fantasy on Parade spectacular celebrating Disney's classic characters. Fantasy on Parade, which park Guests simply adored, became a holiday fixture at the park for the next twelve years, until 1977. (That year saw the debut of the Very Merry Christmas Parade.) Fantasy on Parade was packed with Disney characters, floats, the beloved troop of toy soldiers, and, of course, the ever-popular Santa Claus and his lovably silly reindeer. If that weren't enough, according to a 1965 Disneyland press release, an "honest-to-goodness jet-powered, high-flying spaceman" also thrilled park Guests twice daily. As part of the festivities, a man wearing a jet pack flew down Main Street, U.S.A., around Central Plaza, and into Frontierland for a daring raft landing on the Rivers of America. So, under Walt's watchful eye, homegrown was out, and spectacle was in.

Christmas in Many Lands, Disneyland

G *Japan*
1957

H *Boar's Head and Yule Log, United Kingdom*
1957

I J *Palestine*
1958

K *Parade heralds*
1959

*Parade of Toys,
Disneyland*

A Walt Disney as parade
Grand Marshal, with
granddaughters Joanna
and Tamara Miller
1961

B C 1960

D E 1961

F Hand-bell ringers
dressed as Christmas
trees
1962

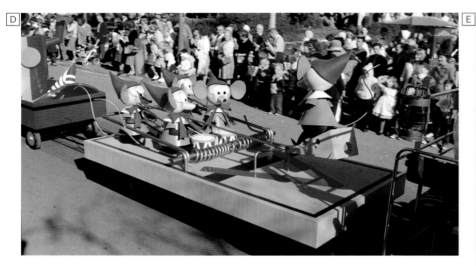

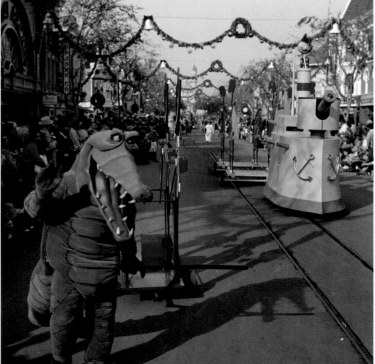

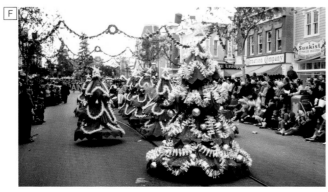

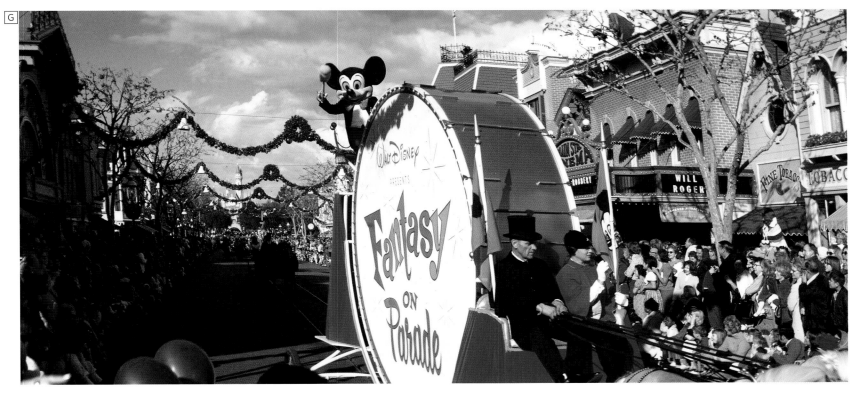

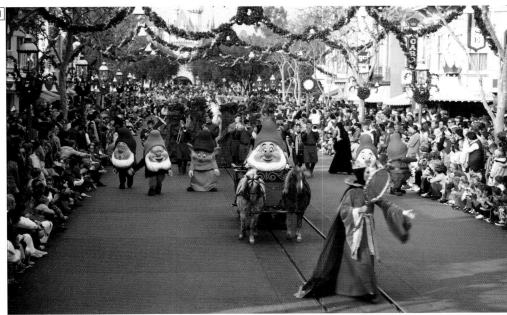

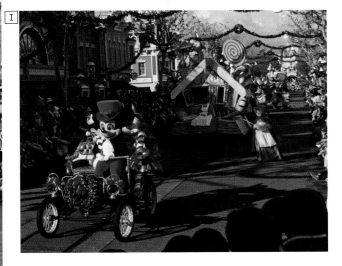

*Fantasy on Parade,
Disneyland*

G H *1970*

*Very Merry
Christmas Parade,
Disneyland*

I *1978*

*Dickens Carolers,
Disneyland*

J *Town Square
1960*

K *Sleeping Beauty
Castle
1961*

The other major holiday event for the winter season that also began in Disneyland in 1957 was the "1st Annual New Year's Eve Party," an event that has been celebrated there every year since. In 1960, the visiting Rose Bowl participants and the Tournament of Roses Queen and Court appeared at the park for the very first time. The connection between Disneyland and the Rose Parade began much earlier though, even before the park was built! Disney's first Rose Parade float entry appeared in 1938, to promote the brand-new feature-length animated film *Snow White and the Seven Dwarfs*.

Seventeen years later, in January 1955, Walt and the staff had their second float in the grand event—promoting another groundbreaking "production" . . . Disneyland. Sponsored by Southern California's popular Helms Bakery, the float was decorated with over seven thousand pink roses and was the recipient of the Judge's Special Award that year for featuring iconic images from the soon-to-be-opened theme park: a giant pink Sleeping Beauty Castle and a version of the Dumbo the Flying Elephant attraction. In the front center of the float was Mickey Mouse himself, and at the back, a tall balloon rose above the float to introduce viewers to the new wonderland to come with one simple word: Disneyland.

Ten years later, in March of 1965, Mr. J. Randolph Richards, president of the seventy-seventh Annual Tournament of Roses, announced that the theme for 1966 would be It's a Small World. Just one year earlier, the iconic Disney-designed and -built attraction had premiered to great acclaim in a UNICEF-sponsored pavilion at the 1964–1965 New York World's Fair and was slated to be installed into its new permanent home in Disneyland. Mr. Richards then announced the obvious choice for grand marshal to accompany that year's theme: Walt Disney, who he praised as the "master showman," who has "brought joy and laughter to millions in every part of the world."

Lillian Disney accompanied her husband to the Rose Bowl game that followed the parade, but it was the host of Disneyland (and Walt's best pal, Mickey) who rode in the grand marshal's car with him that New Year's Day in 1966.

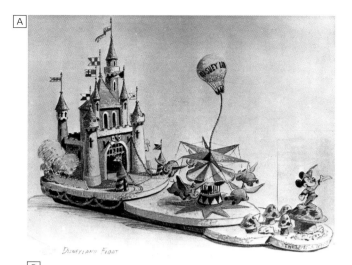

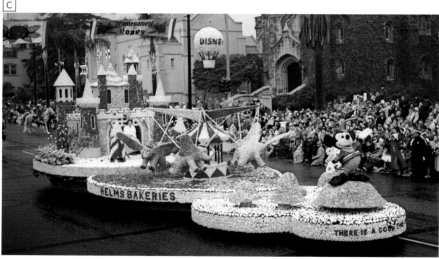

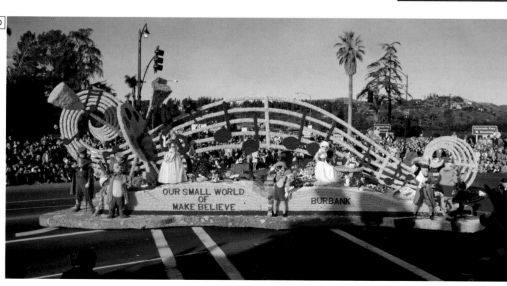

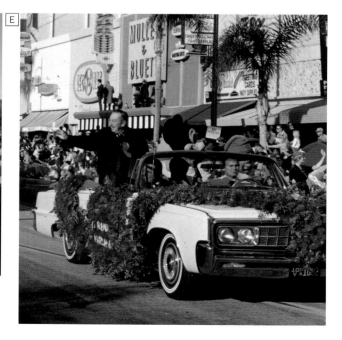

Tournament of Roses Parade

[A] *Concept artwork 1954*

[B] *Float construction 1954*

[C] *Finished float January 1, 1955*

[D] *It's a Small World float January 1, 1966*

[E] *Grand Marshal Walt Disney January 1, 1966*

Disneyland

What the Dickens? ▶ *1960*

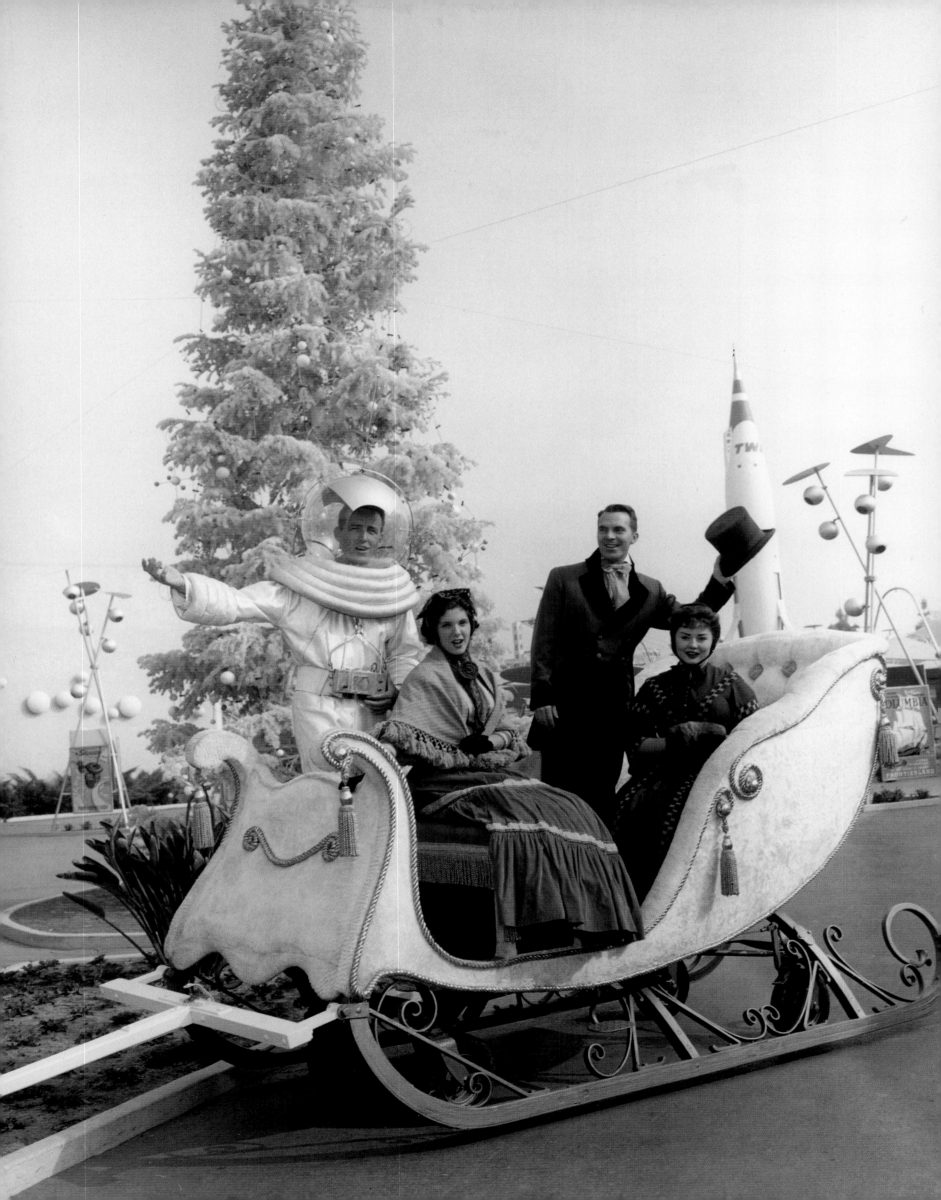

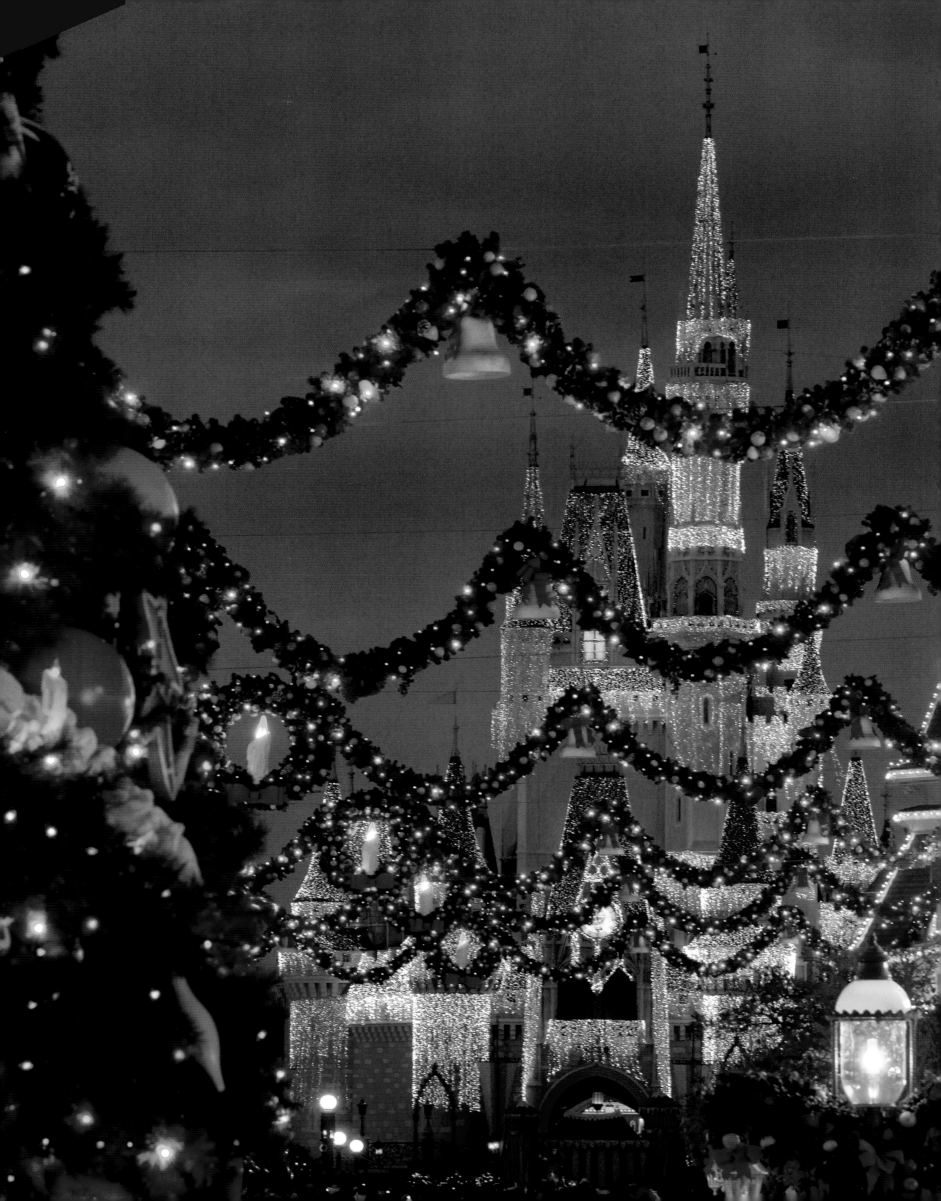

Evoking the Season

Weaving holiday magic into the stories and experiences of the Disney parks

Decorating for the holidays is a tradition we can all relate to. We do it ourselves at home, choosing decorations that reflect our style and that tell our family stories. Scaling up to a theme park means needing a bigger truck, but the idea is essentially the same—reflect and enhance the style and story of each park, land, attraction, shop, and restaurant, and the cultural traditions of each resort's region of the globe. Create the perfect Christmas mood while staying true to the historical or thematic perspective for each location.

And just as we add or change things from year to year, so, too, do the parks. Keeping everything looking fresh is important, of course, so decorations are replaced before they show signs of wear. But there's much more to consider. Once an attraction has been updated, the decorating team will step in and rework the holiday plans to match. Alas, from time to time unusual practical challenges will pop up, such as the need for really tall parade floats ("What do you mean I can't hang my garlands across the street?"). Holiday magic at the Disney parks is a constantly changing kaleidoscope of snowflakes, Santas, and soldiers!

There's no better place to begin our exploration of all that tinsel than at the Magic Kingdom–style parks—where an enchanting mix of holiday fantasy and nostalgia takes over, providing the most enduring memories of the season for many of us. Step through the gates and Guests are immediately greeted with a picture-perfect scene: neat garlands that line the windows; wreaths and bows that adorn each lamppost; toy soldiers guard the impeccable, poinsettia-filled flower beds; and the soothing sounds of Lawrence Welk's 1961 rendition of "White Christmas" all combine to complete the journey back in time.

Though each park has its own distinctive version of that classic Christmas card, there are traditional wreaths and garlands (loaded with baubles, bells, and bows) at all of them. Echoing a real old-time main street, the garlands overhead have a consistent theme—as might be hung by the city—while individual buildings are decorated as if by

Magic Kingdom 2007

the businesses that occupy them. Store-window displays incorporate familiar motifs of greenery and gifts, with a warm seasonal color palette and tweaks as subtle as a bobbin of red thread on a sewing machine.

Beyond Main Street, U.S.A., these are perhaps the most thematically diverse parks, taking Guests on a journey through adventure, fantasy, the land of 'toons, and frontiers of the past and future—and each land has decorations to enrich its place making. In Disneyland, the decor in New Orleans Square evokes a colorful Mardi Gras vibe, though it is in Mickey's Toontown that the trimmings team has clearly had the most fun—taking the theme of each Toontown "business" in outlandish and highly entertaining directions. Little fire hydrants are on display in the garlands that adorn the Firehouse, stamps and packages hang on those on the Post Office, pencils are in those above the Library door, and, wackiest of all, garlands loaded with windup chattering teeth, Slinkys, propeller hats, and (we're not kidding) Santa-clad rubber chickens reside above the Gag Factory.

Before it closed for redevelopment, the Big Thunder Ranch area was used for many years as the Claus family's Disneyland home. Santa's Reindeer Roundup gave Guests the chance to see real reindeer up close and was home to the presidentially pardoned Thanksgiving turkeys in 2005, 2006, and 2009.

Tokyo Disneyland has a tradition of creating elaborate sculptures of Disney characters in holiday settings, and Hong Kong Disneyland modeled its Ice Fantasy on the Chinese custom of holding winter ice festivals. Shanghai Disneyland cleverly layers a consistent style of garland and wreath throughout the resort with location-inspired ornaments—spot acorns on Chip & Dale's Treehouse Treats, for example. Disneyland Paris, meantime, has re-created many European holiday traditions through the years, such as holiday markets and the wonderful Lights of Winter displays. In the Magic Kingdom, check out Gaston's Tavern in Fantasyland. (We know what he uses in all of his decorating.)

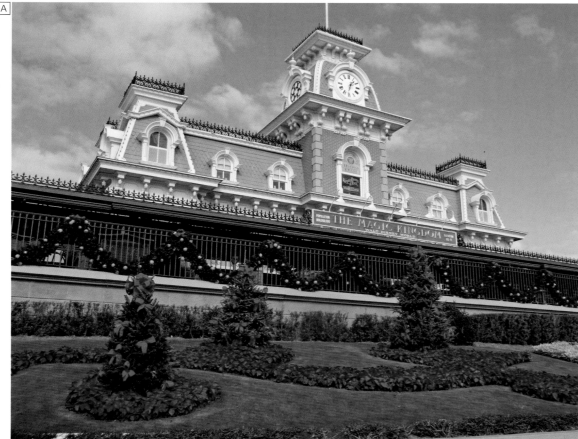

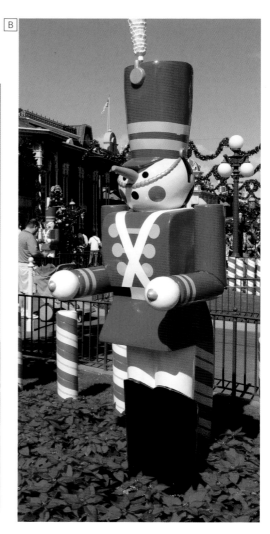

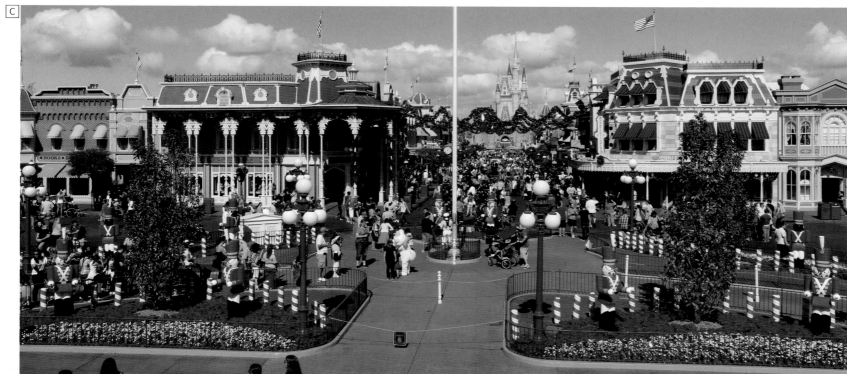

Magic Kingdom

A *Main entrance area*
2008

B *Town Square*
2012

C *Town Square*
(before Christmas
tree installation)
2012

D *Main Street, U.S.A.*
train station decor
detail
2017

E *Town Square*
(underneath the
Christmas tree)
1992

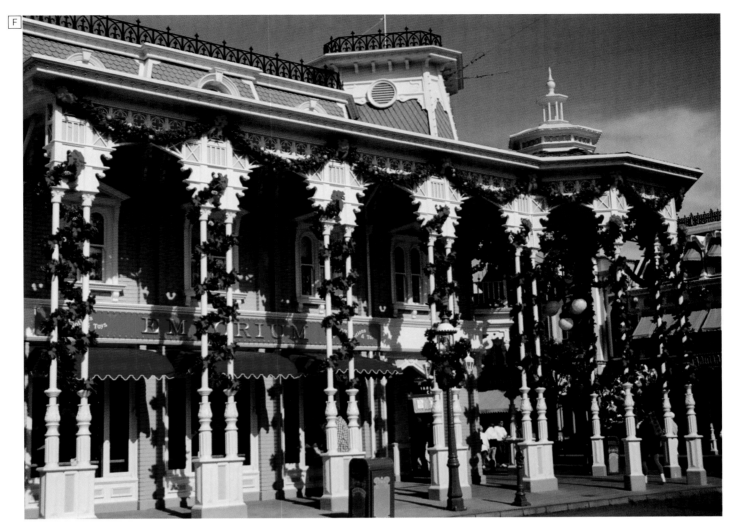

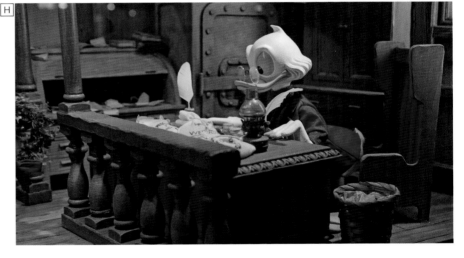

Magic Kingdom

F *Emporium*
 1992

G *Emporium window,*
 Town Square
 2012

H Mickey's Christmas
 Carol *window display,*
 Emporium
 2018

I *Emporium*
 2012

J *Casey's Corner*
 2012

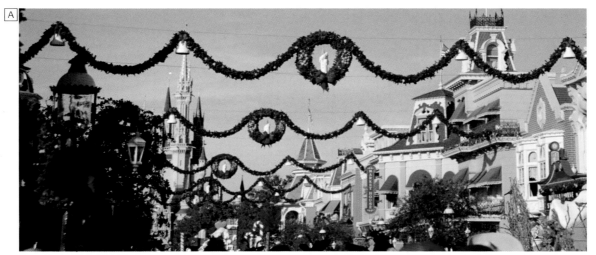

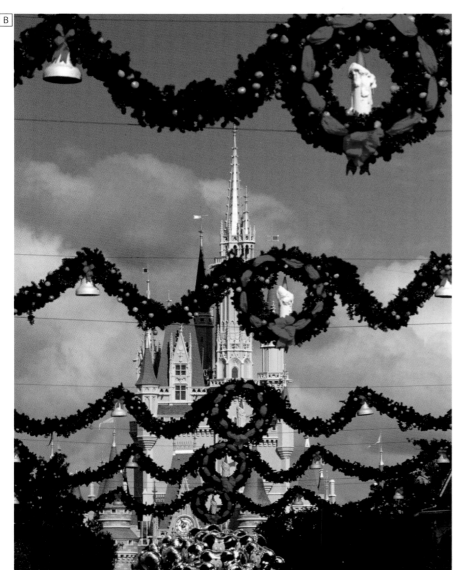

Main Street, U.S.A., Magic Kingdom

A 1992

B 2000

C 2004

D Fire House,
Town Square
2012

E 2017

*Decorative arches
and wreaths on Main
Street buildings
replaced overhead
garlands from 2014*

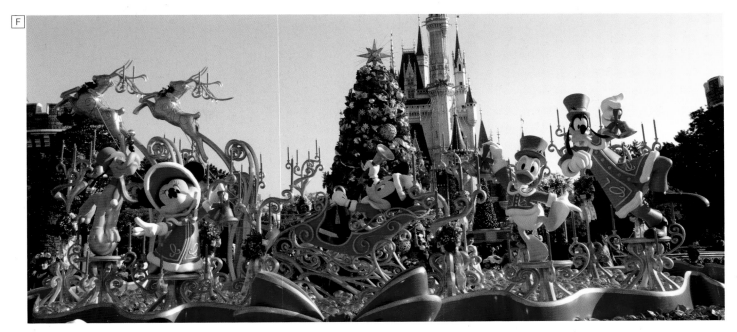

Tokyo Disneyland

F *Plaza*
2007

G H I *Plaza*
2018

J *Grand Emporium,*
World Bazaar
2018

K L *Plaza*
2018

Tokyo Disneyland

A *Adventureland*
2018

B *Polynesian Terrace*
2018

C *The Enchanted Tiki Room*
2018

D *Critter Country*
2017

E *Fantasyland*
2018

F G *Pinocchio's Daring Journey*
2018

H *Cinderella Castle*
2018

Tokyo Disneyland

I J *Hungry Bear Restaurant*
2018

K L *Western Wear*
2018

M *Westernland*
2018

N *Westernland Shootin'*
Gallery
2018

O *Toontown*
2018

P *Toontown*
2017

Q *Toontown Five and Dime*
2017

R *World Bazaar*
2018

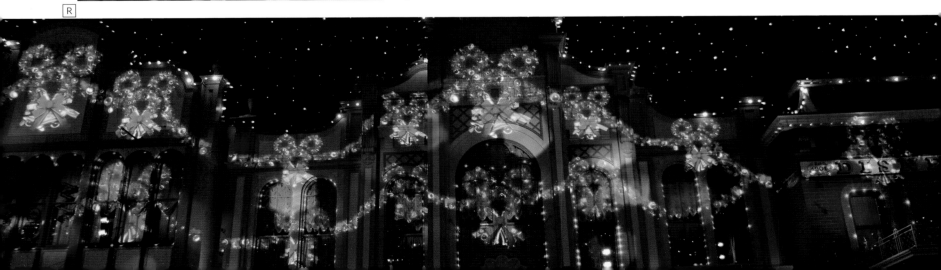

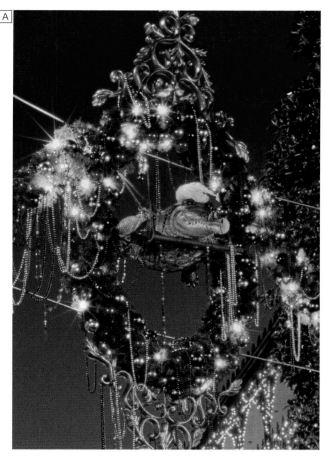

There is a story behind everything Guests experience at a Disney park, and holiday decorations are no different. By way of an example, to inspire a substantial enrichment of the festive bling in New Orleans Square in Disneyland back in 1999, this story line—built on the famed Mardi Gras Krewes (carnival organizations) of New Orleans—was developed:

> "To enhance their overall theme of Holiday Masquerade, the City Council has selected three outstanding krewes to provide the decor and entertainment on their block. The Krewe of Le Masquerade chose an angel motif, a majestic look inspired by the Court of Angels. The Krewe of Boutique Noel explored the legend of Papa Noel with an eccentric alligator twist. And The French Market Krewe looked to the heavens for a celestial holiday filled with stars."

Decorating teams take these ideas as guides that help them when it comes to color choices, ornament design, and lighting, while the Entertainment department expands on these themes and stories by adding music and performance. Together, this creates a harmonious holiday overlay in keeping with the area and with the season.

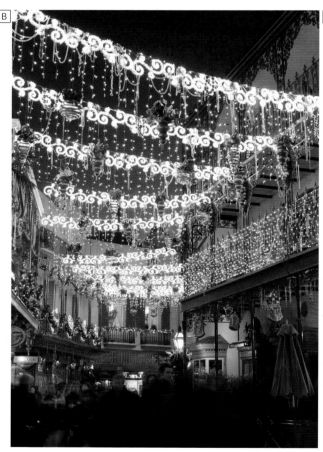

New Orleans Square, Disneyland

[A] *Royal Street 1999*

[B] *Royal Street 2009*

[C][D] *Royal Street 2018*

[E] *Near Cafe Orleans 2018*

[F] *Club 33 balcony 2017*

[G] *Royal Street 2006*

Disneyland

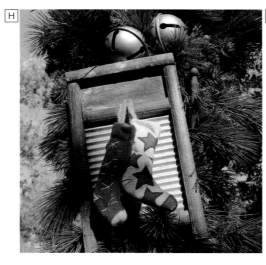

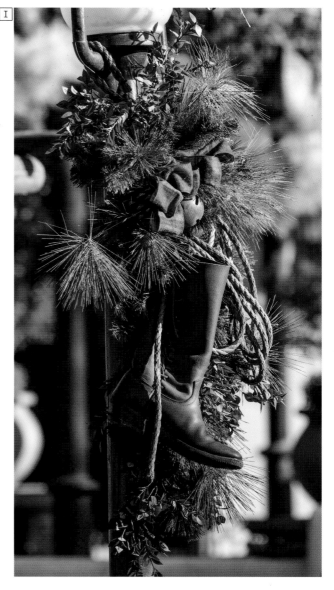

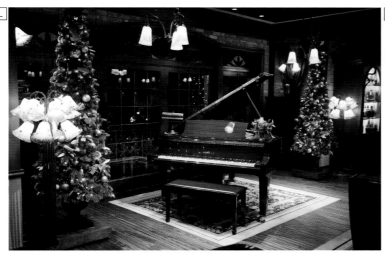

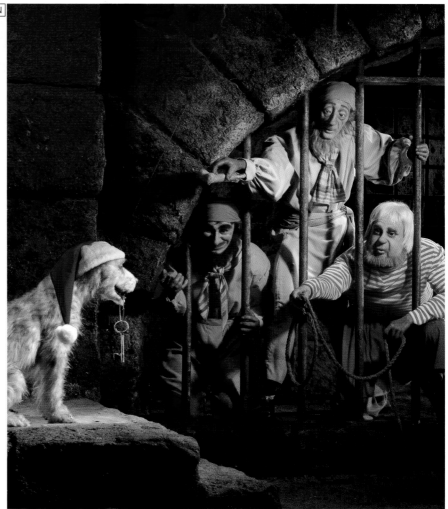

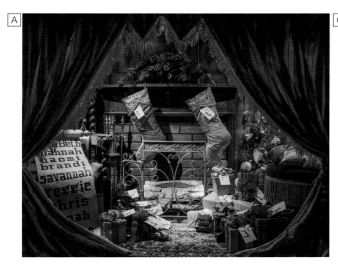

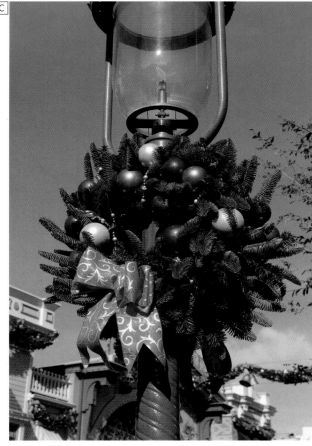

*Main Street, U.S.A.,
Disneyland*

A B *Emporium window
displays
2018*

C D *Decor details
2018*

E *Overhead garlands
2009*

F G *Main entrance area
2018*

H *Town Square
2009*

Mickey's Toontown,
Disneyland

I *Roger Rabbit's
Car Toon Spin
2016*

J *Toontown Post Office
2016*

K *Toontown Library
2016*

L *Toontown Clock Repair
2018*

M *Toontown tree
2002*

N *Gag Factory
2016*

O *Gag Factory
2009*

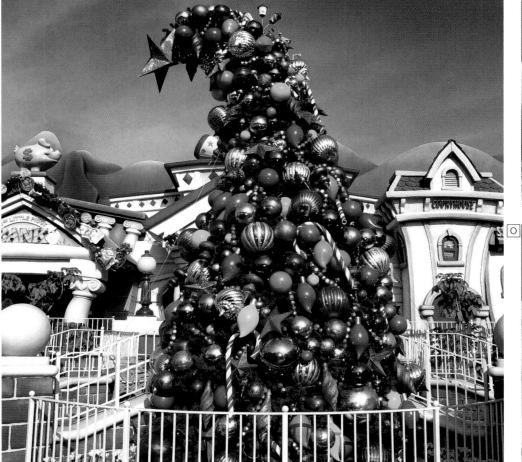

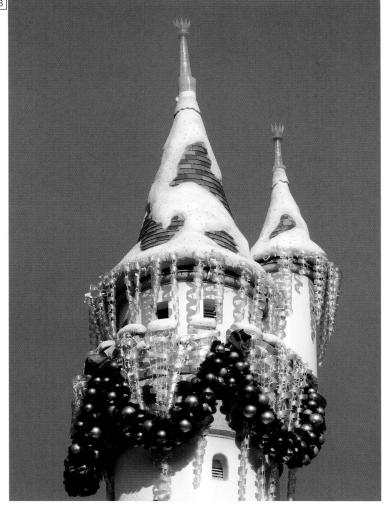

Sleeping Beauty Castle, Disneyland

◄ 2018

C 2003

A 1988

D 2014

B 2018

E 2018

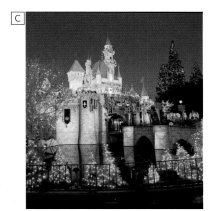

Fantasyland, Disneyland

F Royal Theatre
2018

G Pinocchio's
Daring Journey
2018

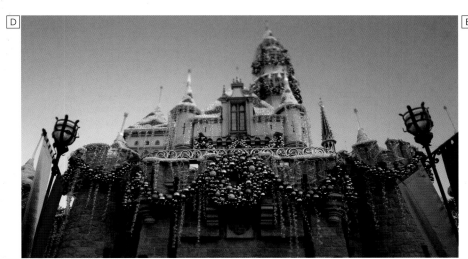

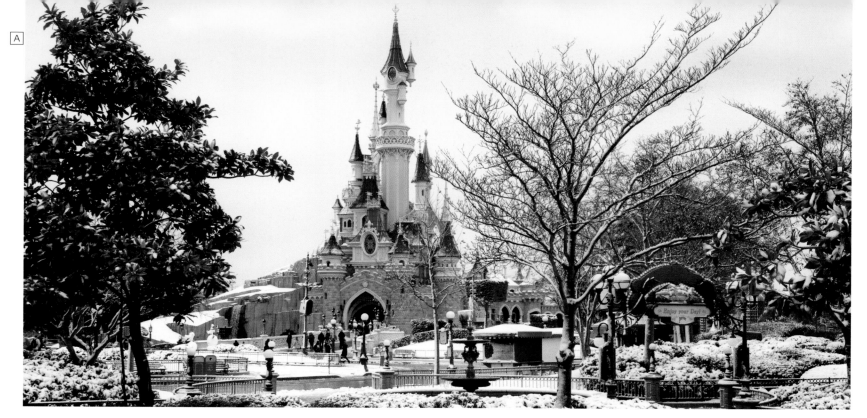

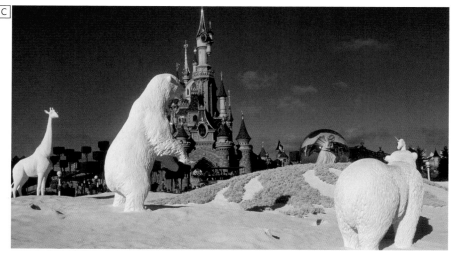

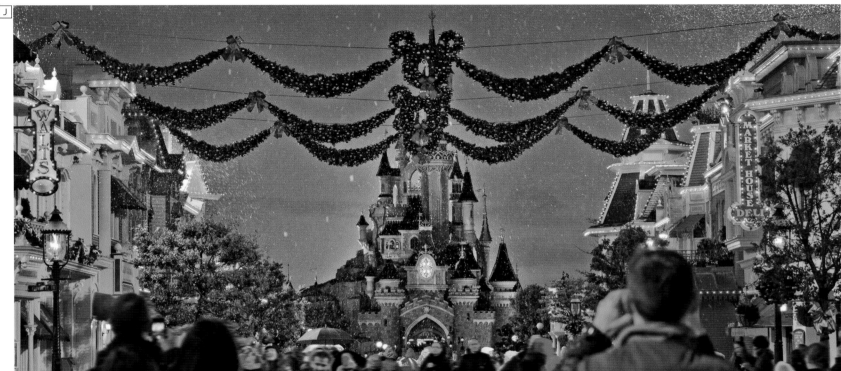

Disneyland Paris

A *Le Château de la Belle au Bois Dormant, December 7, 2012*

B *Town Square*
 2017

C *Central Plaza*
 1995

D *Central Plaza*
 2019

E *La Boutique du Château*
 2017

F G *Town Square*
 2019

H *Winter Market at the Old Mill*
 2009

I *Fantasyland*
 2019

J *Main Street, U.S.A.*
 2013

K *Main Street, U.S.A.*
 2017

Evoking the Season

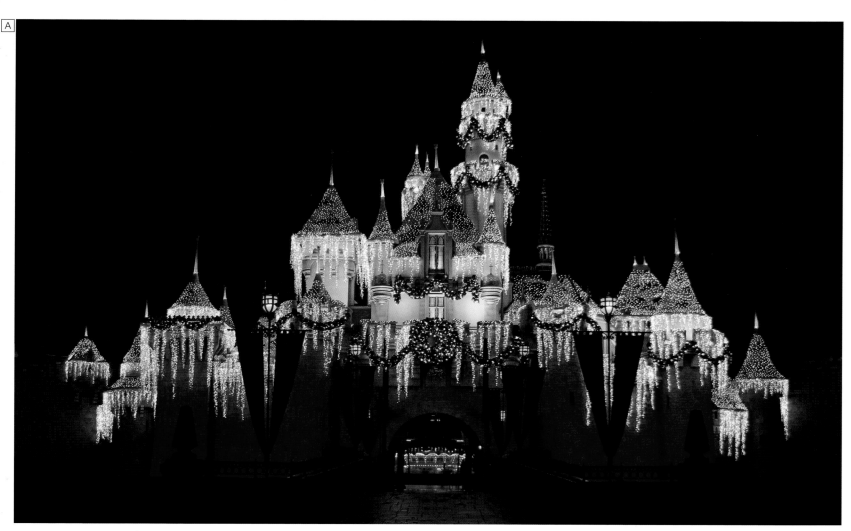

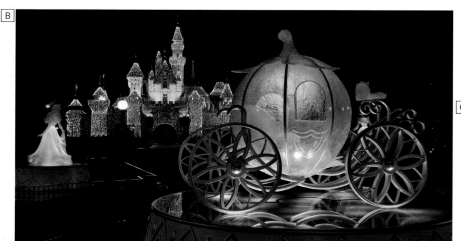

A	Disneyland 2018	C	Disneyland Paris 2011
B	Hong Kong Disneyland 2007		Magic Kingdom 2016 ▶

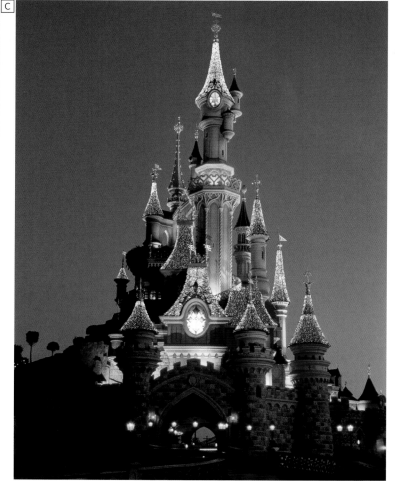

In recent years, spectacular lighting effects have transformed several of the parks' castles into an even more distinct, breathtaking centerpiece of their particular kingdom. Disneyland Paris was first in this endeavor, with the Féerique Spectacle, debuting in 2005, that saw Le Château de la Belle au Bois Dormant draped in thousands of tiny, shimmering, ice-blue lights—part pixie dust and part glistening frost. In 2007, similar transformations were introduced in Hong Kong Disneyland (Sparkling Castle Lights, which appeared each holiday season through 2009), Disneyland (Sleeping Beauty's Winter Castle), and Walt Disney World (Castle Dream Lights). It's the Magic Kingdom, though, that takes the prize for having the most lights at over two hundred thousand! The effects and look can be controlled and choreographed for shows, as with the nightly lighting ceremony in Disneyland. Look close to see subtle waves of sparkle shimmering gently, almost imperceptibly, over the roofs and turrets at other times, too.

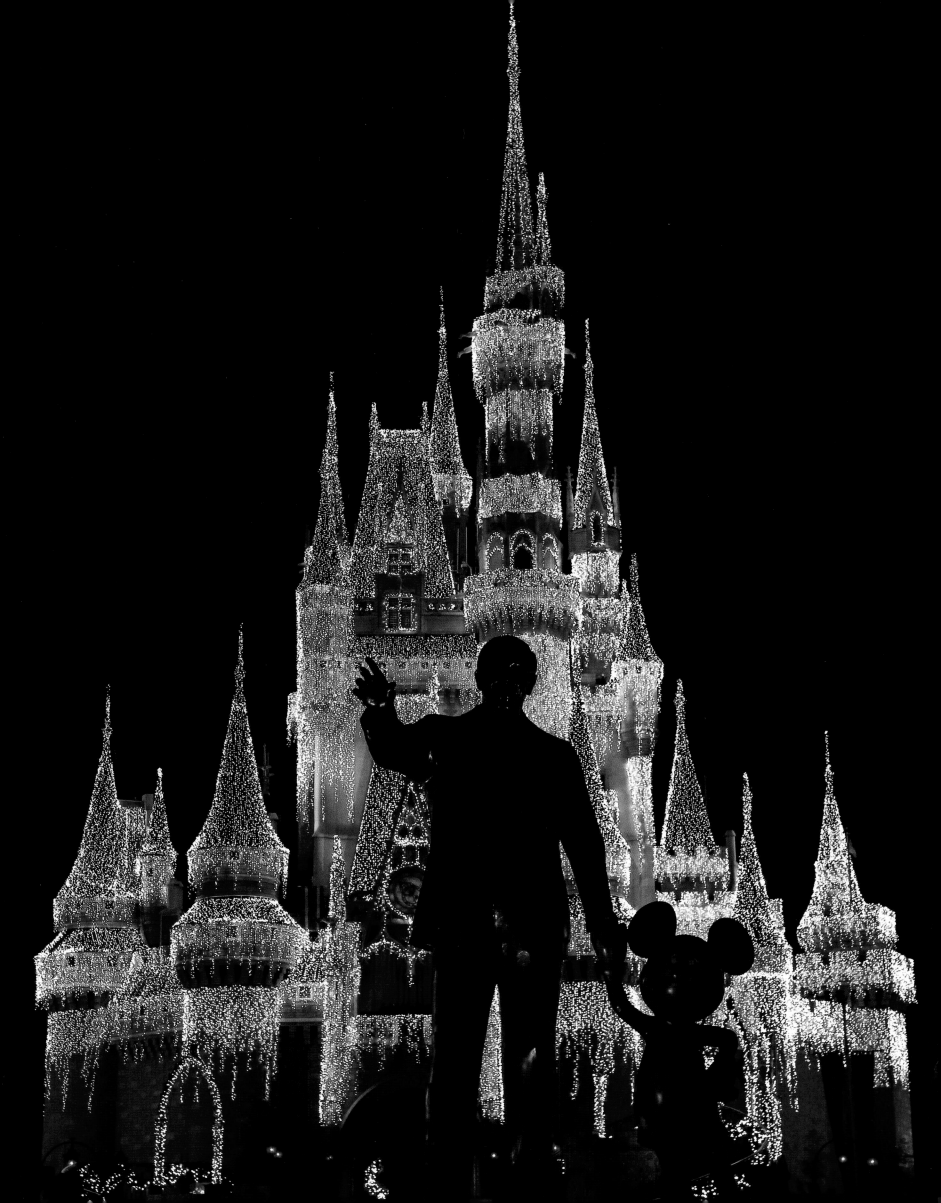

Wreaths with Character

A *Disneyland
1988*

B *Disneyland
2009*

C *Disneyland
2018*

D *Tokyo Disneyland
2017*

E *Disneyland Paris
2019*

F *Shanghai Disneyland
2017*

G *Hong Kong
Disneyland
2018*

H *Magic Kingdom
2005*

I *Magic Kingdom
2017*

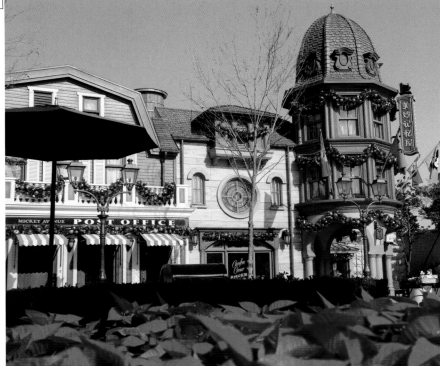

Shanghai Disneyland

J Main entrance area
2017

K Celebration Square,
Mickey Avenue
2017

L Il Paperino ice cream
shop, Mickey Avenue
2017

M Chip & Dale's Treehouse
Treats, Mickey Avenue
2017

N Doubloon Market,
Treasure Cove
2017

O Silly Symphony Music
Store, Mickey Avenue
2017

P Hundred Acre Goods
2017

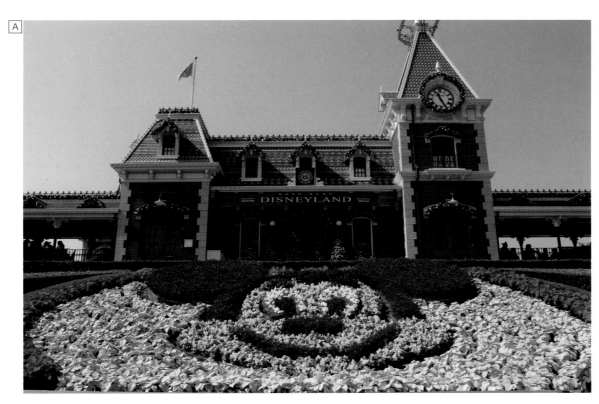

Hong Kong Disneyland

A Main entrance area
2018

B Main Street, U.S.A.
2018

C Town Square
2018

D Central Plaza
2016

E Main Street
Market cart
2016

F G Town Square
2018

H Main Street, U.S.A.
2018

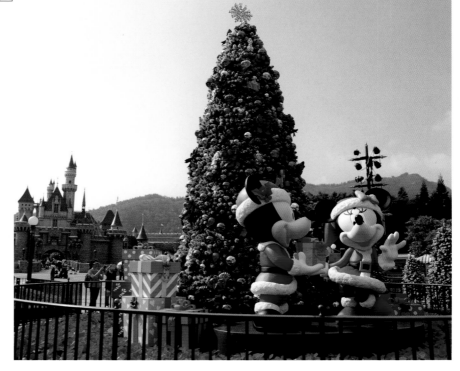

HOT · FRESH · DELICIOUS

SANTA GOOFY'S
HOLIDAY MAILBOX

CENTER STREET
BOUTIQUE

Holiday Magic at the Disney Parks

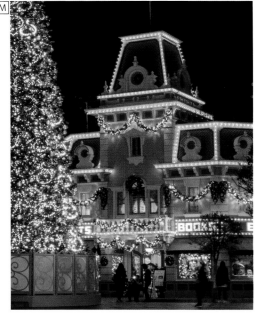

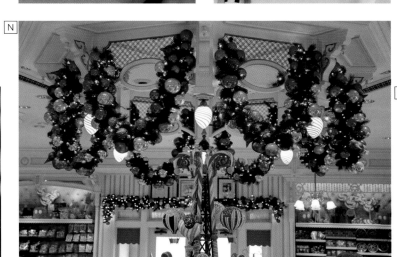

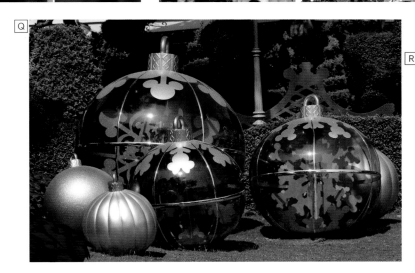

The sight of a bedecked evergreen fir is about as universally iconic a symbol of the season as can be imagined. As we have seen, trees have been featured prominently in Disney holiday decor since the very first Disneyland Christmas in 1955, and it remains the one major element Guests will find at every park, resort hotel, and entertainment district, and on every cruise ship, as well as in some form at just about every shop and restaurant along the way—and even in some attractions.

Just like the general holiday decor, the Magic Kingdom–style parks are the places to find the most classic and traditional trees—such as in the center of World Bazaar in Tokyo, Gardens of Imagination in Shanghai, and (most often) on Town Square in the Hong Kong, Paris, Magic Kingdom, and Disneyland parks. At the two US parks, the signature trees were once real, brought from the forests near Mount Shasta in Northern California (primarily tall white firs, along with shorter red firs for the castle moat in Disneyland). Each Town Square tree typically needed the equivalent of at least two actual trees to make—with up to seven hundred extra branches, which were harvested in the same forest area and used to fill out the main tree. Reinforcement against high winds and the application of fire-retardant paint were also required before lights and decorations could be hung. In 1997, Walt Disney World made the switch to artificial trees, and Disneyland followed in 2008.

Each one of the main Magic Kingdom trees around the world is decorated in its own distinctive style, while following traditional themes—baubles, stars, candles, Santa Claus and toy soldier figurines, candy canes, and gingerbread figures—though the decorations have evolved over time. Take the sixty-foot-tall tree in Disneyland: it went from about six hundred lights and seven hundred ornaments in the 1980s to five thousand lights and two thousand ornaments in 1997, and then seventy-five thousand LED lights in 2008. Many trees are now equipped with those sophisticated LEDs, and the nightly tree lighting ceremonies have become much more than flipping-a-switch. Mickey's Magical Christmas Lights in Disneyland Paris, A Holiday Wish Come True in Hong Kong Disneyland, and A Christmas Enchantment in Shanghai Disneyland are dazzling shows, with rich, multicolored effects conjuring up imagery of snowfall, twinkling stars, candy canes, and more.

Sometimes changes are subtle: in 1998, Disneyland removed all blue ornaments to make the color palette warmer. And sometimes changes are big: the tree celebrating the golden anniversary of Disneyland in 2005 was adorned with five thousand gold ornaments . . . and all of the lights were amber.

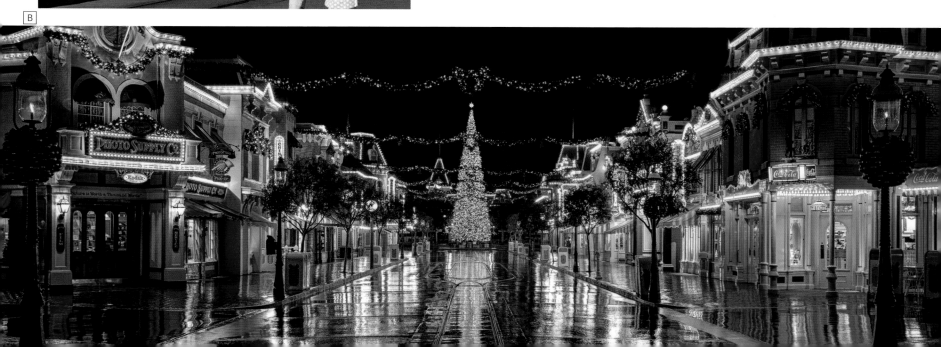

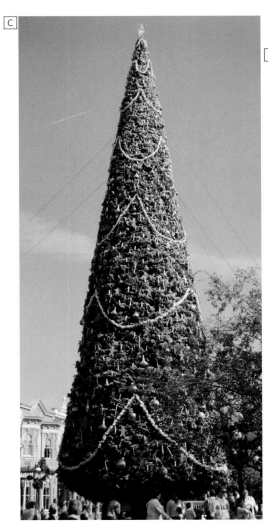

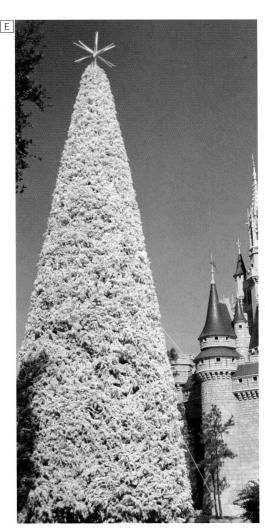

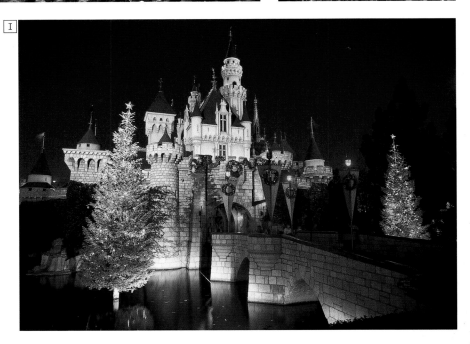

Disneyland

A **Town Square**
2008

B **Main Street, U.S.A.**
2012

G **Town Square**
2013

H **Town Square, fiftieth anniversary tree**
2005

I **Sleeping Beauty Castle**
1999

Magic Kingdom

C **Town Square**
1992

D **Town Square**
1983

E **Cinderella Castle**
1992

F **Town Square**
2008

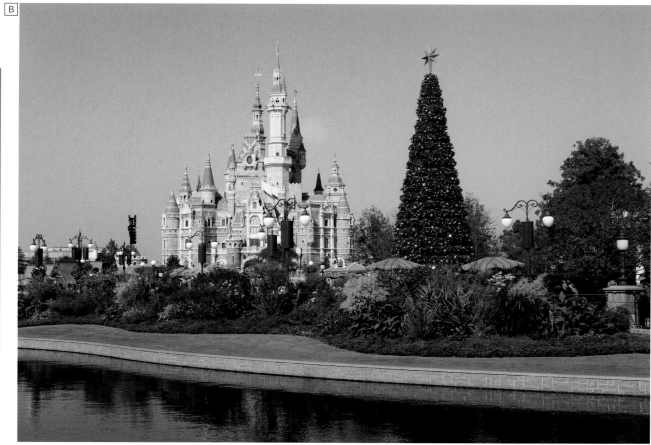

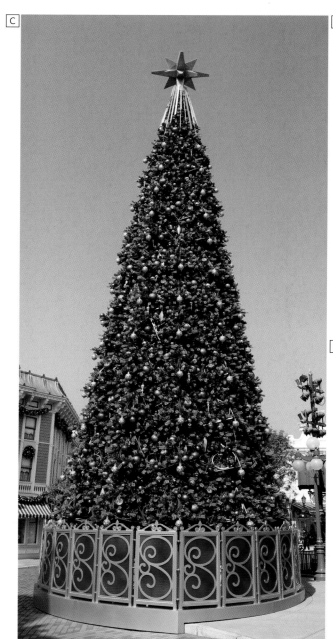

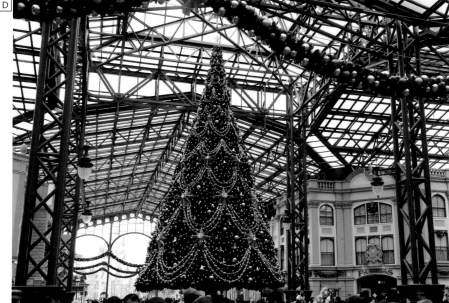

A Shanghai Disneyland
2017

B Shanghai Disneyland
Gardens of Imagination
2017

C Hong Kong Disneyland
Town Square
2018

D Tokyo Disneyland
World Bazaar
2017

E Tokyo Disneyland
Fantasyland
2018

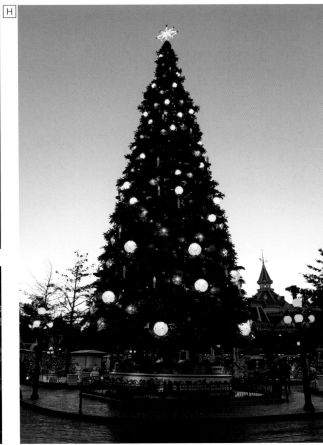

Disneyland Paris

F *Le Château de la Belle
 au Bois Dormant
 2004*

Town Square tree

G — J *2017*

K *1995*

L *2015*

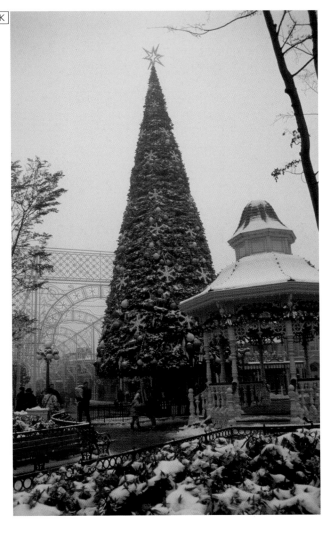

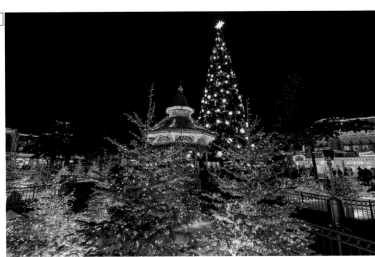

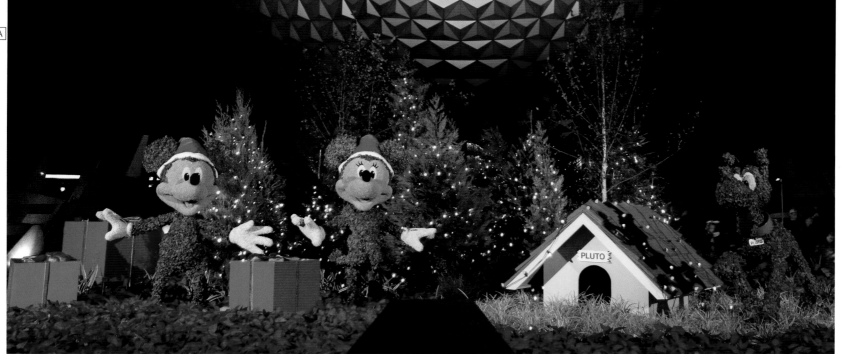

In other Disney parks, the decor naturally reflects the distinctive story line of each land and attraction, and the primary trees tend to reflect the overall themes of their park. The main tree at EPCOT, located at the plaza where Future World and World Showcase meet (and visible to much of the rest of the park), celebrates . . . well, the *world*. Baubles are decorated with the flags of World Showcase countries, banner-shaped ornaments proclaim festive wishes in many languages, and the tree topper is a serene angel holding a world globe in her outstretched hands.

Around World Showcase, each pavilion is decorated in ways that mirror the holiday traditions of that country—miniature piñatas in Mexico, and British-style Christmas crackers in the United Kingdom, for example—or with items that evoke that country's culture in a whimsical way, like hanging miniature clocks on the tree in Germany. Over in Future World, the holiday topiary displays are quite a sight, greeting Guests right at the main entrance. Spaceship Earth provides a perfect EPCOT backdrop, making this a popular photo spot.

No discussion of holiday decorations at EPCOT would be complete without mentioning the Lights of Winter. Inspired by the Italian tradition of *luminarie*—and seen first in Disneyland Paris (1993–2004)—this arcade of twinkling archways stretched the length of the walkway between Future World and World Showcase for the holiday seasons from 1994 through 2008. Gracing the skyline as elegant and intricately sculpted structures by day, the arches came alive each evening, thanks to the placement of thirty thousand colorful lights, dancing to a soundtrack of holiday music—mostly contemporary arrangements of classic holiday melodies. They were a simple yet engaging spectacle that regularly drew a crowd, people happy to sit on a planter and be surrounded by the magic that enveloped them. Every so often a Monorail train would glide between the arches, though it was hardly a distraction. Nearby, the Innoventions Fountain show was synchronized to the same music.

In the early days of what we now know as Disney's Hollywood Studios, the main tree was placed in front of the Chinese Theatre. Keen Disney historians will remember that the Studios park's original layout formed

a giant hidden Mickey—and it was right on Mickey's nose that the tree was planted. In a witty throwback to the era of Hollywood's heyday, the park's Christmas tree was decorated with oversized bubble lights, and around it an equally outsized toy train chugged past models of Los Angeles' various landmarks—the Hollywood sign, the Hollywood Bowl, Union Station, and, naturally, the Disney studio in Burbank. And in close proximity was the iconic Earffel Tower, which this time of year always sported an enormous Santa hat (size 342 ⅜!).

Even though the bubble lights are gone, Disney's Hollywood Studios still decorates with an authentic air of mid-century kitsch—tinsel in Tinseltown . . . but of course. Lampposts along Hollywood and Sunset Boulevards here sport the kind of glittery trees and stars that were all the rage in the 1940s and 1950s. Similar decorations adorned the old Streets of America area before the Osborne Family Spectacle of Lights show moved there in 2004. For the 1992 holiday season, that same back lot area was decorated with balloons brought down from Macy's Thanksgiving Day Parade (Santa Goofy, Kermit, Betty Boop, and some smaller balloons).

Reconfiguration of the park's central plaza area led to having the tree moved to a spot just outside the main entrance starting in 2001. Then, in 2017, it was moved back inside the park to a prime location on Echo Lake as part of a substantial enhancement of holiday decorations throughout the park.

In Disney's Animal Kingdom the decorations have a distinctively hand-crafted feel, as if made by the artisans who inhabit each land, cleverly using materials available around them. In an environment already lush with plants and trees, classic holiday greenery does not always stand out, so rich golds and bright colors make the decorations pop. Holiday overlays were expanded significantly in 2019, including, for the first time, to Pandora—The World of Avatar, where ex-pat humans have decorated with ornaments brought from Earth and new decor they have fashioned using Na'vi materials. Recognizing that the park honors cultures and continents that do not necessarily celebrate western holidays, Discovery Island has a broader, winter solstice theme with a color palette inspired by the

polar auroras. Animals from wintry places are featured, such as reindeer, polar bears, and penguins, though look carefully to find partridges and turtle doves.

Tokyo DisneySea adds fanciful holiday updates throughout the park. The Mediterranean Harbor area is decorated in a sumptuous European style, rich in jewels and jewel tones, while the American Waterfront is home to the park's main Christmas tree and the most elaborate trimmings. Even Scrooge McDuck gets in on the act, with the decorations outside his department store wryly reflecting his monetary view of the world! The harbor itself is a magnificent stage for holiday entertainment on a grand scale (which we'll delve more into later).

Back at the Disneyland Resort, Disney California Adventure has often had a less wintry outlook on the holiday season. Santa's Beach Blast was the theme from 2003 to 2007, with surfboards, sandcastles, and the big man himself sporting shorts and a Hawaiian shirt. Cars Land has some of the most playful, festive interpretations around. The Radiator Springs tree is decorated with hubcaps, and the street is framed by hanging garlands made from automotive air filters, spanner-and-wrench snowflakes, and tires that fill in as wreaths. And traffic cone decor adorns the Cozy Cone Motel. The Resort Enhancement team is particularly proud of the holiday overdressing on Buena Vista Street—the result of much-detailed research into the decorating styles of 1920s and 1930s Los Angeles, making it among the most historically authentic at a Disney park. Cedar garlands adorn the street itself, while the store interiors are inspired by the look found in period photographs. The fifty-foot-tall tree is decorated with ornaments cast and enlarged from 1930s originals that were handed down to team members from personal family collections. And the Santa sleigh with reindeer flying over the eastern end of the park's Hollywood Boulevard is molded from the actual props formerly installed over Hollywood Boulevard itself in the 1930s.

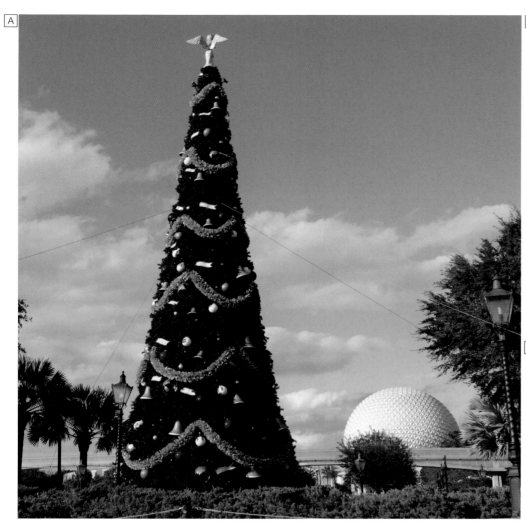

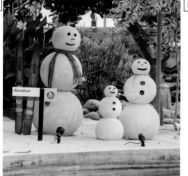

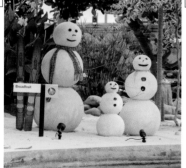

EPCOT

A World Showcase Plaza
2016

B Main tree topper
2017

C Main tree detail
2017

D United Kingdom
2017

E Innoventions Plaza
2016

F World Traveler shop,
International Gateway
2017

G H Living with the Land
2018

I World Showcase
Promenade
2016

J K Mouse Gear store displays
2018

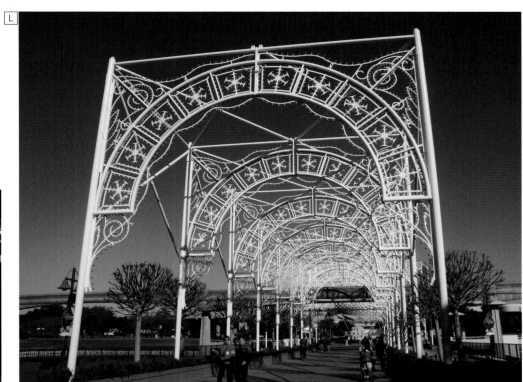

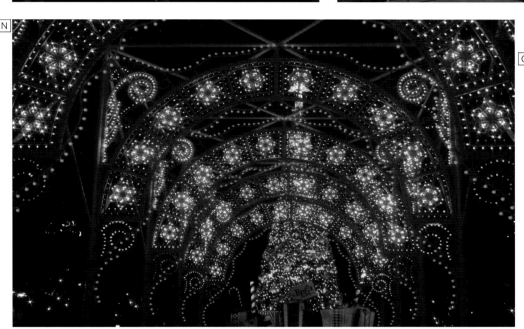

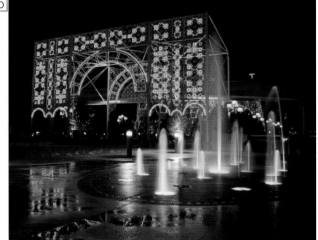

EPCOT

L *Lights of Winter 2008*

M N *Lights of Winter 2005*

O *Lights of Winter 1995*

P *Innoventions Plaza 2006*

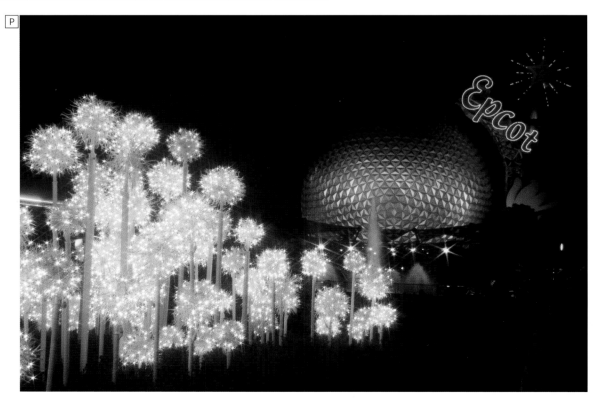

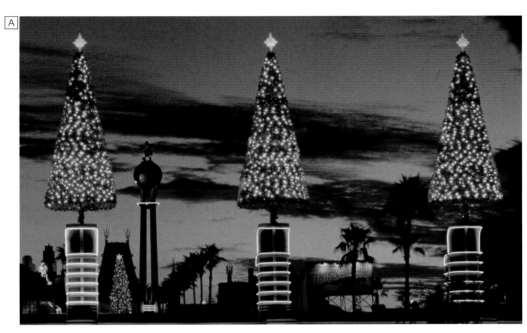

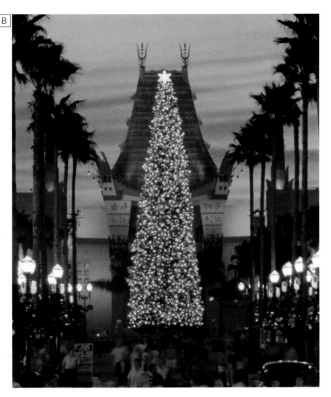

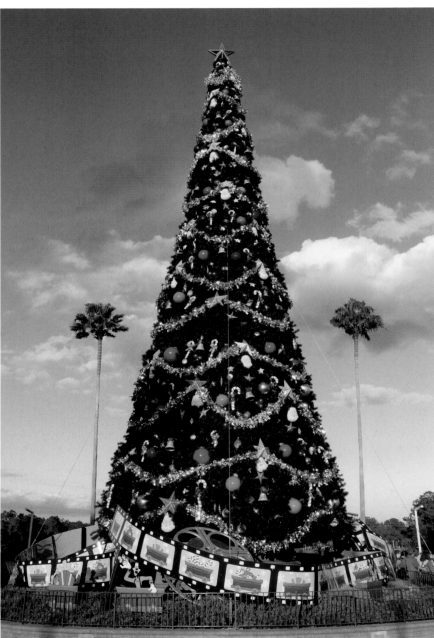

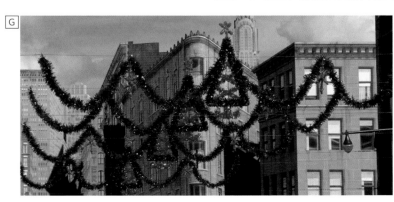

Holiday Magic at the Disney Parks

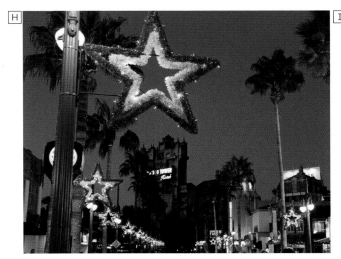

Disney's Hollywood Studios

A *Main entrance area*
 1989

B *Main tree*
 1989

C *Under main tree*
 1992

D *Main entrance area*
 2016

E *Earffel Tower*
 1989

F *Macy's New York Christmas*
 1992

G *Streets of America*
 2000

H *Sunset Boulevard*
 2016

I *Echo Lake*
 2017

J *Hollywood Boulevard*
 2016

K *Echo Lake*
 2017

L *Dinosaur Gertie's Ice Cream of Extinction*
 2017

M *The Darkroom, Hollywood Boulevard*
 2017

N *Disney Vacation Club Information Center, Sunset Boulevard*
 2017

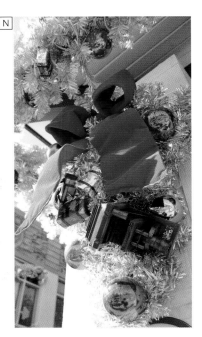

Disney's Animal Kingdom

A Main entrance area
2008

B Riverside Depot,
Discovery Island
2019

C Island Mercantile
2017

D Discovery Island
2019

E Discovery Trading
Company
2017

F Discovery Trading
Company
2019

G Oldengate Bridge,
DinoLand U.S.A.
2019

H I Chester & Hester's
Dinosaur Treasures,
DinoLand U.S.A.
2017

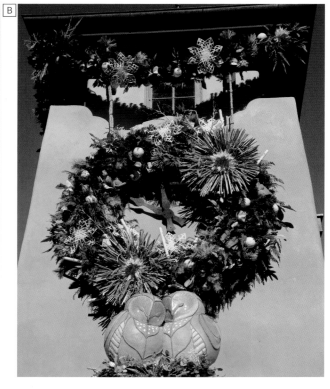

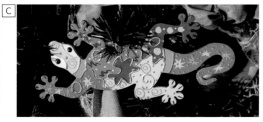

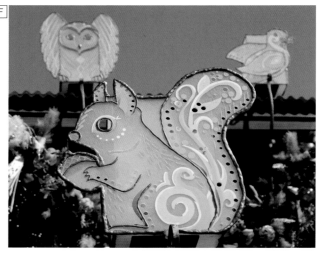

Disney's Animal Kingdom

J *Africa Bridge*
 2017

K *Tamu Tamu*
 Refreshments,
 Africa
 2017

L *Dawa Bar, Africa*
 2017

M *Tusker House*
 Restaurant, Africa
 2017

N — Q *Pongu Pongu Bar,*
 Pandora—The
 World of Avatar
 2019

R *Diwali decor,*
 Anandapur, Asia
 2019

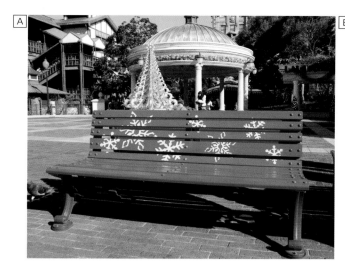

Tokyo DisneySea

A Waterfront Park
2017

B American Waterfront
2017

C Waterfront Park
2017

D McDuck's
Department Store
2017

E Main Christmas tree
and Tower of Terror,
American Waterfront
2017

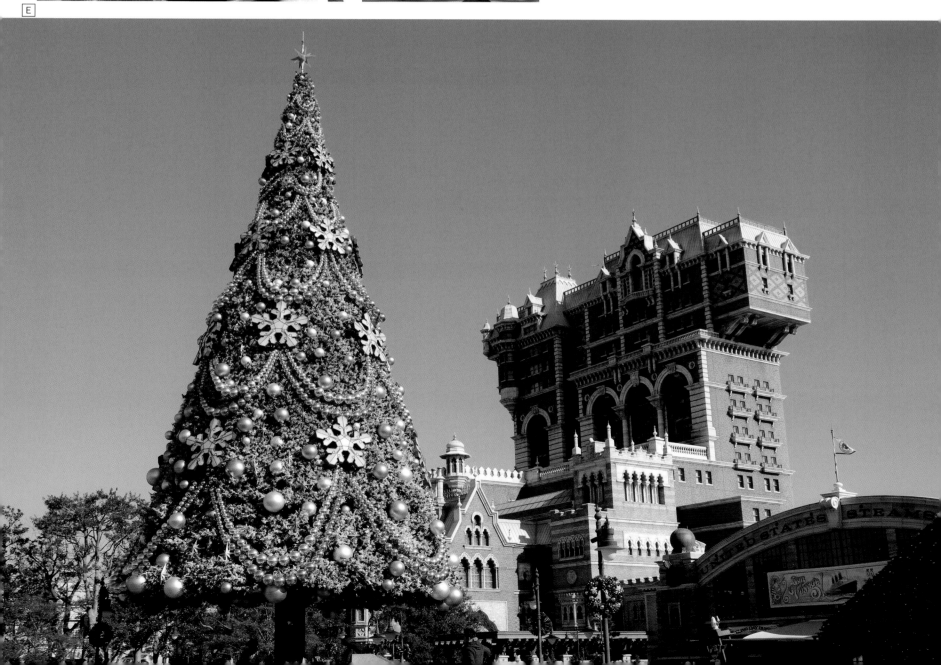

Tokyo DisneySea

F *Lost River Delta*
2018

G *Cape Cod, American Waterfront*
2017

H *Cape Cod Cookoff, American Waterfront*
2017

I *Mermaid Lagoon*
2017

J *Emporio, Mediterranean Harbor*
2017

K *Il Postino Stationary, Mediterranean Harbor*
2017

L *Bella Minni Collections, Mediterranean Harbor*
2017

M *Mediterranean Harbor*
2017

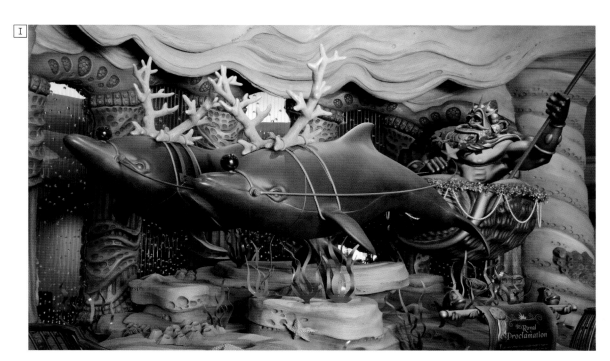

Tokyo DisneySea

A S.S. Columbia,
 American Waterfront
 2017

B Waterfront Park,
 American Waterfront
 2017

C Lost River Delta
 2018

D E Mediterranean Harbor
 2018

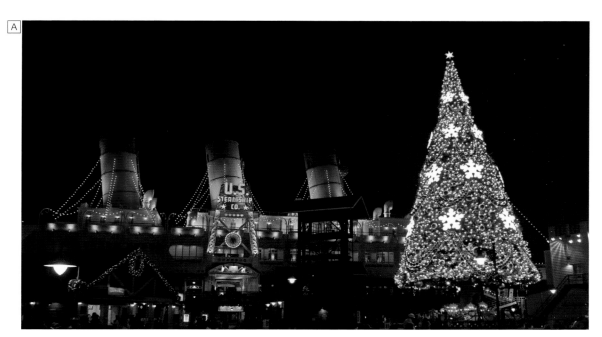

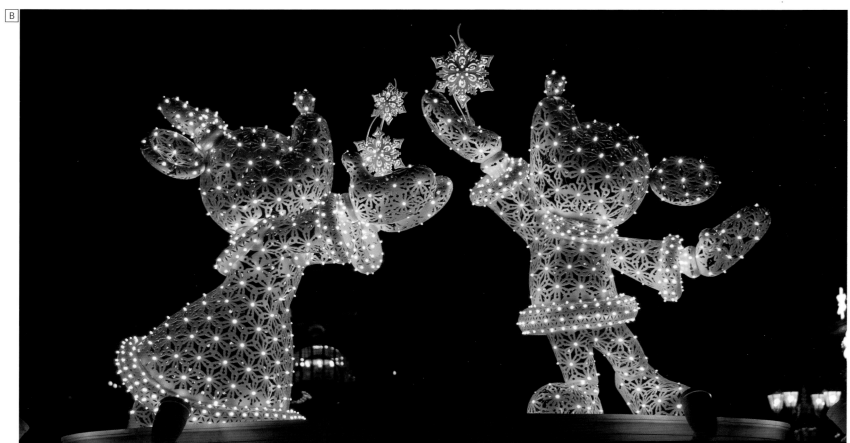

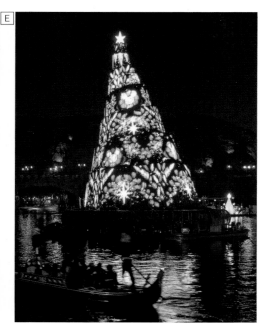

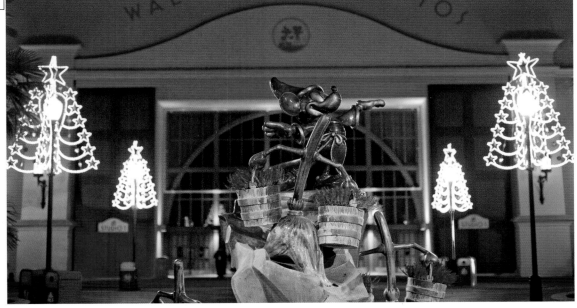

Walt Disney Studios Park, Disneyland Paris

F *Place des Frères Lumière*
 2017

G *Bistrot Chez Rémy*
 2017

H *Ratatouille courtyard*
 2019

I *Place des Frères Lumière*
 2016

J K *Disney Studio 1*
 2017

L *Restaurant en Coulisse*
 2019

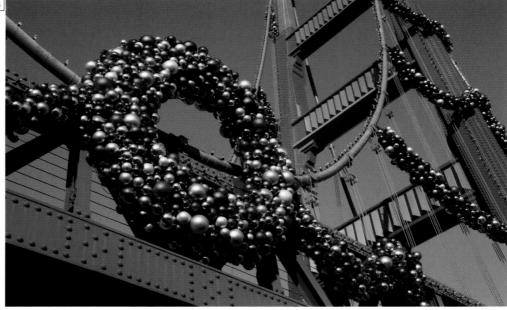

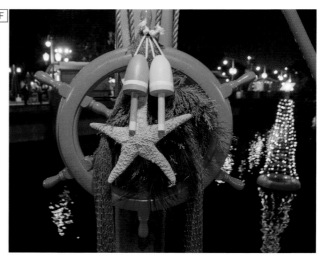

Disney California Adventure

A *Hollywood Boulevard, Sunshine Plaza*
2009

B *Golden Gate Bridge*
2009

C *Main entrance area*
2008

D *Paradise Gardens Park*
2018

E *a bug's land*
2009

F *Pacific Wharf*
2016

G *Monsters, Inc. Mike & Sulley to the Rescue!*
2018

H *Lucky Fortune Cookery*
2018

I *Pacific Wharf Cafe*
2016

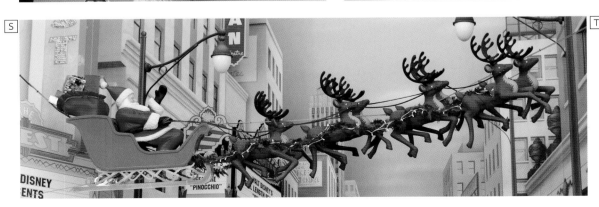

Disney California Adventure

J *Main tree, Buena Vista Street 2018*

K — N *Tree decor 2018*

O *Walt's Barn under main tree 2017*

P *Elias & Company 2018*

Q *Mortimer's Market 2018*

R *Window display, Julius Katz & Sons 2018*

S *Hollywood Land 2016*

T *Window display, Los Feliz Five & Dime 2018*

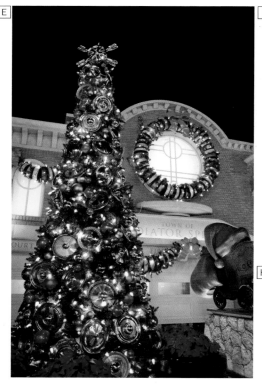

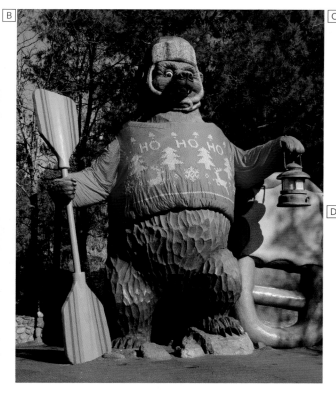

Disney California Adventure

A *Grizzly Peak*
 2018

B *Grizzly River Run*
 2018

C D *Rushin' River Outfitters*
 2018

E *Cars Land*
 2018

F *Gingerbread display,*
 Cozy Cone Motel
 2018

G *Cars Land*
 2018

H *Cozy Cone Motel*
 2015

I *Flo's V8 Cafe*
 2018

J *Cars Land*
 2012

K *Cars Land*
 2018

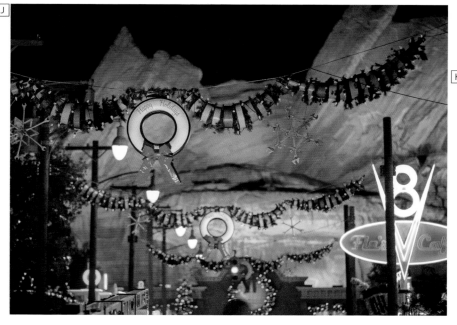

Sweet tooth, anyone?

L Disney California Adventure
Trolley Treats
2017

M Disney California Adventure
Clarabelle's Ice Cream
2018

N Tokyo Disneyland
Pastry Palace
2017

O Tokyo DisneySea
Cape Cod Confections
2017

P Shanghai Disneyland
Sweethearts Confectionery
2017

Q Tokyo Disneyland
World Bazaar Confectionery
2018

R Tokyo Disneyland
World Bazaar Confectionery
2017

S Magic Kingdom
Main Street Confectionery
2018

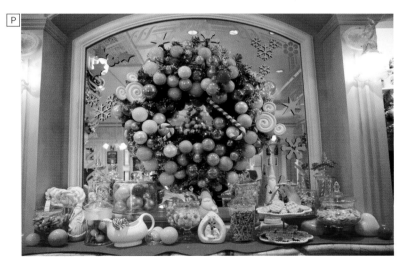

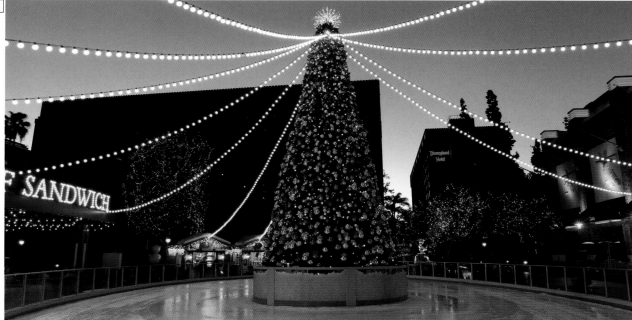

Downtown Disney,
Disneyland Resort

A Ice rink
 2015

B Near Catal
 Restaurant
 2017

C Near Tortilla Jo's
 2017

Shopping, dining, and entertainment districts beyond the parks receive just as much attention to holiday detail. As well as trimming the trees and filling the planters with traditional winter flowers, Downtown Disney in Anaheim installed an ice rink for several holiday seasons. Disney Village in Paris re-creates a classic European winter market with stalls that sell treats, candy, and that "special kind" of winter beverage that warms Mom and Dad . . . and gives them that extra holiday glow.

Disney Springs at Walt Disney World has a wide range of decorating styles, with each shop and restaurant enhancing its own theme. At the Marketplace—oldest of the Disney Springs districts (having opened as the Lake Buena Vista Shopping Village in 1975)—look for classic toys and the kinds of decoration Guests might use (or even make) themselves. The Landing art direction is nautical, while the West Side is contemporary and modern. And Disney Springs' newest district, the Town Center, chooses the classy elegance of chandeliers and an opulent crystal tree topper. In 2016, the Marketplace district debuted a Christmas Tree Trail, featuring a series of displays inspired by some of Disney's most popular films and characters. It has returned each year since, on a progressively grander scale.

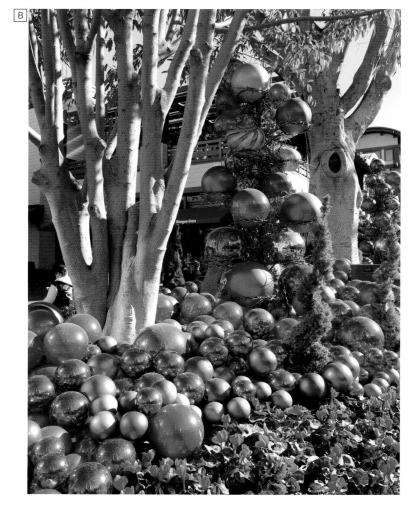

One final, and very important, element of the holiday experience at all of the parks and shopping districts is background music. Though subtler perhaps than a sixty-foot-tall tree, music remains absolutely integral to the story within the parks. And the music is chosen with the same thematic and historical care as all of the decorations. The Main Street, U.S.A. Christmas audio in Disneyland and in the Magic Kingdom, for example, features the work of Felix Slatkin, David Rose, Raymond Lefèvre, Lawrence Welk, and other musicians who were well known, particularly in the mid-twentieth century. All of the tracks were recorded between 1959 and 1968, and the playlist has been setting Disney's festive mood since 1972.

Elsewhere, listen for cowboy Christmas songs in Frontierland, jazzed-up versions of seasonal classics in New Orleans Square, and a new age twist in Tomorrowland. With a sparkle in our eyes and a jingle in our ears, the holiday transformation of all of our favorite Disney park experiences is complete.

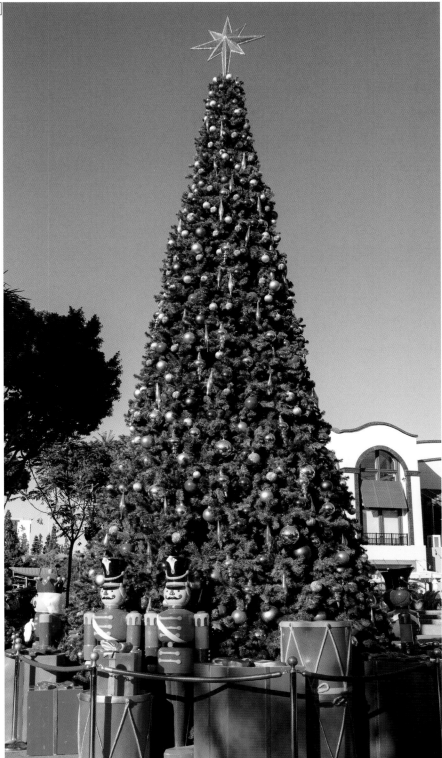

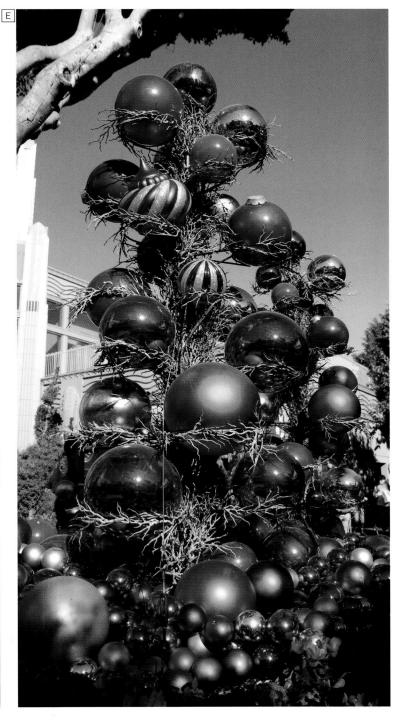

Downtown Disney,
Downtown Disney,
Disneyland Resort

D *Main tree*
2017

E *Near (what was then)*
RideMakerz (and is
now Black Tap)
2017

Tokyo Disney Resort

F *Bon Voyage shop*
2017

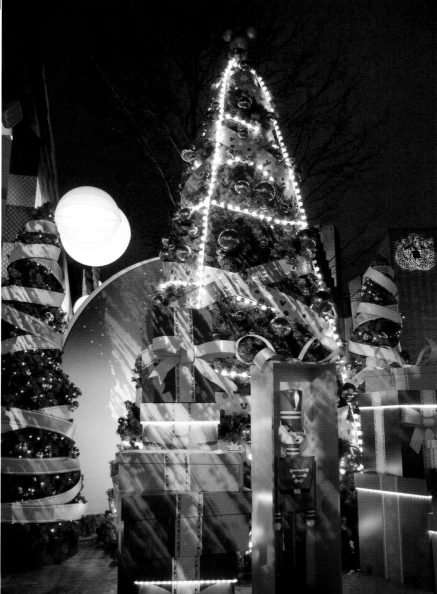

Disney Village,
Disneyland Paris

A *Main tree*
 2017

B *Christmas Market, near*
 The Disney Store
 2017

C *Christmas Market,*
 roasting chestnuts
 2019

D *Disney Village Promenade*
 2017

E *Christmas Market, near*
 Planet Hollywood
 2016

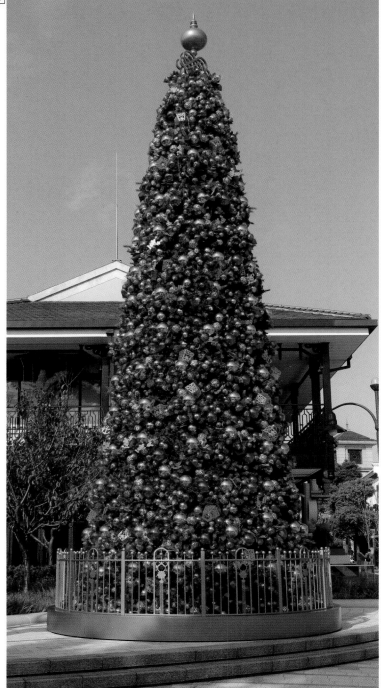

*Disneytown,
Shanghai Disney Resort*

F *Marketplace
2017*

G *Main tree, near
World of Disney
2017*

H *Lakeshore
2017*

I *Broadway Plaza
2017*

J K *Main tree detail
2017*

L *Lakeshore
2017*

M *Marketplace
2017*

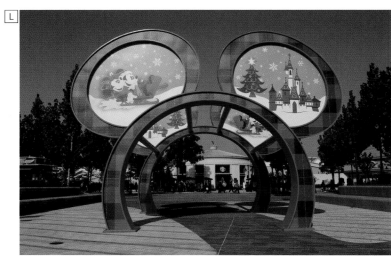

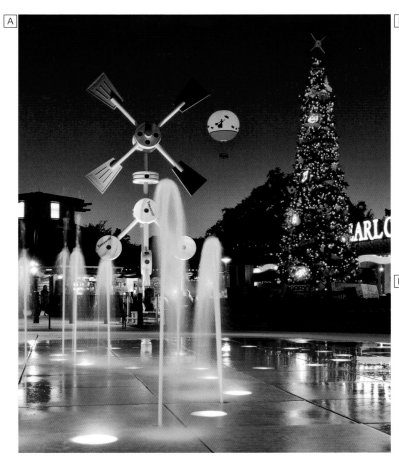

Christmas Tree Trail,
Marketplace, Disney
Springs, Walt Disney World

H Christmas Tree Trail
entrance
2017

I The Little Mermaid *tree*
2018

J Mulan *tree*
2017

K Cinderella *tree*
2017

L Fantasia *tree*
2017

M Tangled *tree*
2017

N One Hundred and One
Dalmatians *tree*
2016

O Dumbo *tree*
2017

P Snow White and the
Seven Dwarfs *tree*
2018

Q Mary Poppins *tree*
2018

*Disney Springs (known as Downtown Disney prior to 2015),
Walt Disney World*

A Marketplace
2009

E Tren-D
2017

BC Marketplace
2016

F World of Disney
2018

D Marketplace
2017

G Disney's Days of Christmas
2017

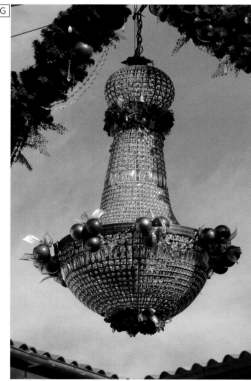

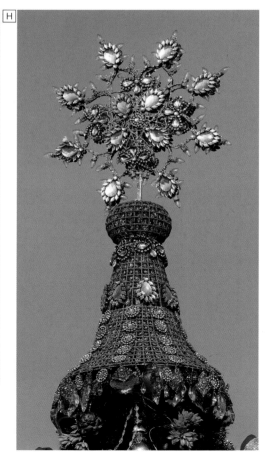

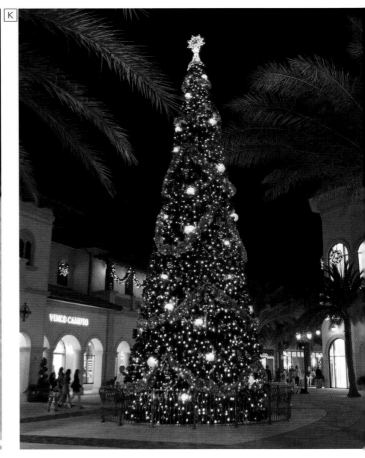

Evoking the Season

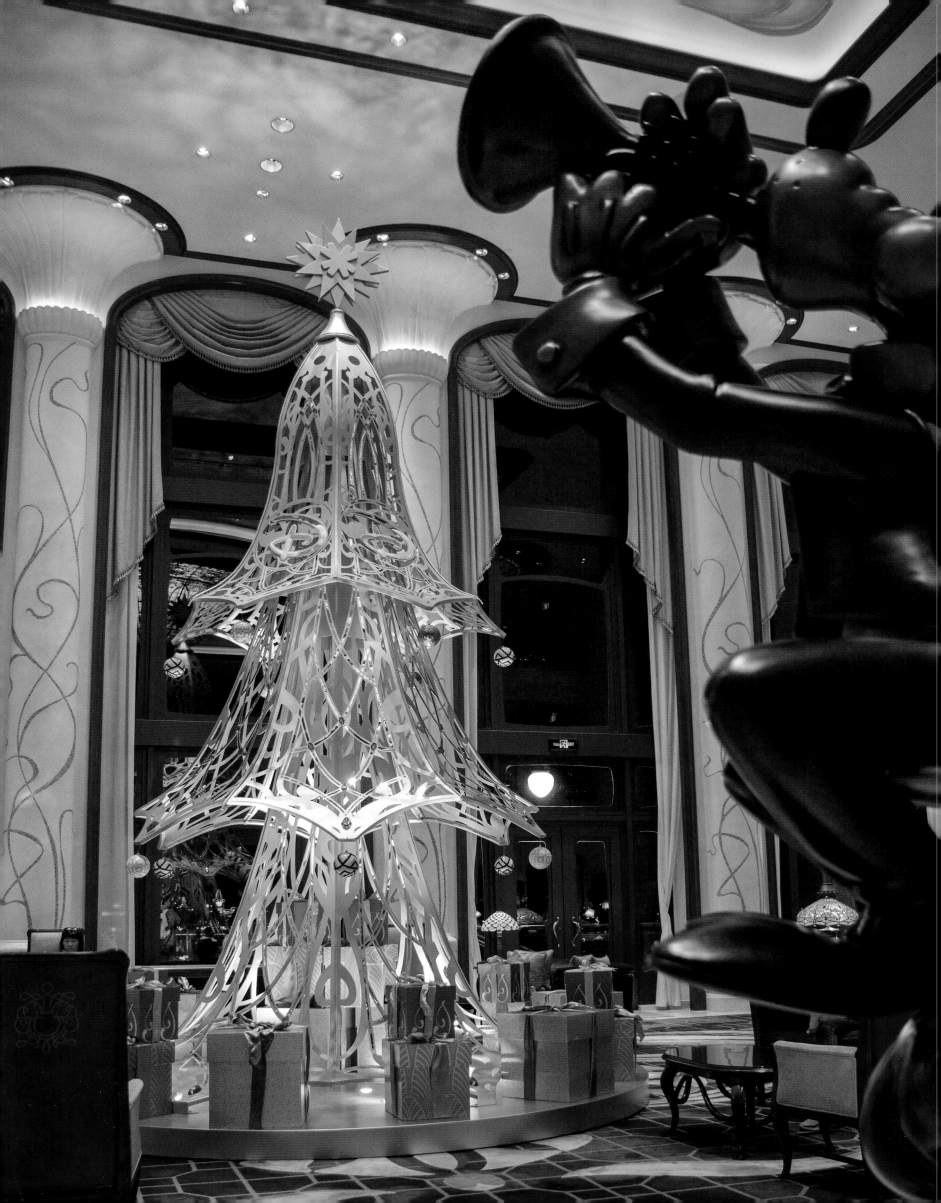

7 Sweet Splendored Dreams

Magical holidays at Disney resort hotels and aboard Disney Cruise Line ships

Decorating Disney resort hotels and Disney Cruise Line ships receives just as much care and attention as do the parks. Each hotel is dressed up for the holidays in ways that reflect its distinctive style or story, and several have established enduring traditions that Guests return to partake in year after year. Driveways approaching a resort hotel may be trimmed with garlands, wreaths, and bows, and surrounding flower beds are filled with poinsettias, but it is inside each property that the fusion of themes and holidays really comes into its own. Protected from the vagaries of weather—a consideration for decorations residing outdoors—and in settings where Guests can study the displays up close, the resorts can showcase intricate ornaments, refined details, and clever craftsmanship.

Delicate flowers adorn the trees and wreaths at Disney's Polynesian Village Resort in Florida and Aulani in Hawaii. At Disney's Art of Animation Resort, there's old-school character sketch art nestling in the paper-white tree branches as well as some cube-shaped ornaments evoking the pixels of today's digital animation process (making square baubles was a new adventure for the ornament suppliers). Retro ornaments, toys, and whimsy are the order of the day at Disney's Pop Century Resort. And each one of Disney's All-Star Resorts showcases its core theme—instruments and musical notes at All-Star Music, bats and balls at All-Star Sports; strips of 35mm film serve as the festive ribbon at the All-Star Movies Resort. Look for eye-catching star-shaped wreaths at all three.

With soaring lobby spaces to welcome Guests, a number of the hotels are able to install impressive trees. Wilderness Lodge, Disney's Animal Kingdom Lodge, and Disney's Grand Floridian Resort & Spa at Walt Disney World, as well as Disney's Grand Californian Hotel & Spa at the Disneyland Resort, all erect striking and distinctively decorated holiday trees. The Grand Californian's American Craftsman architecture is reflected in the decor, which features mica lanterns, woodcut art, and leaping stags atop the tree. Wilderness Lodge uses Native American crafts, miniature tepees, and an occasional antler to dress up trees and garlands throughout the property, while

Shanghai Disneyland Hotel 2017

Disney's Animal Kingdom Lodge turns to traditional handcrafts from many parts of the African continent. The Grand Floridian's earliest lobby trees were fashioned from colorful spirals of poinsettia flowers. Nowadays the look is more traditional, and it is on this extravagant, forty-five-foot-tall specimen that Guests will find some of the most exquisite and elegant ornaments: feathery swans and delicate birdcages.

Another Disney World property blessed with an expansive atrium, Disney's Contemporary Resort, erected an unusual, futuristic, green metallic tree for its first holiday season in 1971. Later, during the 1990s, a hot air balloon filled the north half of the Grand Canyon Concourse for the holidays, and for several years the white lights dotting the building's exterior were changed to a seasonal red and green. The Contemporary likes to do things on an impressive scale, too. From 2009 to 2013 the north end of the building's characteristic A-frame structure sported an immense Mickey-shaped wreath (with a twenty-five-foot diameter circle and ears measuring thirteen by eighteen feet). At seventy feet tall, the Contemporary's main Christmas tree comes in as the tallest of all at Walt Disney World; it has the largest tree topper, too: a five-foot-high star. Placed on the main promenade in front of the resort and decorated with forty thousand lights, this tree is a grand sight for passengers aboard the many buses plying World Drive between the Magic Kingdom and points all around Walt Disney World.

Hotels with a more intimate lobby setting are just as conscious and thoughtful about the holiday scene and ambience that they are setting. Disney's Yacht and Beach Club Resorts at Walt Disney World are particularly notable for the detailing that goes into their decorations—a tree "swimming" in sea life (fish, seashells, starfish, and turtles) at the Beach Club, and a shipshape flotilla of boats and watercraft models throughout the Yacht Club. *Beach*-iness is, naturally, the order of the day aboard the Disney Cruise Line ships, too, and at Castaway Cay—where life preservers become wreaths and tropical climes mean "snowmen" are fashioned from sand.

At the Fort Wilderness Resort and Campground, the official decorations are a down-home mix of plaid and handcrafts (look for little pairs of mittens nestled among the greenery). But Disney's own decorations are just part of the story here, for Guests themselves mount the most extraordinary spectacles: their tents and trailers this time of year seeming to disappear behind remarkable displays of lights, garlands, and inflatable lawn art. The Fort Wilderness Cast is happy to encourage this—organizing friendly decorating contests and even a parade of festively trimmed golf carts. The time and energy which goes into creating these displays reflect a touching passion for the holidays and for Disney, though we do wonder how some of these Guests manage to fit everything into their vehicles and bring it all here in the first place!

Other resorts may not offer the space for expansive inflatable displays, but Guests commonly trim hotel rooms with their own sparkle and cheer. Disney Vacation Club properties are the most noticeably festooned, as families bring the holidays to their home away from home. At some resorts, the Disney florist can help Guests enhance their room, while others offer packages that set up festive lights and trimmings in advance.

All of the resorts at Disneyland Paris get into the seasonal spirit with cleverly themed decor: cowboy boots and hats at Hotel Cheyenne; sombreros and chili peppers at Hotel Santa Fe; a rustic, woodsy charm at Sequoia Lodge; and a distinctly nautical motif at Newport Bay Club. Grandest of all, of course, is the Disneyland Hotel, decorated with an eye to the finer things of a traditional Victorian Christmas; there's two impressive trees—one in the main lobby where Guests enter and check in, and another in the central atrium of the main building.

At the Tokyo Disney Resort, perhaps the most impressive of the hotel displays awaits at the Disney Ambassador Hotel, where the entire driveway and garden area comes alive with a shimmering light show each evening. On a smaller scale, the Disney Resort Cruiser bus fleet, ferrying Guests between points all across the resort, adds wreaths and ornaments—amusingly, even a tiny little wreath around each bus's tail (yes, the buses have mouse tails!). The Shanghai Disneyland Hotel erects a stylish and stylized gold tree, reflecting the art nouveau sophistication of its expansive lobby. And over at the Hong Kong Disneyland Resort, each hotel decorates with an emphasis on its particular theme. For instance, steamer trunks and suitcases instead of presents are placed underneath the main tree at the Disney Explorers Lodge.

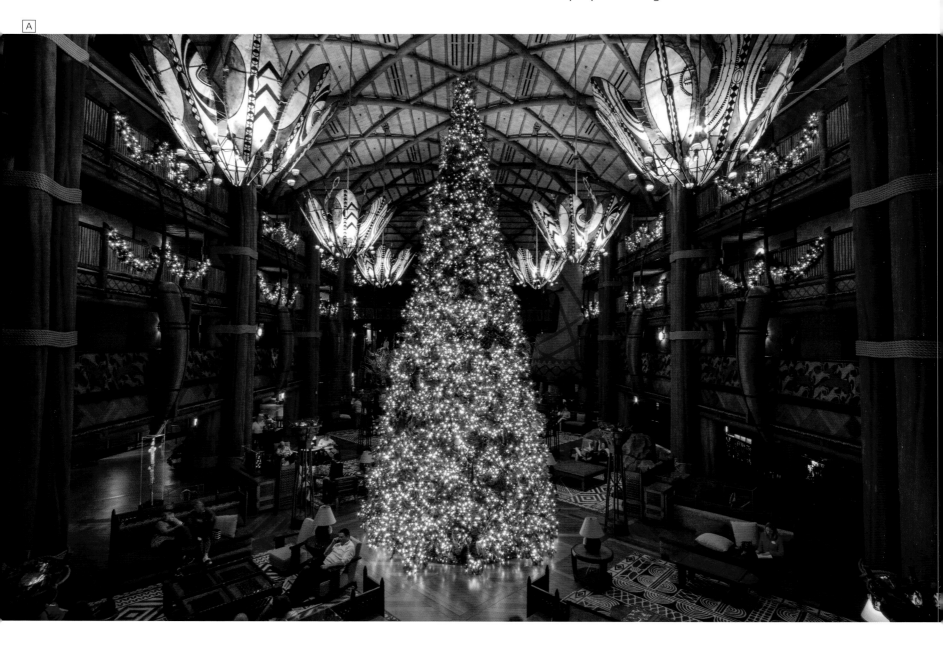

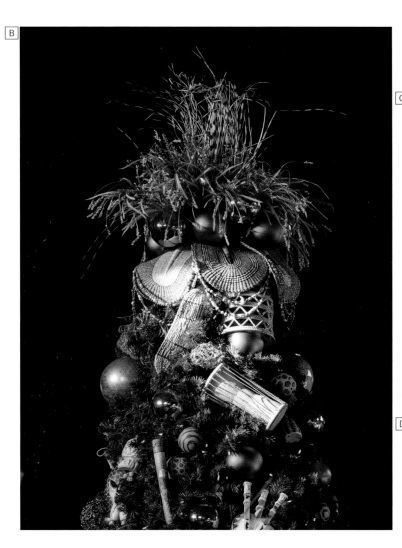

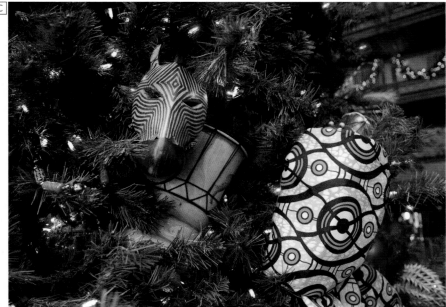

Disney's Animal Kingdom Lodge, Walt Disney World

A *Jambo House lobby*
 2018

B *Jambo House, main tree topper*
 2017

C *Jambo House, main tree detail*
 2017

D *Jambo House, Boma restaurant*
 2017

E *Kidani Village, lobby tree detail*
 2017

F *Jambo House, Zawadi Marketplace*
 2017

G *Kidani Village, lobby tree detail*
 2017

H *Jambo House, Zawadi Marketplace*
 2018

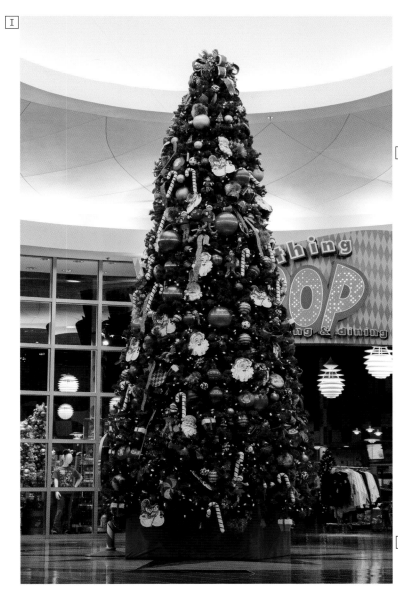

Art of Animation Resort,
Walt Disney World

A *Animation Hall tree*
 2012

B *Ink & Paint Shop*
 2017

C *Animation Hall tree*
 2017

D *Animation Hall*
 tree detail
 2017

E F *Front desk*
 2017

Pop Century Resort,
Walt Disney World

G *Classic Hall*
 2012

H *Everything POP*
 2017

I *Classic Hall tree*
 2018

J K *Classic Hall*
 tree detail
 2017

L *Classic Hall*
 tree detail
 2018

Caribbean Beach Resort, Walt Disney World

A *Old Port Royale 2018*

B *Banana Cabana 2018*

C D *Old Port Royale 2018*

E *Centertown Market 2018*

F *Old Port Royale 2018*

G *Custom House 2017*

H *Aruba village 2017*

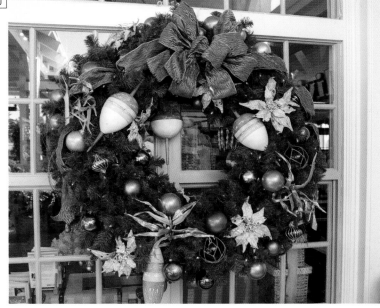

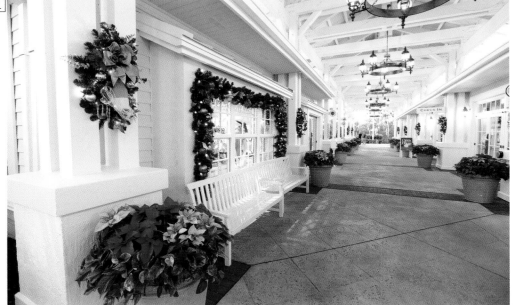

*Old Key West Resort,
Walt Disney World*

I *Marina*
2017

J *Olivia's Cafe*
2017

K *Hospitality House
tree detail
2018*

L *Main breezeway
2012*

M *Conch Flats General Store
2017*

N *Hospitality House
2012*

O P *Hospitality House
tree detail
2017*

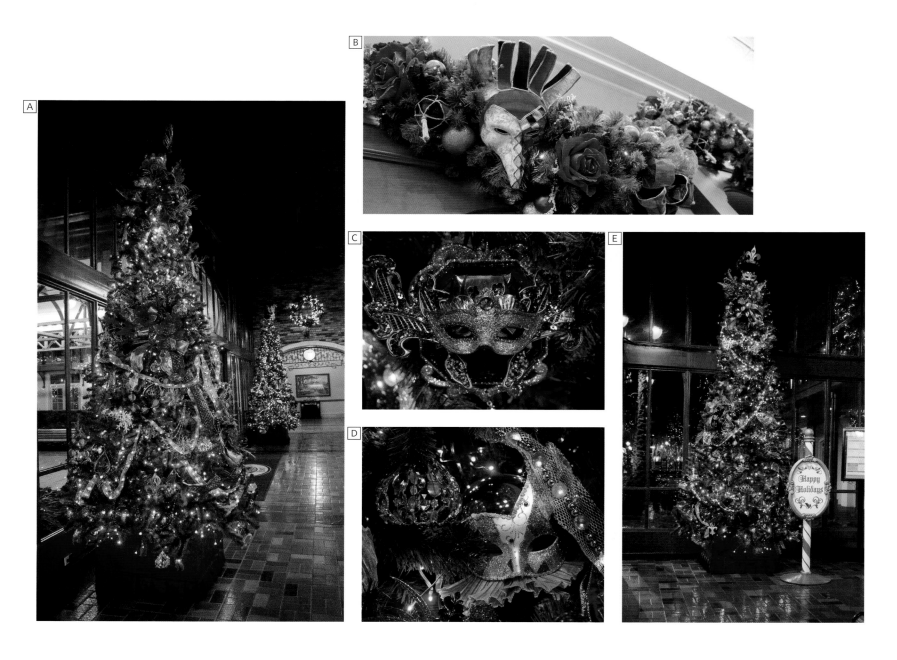

Holiday Magic at the Disney Parks

Port Orleans Resort–French Quarter, Walt Disney World

- [A] *Main Lobby*
 2018

- [B] *Jackson Square Gifts and Desires*
 2017

- [C][D] *Main lobby tree detail*
 2018

- [E] *Main Lobby*
 2018

Port Orleans Resort–Riverside, Walt Disney World

- [F] *Fulton's General Store*
 2017

- [G] *Main lobby*
 2018

- [H] *Main lobby tree*
 2017

- [I] *Fulton's General Store*
 2017

- [J] *Boatwright's Dining Hall*
 2017

Saratoga Springs Resort & Spa, Walt Disney World

- [K] *Main lobby tree*
 2017

- [L] *The Artist's Palette*
 2017

- [M] *Main lobby*
 2012

- [N] *The Turf Club Bar and Grill*
 2018

- [O] *The Turf Club Bar and Grill*
 2017

- [P] *The Artist's Palette*
 2018

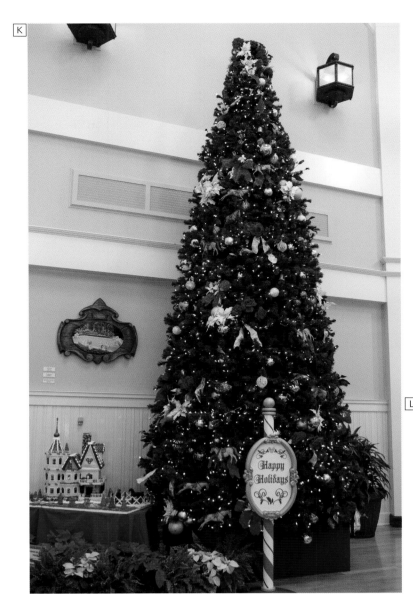

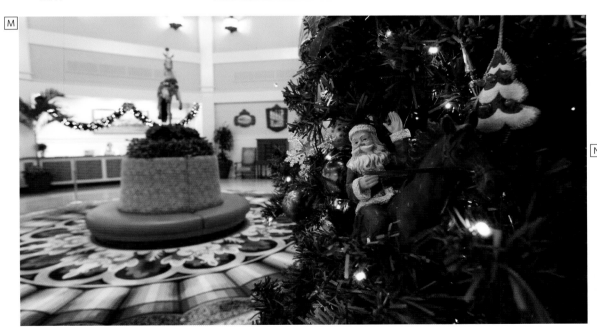

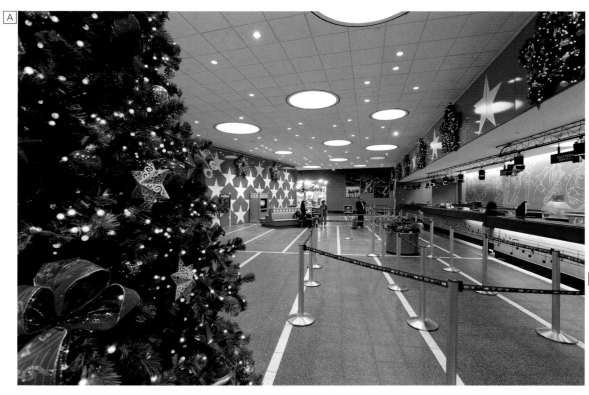

All-Star Music Resort,
Walt Disney World

A B Main lobby
2012

C Maestro Mickey's
2017

D E Main lobby tree detail
2018

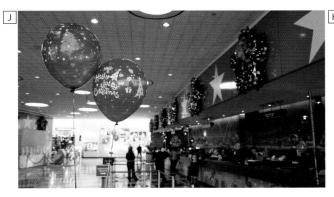

*All-Star Movies Resort,
Walt Disney World*

F *Cinema Hall
2017*

G *Main lobby
2012*

H *Cinema Hall
2017*

I *World Premiere Food
Court
2018*

J *Main lobby
2017*

K *Donald's Double
Feature
2017*

*All-Star Sports Resort,
Walt Disney World*

L *Main lobby tree
2018*

M *Stadium Hall
2018*

N *Sport Goofy Gifts and
Sundries
2017*

O *Main lobby tree detail
2017*

P *Main lobby
2018*

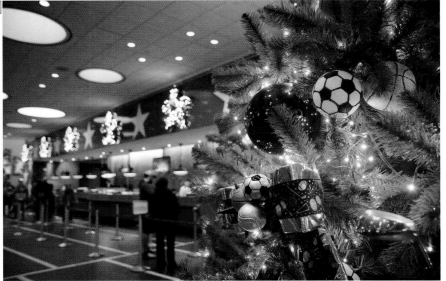

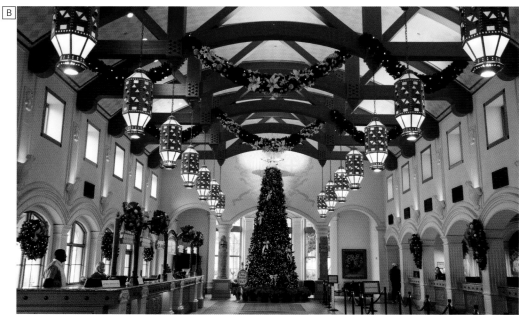

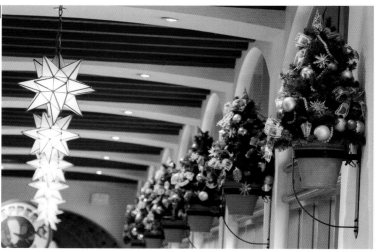

Coronado Springs Resort, Walt Disney World

A Main tree topper 2018

B Main lobby 2017

C Main lobby 2018

D Panchito's Gifts 2017

E El Centro 2017

F Barcelona Lounge tree 2019

G Gran Destino Tower lobby 2019

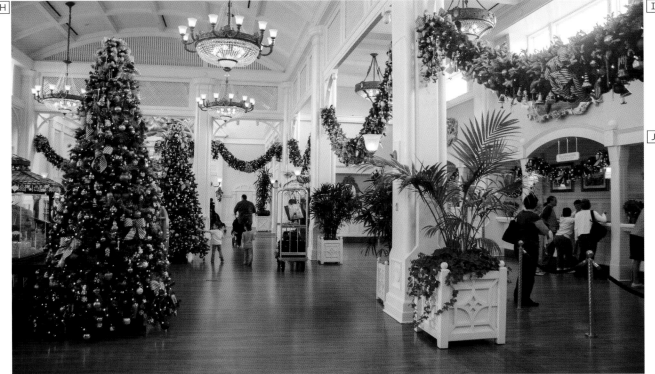

BoardWalk Inn and
Villas, Walt Disney World

Main lobby

H 2009

I J 2017

K 2018

L M 2017

N 2012

Exterior

O Village Green
2005

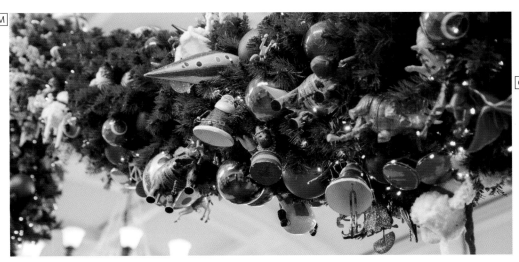

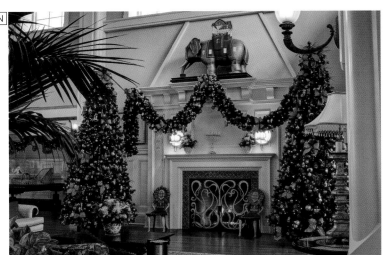

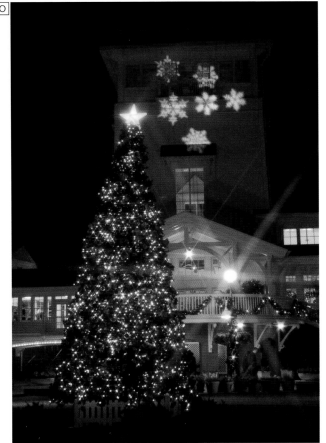

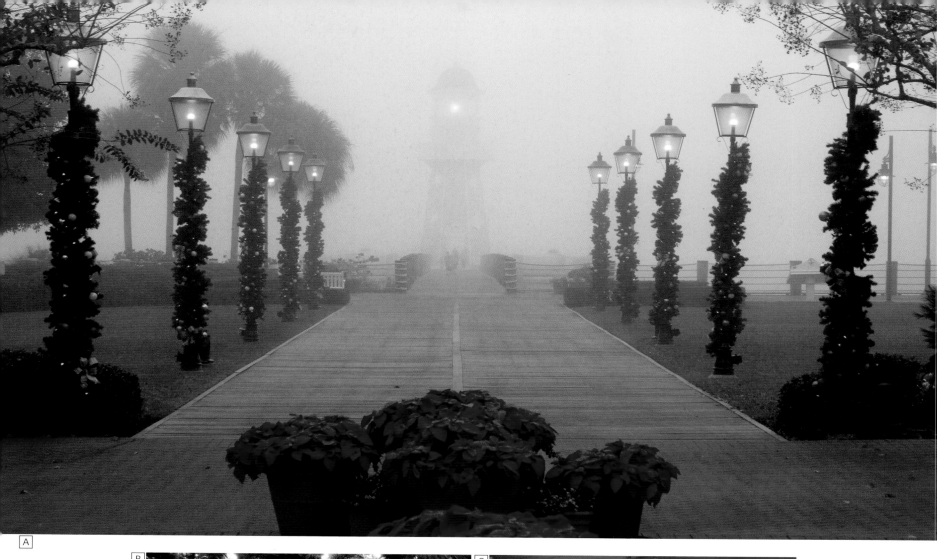

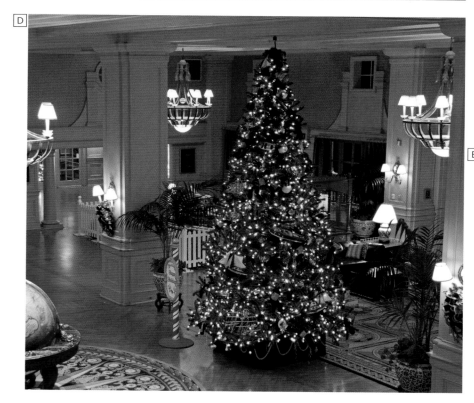

Yacht Club Resort, Walt Disney World

A Towards the dock
2016

B Main lobby tree detail
2016

C D Main lobby
2016

E The Market at Ale &
Compass
2017

Beach Club Resort, Walt Disney World

F Main lobby
2009

G Lobby tree detail
2009

H Lobby tree detail
2016

I Beach Club
Marketplace
2017

J Lobby tree detail
2016

K Beaches & Cream
2017

L Gardens
2009

M Beach Club Villas
2017

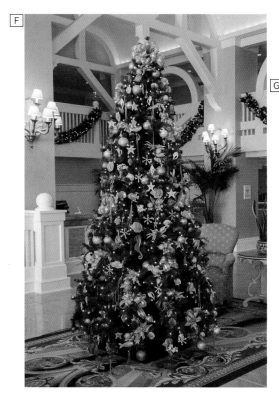

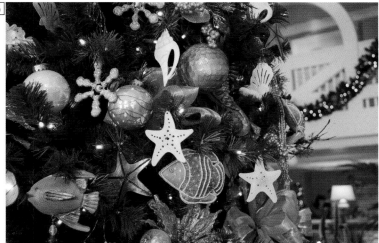

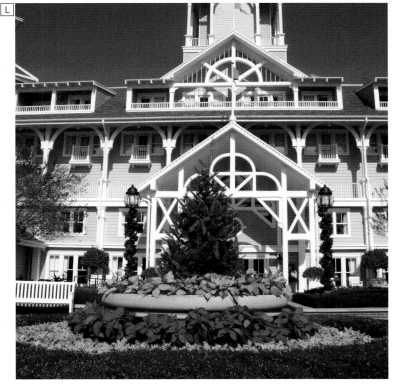

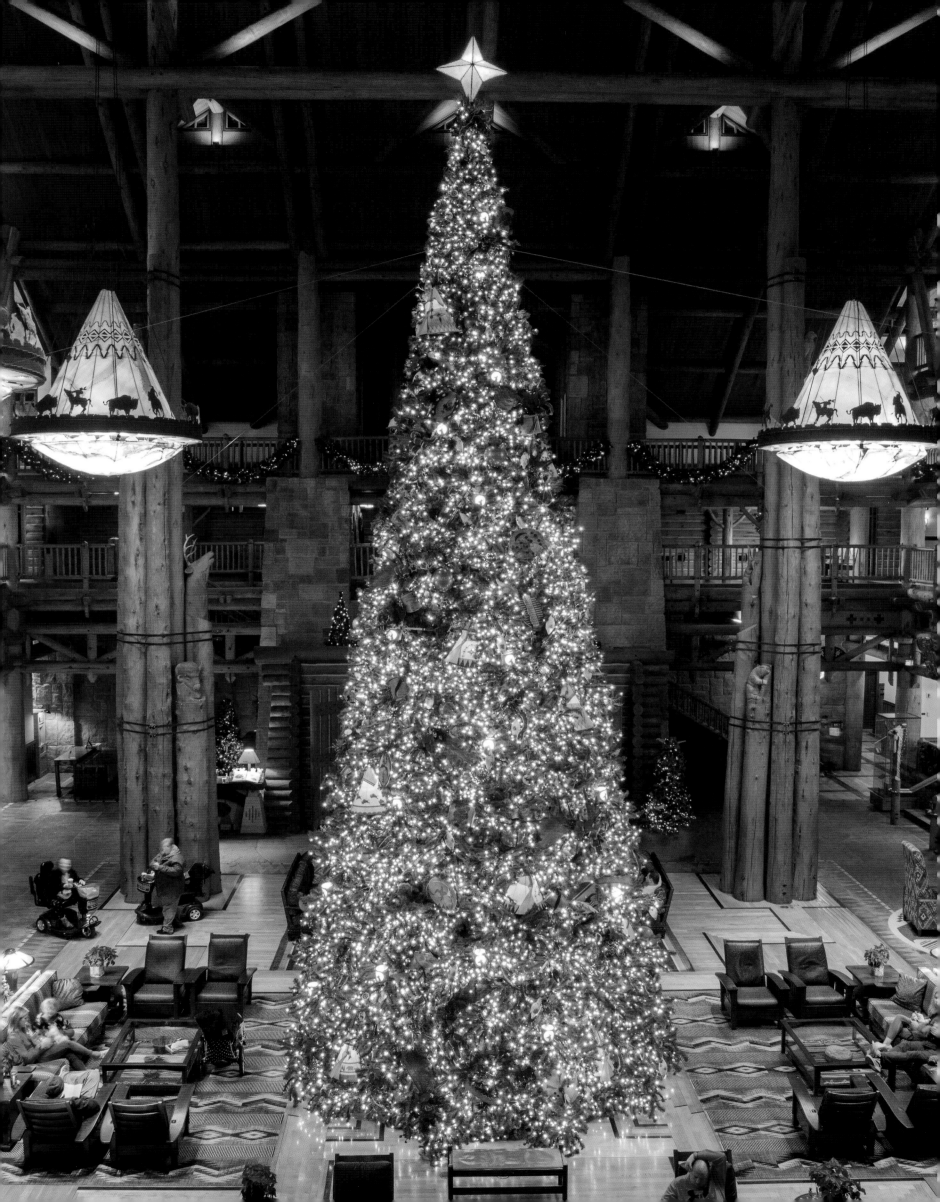

Wilderness Lodge,
Walt Disney World

◄ *Main lobby*
2018

A B *Territory Lounge*
2017

C D *Main lobby*
2017

E *Lobby balcony*
2018

F *Wilderness Lodge*
Mercantile
2017

G *Main tree detail*
2018

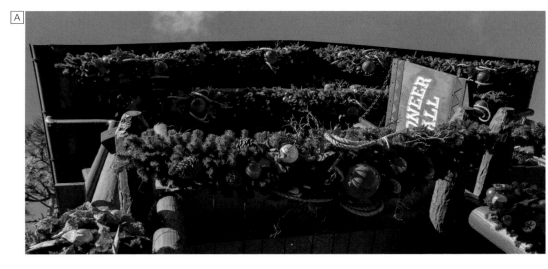

Fort Wilderness Resort and
Campground, Walt Disney World

A *Pioneer Hall*
2018

B *Main tree, Settlement area*
2018

C D *Crockett's Tavern*
2012

E *Main tree, Settlement area*
2018

F G *Settlement Trading Post*
2017

H *Main tree, Settlement area*
2017

I *Guest campsite*
2009

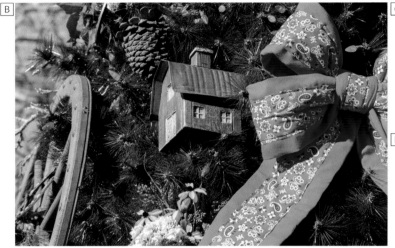

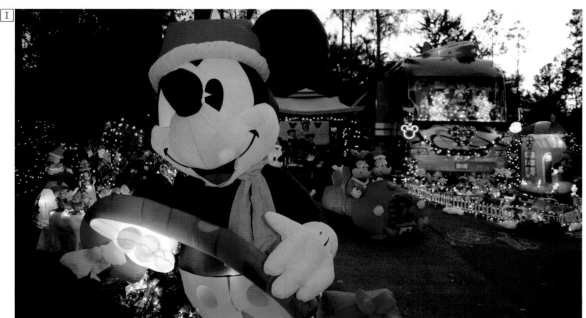

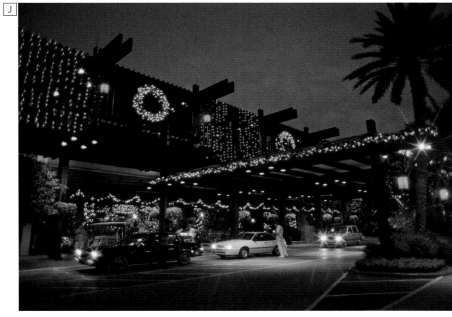

*Polynesian Village Resort,
Walt Disney World*

J Port Cochère
 1988

K Monorail and palms
 1988

L Great Ceremonial House
 2012

M Marina
 2017

N Great Ceremonial House
 2016

O Main lobby tree detail
 2016

P BouTiki shop
 2017

*Shades of Green,
a military-owned
resort within Walt
Disney World*

Q Main driveway
 2018

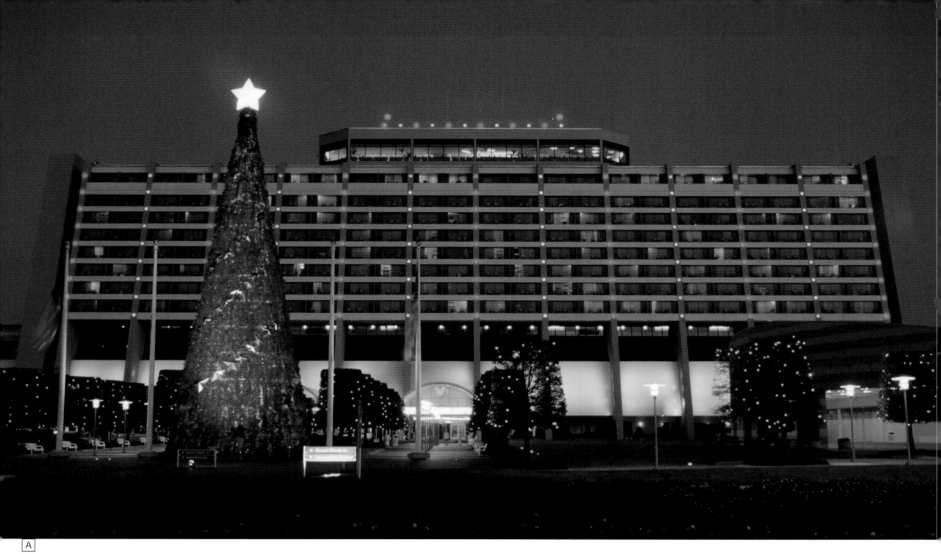

Contemporary Resort,
Walt Disney World

A *View from World Drive*
 1995

B *Grand Canyon
 Concourse*
 1989

C *Main lobby*
 1995

D *Jolly Holidays
 Dinner Show*
 1992

E *World's largest
 Mickey wreath!*
 2009

F *Ballroom foyer*
 2018

G *Contempo Cafe*
 2018

H *Front desk*
 2017

I *Bay Lake Tower lobby*
 2018

J *Bay View Gifts*
 2017

K *View from World Drive*
 2017

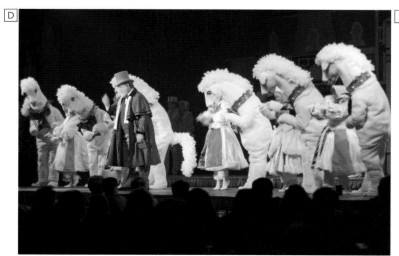

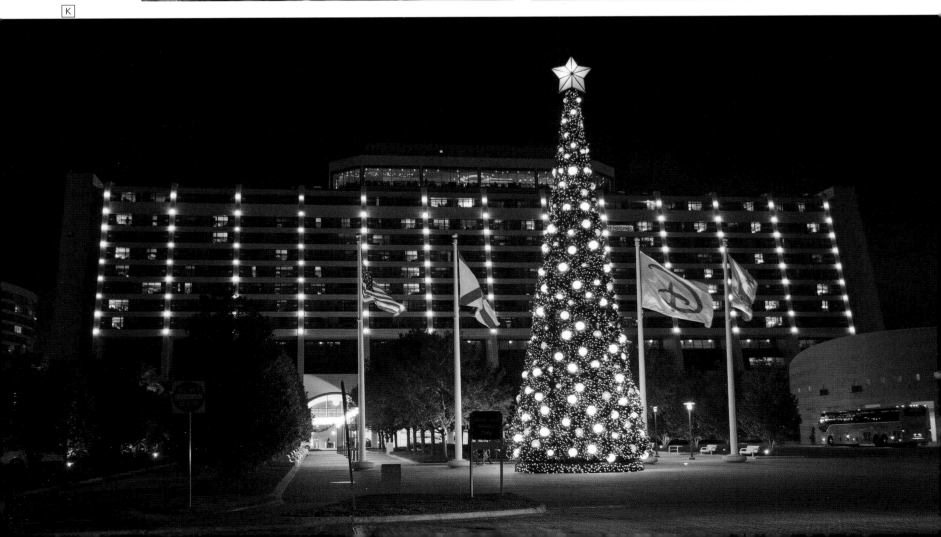

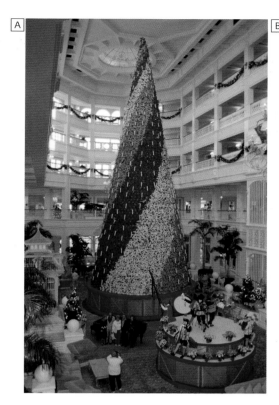

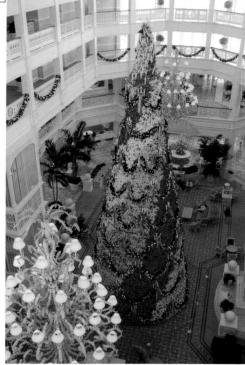

Grand Floridian Resort & Spa, Walt Disney World

[A] *Main lobby*
1988

[B] *Main lobby*
1992

[C] *Grand Staircase*
2017

[D] *Main lobby*
2016

[E] *Main tree detail*
2016

[F] *Main entrance area*
2009

Main lobby ▶
2018

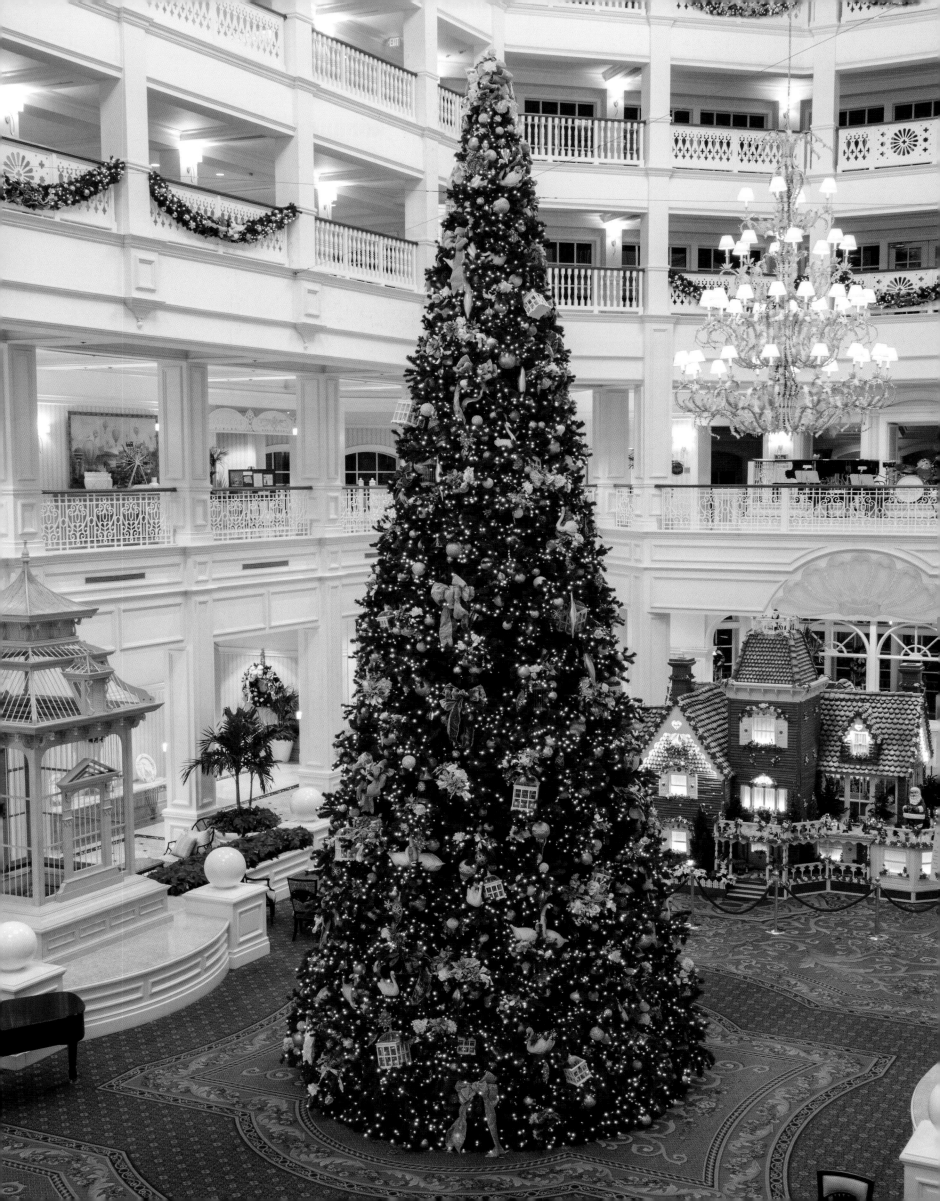

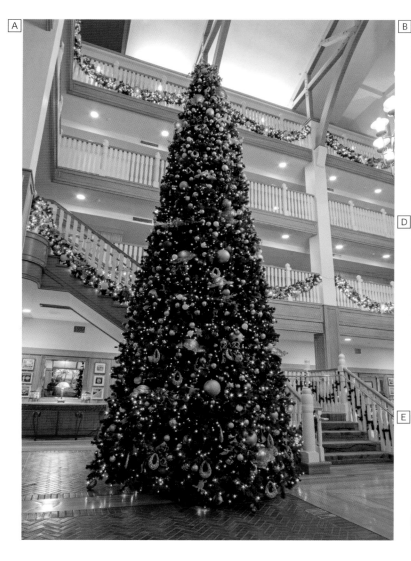

Vero Beach Resort

A Main lobby
2018

B Main building
2018

C Island Grove
Packing Company
2018

D Lobby tree detail
2018

E Main lobby
2018

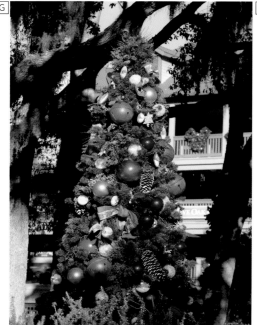

Hilton Head Island Resort

F G Live Oak Lodge
2018

H Big Murggie's Den
2018

I Community Hall
2018

J K Big Murggie's Den
tree detail
2018

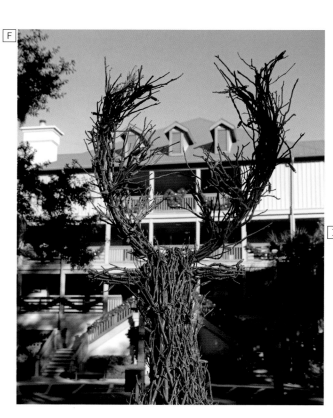

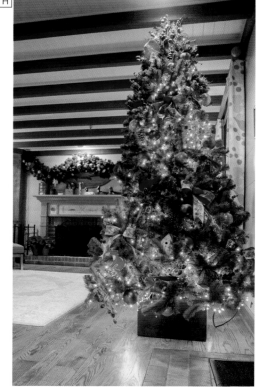

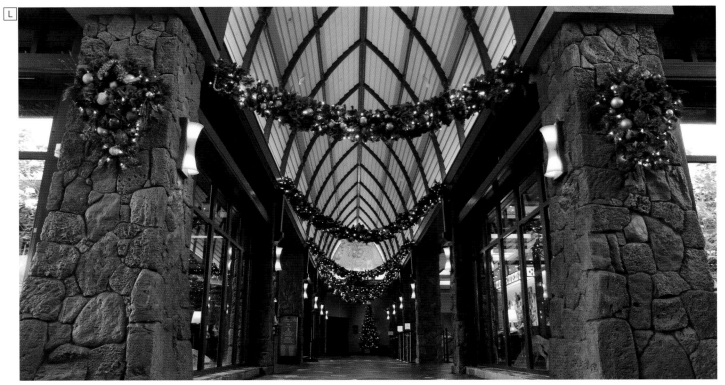

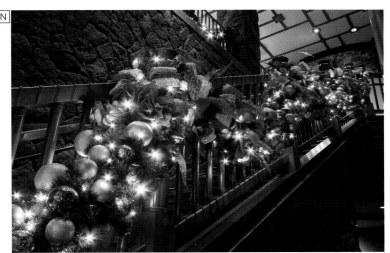

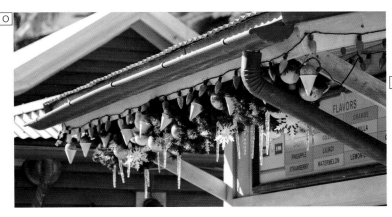

Aulani

L M *Main lobby*
2018

N *Main staircase*
2018

O *Papalua Shave Ice*
2018

P *Aunty's Beach House*
2018

Q *'AMA'AMA – Contemporary
Island Cooking*
2018

R *The Lava Shack*
2018

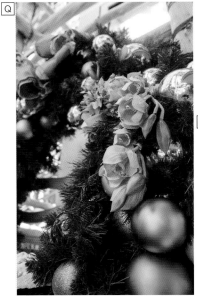

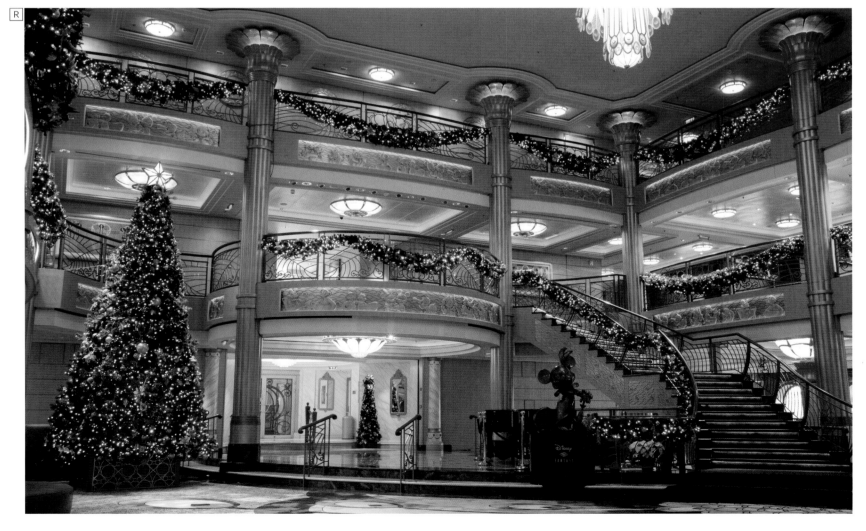

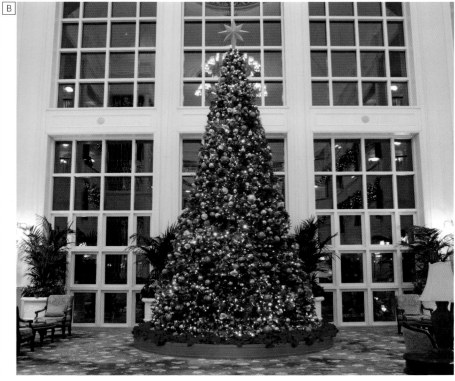

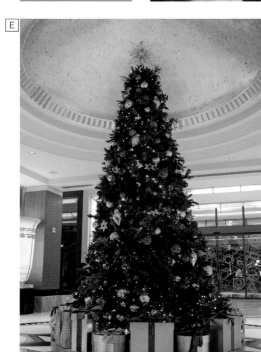

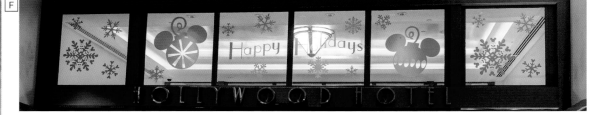

Hong Kong Disneyland Hotel

A B Grand Salon
2018

C Guest room door
2018

D Conference Center
2018

Hollywood Hotel, Hong Kong Disneyland Resort

E Main lobby
2018

F Main entrance area
2017

Disney Explorers Lodge, Hong Kong Disneyland Resort

G H Main lobby tree
2018

I Front desk
2018

J Main lobby tree
2018

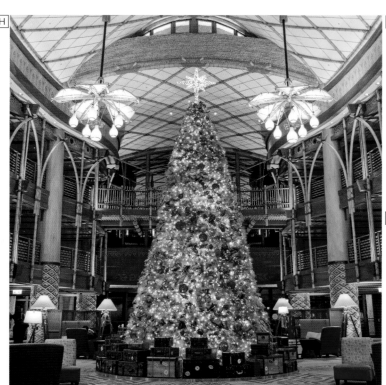

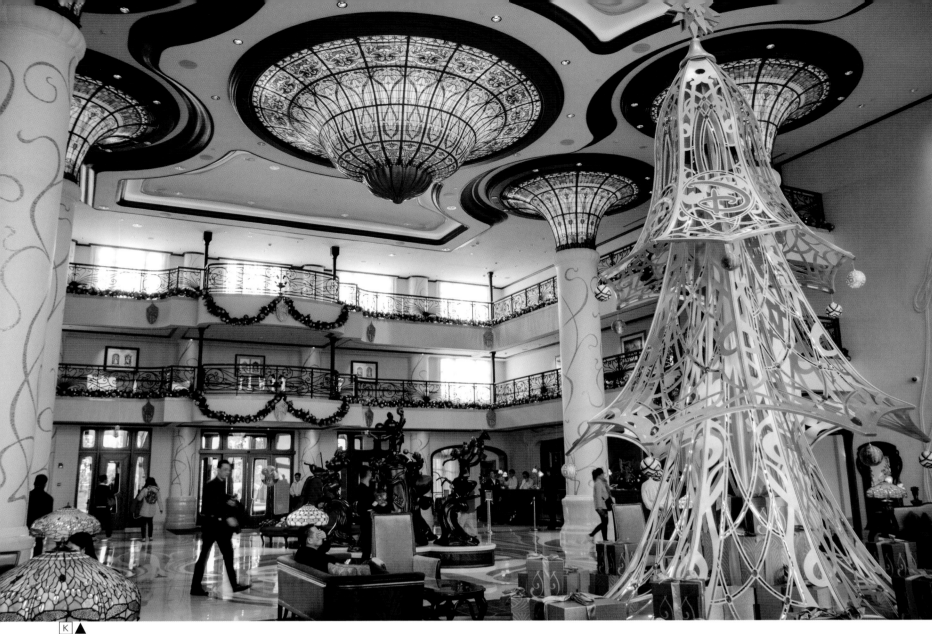

Shanghai Disneyland Hotel

K *Main lobby*
2017

L M *Lobby tree detail*
2017

N *Magic Kingdom Club*
2017

O *Main lobby*
2017

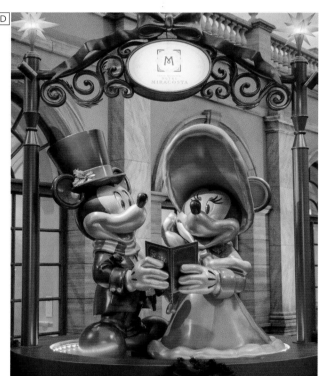

Disney Ambassador Hotel, Tokyo Disney Resort

A B *Main driveway 2017*

C *Tick Tock Diner 2018*

Tokyo Disney Celebration Hotel

G *Wish lobby 2018*

H *Discover lobby 2018*

Hotel Miracosta, Tokyo Disney Resort

D *Main entrance area 2018*

E *Banquet lobby 2018*

F *Main lobby 2017*

Tokyo Disneyland Hotel

 I *Disney Mercantile*
 2018

 J K L *Main lobby*
 2017

*Disney Resort Cruiser shown at
the Disney Ambassador Hotel,
Tokyo Disney Resort*

 M *Exterior overview*
 2017

 N *Roof ornament detail*
 2018

 O *Front detail*
 2017

 P *Rear detail*
 2017

Disneyland Hotel, Disneyland Paris

A B Main lobby
2017

I Fantasia Gardens
1993

C Holiday package
Guest room
2017

D E Café Fantasia
2017

Hotel New York,
Disneyland Paris

F G Main Street
Lounge
2017

J Holiday package
Guest room
2014

H Main corridor
2017

K L Rockefeller Plaza
2017

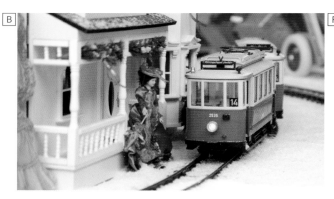

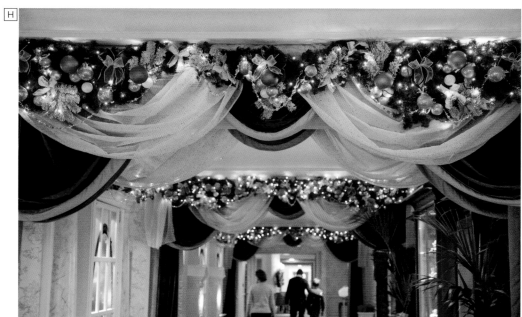

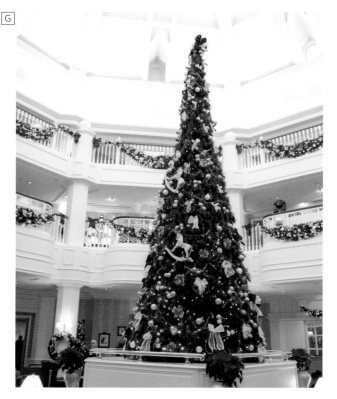

Holiday Magic at the Disney Parks

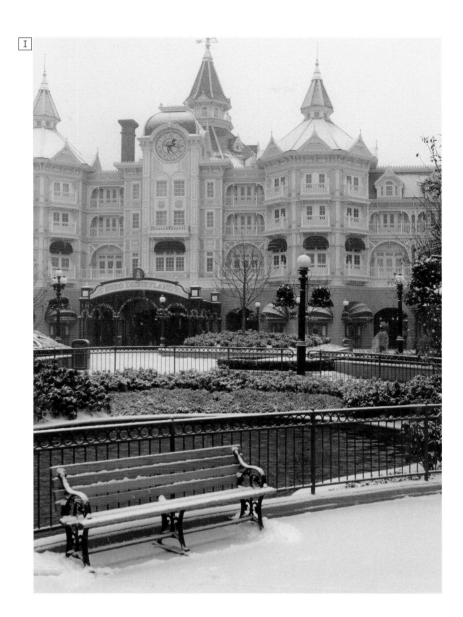

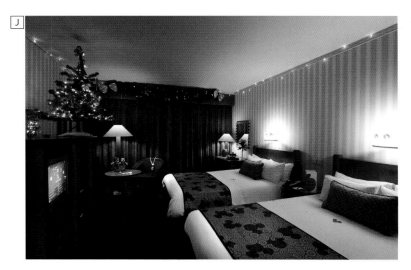

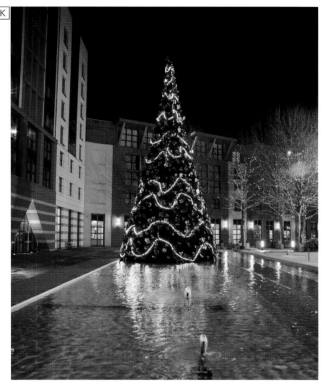

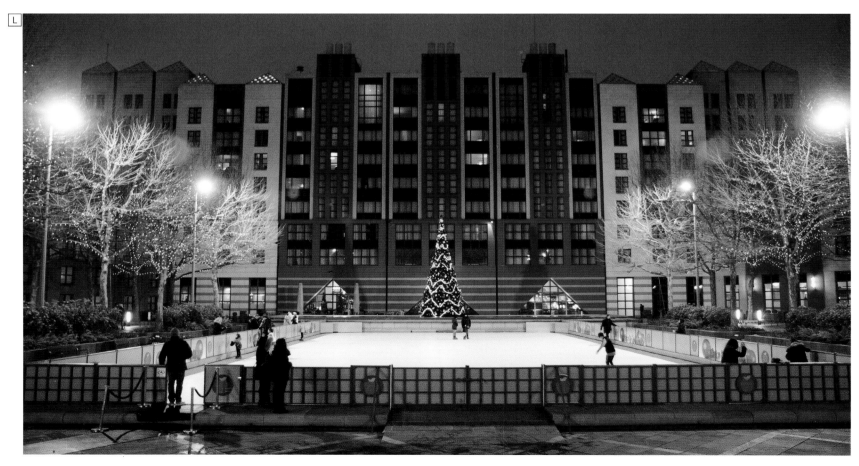

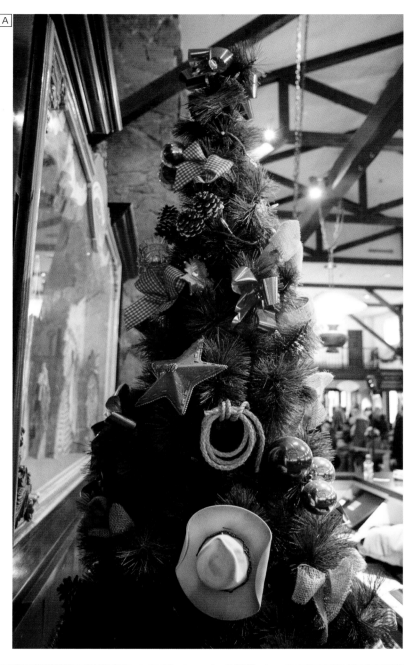

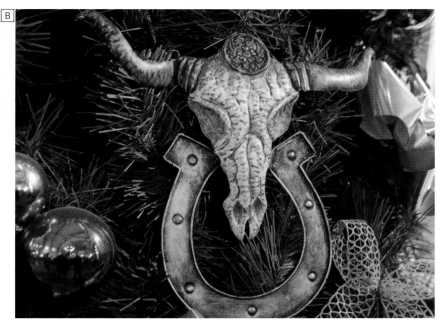

Hotel Cheyenne,
Disneyland Paris

[A] *Main lobby*
2017

[B] *Lobby tree detail*
2017

[C] *Main lobby*
2017

Hotel Santa Fe,
Disneyland Paris

[D] *Main lobby*
2017

[E] *Main building*
2017

Newport Bay Club,
Disneyland Paris

F *Yacht Club restaurant*
 2017

G *Captain's Quarters lounge*
 2017

H I *Main lobby*
 2017

Sequoia Lodge,
Disneyland Paris

J *Main lobby*
 2017

K *Front desk*
 2017

L *Hunter's Grill restaurant*
 2017

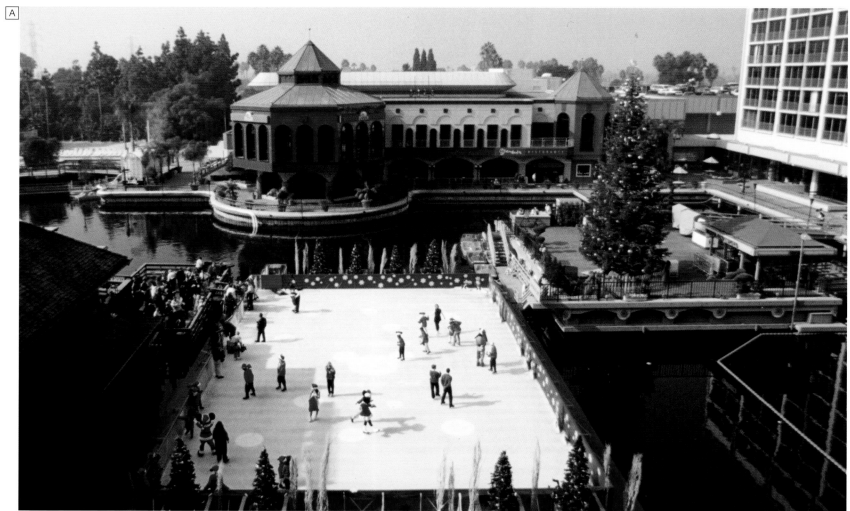

Disneyland Hotel

[A] *Holiday Harbor*
1995

[B] *Michelle Kwan, as Pocahontas, opens the Holiday Harbor ice rink*
1995

[C] *Porte-cochère*
2018

[D] *Candy Cane Lane*
1992

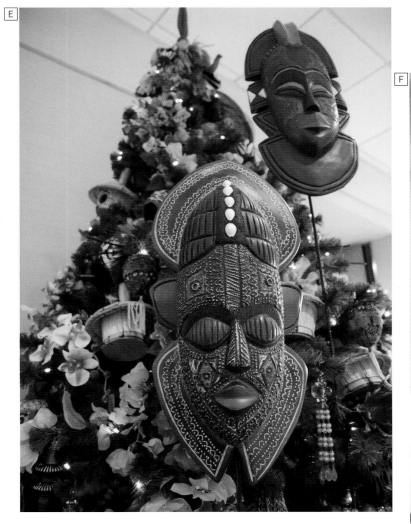

Disneyland Hotel

E Adventure Tower lobby
 2017

F Fantasy Tower lobby
 2017

G Frontier Tower lobby
 2017

H Goofy's Kitchen foyer
 2018

I Fantasy Tower lobby
 2016

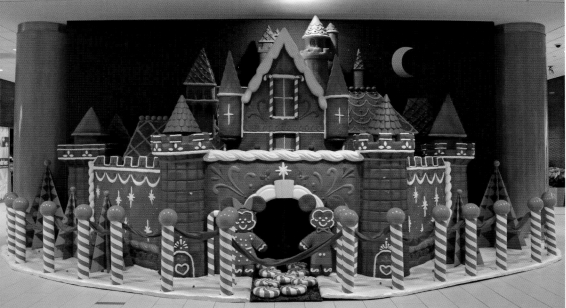

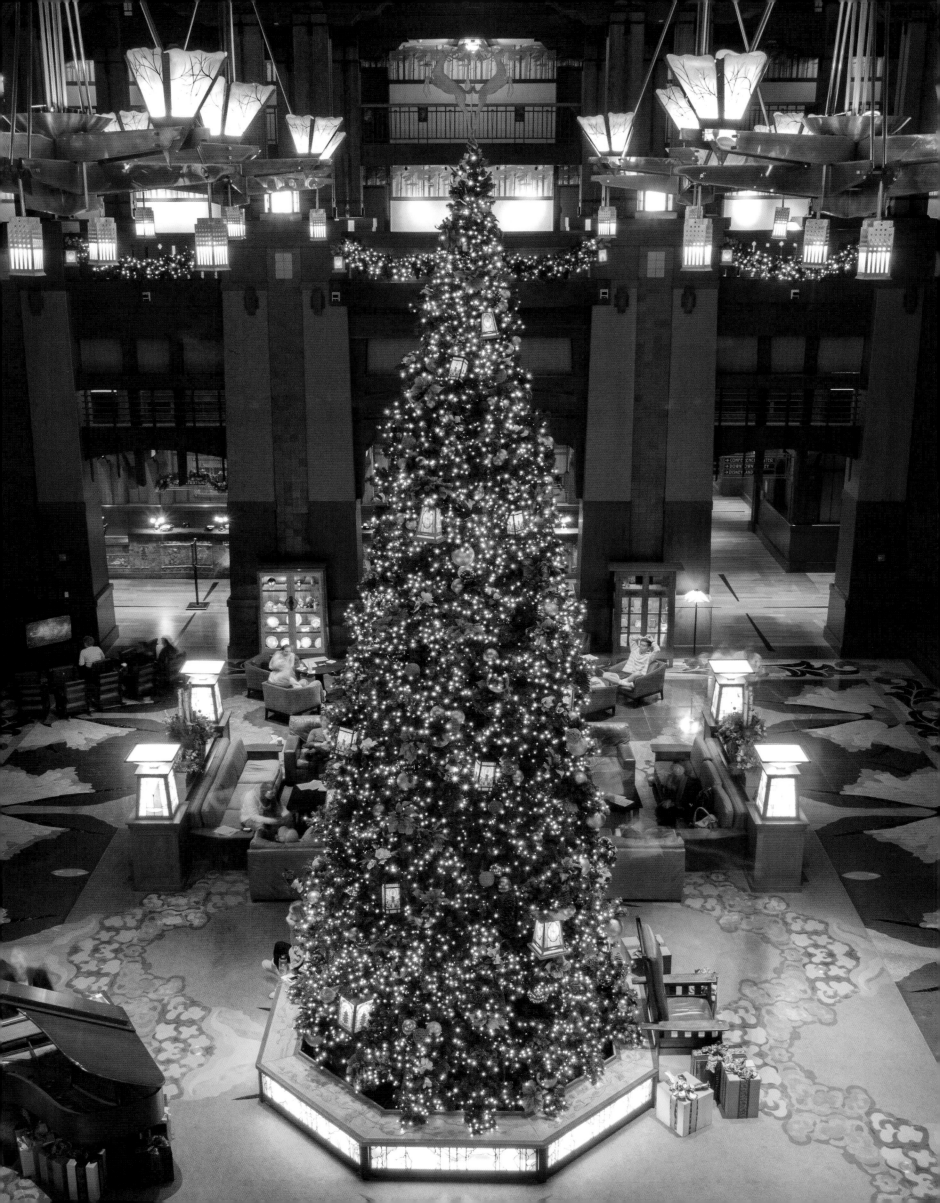

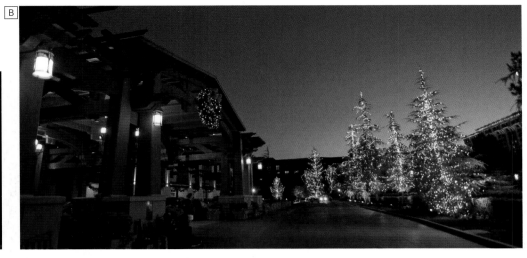

Grand Californian Hotel & Spa, Disneyland Resort

A *Great Hall*
2018

B *Main entrance area*
2011

C *Disneyland Drive gate*
2018

D *Great Hall tree detail*
2017

E *Great Hall tree topper*
2017

F *Main entrance area*
2011

G *Hearthstone Lounge tree topper*
2017

H *Holiday package Guest room*
2018

I *Great Hall*
2014

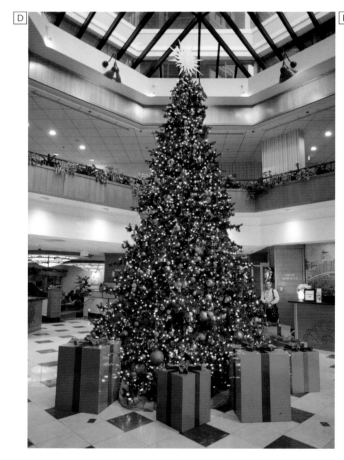

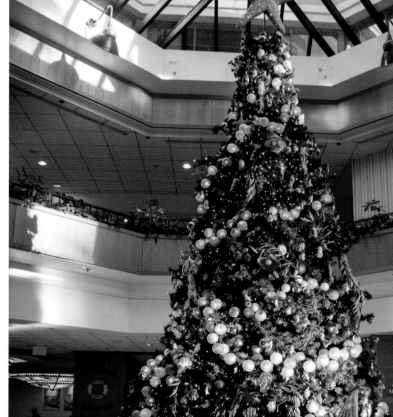

*Paradise Pier Hotel,
Disneyland Resort*

Main lobby tree

A B C *2017*

D *2011*

E *2017*

Beyond simply hanging decorations, the environment of a hotel—which by nature is less crowded and perhaps less frenzied than one of the parks—lends itself to providing wonderful seasonal experiences, too. During the 1980s and early 1990s the Disneyland Hotel created Candy Cane Lane along the east side of the Sierra Tower (now named Adventure Tower)—a holiday village for shopping and snacking with a pint-size Toyland railroad to ride. And from 1995 to 1997 an ice rink was set up in the hotel's central marina. These ideas have returned nearby in recent years, with Olaf's Frozen Ice Rink debuting in the shadows of the Adventure Tower in 2012, surrounded by the colorful chalets of the Downtown Disney Winter Village. And a skating rink was the winter centerpiece at Hotel New York in Disneyland Paris, evoking the iconic scene from Rockefeller Center (with the hotel's Midtown skyscraper facade as a backdrop).

During the 1990s, many of the resorts at Walt Disney World served punch or chestnuts and hosted storytellers each evening during the holiday season; the sounds of live music/entertainment also filling resort lobbies at this time of year—a tradition which continues to this day. Entertainment can also be on a grand scale—presented as the Joyous Celebration in 1991 and then as the Jolly Holidays Dinner Show Spectacular from 1992 to 1998, a one-hundred-strong cast of characters and performers along with an all-you-can-eat holiday feast took over the Contemporary's vast Fantasia Ballroom.

Back in Anaheim, there's a special nostalgia for the Fantasy Waters show, which was retired in 2007. Originally called Dancing Waters, the show was first created all the way back in 1952 and had been presented in Berlin, London, New York, and many Western US cities before finding a permanent home at the Disneyland Hotel in 1970. The Christmas version of the show featured well-known carols of the season and narration by the longtime voice of Disneyland and Disney Legend Jack Wagner.

Around Walt Disney World, elaborate gingerbread displays are among the most unforgettable resort holiday presentations Guests experience. Fashioning gingerbread into shapes and figures has been a custom for hundreds of years, and the building of gingerbread model houses can be traced back at least to the early 1800s when the fairy-tale "Hansel and Gretel" popularized the idea. Modest gingerbread houses have been part of Disney's seasonal decor for many years. However, the love for such displays kicked into high-gear in 1999, when the Grand Floridian's executive pastry chef, Erich Herbitschek, along with his team of Culinary and Scenic Services artists, launched the tradition at Disney of creating truly mammoth, spice-

infused spectacles. Each resort plans its own display, and all the baked elements that go into them are made fresh each year—a process that can start as early as June. The designs incorporate all sorts of Disney characters and traditional holiday elements, generally reflecting the theme of the resort itself, too: at the Contemporary, for example, the figures have often been inspired by the Mary Blair murals gracing the main atrium, and the miniature buildings in the Yacht Club's winter village are named for the resort's own restaurants and shops.

Best-known, and perhaps most fondly remembered, are the Beach Club carousel and the life-sized gingerbread house at the Grand Floridian. The carousel of four majestic, chocolate horses is a familiar sight, circling gracefully in the Beach Club lobby. Look closely to find clever creative changes from year to year. The horses themselves are decorated differently (their names playfully inspired by their themes), the number of gingerbread pieces is carefully calculated to match the year (2,019 pieces in 2019), and an extra hidden Mickey is added, so there is one for each year the display has been presented.

Erich's original—and mightily impressive—gingerbread house at the Grand Floridian still annually tops the popularity charts, though. Coming in at over seventeen feet tall, the "house" is large enough to operate as a candy shop where Guests can buy a range of sweet treats from the bakery elves inside. (The most popular item is, of course, the gingerbread shingle.) The outside is covered with those shingles, then ornamented with flowers and flourishes made from icing. Festive figurines adorn the porches and ledges; each one is molded from solid white chocolate and hand-painted using colored cocoa butter. The resort's pastry team thoughtfully provides a recipe in case Guests hope to re-create it at home: 1,050 pounds of honey, eight hundred pounds of flour, six hundred pounds each of chocolate and powdered sugar, thirty-five pounds of spices, and 140 pints of egg whites. Good luck! Though the rest of the hotel's decorations are installed while Guests are asleep, the gingerbread house is assembled during the day. Guests fortunate enough to time their visit can watch the magical process unfold, meet the team, and learn their gingerbread tips.

The tradition of these epic-scale sweet and spicy sculptures has been taken up at other Disney locations, too, and on the cruise ships. The Grand Californian Hotel & Spa team builds a gingerbread house inspired by the hotel's own arts and crafts architecture, while Cast Members at the Disneyland Hotel in Paris construct a fashionable Victorian villa right in the main lobby. After seeing (and smelling) these amazing creations, who can truthfully say they have not secretly harbored thoughts of trying to replicate this at home for themselves!

While the gingerbread itself lasts just one season onstage, the supporting structures are kept and reused the following year. At Walt Disney World, the Scenic Services department has developed a rather unusual recycling technique for these structural components as they are carefully taken apart and stored. After the shingles and other baked elements are removed, a sugary residue remains, and the panels are laid out at the Tree Farm backstage, providing Disney's bee colonies an unusual source of winter food.

Aulani Gingerbread display 2018

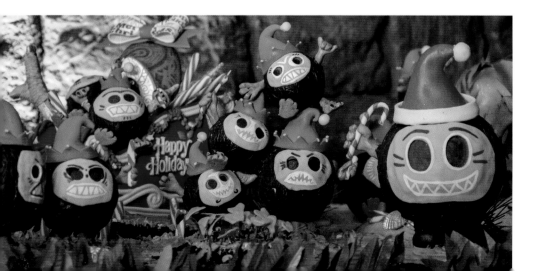

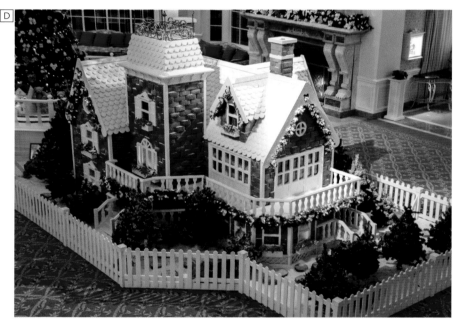

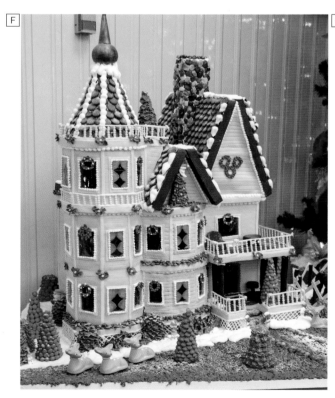

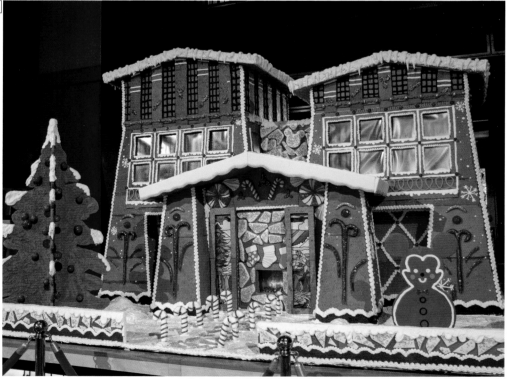

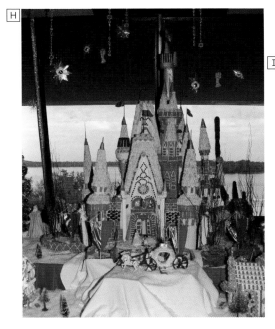

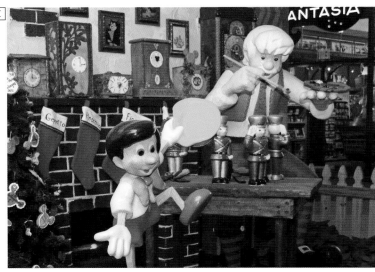

Wilderness Lodge, Walt Disney World

A *Main lobby*
 1994

Port Orleans Resort—French Quarter, Walt Disney World

B *Main lobby*
 1993

Polynesian Village Resort, Walt Disney World

C *Great Ceremonial House*
 2008

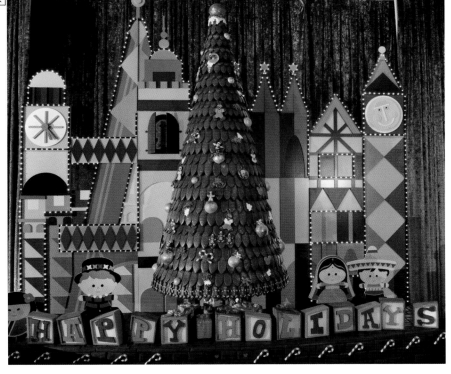

Disneyland Hotel, Disneyland Paris

DE *Main lobby*
 2019

Saratoga Springs Resort & Spa, Walt Disney World

F *Main lobby*
 2017

Grand Californian Hotel & Spa, Disneyland Resort

G *Great Hall*
 2018

Contemporary Resort, Walt Disney World

H 1992

I 2008

J 2011

K 2012

L 2017

MNO 2018

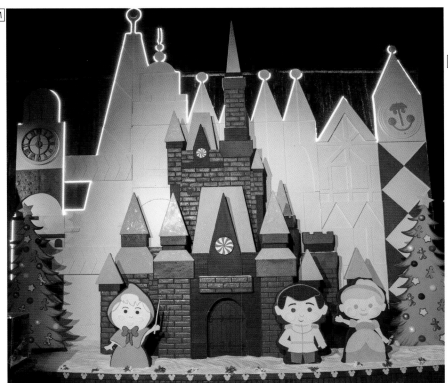

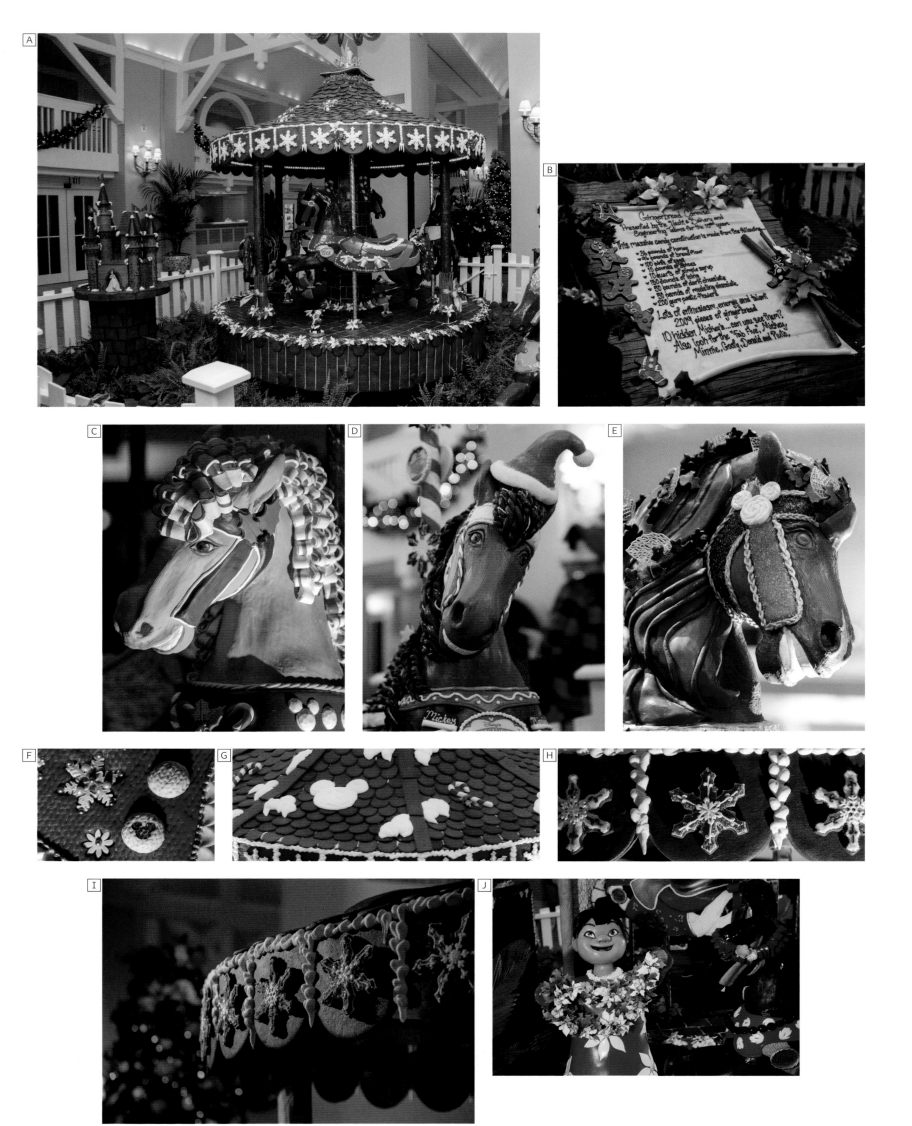

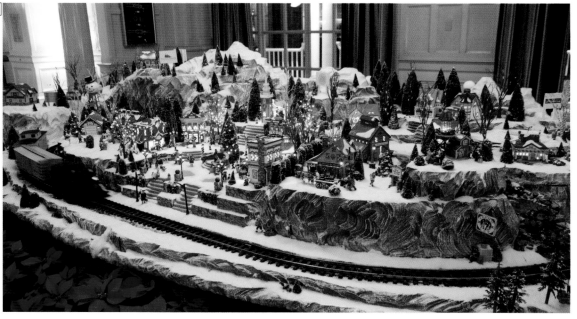

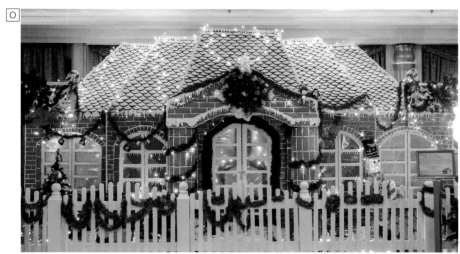

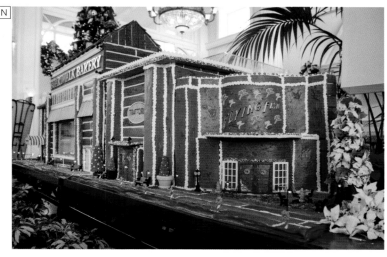

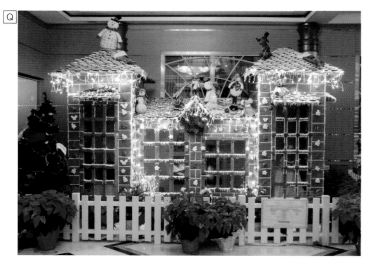

*Beach Club Resort,
Walt Disney World*

A B *2009*

C — F *2018*

G *2016*

H *2018*

I J *2017*

*Yacht Club Resort,
Walt Disney World*

K L *2016*

*BoardWalk Inn
and Villas, Walt
Disney World*

M *2009*

N *2017*

*Disney Cruise Line
ships*

O Disney Fantasy
2018

P Disney Dream
2018

Q Disney Magic
2018

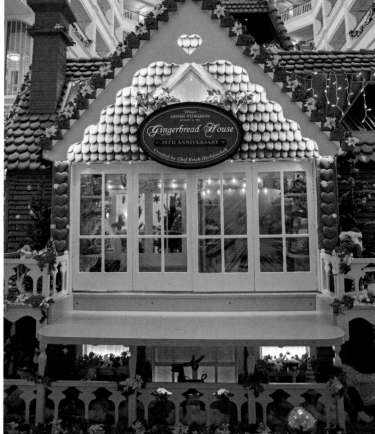

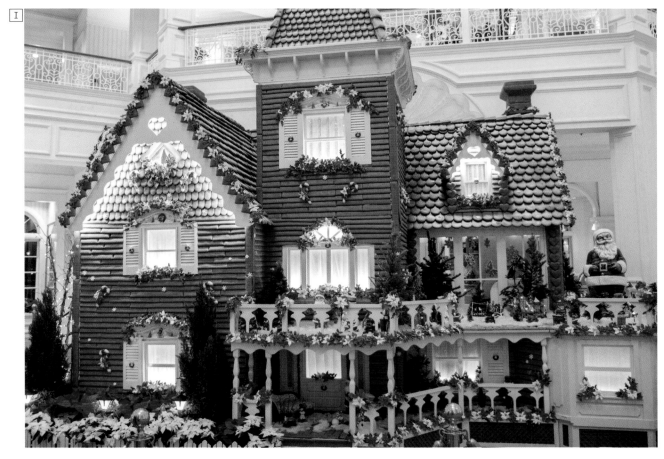

Grand Floridian Resort & Spa, Walt Disney World

A *Window detail*
2009

B *Chocolate figurine*
2017

C *Decor detail*
2017

D E *Chocolate figurines*
2017

F *Storefront*
2018

G *Chocolate figurine*
2017

H *Chocolate figurine*
2011

I *Front view*
2018

J *Chocolate figurine*
2018

K *Chocolate figurine*
2017

L *View from second*
floor balcony
2018

M N *Decor details*
2016

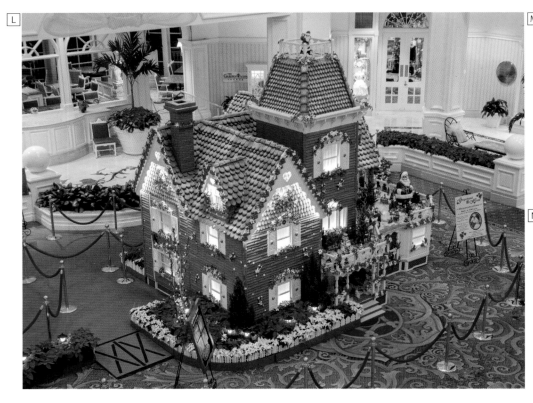

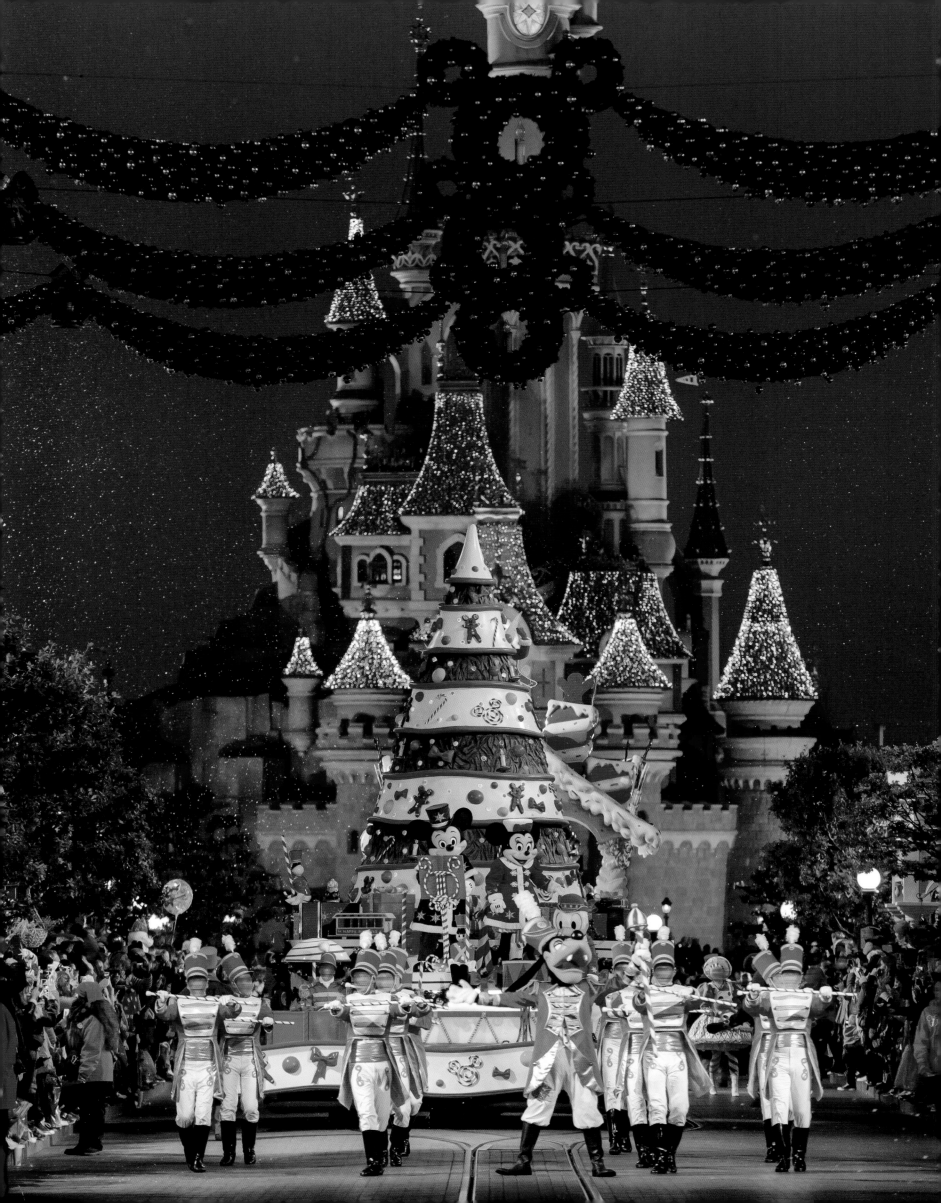

Holiday Spectacles

Holiday magic comes to life in the streets, on stage, and in the skies

Entertainment—parades, shows, fireworks, and other special presentations—is a cornerstone of the Disney experience all year long. As we have seen, Disneyland established distinctive themed entertainment during its very first holiday season in 1955, and the tradition of creating unique shows celebrating Christmas, Hanukkah, and New Year's has grown richer ever since. Is it our imagination that these holiday spectacles are just a little bigger and grander than the usual parades and pyrotechnics? Certainly, some of the elements from these shows have become such treasured traditions—like the toy soldiers—that they are instantly recognizable as Disney at Christmas.

Parades typically attract the largest audience of any park entertainment. The sheer scale of the "stage" allows a great many Guests to experience them, and practically every part of the parade route offers a good view as the floats glide by. In Disneyland and in the Magic Kingdom, holiday-time processions have often been montages of familiar characters and floats from other parades, dressed up with lights and garlands.

The name Very Merry Christmas Parade was introduced on both coasts in 1977, along with a soundtrack of bells and trumpets to herald in the season. In Disneyland, the full production of the Very Merry Christmas Parade is remembered most fondly for its nighttime performances, with the added magic of darkness, elaborate show lighting along the route, and what passes for a brisk winter chill in Southern California. A shorter, simpler version would play on weekday afternoons in early December.

The 1995 debut of A Christmas Fantasy in Disneyland ushered in a new era of holiday parades—no longer simply a medley of character vignettes, this cavalcade reimagined the music and all of the parade units with a top-to-tail Christmas story line.

Disneyland Paris 2014

The Magic Kingdom parade has consistently been one of the park's most ambitious productions, with many floats, live bands, and live animals. Rechristened Mickey's Once Upon a Christmastime, the celebration received its own musical and artistic reimagining in 2007. Disney parks in Tokyo, Paris, and Hong Kong continue to present holiday parades with many of the same, familiar elements too—snowmen, reindeer, gingerbread characters, and, of course, Santa Claus.

Among the toys and toy costumes seen in all of these parades, possibly the most beloved are the toy soldiers. Inspired by Disney's 1961 film *Babes in Toyland*, this colorful troupe of troopers marches along the street with near-military precision, their boots designed to clomp noisily on the pavement as they go. Some of them play musical instruments. (Really, how do they do that in those costumes?)

There are other costumes, too, which have become iconic for their appearances in these parades, even as they have been updated through the years—the snowmen/snowwomen, gingerbread people, and those comical reindeer dancing in formation ahead of Santa. Disneyland Paris has, on occasion, even brought real, live reindeer to lead Santa's sleigh.

Holly and tinsel on the floats, Christmas costumes for the performers, and updated, festive music can give a park's regular parade new holiday flair. Mickey's Jammin' Jungle Parade became Mickey's Jingle Jungle Parade at Disney's Animal Kingdom (2004–2013), while over at what we now know as Disney's Hollywood Studios, Stars and Motor Cars became the Hollywood Holly-Day Parade (2003–2007).

Even the classic Main Street Electrical Parade has had special seasonal variations, cleverly weaving familiar Christmas melodies through its electro-synthe-magnetic soundtrack—first applied in Disneyland Paris (1992–2002), and then at Walt Disney World (1998 and 1999). The spectacular Electrical Parade Dreamlights in Tokyo Disneyland has received a similar update each holiday season since 2006.

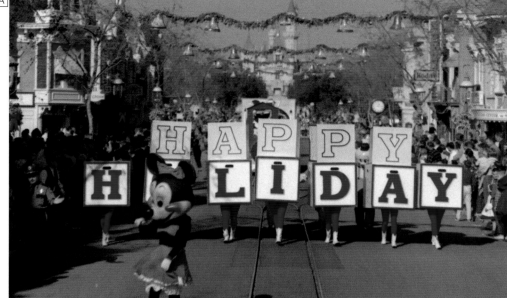

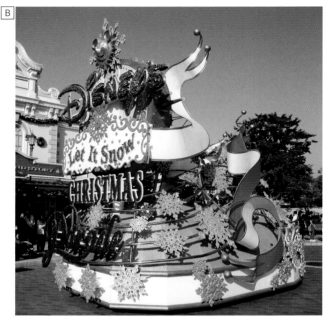

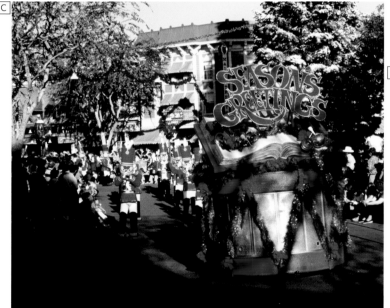

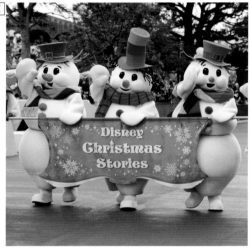

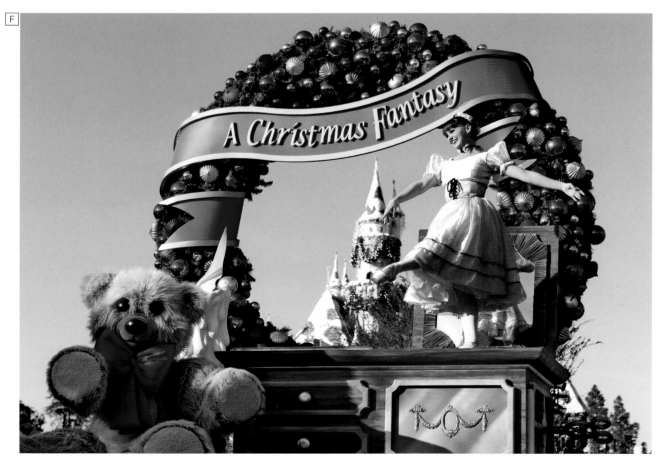

Christmas parades

A Disneyland
Parade of Toys
1961

B Hong Kong Disneyland
Let It Snow Christmas
Parade
2007

C Disneyland
Very Merry Christmas
Parade
1978

D Disneyland
A Christmas Fantasy Parade
2005

E Tokyo Disneyland
Disney Christmas Stories
Parade
2018

F Disneyland
A Christmas Fantasy Parade
2014

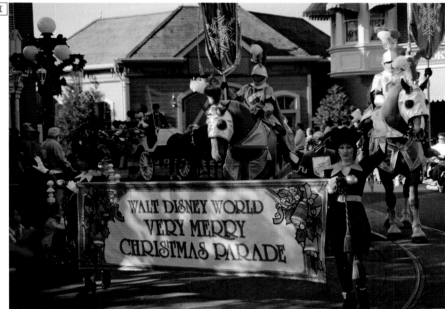

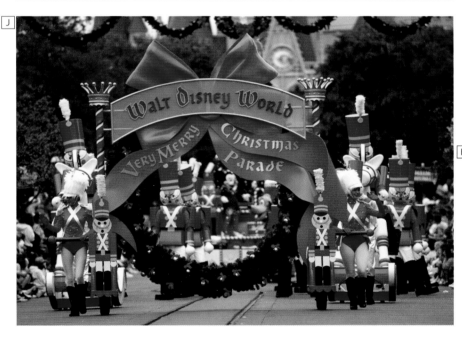

Magic Kingdom

G *Mickey's Very Merry Christmas Parade*
1998

H *Very Merry Christmas Parade*
1977

I *Mickey's Very Merry Christmas Parade*
1992

J *Mickey's Very Merry Christmas Parade*
2005

K *Mickey's Once Upon A Christmastime Parade*
2013

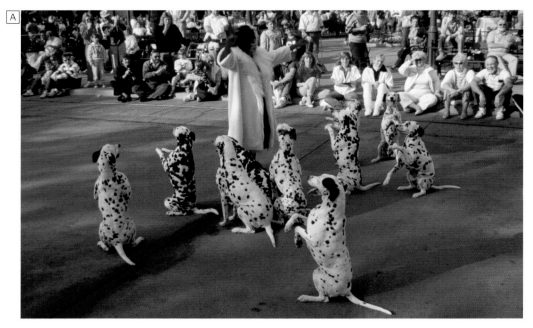

Disneyland

A B *Fantasy on Parade*
 1985

*Mickey's Very Merry Christmas
Parade, Magic Kingdom*

C *1998*

D *1980*

E *1990*

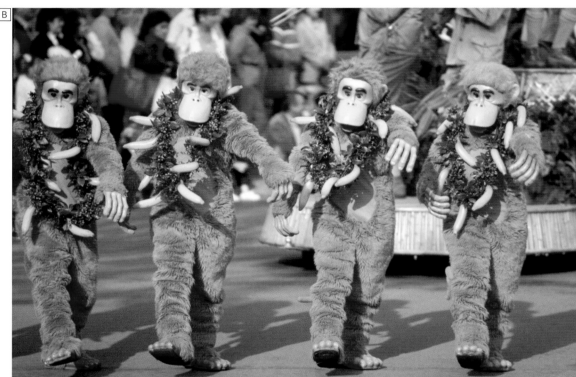

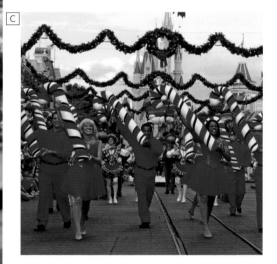

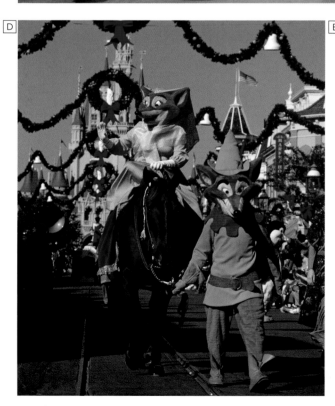

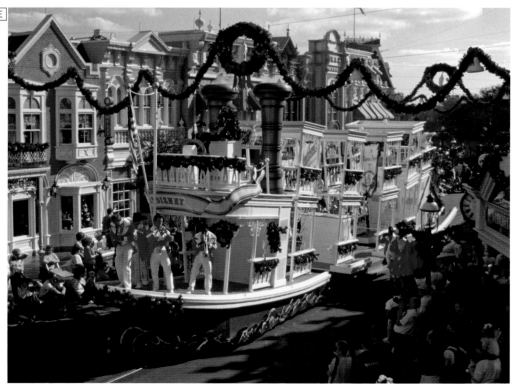

Very Merry Christmas Parade,
Magic Kingdom

F 1976

Mickey's Very Merry Christmas
Parade, Magic Kingdom

G 1995 J 1996

H 1998 K 1992

I 1995

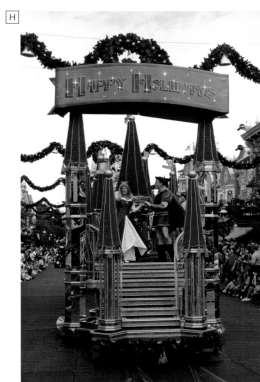

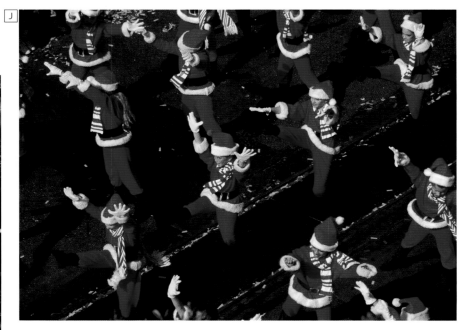

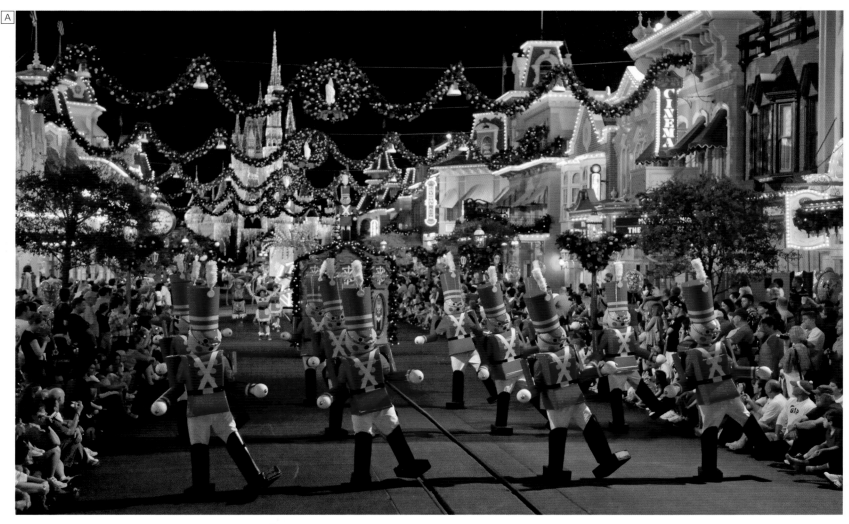

Magic Kingdom

A Mickey's Once Upon a Christmastime Parade
2009

B Mickey's Once Upon a Christmastime Parade
2016

C Very Merry Christmas Parade
c. 1976

D Mickey's Very Merry Christmas Parade
1992

Hong Kong Disneyland

E Let It Snow Christmas Parade
2007

Tokyo Disneyland

F Disney Christmas Stories Parade
2017

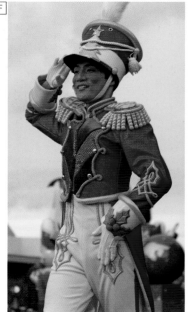

Disneyland

G *Very Merry Christmas
 Parade*
 1978

H *A Christmas Fantasy
 Parade*
 2015

I *A Christmas Fantasy
 Parade*
 2015

Disneyland Paris

J *Christmas Parade*
 1998

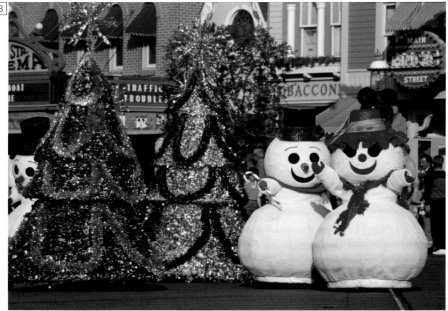

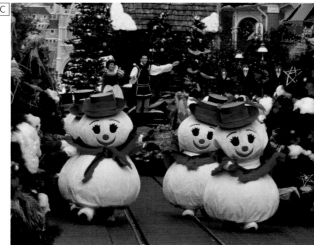

A Magic Kingdom
Mickey's Very Merry Christmas
Parade
1992

B Disneyland
Very Merry Christmas Parade
1986

C Magic Kingdom
Mickey's Very Merry Christmas
Parade
1998

D Disneyland Paris
Disney's Christmas Parade!
2017

E Disneyland
A Christmas Fantasy Parade
2015

F Tokyo Disneyland
Disney Christmas Stories Parade
2018

G Disneyland
A Christmas Fantasy Parade
2009

H Disneyland Paris
Christmas Parade
2014

I Magic Kingdom
Very Merry Christmas Parade
1977

J Tokyo Disneyland
Disney Christmas Stories Parade
2017

K Hong Kong Disneyland
Let It Snow Christmas Parade
2007

L Magic Kingdom
Mickey's Once Upon A Christmastime Parade
2007

M Magic Kingdom
Mickey's Once Upon A Christmastime Parade
2009

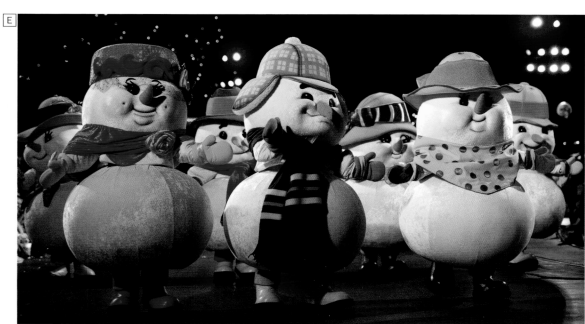

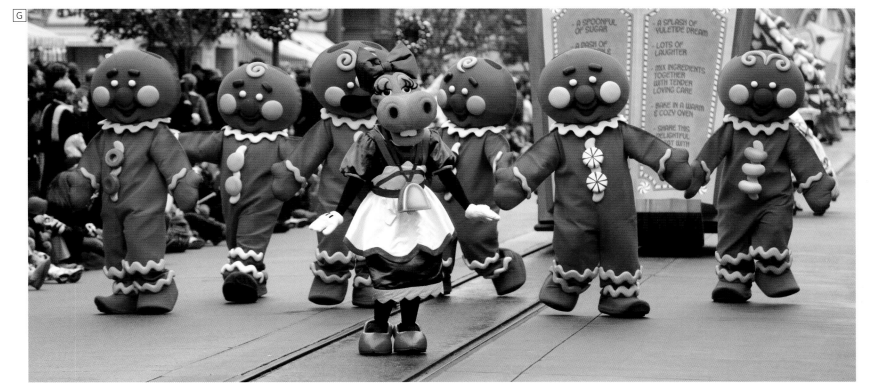

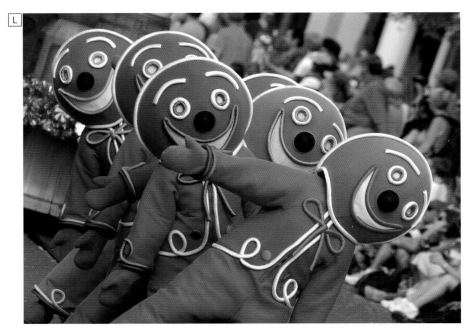

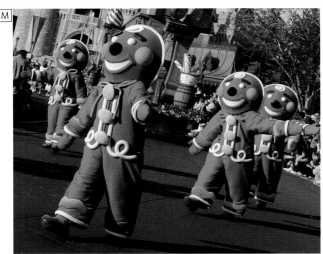

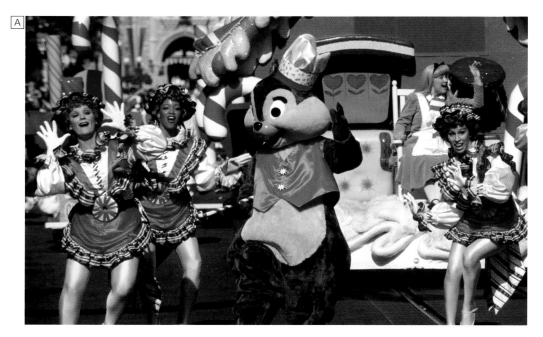

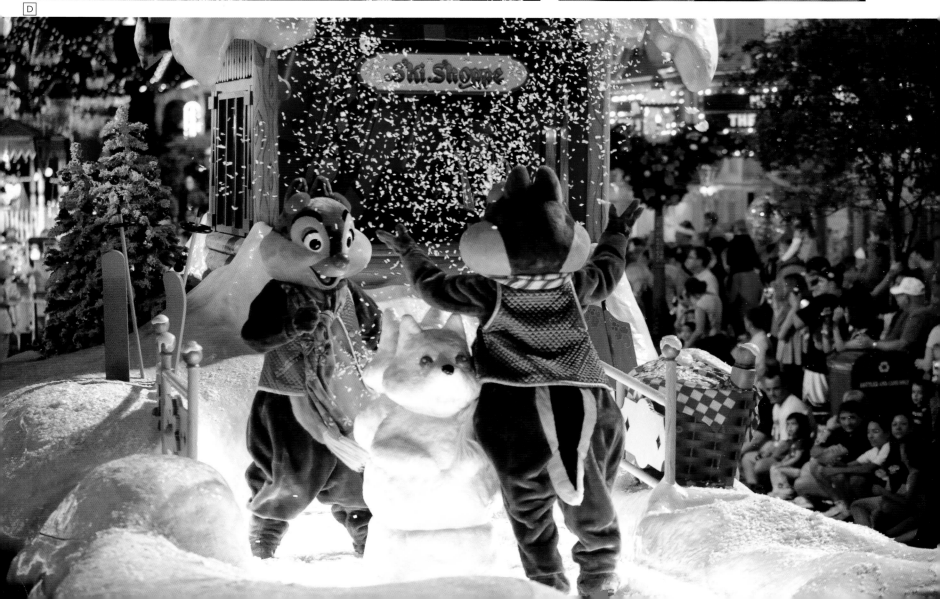

Magic Kingdom

- A *Mickey's Very Merry Christmas Parade 2001*

- B C *Mickey's Once Upon A Christmastime Parade 2018*

- D *Mickey's Once Upon A Christmastime Parade 2009*

E *Tokyo Disneyland*
Disney Christmas Stories Parade
2018

F G *Tokyo Disneyland*
Disney Christmas Stories Parade
2017

H *Tokyo Disneyland*
Disney Christmas Stories Parade
2018

I *Magic Kingdom*
Mickey's Once Upon A Christmastime Parade
2009

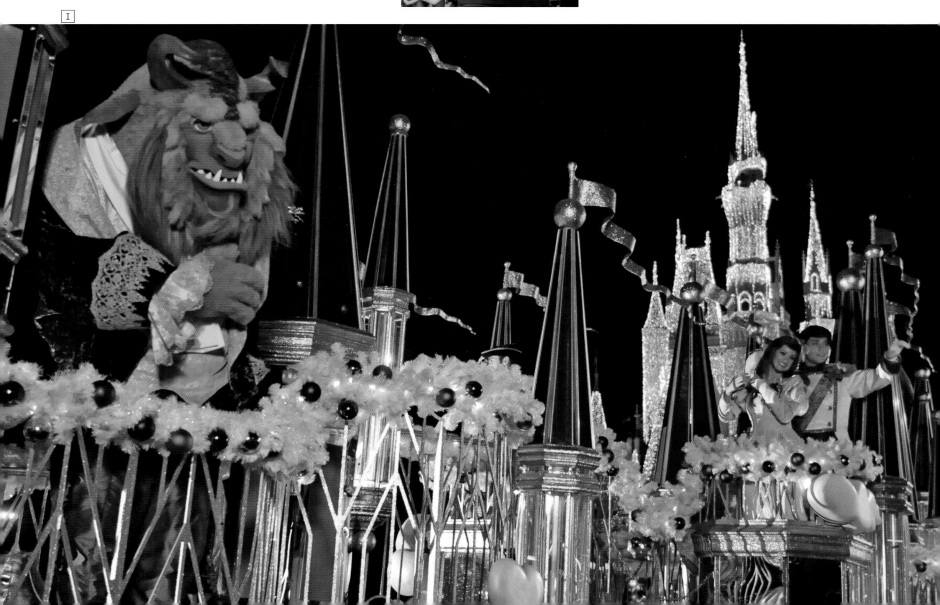

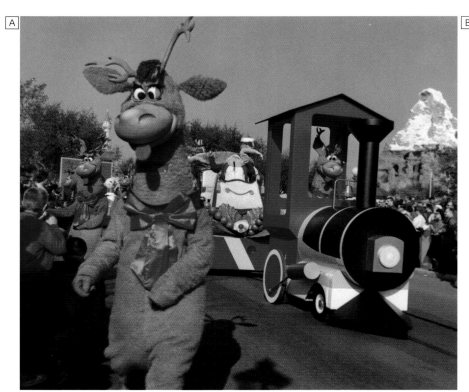

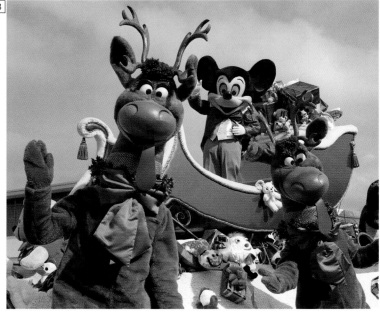

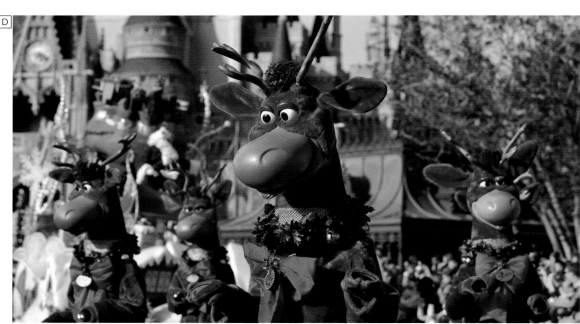

Disneyland

A *The Christmas Parade*
 1986

B *Fantasy on Parade*
 1972

C *Fantasy on Parade*
 1965

*Mickey's Once Upon a
Christmastime Parade,
Magic Kingdom*

D *2009*

E *2013*

2016 ▶

Holiday Magic at the Disney Parks

A ▲

B ▼

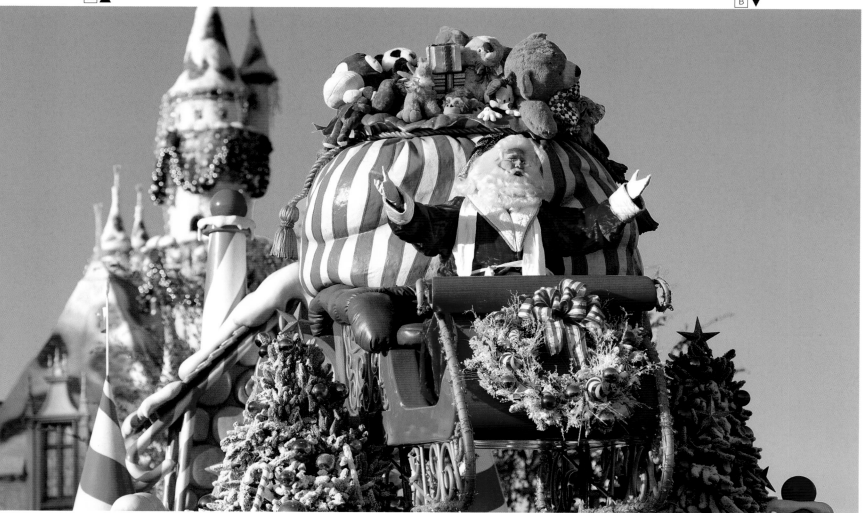

Holiday Magic at the Disney Parks

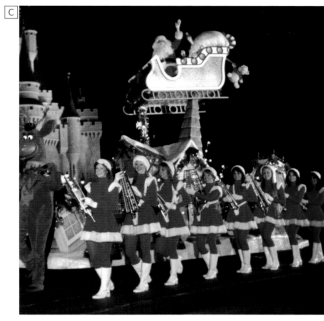

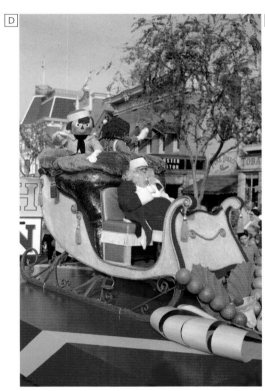

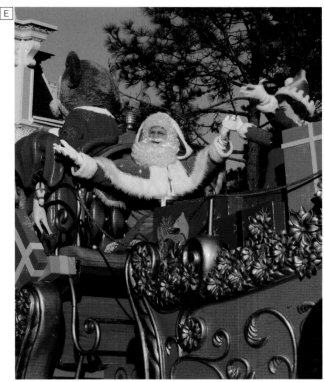

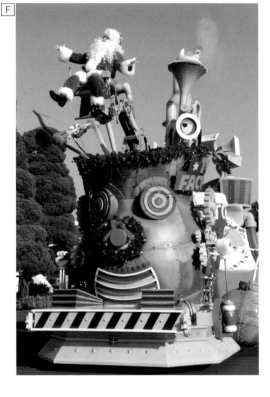

A *Disneyland Paris*
 Christmas Parade
 2002

B *Disneyland*
 A Christmas Fantasy Parade
 2015

C *Magic Kingdom*
 Very Merry Christmas Parade
 1979

D *Disneyland*
 Christmas In Many Lands Parade
 1961

E *Disneyland Paris*
 Disney's Christmas Parade!
 2017

F *Tokyo Disneyland*
 Christmas Parade
 2007

G *Disneyland*
 A Christmas Fantasy Parade
 2009

H *Disneyland*
 A Christmas Fantasy Parade
 2000

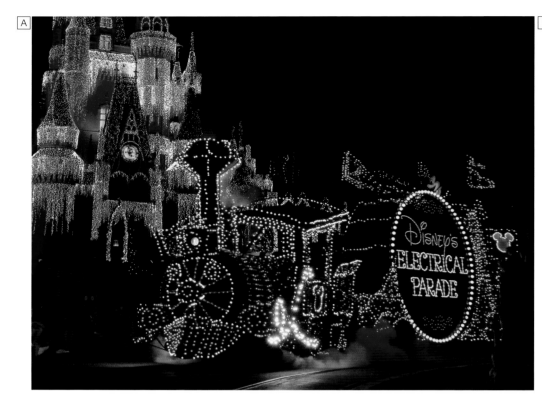

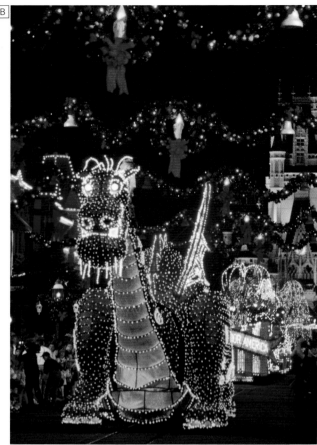

A *Magic Kingdom*
Disney's Electrical Parade
2012

B *Magic Kingdom*
Main Street Electrical Parade
1999

C *Disneyland Paris*
Main Street Electrical Parade
1993

D *Disney's Animal Kingdom*
Mickey's Jingle Jungle Parade
2004

E *Disney's Animal Kingdom*
Mickey's Jingle Jungle Parade
2004

Theater and stage presentations are another mainstay of park entertainment. Holiday shows of one kind or another have been produced every year at every park—many more than we can recount here, though we hope we have included some of your favorites. Several of the most memorable shows return year after year, becoming traditions themselves, and some from the past are still warmly remembered even though they are no longer performed.

EPCOT debuted Holiday Splendor at the America Gardens Theatre in 1985, with host Debby Boone recalling holiday traditions from cultures around the world in words and music, including Hanukkah, Chinese New Year, and Christmas, along with other winter festivals and pagan rituals which still influence today's celebrations. The show ended with "Let There Be Peace on Earth," which has become something of a holiday anthem at EPCOT, used again as the finale for Holiday IllumiNations, the holiday tag for IllumiNations: Reflections of Earth, and sometimes at the end of the Candlelight Processional. Holiday Splendor played for several more years, with hosts Carol Lawrence (1986–1991) and John Davidson (1992).

In the nearby Magic Kingdom, Mickey's Magical Christmas Tale was the holiday happening from 1976 to 1980, while Minnie Mouse and Melvin the Moose came together for shows variously called Christmas Follies, Chrismoose Follies, and Miss Minnie's Country Christmas presented at the Fantasy Faire stage (also known as the Fantasyland Pavilion), Mickey's Starland, or the Diamond Horseshoe from 1983 to 1997. (Similar holiday shows played at Carnation Plaza Gardens in Disneyland—practically under the same titles as Christmoose Follies, Christmas Fantasy Follies, and Christmas Follies—between 1985 and 1990.)

Clement Clarke Moore's timeless 1822 poem "A Visit from Saint Nicholas" was memorably reimagined as Mickey's 'Twas the Night Before Christmas at the Tomorrowland

Disneyland Paris Mickey's Christmas Big Band 2017

Theater (renamed the Galaxy Palace Theater in 1990) from 1984–1989 and 1993–2008: "Not a creature was stirring, except Mickey Mouse!" For the ultimate rum-soaked fruitcake of holiday spectaculars, though, head to the forecourt stage of Cinderella Castle in the Magic Kingdom, where huge casts of performers, reindeer, soldiers, snowmen, and characters dressed in their holiday finest have awed audiences with Holiday Fantasy (1973–1981), A Sparkling Christmas Spectacular (1982–1998), Celebrate the Season (1999–2015), and Mickey's Most Merriest Celebration (which debuted in 2016). The scale of the stage itself, with Cinderella Castle as a backdrop, makes a fantastic setting for these shows, augmented with ever grander lighting, projection, and pyrotechnic effects.

Celebrating all that's jazz, a holiday version of Big Band Beat has played at the Broadway Music Theater in Tokyo DisneySea since 2006, and Mickey's Christmas Big Band debuted on the Videopolis Theatre's stage in Disneyland Paris for the 2017 season. Mickey himself takes the limelight for an energetic drum solo.

In Disneyland, one of the most affectionately remembered stage productions is Mickey's Nutcracker, which played at Videopolis (now the Fantasyland Theater) in 1991 and 1992. Inspired—loosely, it has to be said—by Tchaikovsky's enormously popular 1892 ballet, the show cast Mickey as the eponymous kitchen gadget, gifted to Minnie at her Christmas party. When night fell, magical dreams brought him to life, and the two of them embarked on an adventure to Candyland, along with a group of hungry soldiers (who would break into a Rockettes-like song-and-dance number at every opportunity). The entertaining and musically genre-bending journey took them through the evil Rat King's Brooklyn rap, Queen of the Snowflake Forest's Motown soul, a snippet from "Waltz of the Flowers" played on a touch-tone phone, and the original "Russian Dance" rearranged as a country hoedown. The addition of amusing lyrics made the experience complete. Tchaikovsky would have been proud.

Another unique and oft-remembered show is The Glory and Pageantry of Christmas at Walt Disney World. This living nativity was staged at the Lake Buena Vista Shopping Village (now the Marketplace district of Disney Springs) when it opened in 1975 and was a mainstay for twenty Christmas seasons. As the Innkeeper recounted Jesus' birth, actors portraying Mary, Joseph, the angels, kings, and shepherds would enter the stage and assume their places, building the familiar scene around the manger as the story unfolded, culminating with a little drummer boy wending his way carefully among the poised figures to reach Mary's side.

The production was beautifully simple in its setting and execution—majestic and dramatic—with inspirational choral accompaniment from the Re'Generation singers (the same group which performs at EPCOT as the Voices of Liberty). Guest Control Cast Members wore tuxedos, emphasizing the dignity of the presentation. And they were a necessity—even with as many as three performances each night, crowds queued for hours to fill the temporary bleachers set up around the stage. The show was presented for the last time during the 1994 Christmas season.

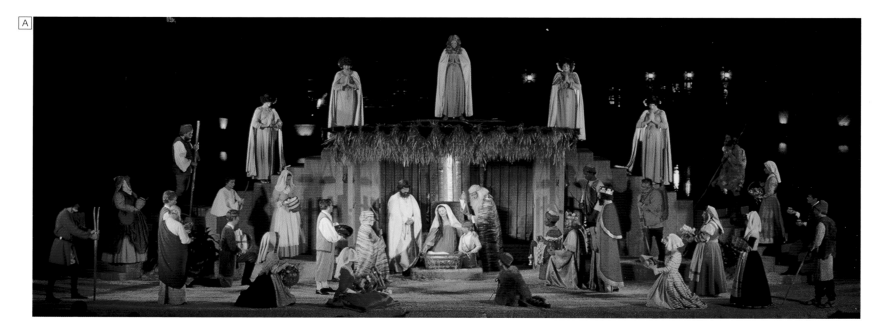

Disney Village Marketplace, Walt Disney World

A *The Glory and Pageantry of Christmas*
 1982

Disneyland

B *Christmas Follies*
 1990

C D *Mickey's Nutcracker*
 1991

E *'Twas the Night*
 Before Christmas
 1982

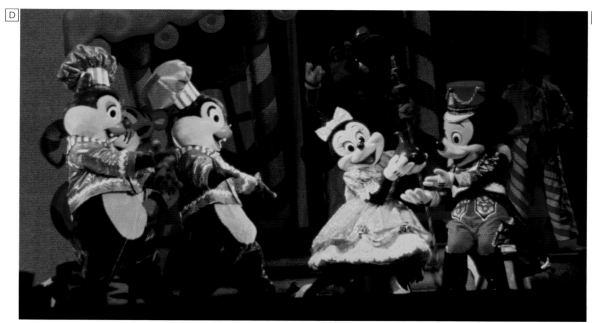

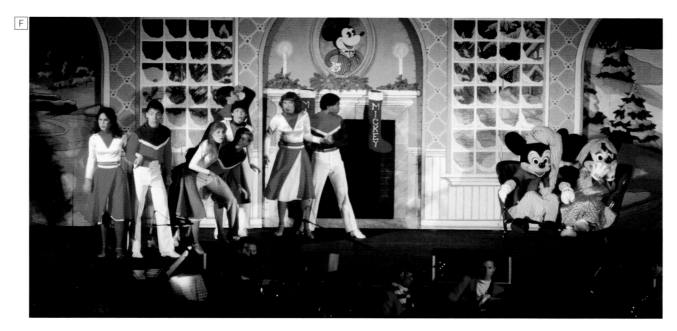

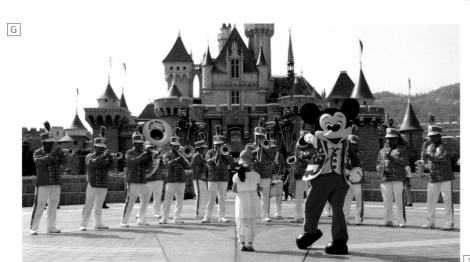

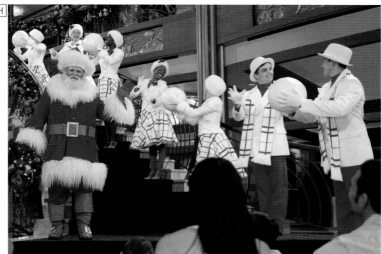

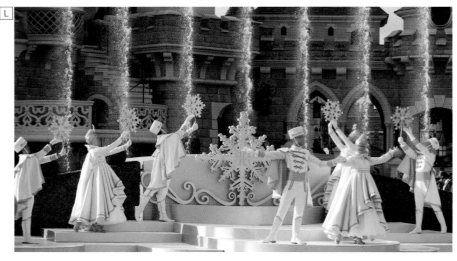

F Magic Kingdom
*Mickey's 'Twas The Night
Before Christmas*
1982

G Hong Kong Disneyland
Guest Holiday Conductor
2016

H Disney Cruise Line ship,
Disney Dream
*Santa's Winter
Wonderland Ball*
2014

I Hong Kong Disneyland
Drum Men
2016

J Tokyo DisneySea
A Perfect Christmas
2017

K Tokyo DisneySea
A Perfect Christmas
2017

L Disneyland Paris
Les Vœux Royaux de Noël
2015

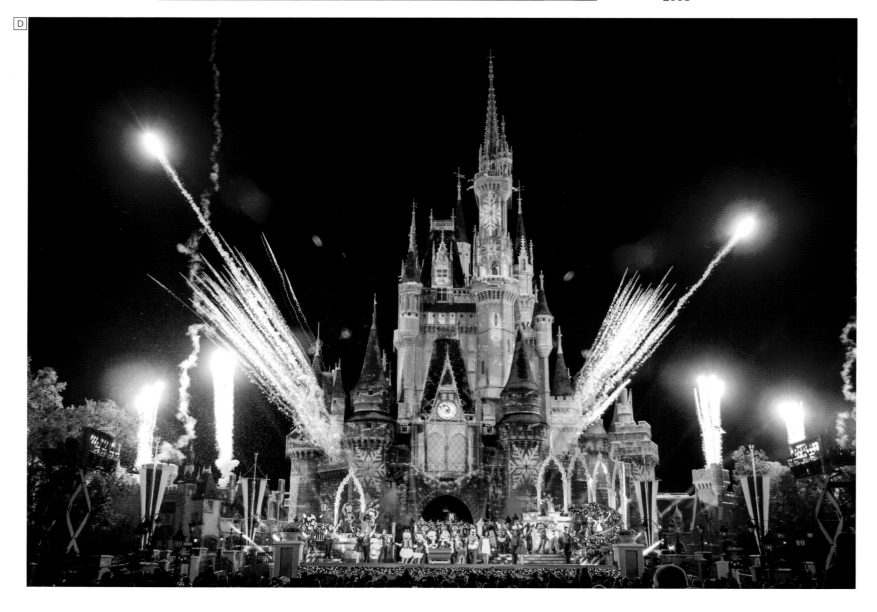

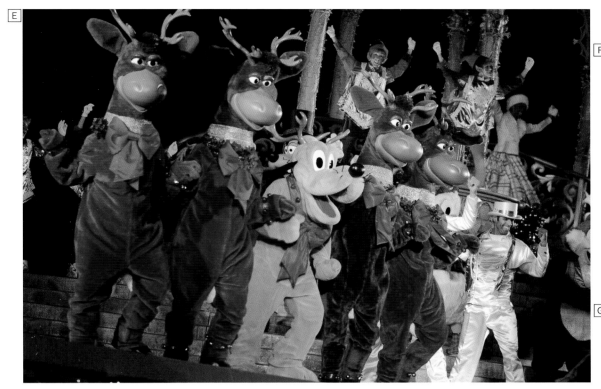

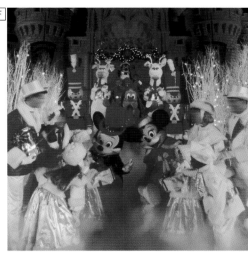

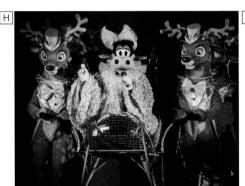

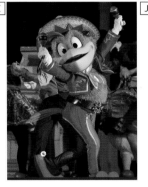

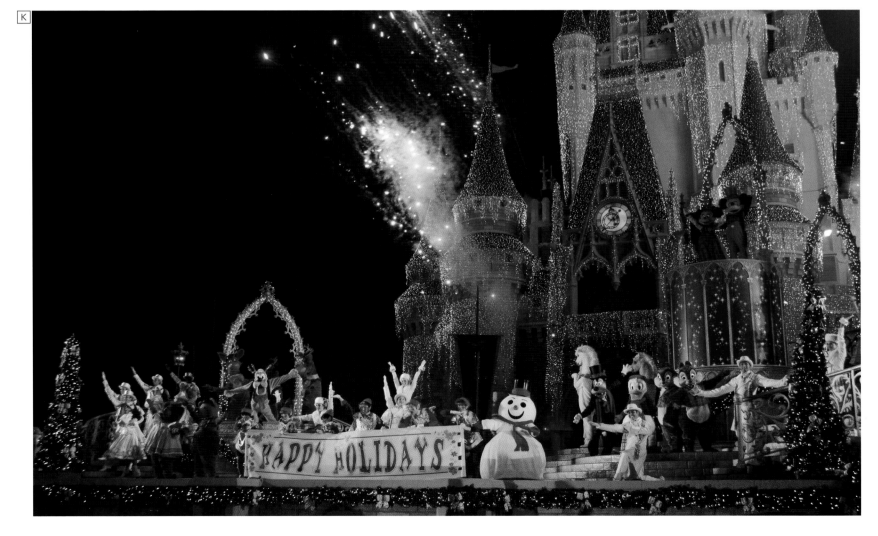

Lakes and lagoons at the Disney resorts provide an appealing "stage" for nighttime entertainment, especially during the winter when northern hemisphere days grow shorter. At Tokyo DisneySea, Candlelight Reflections bowed on the Mediterranean Harbor in 2003 and returned each November and December through 2009. Rafts of candelabra and colorfully costumed characters gracefully circled the lagoon to a soundtrack layering "Deck the Halls," with Ravel's "Boléro"—and the result was a visual treat as the flickering lights played off the rippling water. Colors of Christmas has played there since 2012, and the spectacular lagoon is the setting for another show, A Perfect Christmas, which runs during the day. Paradise Bay in Disney California Adventure hosted Disney's LuminAria for the park's opening holiday season in 2001 and has presented seasonal versions of World of Color there since—a *Prep & Landing* preshow in 2011 and 2012, World of Color Winter Dreams from 2013 to 2015, and World of Color—Season of Light since 2016. Eagle-eared Guests will recognize that some of LuminAria's music is still being used during the holiday castle lighting in Disneyland.

Lake Buena Vista at Disney Springs was the setting for a brand-new kind of airborne creativity during the 2016 holiday season. A show called Starbright Holidays, developed in collaboration with the high-tech company Intel, used three hundred individual drones, which were flown in formation and choreographed to music. Each drone, measuring about fifteen inches across (and weighing only ten ounces), was essentially invisible against the darkened sky save for a bright, color-changing LED light. With clever programming and careful flight control, these airborne points of light danced in a three-dimensional sparkle.

EPCOT has presented nighttime fountain light and fireworks displays on the World Showcase Lagoon practically since its opening, and those regular shows—Carnival de Lumière in 1982, A New World Fantasy in 1983, Laserphonic Fantasy from 1984 to 1987, and IllumiNations from 1988 to 1993—were typically performed during the winter holiday season. Then, from 1994 to 1998, an entirely new show was presented between Thanksgiving and the end of December each year: Holiday IllumiNations. Narrated with characteristic warmth by Walter Cronkite—and centered on themes of peace and harmony—the show featured classic Christmas and Hanukkah melodies performed by the Czech Symphonic Orchestra, Sandi Patty, and the Ramaz School Children's Choir, and concluded with a touching rendition of "Let There Be Peace on Earth" by the Boys Choir of Harlem, during which a voice from each World Showcase country shared a seasonal greeting in their own language. Though IllumiNations: Reflections of Earth became a year-round show in 1999, that stirring finale was added back for the yuletide from 2004 through the show's final holiday season in 2018—and with a particularly spectacular pyrotechnic climax.

Of course, fireworks have been a key element of the Disney experience from as early as 1956, and many parks have created special winter holiday shows through the years. The version of Fantasy in the Sky at Walt Disney World was presented for the resort's first Thanksgiving and New Year's celebrations in 1971; and for longer runs, starting in December, the following year. Wishes: A Magical

Gathering of Disney Dreams debuted in October 2003 as a year-round daily fireworks spectacle in the Magic Kingdom; it even played on many holiday evenings until the show's final winter season in 2016. For Mickey's Very Merry Christmas Party, an extra segment, known as a tag, was attached to the end of Fantasy in the Sky or Wishes, memorably launching shells from additional sites around the perimeter of the Magic Kingdom for a remarkable 360-degree experience, all to a lush arrangement of "Deck the Halls" performed by the Robert Shaw Chorale. In 2005, a new holiday show was introduced—Holiday Wishes: Celebrate the Spirit of the Season—presented for Mickey's Very Merry Christmas Party (retaining the all-around-you spectacle) and remained the regular daily show around Christmas and New Year's through 2018, before Minnie's Wonderful Christmastime Fireworks debuted in 2019. At the Tokyo Disney Resort, Guests in both parks watch the seasonal firework display at the same time, with a soundtrack of familiar holiday melodies broadcast throughout the resort.

Back in Disneyland, records note that the 1961 version of the Christmas in Many Lands Parade featured daytime fireworks, though that appears to have been a one-off. A full holiday fireworks show arrived in 2000 with Believe . . . in Holiday Magic, which is notable not just for a glorious pyrotechnics presentation, but for the gingerbread-scented "snowfall" that follows. The crowd's reaction to these flurries of artificial snowflakes wafting gently down from above, particularly with local youngsters who may never have seen real snow, is something to behold. The lovely rendering of "White Christmas" that accompanies the snowfall is provided by noted country musician Kellie Coffey (who was also featured during Illuminations: Reflections of Earth at EPCOT). Pyrotechnics have often topped off New Year's Eve celebrations too—but more on that later.

In recent years, sophisticated digital projection systems have augmented traditional fireworks for shows such as Disney Dreams of Christmas in Disneyland Paris, and Wayne and Lanny's predictably comic caper Jingle Bell, Jingle BAM!, introduced in Disney's Hollywood Studios in 2016. For the 2017 holidays, colorful projected graphics transformed The Twilight Zone Tower of Terror attractions at both Disney's Hollywood Studios and Walt Disney Studios Park at Disneyland Paris. Sunset Seasons Greetings in Disney's Hollywood Studios presents a series of character-inspired vignettes on The Hollywood Tower Hotel—Mickey and Minnie painting a romantic old-time Christmas scene, the Toy Story gang wrapping the whole building up as a giant parcel, and the Swedish Chef turning it into a gingerbread house, for example. All are accompanied by jolly music and "snowfall." In Disneyland Paris, the Tower of Terror provides a dramatic backdrop to the Production Courtyard stage, where Goofy's Incredible Christmas (L'Incroyable Noël de Dingo) brought together live performers, fireworks, and projection as Goofy helped Santa and his elves (as only Goofy can!).

The debut of Disney Gifts of Christmas in Tokyo Disneyland also took place in 2017. Here, Cinderella Castle is the canvas for projection, pyrotechnics, and laser effects, with a lively montage of holiday music, as Mickey's friends bring presents, which are placed under his tree.

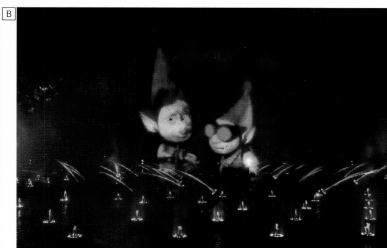

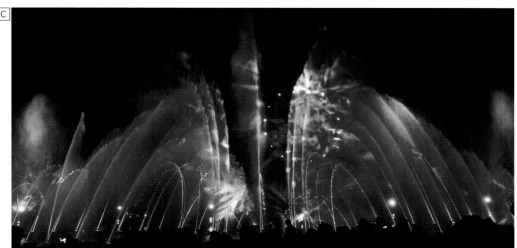

A *Disney Springs, Walt Disney World*
Starbright Holidays
2016

B *Disney California Adventure*
World of Color, Prep & Landing *preshow*
2012

C *Disney California Adventure*
World of Color - Winter Dreams
2015

D *Tokyo DisneySea*
Candlelight Reflections
2008

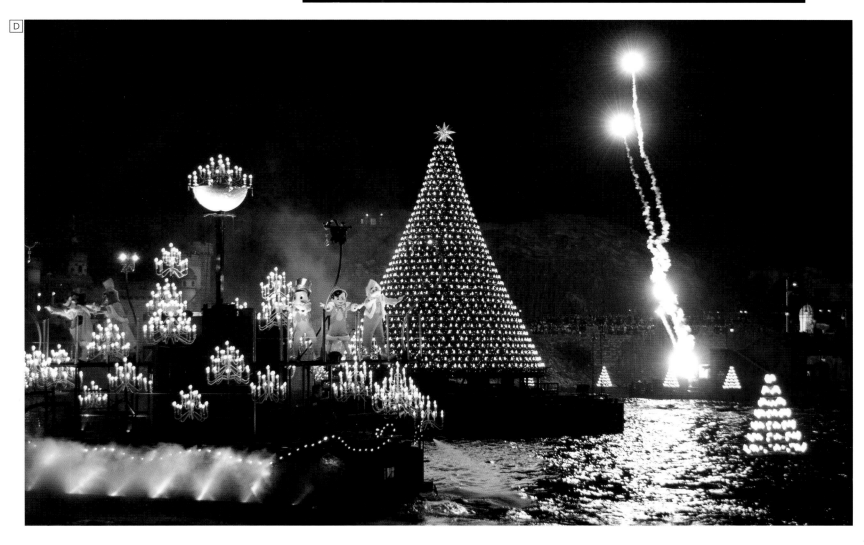

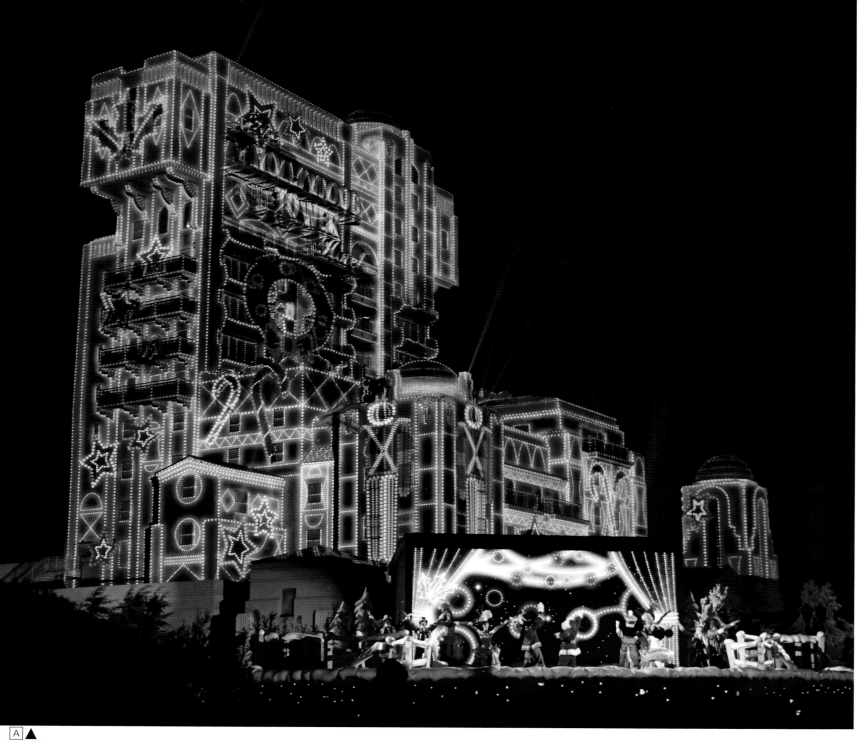

A ▲

B
▶

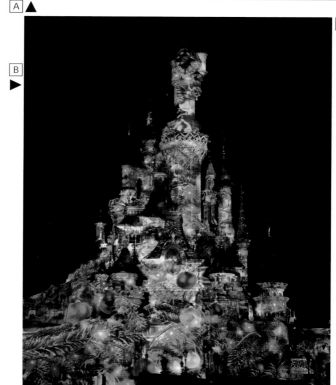

C
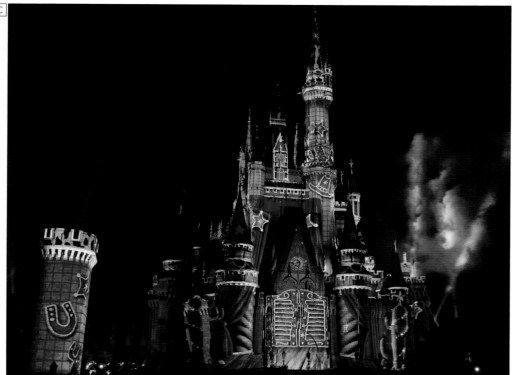

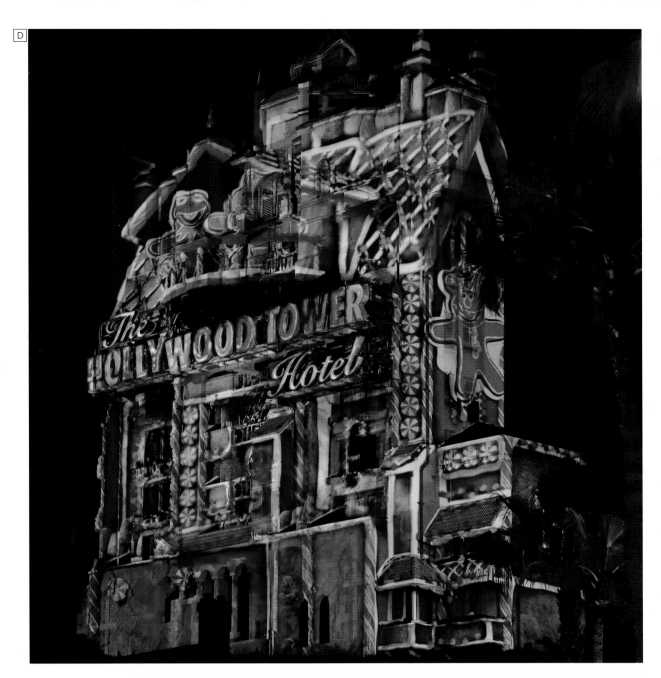

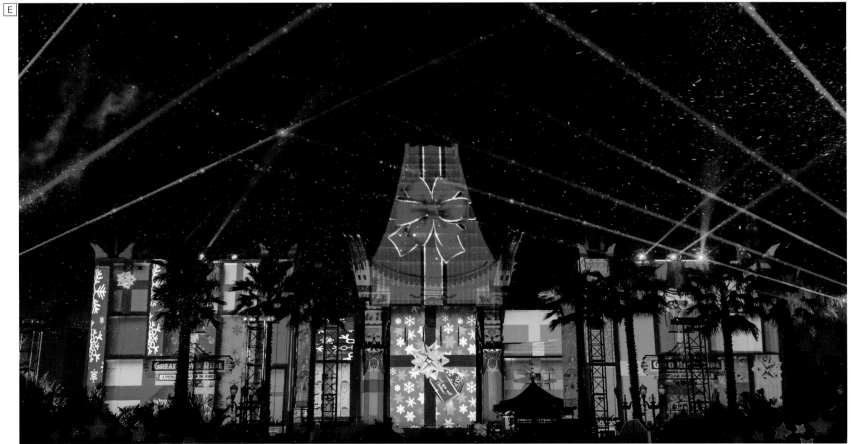

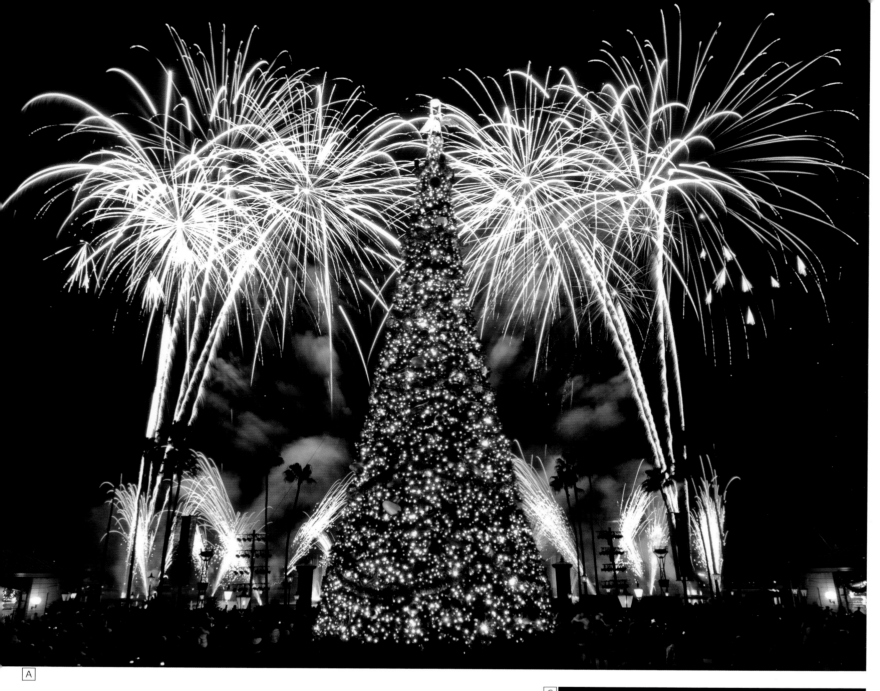

A

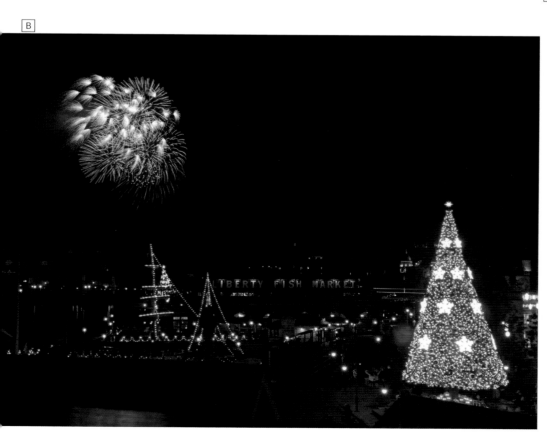

B

C

Holiday Magic at the Disney Parks

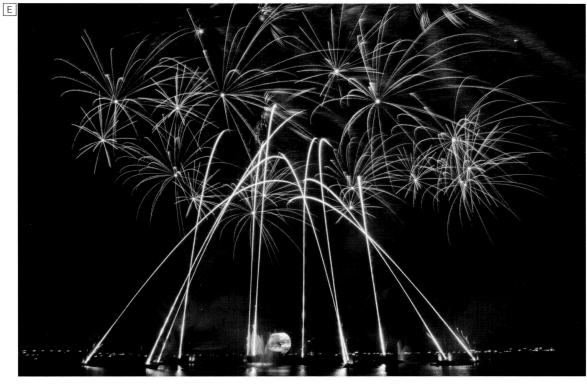

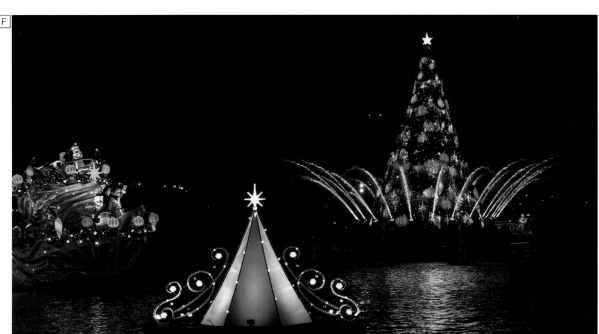

Following Pages

Disneyland Paris
Disney Dreams of Christmas
2014 ▶

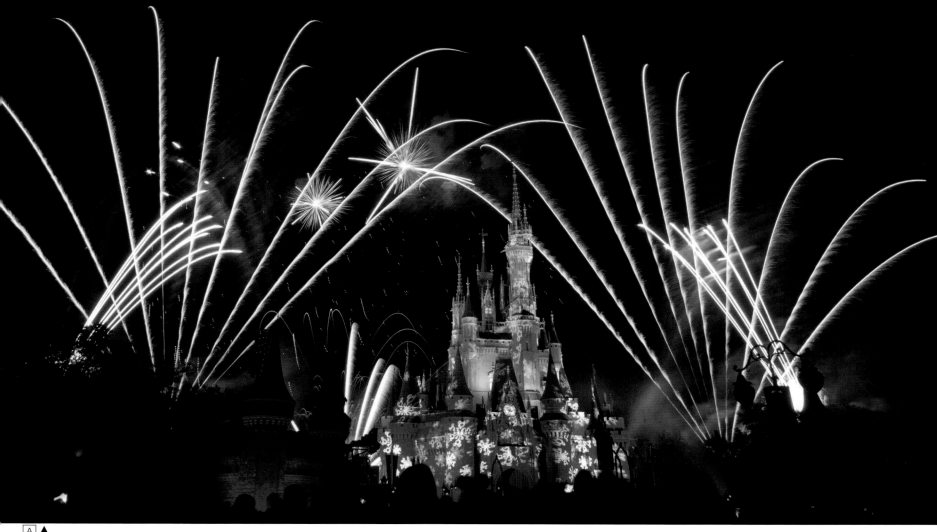

Magic Kingdom

A *Holiday Wishes*
 2018

B *Fantasy in the Sky*
 2000

C *Holiday Wishes*
 2009

D *Minnie's Wonderful Christmastime Fireworks*
 2019

Believe . . . in Holiday Magic, Disneyland

E F *2016*

G *Main Street, U.S.A. projection*
 2018

H *2016*

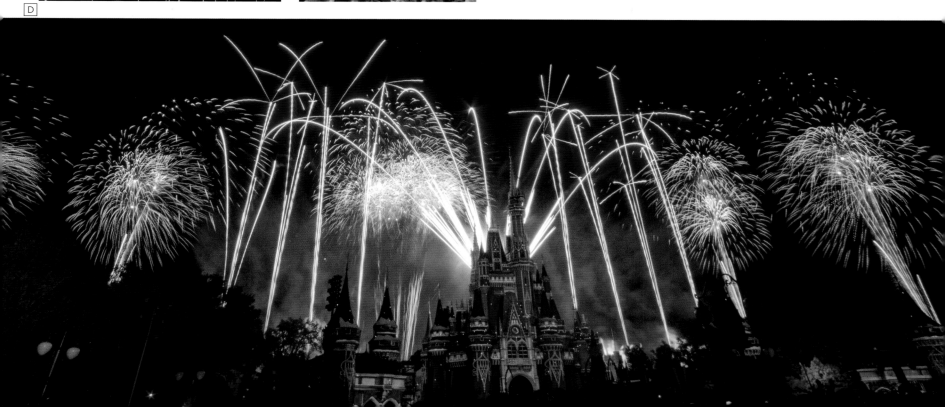

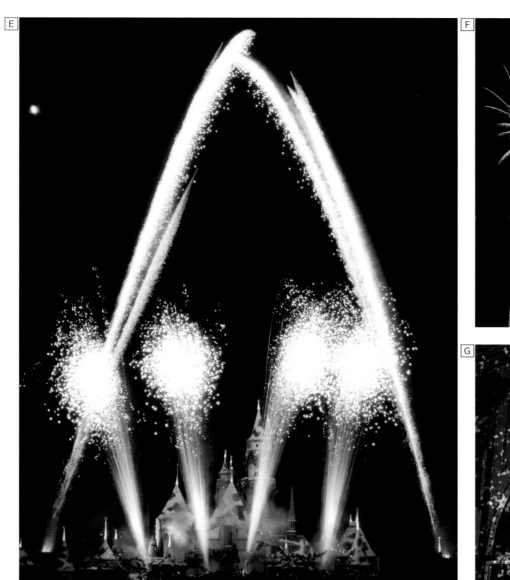

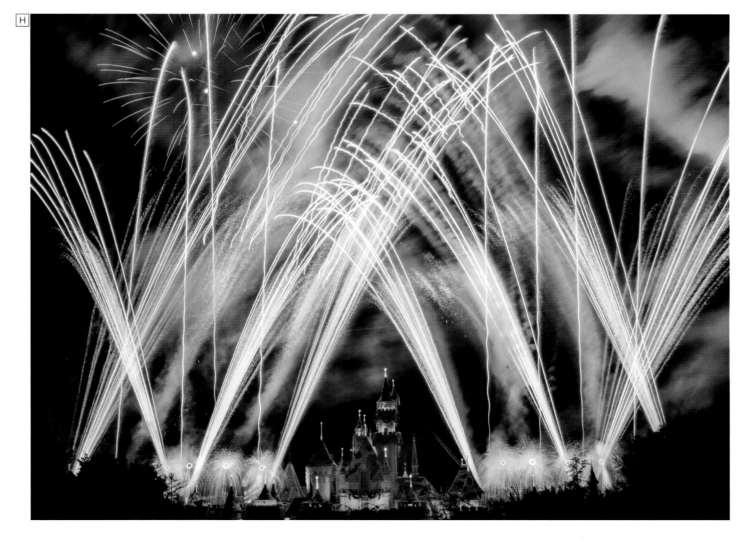

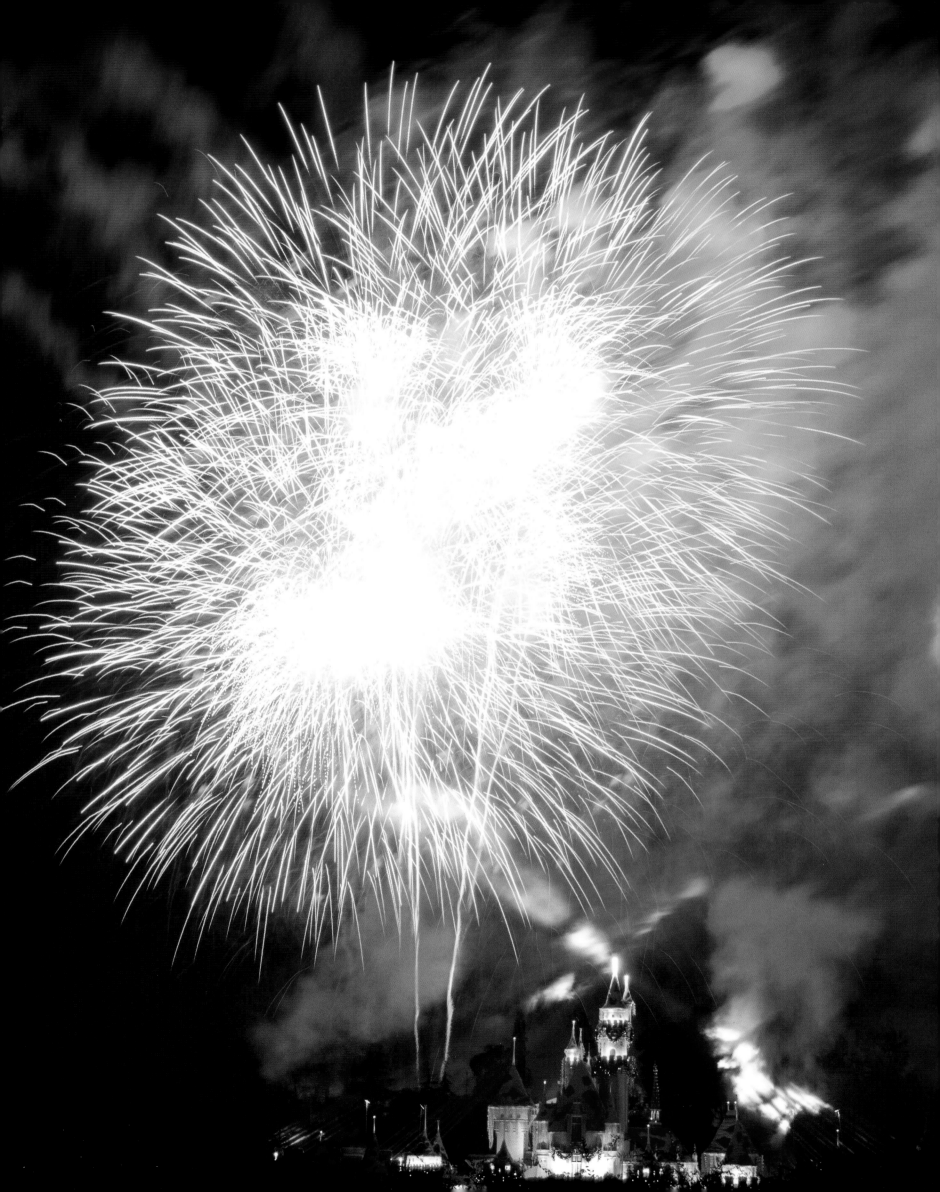

Believe . . . in Holiday Magic, Disneyland

◄ *View from Main Street, U.S.A.*
2016

[A] *View from Black Spire Outpost at Star Wars: Galaxy's Edge*
2019

Disney's Animal Kingdom

[B] *Winter Tree of Life Awakenings*
2019

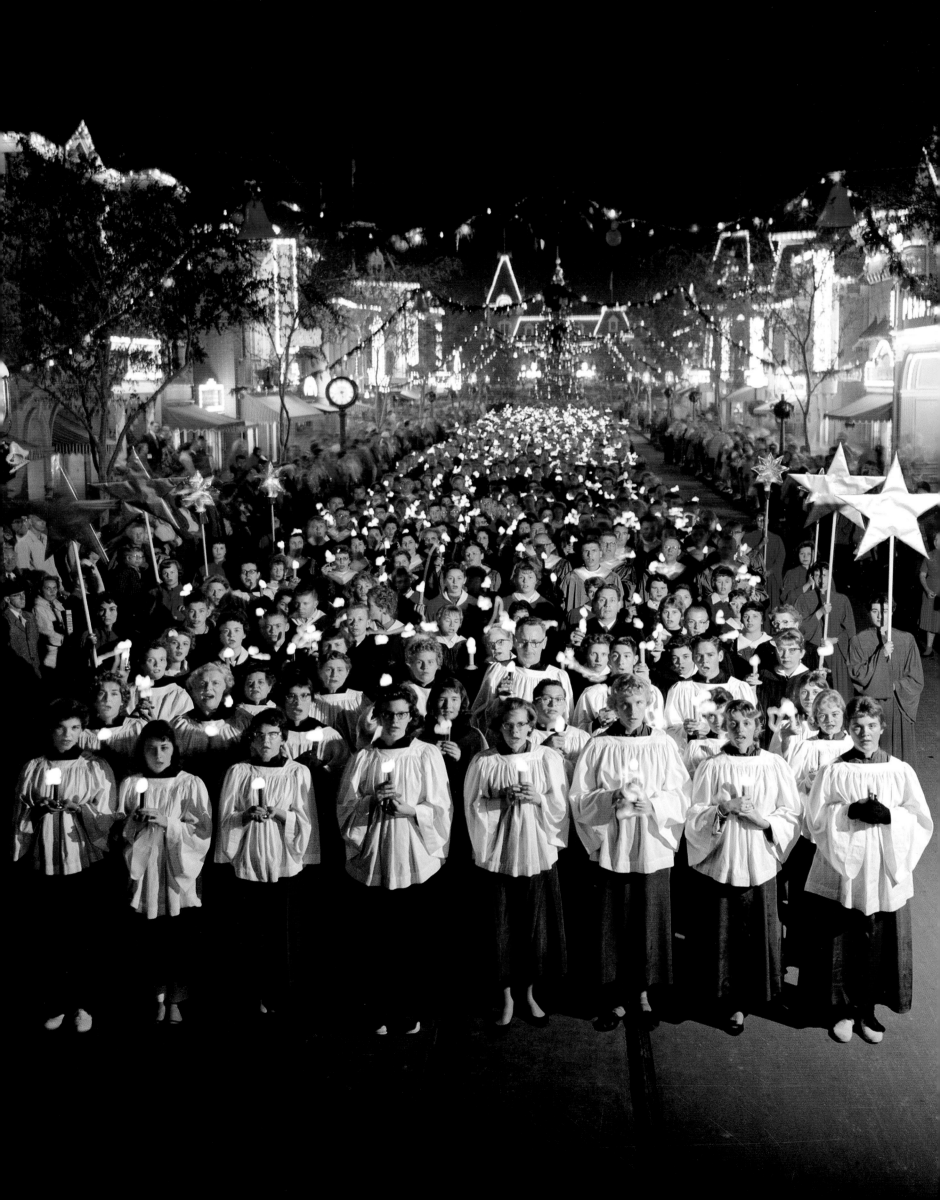

Candlelight

It came upon the midnight clear, that glorious song of old

It is 5:30 p.m., on the evening of December 22, 1959, and Disneyland is arrayed in all its festive holiday finery, a whimsical wonderland with colored lights, ornaments, holly wreaths, garlands, and brightly decorated Christmas trees adorning Main Street, U.S.A. A large crowd is gathered along both sides of the street, chattering happily about the festive decor and the day's special activities: colorful international folk dance groups performing throughout the park, and the Parade of All Nations, presenting holiday traditions from thirty different nations and featuring Walt Disney himself as grand marshal. There is a sudden hush as the streetlights slowly fade and majestic organ music rings out over the square. And then the crowd stills, at most murmurs in awed appreciation and reverence as a massed choir of 2,574 robed singers, each carrying a lighted candle, begins a slow procession from Town Square to the forecourt of Sleeping Beauty Castle, singing the glorious hymn, "Oh, Come, All Ye Faithful."

The Candlelight Procession and Ceremony is one of the oldest and most beloved traditions in the sixty-year-plus history of the Disney parks. When Disneyland celebrated its first Holiday Festival in 1955, a group of twelve Dickens Carolers, under the direction of Dr. Charles C. Hirt (of the University of Southern California), performed in various locations throughout the park. To make the celebration even merrier, 257 different guest choirs and bands from Southern California and neighboring states were also invited to come and perform at the park, a few each day, in the Disneyland bandstand, which was rechristened the Christmas Bowl for the season. On November 25, the second afternoon of the thirty-nine-day festival held that initial year, the Dickens Carolers and a three-hundred-member massed chorus comprised of that day's visiting choirs stood together on the train station steps and sang a selection of Christmas carols accompanied by the visiting bands. The following year, on December 15, 1956, again under Dr. Hirt's direction, the Dickens Carolers and singers from eight visiting choirs again performed as a group on the station steps during the day, this time accompanied by the Disneyland Band.

On December 22, 1957, the multi-choir event expanded as the simple performance was moved from the train station to the other end of Main Street, U.S.A. Immediately following the Christmas Around the World Parade, nine hundred singers from nine different choirs moved from Fantasyland through Sleeping Beauty Castle while singing "Adeste Fidelis." The plan was for the procession to end at Central Plaza, where the choir would form a circle in the street and sing for attending Guests. Unfortunately, due to the unexpected size of the crowd that had gathered, the performers were unable to form in a planned circle and instead informally grouped themselves around the Disneyland Band, where the abbreviated concert consisted only of "Hark! The Herald Angels Sing" and "Silent Night."

Even with that hiccup, the choirs and carolers were so well received that year by Disneyland Guests that in 1958, Dr. Hirt suggested that performances by even larger massed choir groups would be a welcome addition to future holiday events. So, in December of 1958, the Candlelight Processional was held for five successive nights, with singers from multiple choirs heading from City Hall to Central Plaza, led by the Disneyland Tour Guides who were called Star Carriers. Then the massed choirs performed, under Dr. Hirt's direction, the wonderful seventeenth-century "Christmas Hymn (While by Thy Sheep)," arranged by Hugo Jungst (with the Dickens Carolers singing the stirring antiphonal echo from the nearby Sleeping Beauty Castle balcony). Another special choral event took place during the 1958 Christmas season: on December 24 of that year, a performance of youth choirs was held during the day. In the following year, both adult and youth choirs were integrated together, marking the next important chapter of the Candlelight story.

In 1960, the ceremony was moved back to the Town Square section of Main Street, U.S.A. and took the presentation formation that is so beloved today by Disneyland Guests, with choral bleachers set up on the train station platform and steps, giving Guests a much better view. For the first time, a celebrity narrator was also added to the program when actor Dennis Morgan

Disneyland 1959

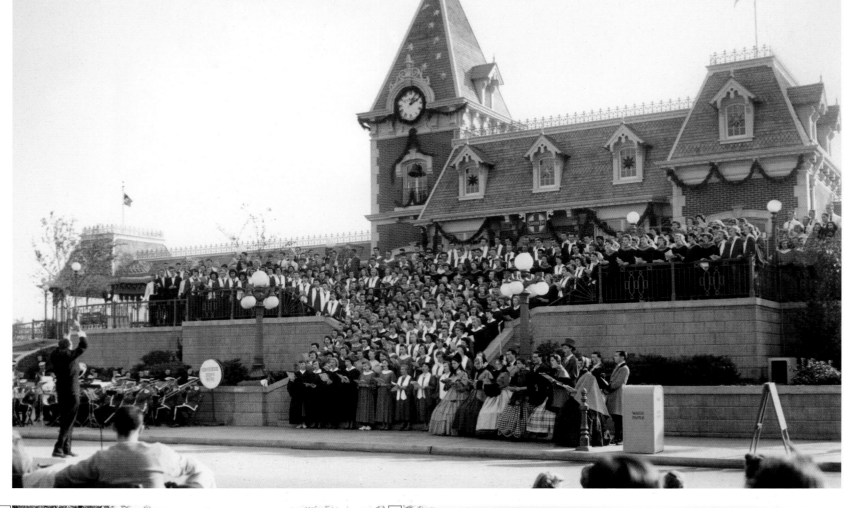

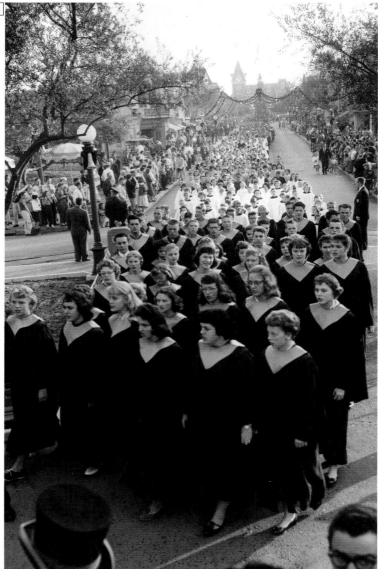

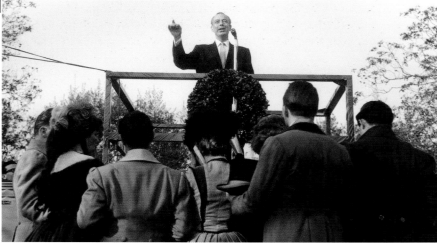

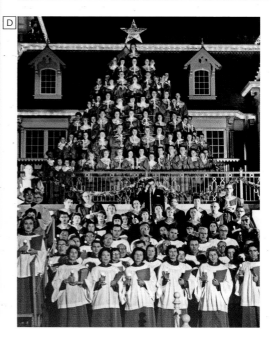

Disneyland

A *Massed Choirs Performance,
December 15, 1956*

B *Youth Choirs Processional,
December 24, 1958*

C *Dr. Charles C. Hirt and
Dickens Carolers,
December 24, 1958*

D *Candlelight Ceremony with
Dennis Morgan, narrator,
December 18, 1960*

E *Tour Guides as Star Carriers,
December 18, 1960*

F *Howard Keel, narrator
1987*

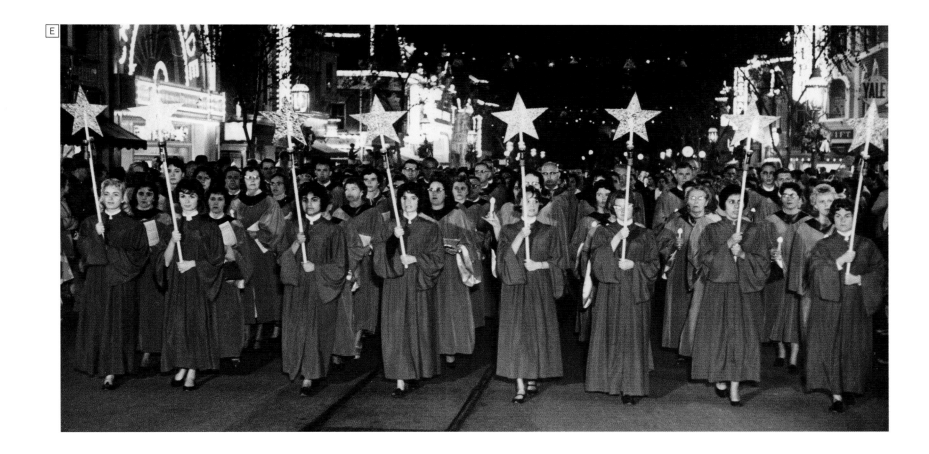

was invited to read portions of the biblical Christmas story between the singing of the classical hymns. This tradition has continued ever since, with famous celebrities including Cary Grant, John Wayne, Henry Fonda, Jimmy Stewart, Gregory Peck, Charlton Heston, James Earl Jones, Dick Van Dyke, Olympia Dukakis, and many others donating their eloquence to the program.

The "Living Christmas Tree" featuring the Western High School A'Capella Choir, was also incorporated into the Candlelight Ceremony in 1960 as a centerpiece for the massed choir. Western had presented their impressive choral program at the park the previous two years, on a specially constructed "tree" made of risers. It was so well received that they were given this annual place of honor in Candlelight gatherings for the next twenty-one years until their director, Alexander Encheff, retired in 1981. In 1982, the newly formed Disney Employee Choir (volunteer Disney Cast Members from the parks, studios, and Walt Disney Imagineering units) was selected to fill their place, an honor they have held ever since.

Over the years, the program has grown from a simple procession of candlelit carolers into a magnificent classical concert with a thousand-voice-strong massed choir, featuring the Living Christmas Tree, Disneyland Orchestra and Fanfare Trumpeters, guest bell choirs, soloists, sign language interpreters, celebrity narrators, and conductors. Aside from a short spell at the Fantasyland Theater (1999–2004), the production has been staged in that same Town Square location. Dr. Charles Hirt continued to direct the program well into the 1970s (before being assisted and then followed by several other very talented mass choir conductors, including James Christensen, Sheldon Disrud, Dr. Gary Bonner, Dr. Albert McNeil, Dr. Fred Bock, Bruce Healey, and Nancy Sulahian).

The popularity of the event in Disneyland made it a must-have for Walt Disney World Guests, and it debuted there at the inaugural holiday season of the Magic Kingdom on December 18 and 19, 1971. The Magic Kingdom version was originally presented in front of Cinderella Castle, before moving to the familiar location on Town Square in front of the Train Station, just as in Disneyland, with a Living Christmas Tree, the Dickens Carolers, and a celebrity narrator. The narrator in 1971 was actor Rock Hudson, who enjoyed participating so much that he went on to narrate there several more times. Candlelight remained at the Magic Kingdom until 1993, when it moved to the American Gardens Theatre in EPCOT (where it is still held each year). Disney Guests at EPCOT flock to the ceremony in ever-growing numbers to catch a performance on many nights each year, that starts around Thanksgiving and continues through the New Year, with multiple guest narrators participating throughout the season.

For both Guests and participants, Candlelight is a much-loved annual holiday tradition, and the majestic spectacle is a not-to-be-missed experience. Many come to hear the glorious music and view the spectacular decor, but for all of its grandeur, the event is particularly beloved for its simple message of peace and goodwill to all mankind.

Actor Howard Keel, who narrated the ceremony at both Walt Disney World and Disneyland in the 1980s, put it best: "I've never been a very religious person, but when you stand up there for all of those people with that incredible chorus and orchestra beside you, it's a wonderfully moving experience. In fact, I was so moved I could hardly speak."

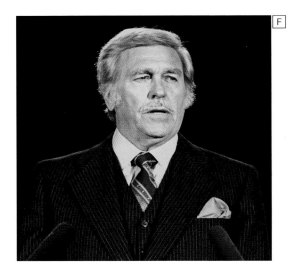

Magic Kingdom

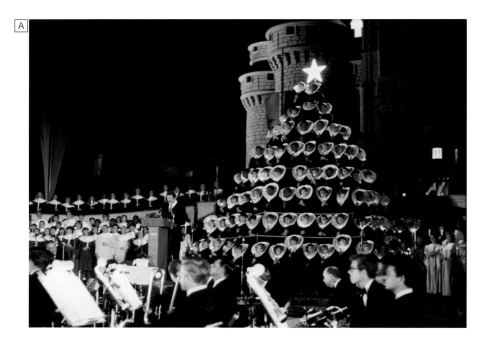

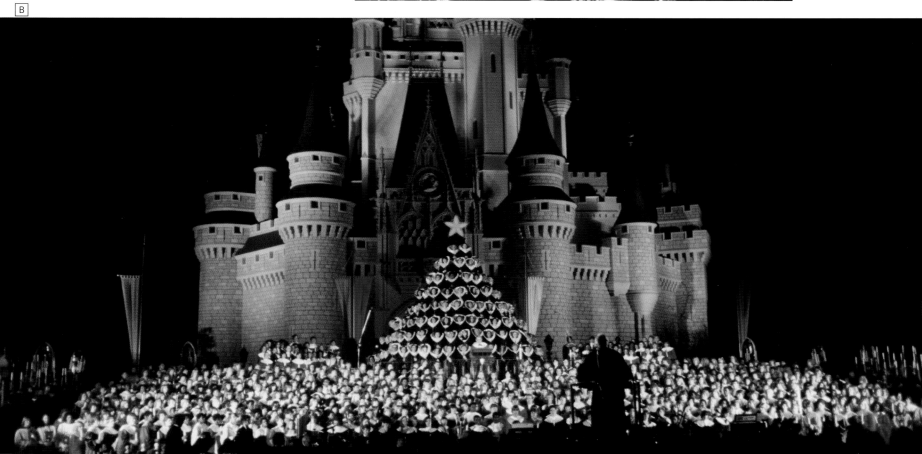

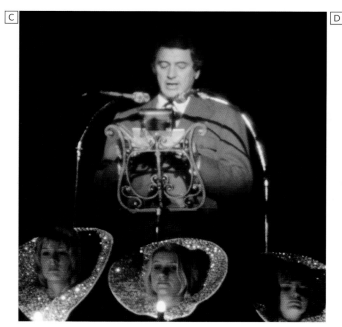

Magic Kingdom

E *Town Square*
 1983

F *Town Square, Dickens Carolers and*
 Living Christmas Tree
 1976

G *Town Square with Paula Zahn, narrator*
 1992

H *Town Square*
 1977

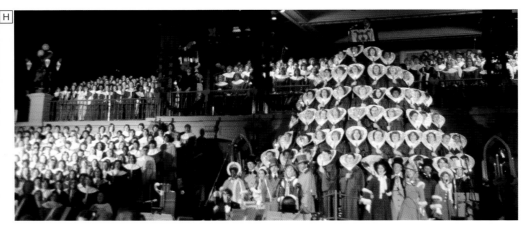

Candlelight

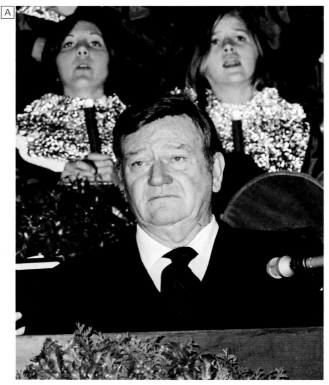

Disneyland Candlelight Narrators

A *John Wayne*
1971

B *Jimmy Stewart*
1975

C *Rock Hudson*
1976

D *Cary Grant*
1978

E *Jason Robards*
1981

F *Elliot Gould*
1979

Holiday Magic at the Disney Parks

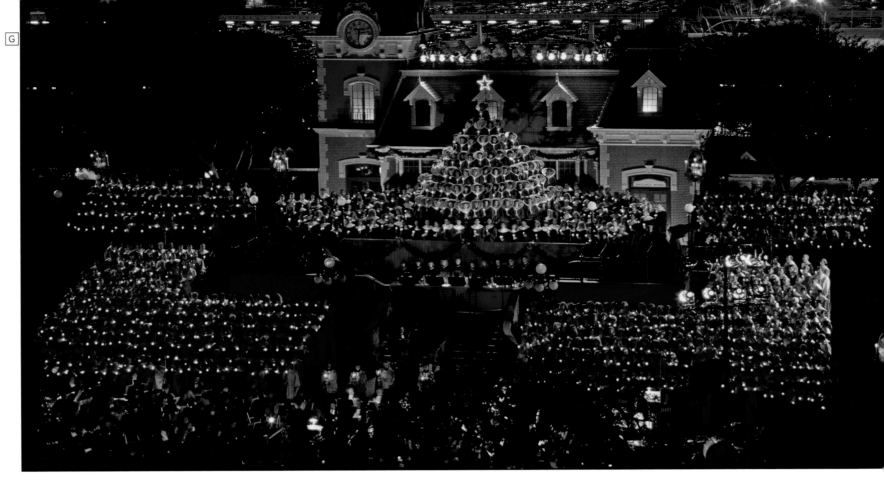

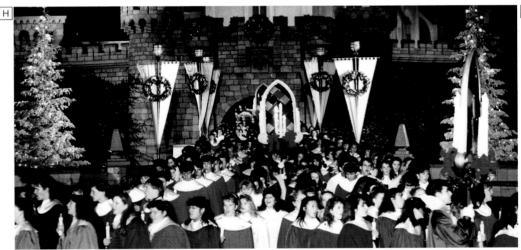

Disneyland

G *Town Square with Robert Urich, narrator
 1991*

H *Procession leaving Sleeping Beauty Castle, heading to Town Square
 1987*

I *Michael York, narrator
 1993*

J *James Earl Jones, narrator
 1990*

America Gardens Theatre, EPCOT

K *Phylicia Rashad, narrator
 2000*

Disneyland

A *Geena Davis,
 narrator
 2015*

B *Nancy Sulahian,
 director
 2006*

C *Processional on
 Main Street, U.S.A.
 2009*

D *Processional on
 Main Street, U.S.A.
 2015*

E *Hector Elizondo, narrator
 2006*

F *Processional wends through the crowds
 on Town Square
 2011*

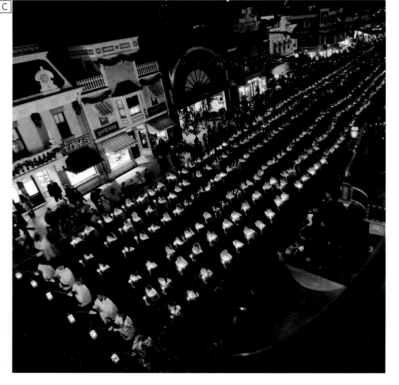

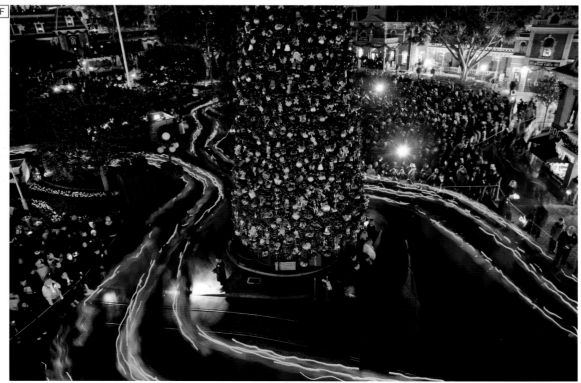

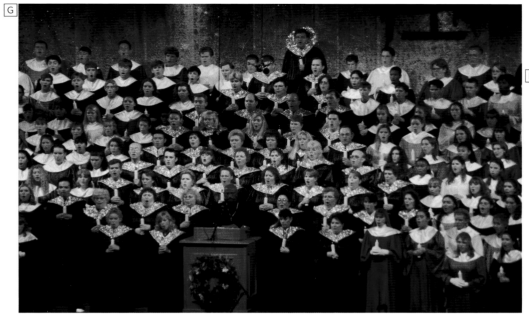

America Gardens Theatre, EPCOT

G *Massed Choirs with
Louis Gosset Jr., narrator
1995*

H *Herald Trumpeters
1995*

I *Dr. John V. Sinclair,
director
2009*

J *Jodi Benson, narrator
2018*

K *Whoopi Goldberg,
narrator
2014*

L *Full cast of performers
2009*

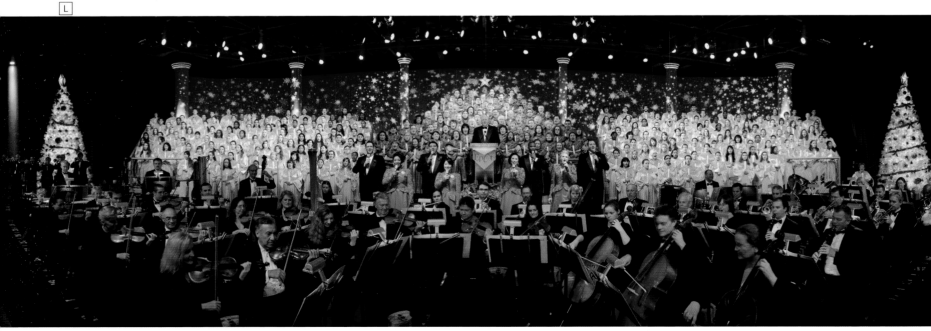

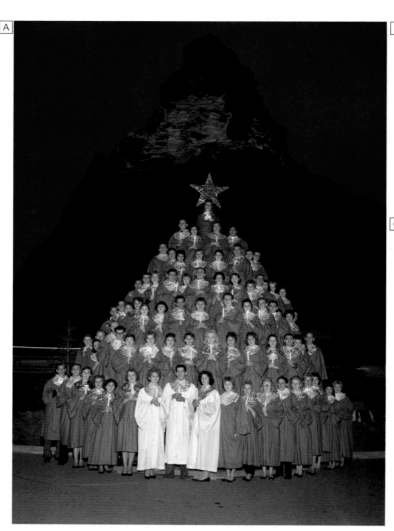

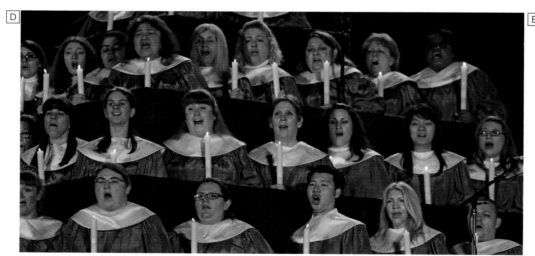

Living Christmas Tree, Disneyland

A Western High School A'Capella Choir
1960

B Town Square
1989

C Town Square
2009

D Town Square
2013

E Nancy Sulahian, director
2008

F Bruce Healey, director
2007

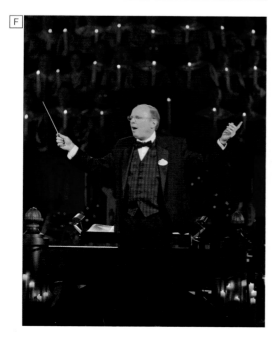

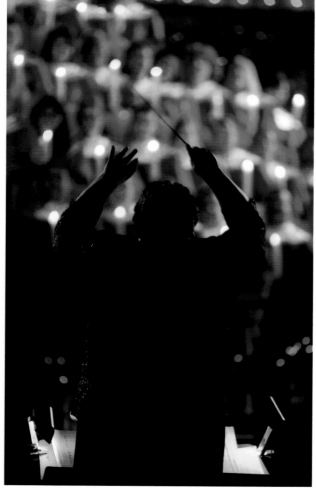

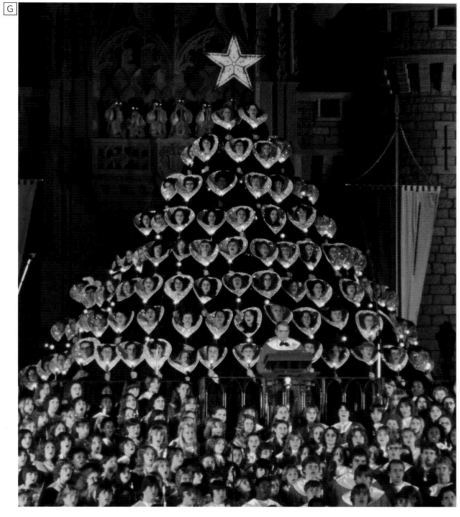

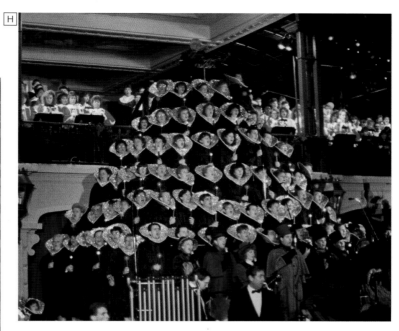

Living Christmas Tree, Walt Disney World

Magic Kingdom

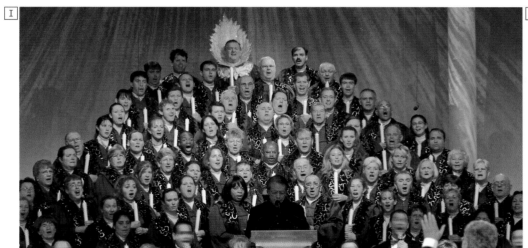

EPCOT

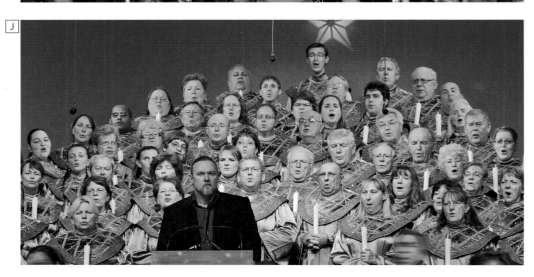

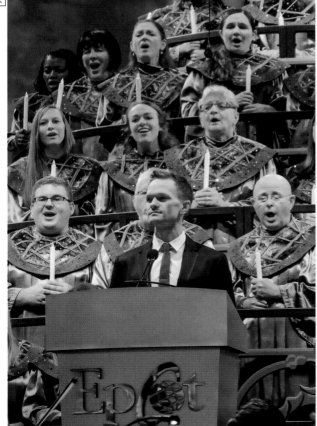

Disneyland
**Candlelight Dress Rehearsal,
December 1, 2016, after park closing**

A *Fanfare Trumpeters
atop Main Street Station*

B *The full Disney Employee Choir
fills the choir risers*

C *"Voice of Disneyland" Bill Rogers
stands in for the narrator during
dress rehearsals*

D *Nancy Sulahian, director*

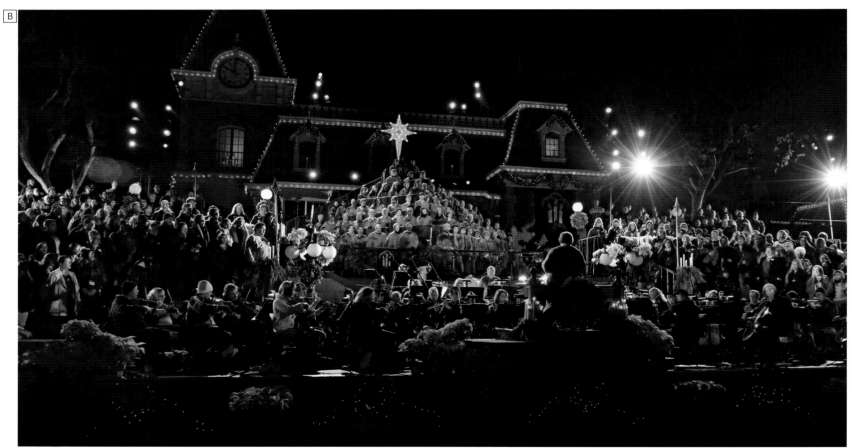

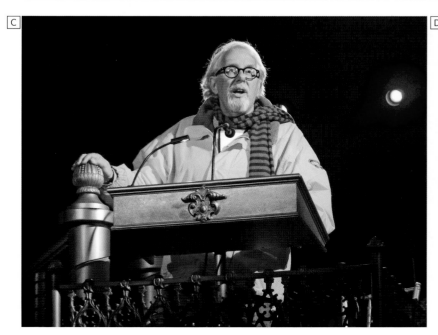

Disneyland
Candlelight Backstage Rehearsal

E Full rehearsal in the parade warehouse (day of performance) 2004

F John Forsythe, narrator 1989

G Dr. Gary Bonner, director 1991

H Jim Wilbur, Disney Employee Choir Director 2018

I Full rehearsal backstage (day of performance) 1991

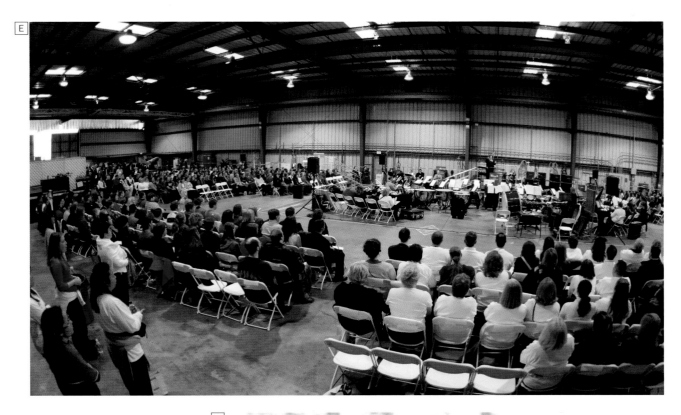

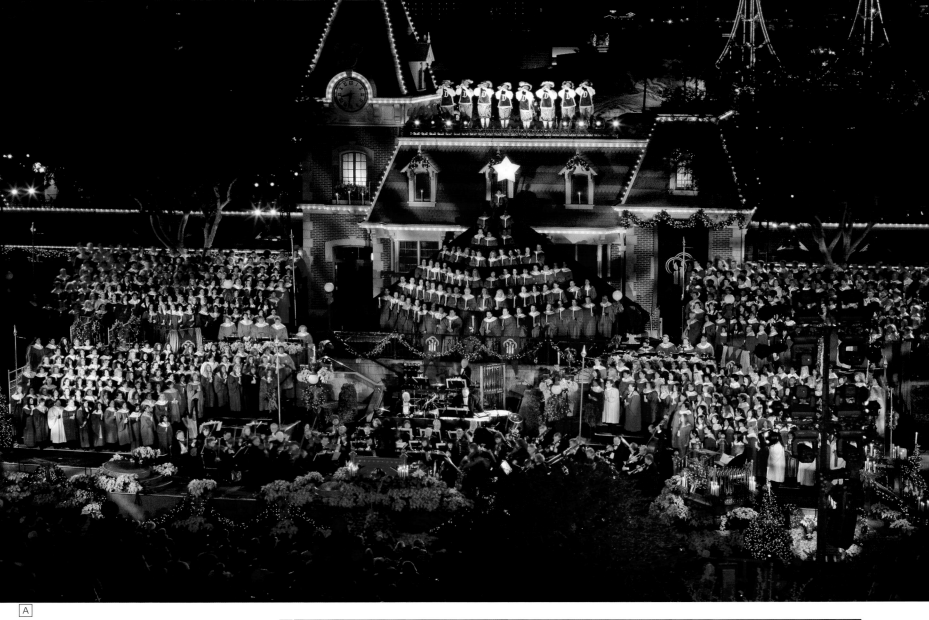

A

Disneyland

A Town Square
2005

B Gary Sinise,
narrator
2011

C Fanfare Trumpeters
2011

D Dick Van Dyke,
narrator
2005

E Marie Osmond,
narrator
2004

F Kurt Russell,
narrator
2012

G John Stamos,
narrator
2012

B

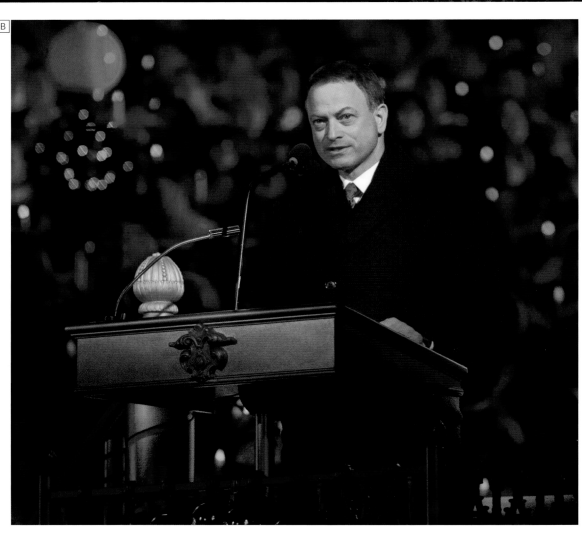

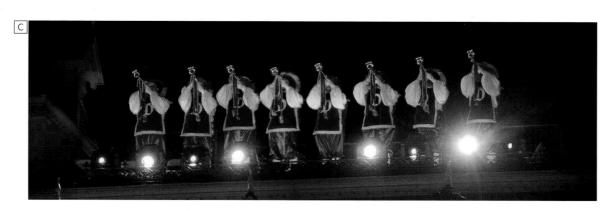

Party Time for the Holidays

Festive feasts and festivals, and the merriest of mouse-eared merrymaking

Disney parks host all sorts of special events throughout the year, ranging from artist signings and intimate dinners at a signature restaurant to festivals large enough to take over a whole park. No matter the size, though, the intent is to create a special experience—something a little bit different from the usual. Considering how much *we* have turned the winter holiday season into party time in our family and work environments, it is no surprise that there are many special holiday-oriented events at the Disney parks.

The biggest Disney holiday bash nowadays is Mickey's Very Merry Christmas Party, held at the Magic Kingdom. What started out as a one-night-only event in 1983 has grown and is now conducted over more than twenty-five nights, from shortly after Halloween to just before Christmas, and it has become so popular that party tickets—separate from regular park admission passes—are snapped up as much as six months ahead. The party takes over the whole park with many attractions operating, though there's usually a few creative tweaks to let Guests know elves are running the show for a change—lighting and projection effects, snowfall on Main Street, U.S.A., and updated background music, for example.

During the 1990s many onstage Cast Members would augment their regular costumes with red and white woolly scarves and hats. If not quite thematically pure, seeing those jolly, festive stripes on a Haunted Mansion costumed Cast Member brought just the right amount of fun and funny to the evening.

Mickey's Very Merry Christmas Party brings together all the seasonal spectacles of the Magic Kingdom: the Christmas parade, stage shows (including the grandest productions on the castle forecourt stage), and holiday fireworks, many of which are either exclusive to the event or are presented during regular operating hours only for a short period in late December. In past years, Rudolph was known to substitute for Tinker Bell during the fireworks show, red nose aglow, as he glided gracefully from the castle down to Tomorrowland. Characters appropriate for the celebration, like Scrooge McDuck, appear for photos and autographs, and classic characters will turn out in special winter party togs. Admission has typically included cookies and drinks (available around the park), and for several years Guests received a commemorative button.

Before the PhotoPass service was available, a professional photography firm was on hand to take Guest photos—an impressive undertaking given the numbers involved. But somehow all of those film rolls were tracked and the correct photograph would arrive in the mail a couple of weeks later.

EPCOT is now a regular host to large-scale festivals that overlay special experiences on the realms of Future World and World Showcase and extend the park's international and cultural perspectives. The first of those festivals was Holidays Around the World, which has been a firm fixture on the year-end calendar since 1995 (known as EPCOT International Festival of the Holidays since 2017). Described as "a celebration of stories and traditions that bring the world closer together at this time of year," performers at each World Showcase pavilion share how the people of each country celebrate at this time. Through the years, these celebrations have included Los Tres Reyes Magos (The Three Kings) in Mexico, Julenissen in Norway, the Monkey King in China, La Befana in Italy, the Daruma Seller in Japan, Taarj in Morocco, and Père Noël in France. Storytellers at The American Adventure pavilion share accounts of Hanukkah and Kwanzaa.

Restaurants around the park have often joined in by offering treats of the season; this concept was expanded significantly in 2016 with a series of pop-up dining locations serving Christmas dishes and (in the grand EPCOT tradition of toasting around the world) tinsel-topped tipples like cinnamon whisky eggnog, hot chocolate with peppermint schnapps, and caramel glühwein.

Magic Kingdom 2017

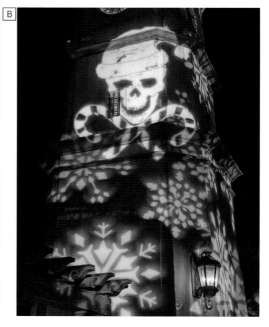

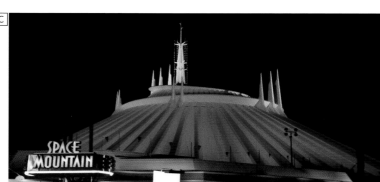

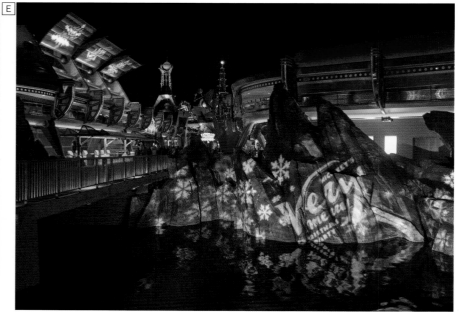

Mickey's Very Merry Christmas Party,
Magic Kingdom

A *Main entrance area*
 2008

B *Pirates of the*
 Caribbean
 2018

C *Space Mountain*
 2017

D *Main Street, U.S.A.*
 2016

E *Tomorrowland*
 2017

F *Main Street, U.S.A.*
 2016

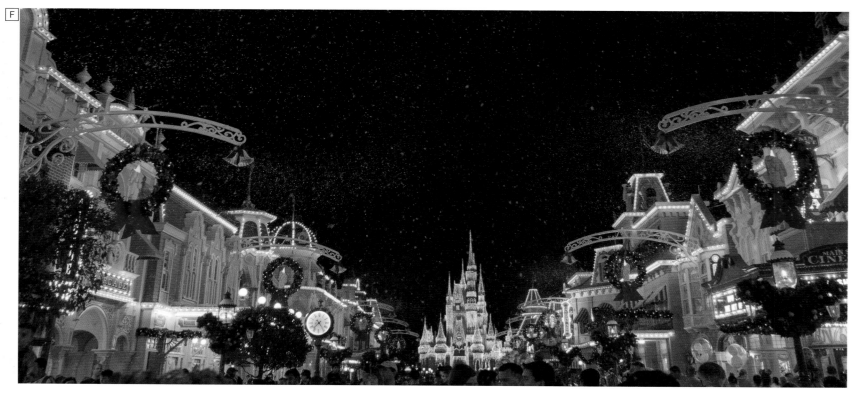

 Holiday Wishes
2017

I *Holiday Wishes*
2018

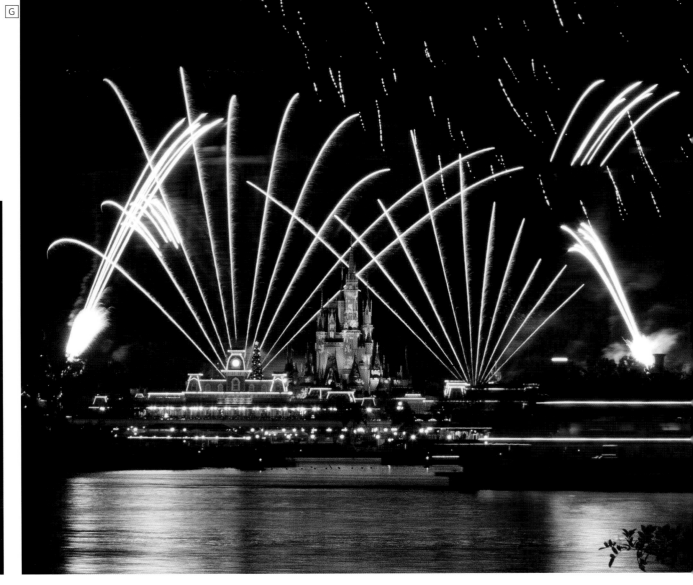

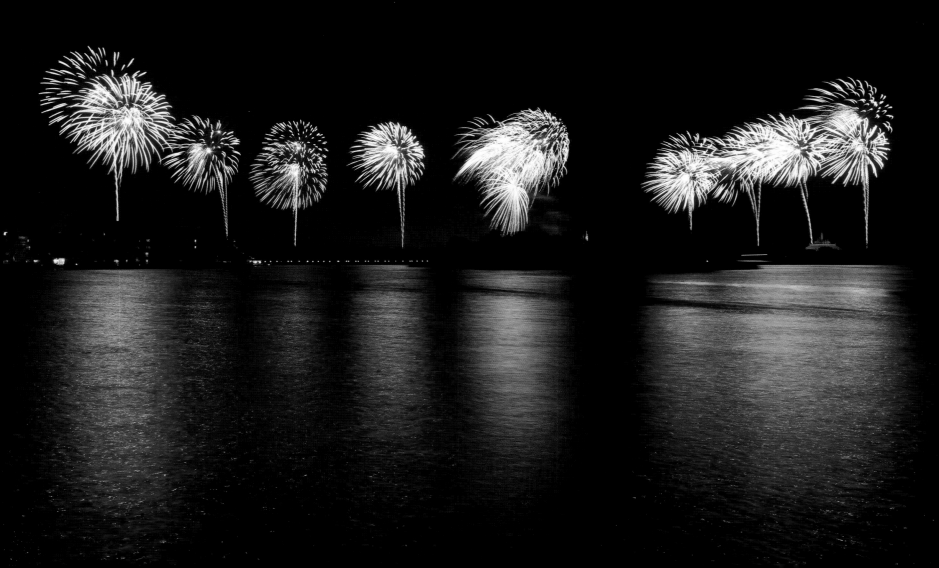

Mickey's Very Merry Christmas Party, Magic Kingdom

A *Holiday Cinnamon Roll*
2017

B *Sandy Claws Cake Push-Pop*
2017

C *Red Velvet Peppermint Cupcake*
2017

D *Yule Log*
2017

Holidays Around the World, EPCOT

E *Kwanzaa Storyteller, American Adventure*
2004

F *Hanukkah Storyteller, American Adventure*
2004

G *Helga and the Nutcracker, Germany*
2010

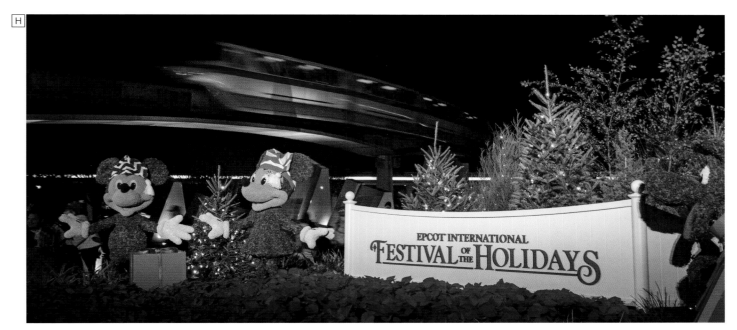

International Festival
of the Holidays, EPCOT

H Main entrance area
2017

Holidays Around
the World, EPCOT

I Julenissen, Norway
1995

J Santa Claus, Norway
2000

K Santa Claus, Canada
1995

L Taarj Drummer, Morocco
1995

M Father Christmas,
United Kingdom
2010

Building on the concept of Holidays Around the World, Disney California Adventure debuted Festival of Holidays in 2016. Here, the themed dining experiences are more prominent, with pop-up food counters serving upward of sixty special menu items: roast turkey sliders, turkey potpie and cranberry, mocha yule logs, gingerbread, sticky toffee pudding, pumpkin spice hot chocolate, bourbon cider, and more. Musical entertainment selected this time of year celebrates holidays from all around the world, especially reflecting the strong influence in California of Latin and Asian cultures.

Many parks and resort hotel restaurants create holiday menus throughout the season, of course, augmenting their usual bills of fare with themed gastronomic delights—most often for the dessert portion of the meal—and candy store shelves are piled high with sweet treats shaped like Santa, flavors of cinnamon and peppermint, jauntily striped candy canes, and all manner of holiday icons molded from chocolate. Celebrating a grand European tradition, restaurants in Disneyland Paris offer extra-special dinners for Réveillon de Noël (Christmas Eve) and Réveillon de la Saint-Sylvestre (New Year's Eve)—lavish buffets and sumptuous five-course menus served with extra sprinklings of style and sparkle. Whether they are signature or quick service (or simply an outdoor vending cart on Main Street, U.S.A.), most dining locations find some way to enhance their offerings with a winter twist.

The biggest party night of the year is New Year's Eve itself, and Disney resorts all around the world have usually toasted this turn of the calendar in style—through special restaurant menus, drinks, and abundant supplies of party hats and noisemakers, and often concluding it all with a particularly grand fireworks spectacle. The Magic Kingdom–style parks and EPCOT are renowned for their New Year's celebrations, sometimes becoming so popular that the parks reach full capacity. Counting down to a new year was, for many years, the nightly finale at the Pleasure Island complex at Walt Disney World, and so December 31 itself was made extra-special with liberal libations and a memorable climax of pyrotechnics and confetti. US television networks have often incorporated live telecasts from the Disneyland Resort or Walt Disney World in their New Year's Eve schedule, with celebrity hosts and top musical performers. Disneyland has been known to chime in midnight twice—the first at nine o'clock for an East Coast television audience, and then again three hours later when the clocks are truly striking twelve out West.

And the party season is not necessarily even over by early January. Lunar New Year is a major celebration in Shanghai Disneyland and Hong Kong Disneyland and has also become a tradition at Disney California Adventure. Parks and resort hotels are decorated, characters will appear in special costumes, performances of traditional Lunar New Year entertainment abound, and restaurants offer special menu choices. Guests write their own New Year's wishes on special wishing cards, as they look forward to the twelve months ahead. And since the Chinese zodiac associates each year with an animal, there are many opportunities for Disney characters to take center stage. Goofy and Pluto, for example, had lots of fun welcoming the Year of the Dog in 2018.

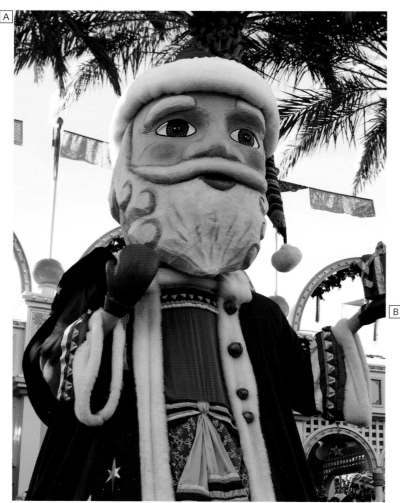

One last holiday party worth noting, and one Guests may still hear Disney Cast Members reminiscing about, is the Disney Family Holiday Party. Essentially the office Christmas party, these were private evenings in Disneyland and in the Magic Kingdom for all Disney cast and crew in the area, along with their families. To allow as many employees as possible to enjoy the parks as Guests, executives and management were recruited to work in shops and operate attractions—often with entertaining results. Once upon a time, the Disney cast was small enough to fit all together at once in one park. Then, as the company grew, the party expanded to multiple dates and, eventually, outgrew the logistical practicalities of private-party nights altogether. But the memories of a favorite company vice president serving hot dogs or sweeping trash still linger in the minds of those lucky enough to have experienced and witnessed these magical evenings.

Festival of Holidays,
Disney California Adventure

A Viva Navidad
2015

B Festival of Holidays photo location
2017

Holiday Beverages

C Florida Orange Groves Sparkling
Cranberry Wine, EPCOT
2017

D Canadian Ice Wine Flight, EPCOT
2017

E "Christmas Cake" Drink,
Disney Cruise Line ships
2014

F Champagne, Disneyland Hotel,
Disneyland Paris
2016

G Frozen Coffee with TAP 357 Maple
Rye, EPCOT
2017

H Hot Holiday Drinks,
Shanghai Disneyland
2017

I Christmas Coffee,
Hong Kong Disneyland
2016

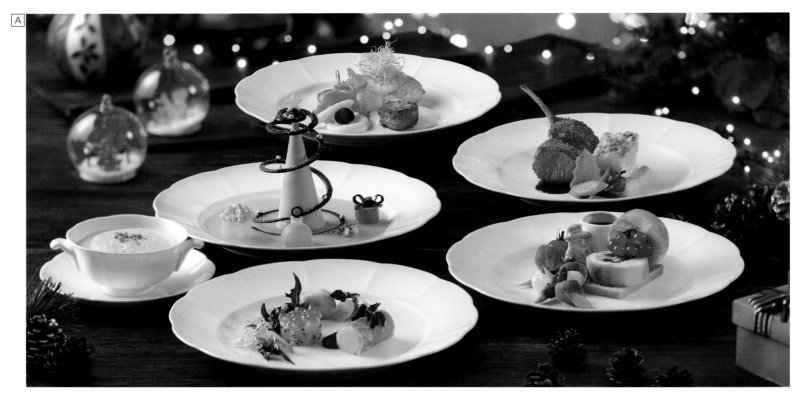

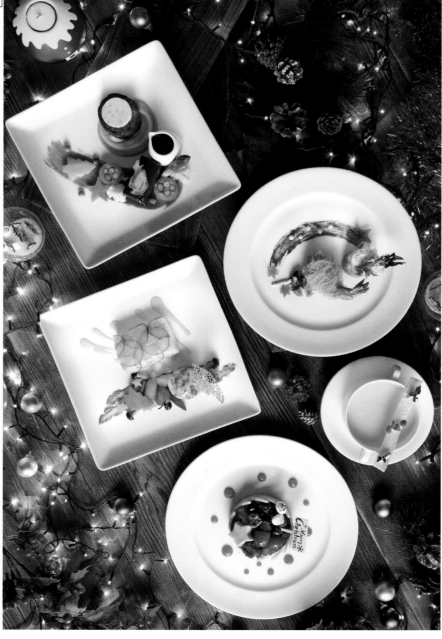

Holiday Feasts

A *Hong Kong Disneyland*
2016

B *Holiday Prime Rib of*
Angus Beef, Carthay
Circle Restaurant, Disney
California Adventure
2016

C *Hong Kong Disneyland*
2016

D *Turkey Leg Feast,*
Shanghai Disneyland
2017

Holiday Desserts

E **Holiday Ginger Caramel Monkey Bread, Carthay Circle Restaurant,** *Disney California Adventure* 2016

F **Christmas Dessert,** *Disney Cruise Line ship,* Disney Dream 2014

G **Holiday Mickey Dessert,** *Hong Kong Disneyland* 2016

H **Gingerbread Beignets with Eggnog Crème Anglaise, Cafe Orleans,** *Disneyland* 2013

I **Gingerbread Chocolate Souffle,** *Grand Floridian Resort & Spa, Walt Disney World* 2001

J **Holiday Roulade,** *EPCOT* 2017

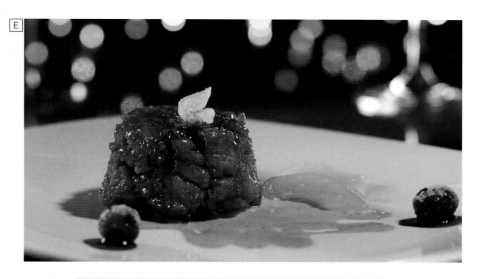

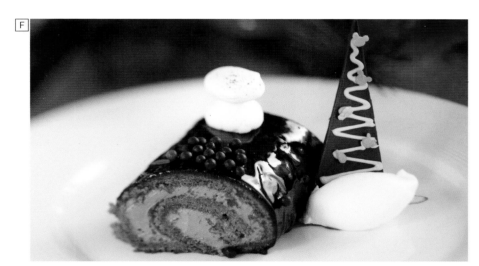

A

B

C

D

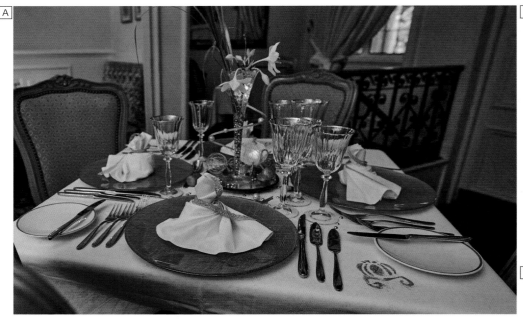

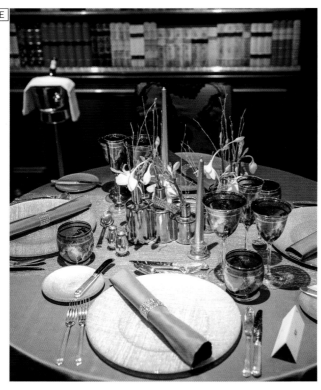

Walt's - an American Restaurant

Second Seating

Adult Menu

Slow-baked egg, gingerbread emulsion and smoky bacon crisps
Crab meat ravioli, langoustine escabeche, vinaigrette jelly, orange foam and salad from the sea
Newburg-style John Dory, buttered-braised winter vegetables, black bread crumble
Interlude:
Green apple sorbet, Jim Beam Bourbon
Canon of lamb stuffed with pepper jack cheese,
mac 'n' cheese with truffled artichoke cream, mixed leaf salad
Cheese Board:
Fourme d'Ambert, Chaource and Beaufort
Festive Dessert
Coffee and petits fours

Children's Menu

Chef's Appetiser
Marinated salmon, preserved lemon cream, crispy avocado dipping sticks
Chicken supreme with porcini mushroom sauce, potatoes dauphinoise and mixed vegetables
Festive Dessert
Old-fashioned sweets

Réveillon de Noël,
Disneyland Paris

A B L'Auberge de Cendrillon
2014

C Le Bistrot Chez Rémy
2014

D Walt's—an American
restaurant
2016

Disneyland Hotel,
Disneyland Paris

E Founders Club
2015

Shanghai Disneyland Hotel

F Aurora Christmas Feast
2017

G Lumiere's Kitchen
Christmas Buffet Feast
2017

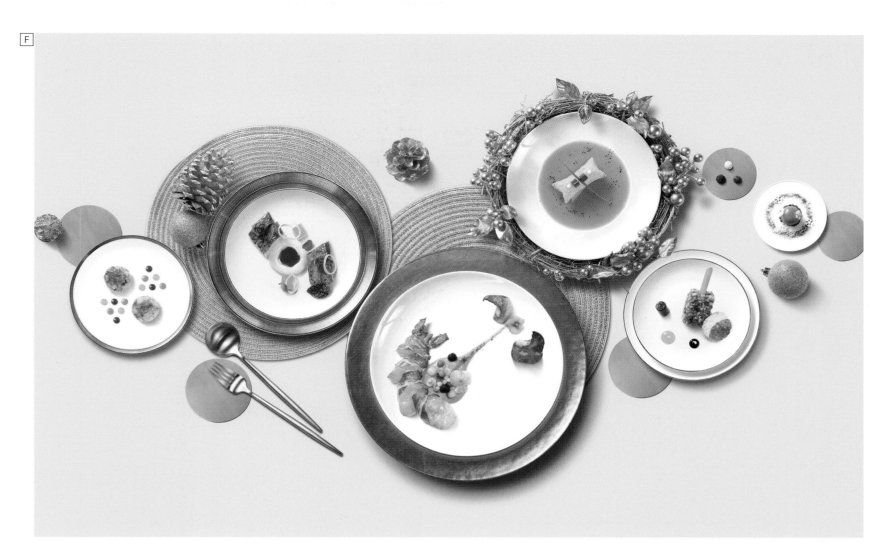

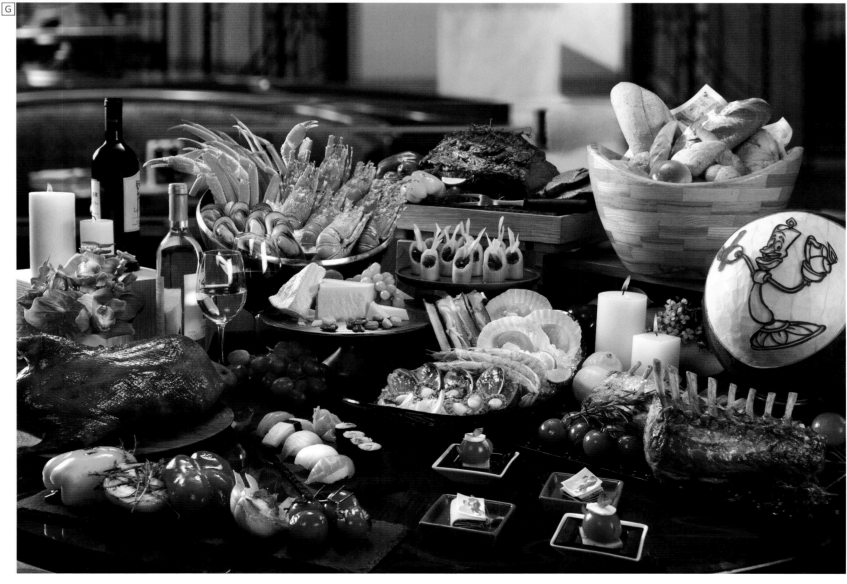

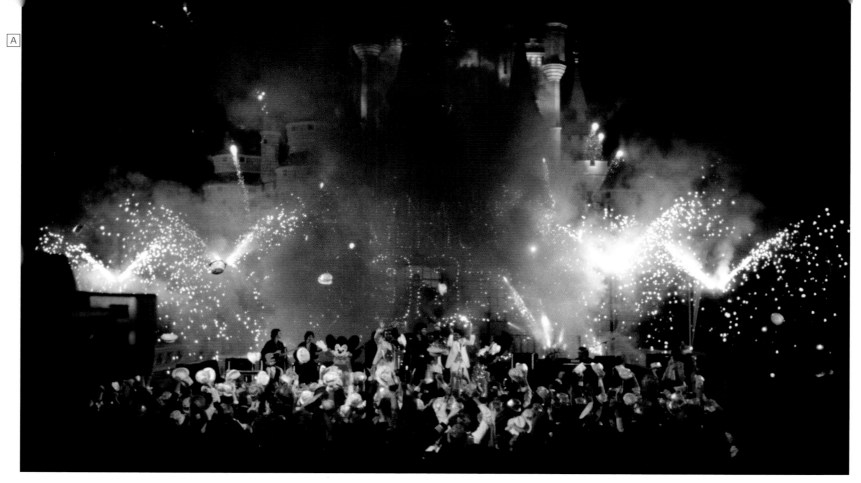

CBS New Year's Eve television specials, Magic Kingdom

A *Gladys Knight & The Pips and Eddie Rabbitt*
December 31, 1982

B *Gladys Knight*
December 31, 1982

C *Janie Fricke*
December 31, 1983

D *Dance troupe*
December 31, 1983

E *Chaka Khan*
December 31, 1984

New Year's Eve

F *Disneyland*
Special event ticket
December 31, 1957

G *Disneyland*
December 31, 1970

H *Disney Cruise Line ship*, Disney Wonder
December 31, 1999

I *EPCOT*
December 31, 1990

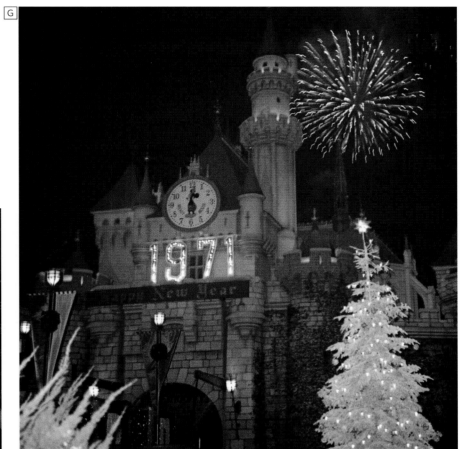

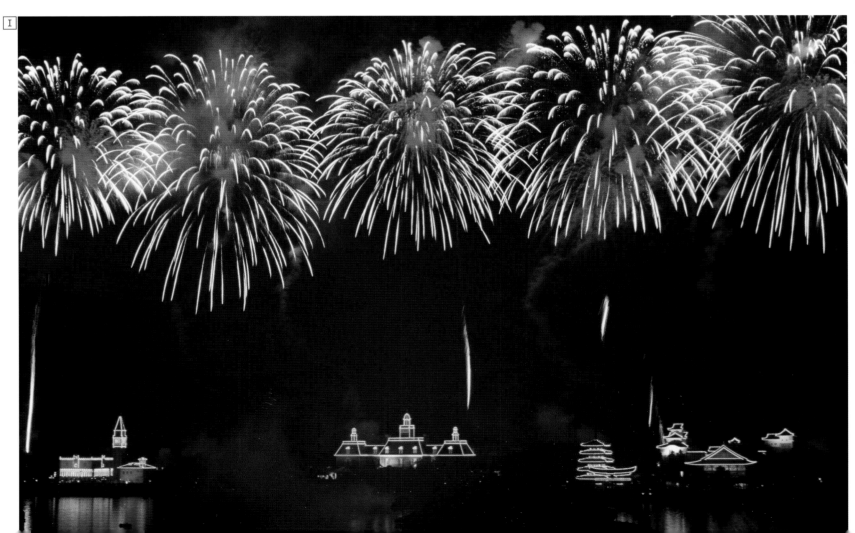

*Chinese New Year,
Shanghai Disney Resort*

A *Disneytown, Year of the
Rooster (2017)*

B *Main entrance area, Year
of the Pig (2019)*

C *New Year Wishes show,
Year of the Rooster (2017)*

D *New Year Feast, Year of
the Dog (2018)*

*Chinese New Year,
Hong Kong Disneyland*

E *Town Square, Year of the
Rooster (2017)*

F *New Year Feast, Year of
the Dog (2018)*

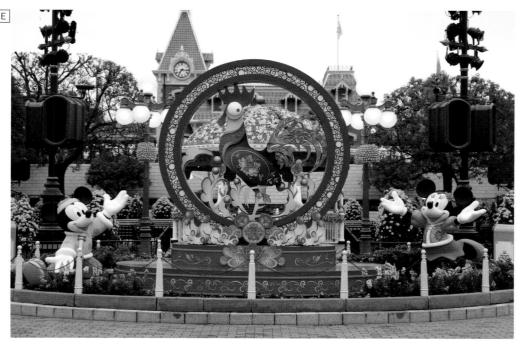

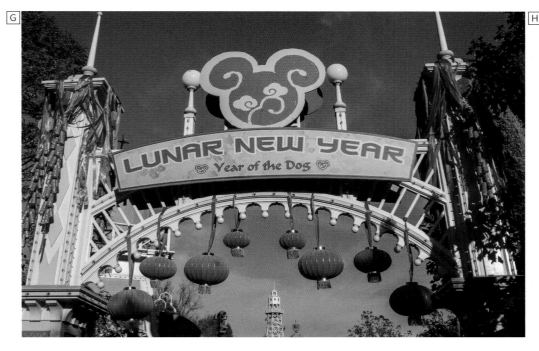

Lunar New Year,
Paradise Gardens Park,
Disney California Adventure

G H Year of the Dog (2018)

I Decor detail, Year of the Dog (2018)

J Shanghai Disneyland–branded balloons for sale, Year of the Dog (2018)

K Lucky Wishing Wall, Year of the Dog (2018)

L Decor detail, Year of the Dog (2018)

M N Year of the Pig (2019)

O Mulan's Lunar New Year Procession, Year of the Pig (2019)

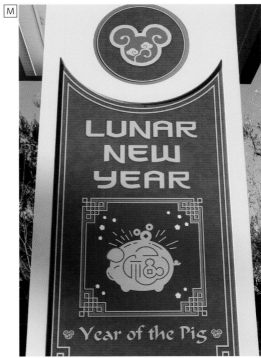

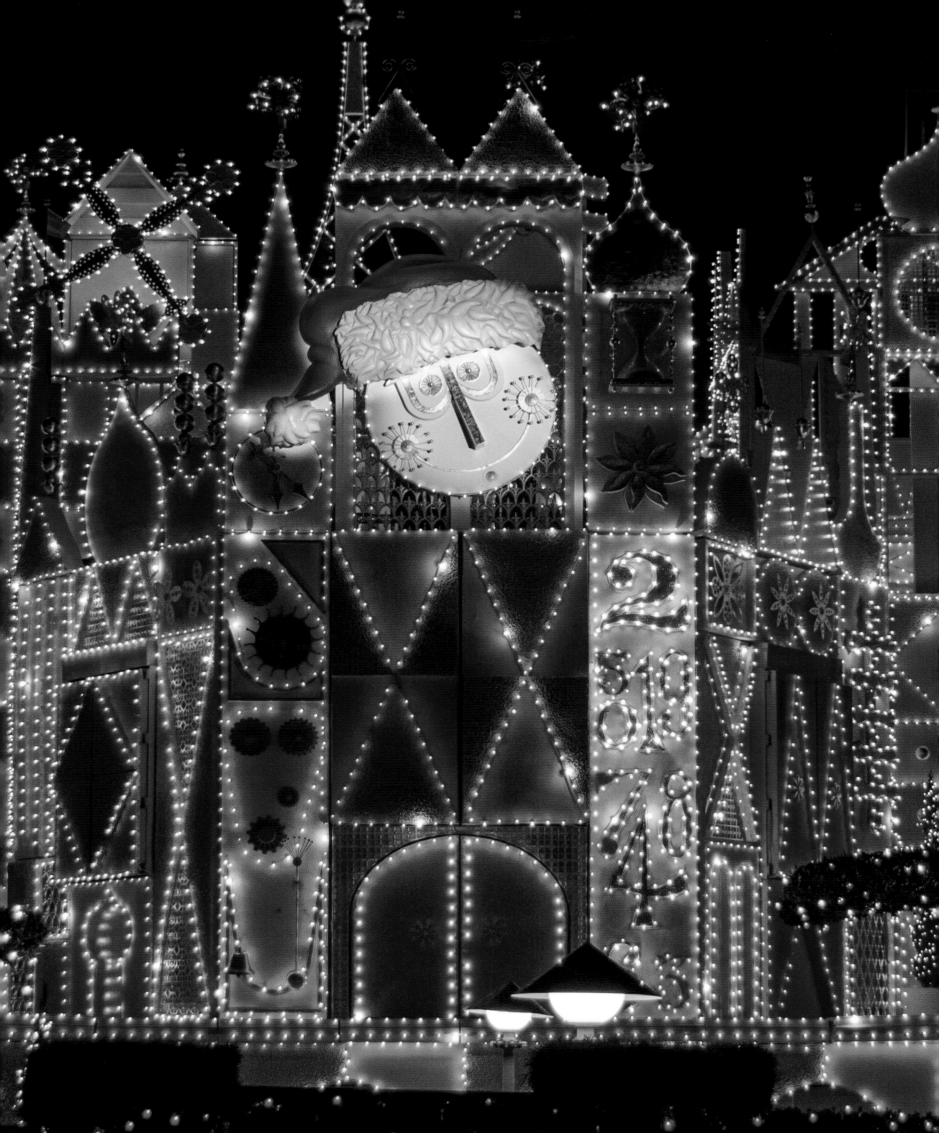

Magical Transformations

Unwrapping Disney's most dazzling worlds of winter holiday wonder

The environment of a land at one of the parks and, especially, the setting inside an attraction are put together with great care. Everything Guests see and hear is tied into the story line, which means that changes to that narrative are a big deal. And so, aside from an occasional festive decoration or musical update (Christmas carols from the organ at the Swiss Family Treehouse, for instance), most attractions remain in their usual, familiar, classic state through the holidays.

There are a few cases, however, where the autumn and winter holiday seasons bring magical makeovers, transforming some of those familiar attractions into something new and different. Jungle Cruise becomes Jingle Cruise, and global holiday celebrations through the eyes of its children transfigure It's a Small World. It might be quite subtle, as with the miniature trees, garlands, and wreaths added to Storybook Land Canal Boats scenes in Disneyland. Or it may be epic in scale, as were the Osborne Family Spectacle of Lights in Disney's Hollywood Studios. Plus, Jack Skellington's metamorphosis of the Disneyland and Tokyo Disneyland Haunted Mansions deserved a chapter all of its own here.

The notion of wholesale makeovers for an attraction, though, began with those silly singing country bears at the Country Bear Jamboree. The attraction was an immediate hit in 1971 as an opening day draw for the Magic Kingdom, before debuting in Disneyland just six months later and opening with Tokyo Disneyland in 1983. As a theatrical presentation, it was also a natural candidate for periodic show updates. Fresh costumes and programming for the animation could be swapped in quickly, so Walt Disney Imagineering created the Country Bear Christmas Special for the 1984 holiday season in Disneyland and in the Magic Kingdom. Tokyo Disneyland followed in 1988 with a similar presentation called Jingle Bell Jamboree.

Disneyland
It's a Small
World Holiday
2016

All of the usual bear-band cast have roles in the holiday version, now decked out in their winter togs, including the comedy trio of Melvin, Buff, and Max hanging on

the theater wall. In fact, Melvin the moose's rendition of "Rudolph the Red-Nosed Reindeer" (voiced by Frank Welker) kicks off the proceedings, much to the dismay of Max the actual deer, sporting a red light bulb on his nose. Henry is master of ceremonies (voiced by Pete Renaday), and opens the show with "It's Beginning to Look a Lot Like Christmas," ably accompanied by Gomer on the piano; he then joins the Five Bear Rugs for "Tracks in the Snow." The Rugs return a few more times in between the solo acts that follow.

Poor, hapless Wendell sings "The Twelve Days of Christmas" (sort of), followed by the ample and flirtatious Trixie's soulful "Hibernatin' Blues." Liver Lips McGrowl channels the King himself in "Rock and Roll Santa," with Terrence (and his pet penguin) shivering his way through "Blue Christmas." The Sun Bonnets—Bubbles, Bunny, and Beulah—deliver a sparkling "Sleigh Ride," then Ernest and the Rugs sing "Hungry as a Bear." A high point in the presentation, literally, has Teddi Barra descend from the ceiling on a swing as she croons "The Christmas Song" (Henry is smitten), and then Big Al delivers a woebegone "Another New Year." After that most of the cast returns for an ensemble finale of "Let it Snow," "Rudolph the Red-Nosed Reindeer," and "Winter Wonderland."

Henry opens the Tokyo Disneyland production with "Jingle Bells," Trixie sings "Merry Little Christmas," Big Al's big blue number is "Auld Lang Syne," and in the finale "Santa Claus Is Coming to Town" takes the place of "Let It Snow." Otherwise the program in Tokyo Disneyland is essentially the same as the US version, save for a number of the songs being sung in Japanese.

In Disneyland, the Country Bear Christmas Special was presented for the last time during the 2000 holiday season, before the attraction closed in the summer of 2001. Walt Disney World last presented its version of the show in 2005. Tokyo Disneyland still includes Jingle Bell Jamboree, however, placing it in the rotation of three Country Bear shows it presents during the year, as part of the holiday celebrations there.

Country Bear Christmas Special,
Magic Kingdom

A Melvin
1984

B Henry, Master of Ceremonies
1984

C Trixie
1984

D Liver Lips McGrowl
1984

E Terrence
1984

F The Sun Bonnet Trio (Bubbles, Bunny, and Beulah) and
the Five Bear Rugs (Zeke, Zeb, Ted, Fred, and Tennessee)
with baby Oscar
1984

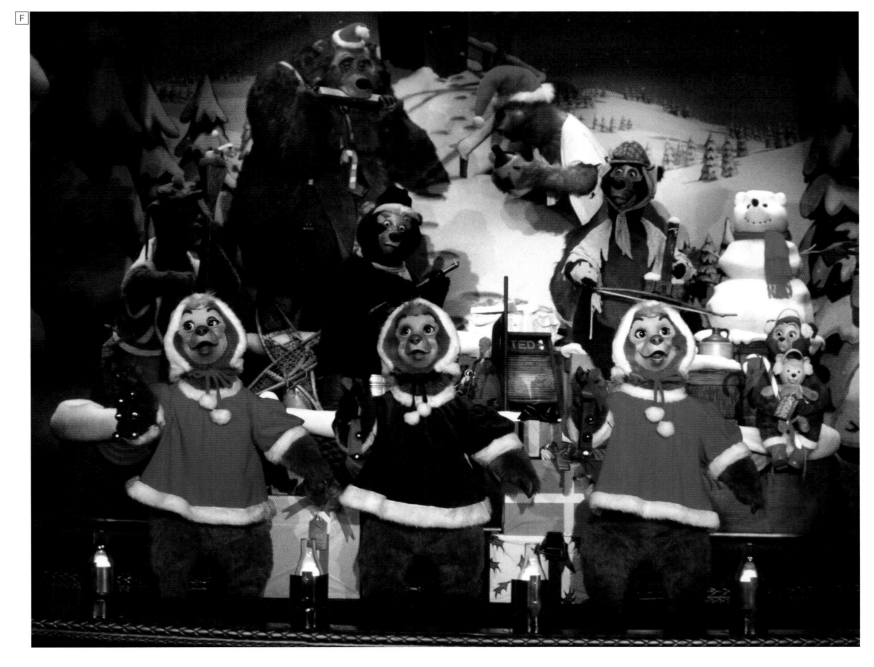

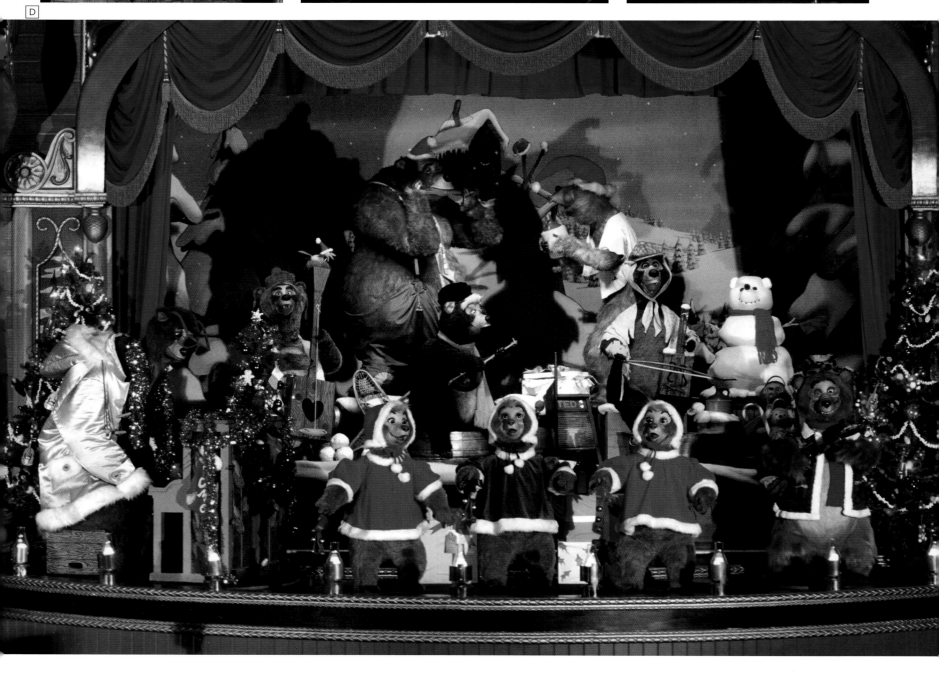

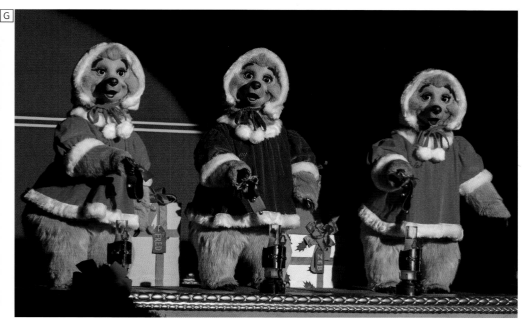

Country Bear Christmas Special,
Magic Kingdom

A Ernest
 1984

B Teddi Barra
 1984

C Big Al
 1984

D Finale: Gomer and Wendell join the Five Bear
 Rugs, baby Oscar, and The Sun Bonnet Trio
 1984

Jingle Bell Jamboree, Tokyo Disneyland

E Melvin, Buff, and Max H Zeb
 2017 2018

F Wendell I Tennessee
 2018 2018

G The Sun Bonnet Trio J Baby Oscar
 (Bubbles, Bunny, and Beulah) 2018
 2018

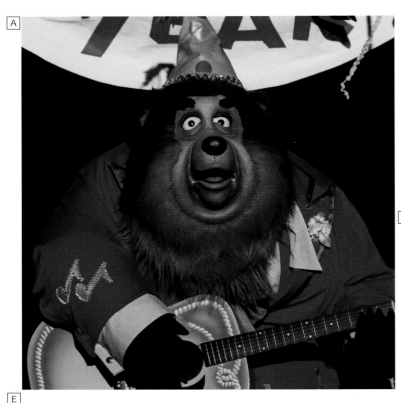

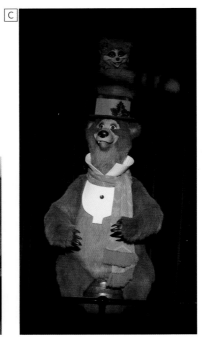

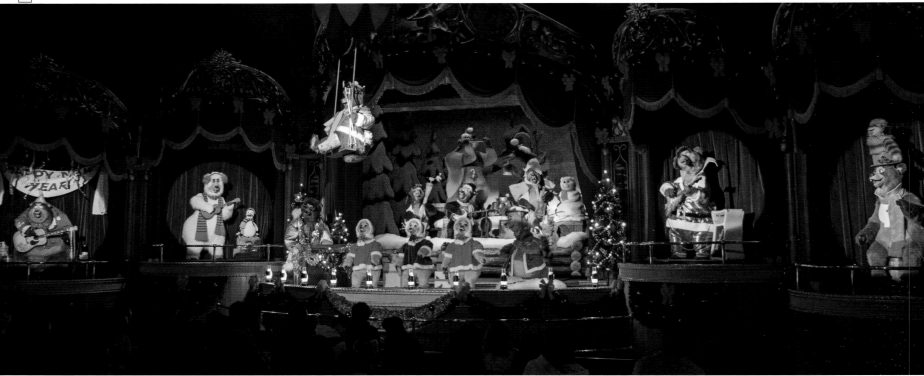

Jingle Bell Jamboree, Tokyo Disneyland

A Big Al
 2018

B Sammy
 2018

C Henry and Sammy
 2018

D Teddi Barra's cast
 2018

E Finale with the full cast
 2017

F G Attraction entrance
 2018

Walt Disney realized that what makes Disneyland unique and different are the details. Inspired by his fascination with miniatures, Storybook Land Canal Boats has been celebrating the holidays in its own special way since 1997. The Resort Enhancement team brings the holidays to each setting with a delicate balance of subtle storytelling and handmade decorations, with the hope that all the characters live merrily ever after.

However subtle, these tiny details must still support and enhance the story of each miniature set. In Pinocchio's village, Geppetto, master toy maker, is hard at work for his busy Christmas season, and only has time to decorate his toy shop just a little. The villagers around him, however, have put wreaths on their doors, hung garlands on the buildings, and put a Christmas tree in Town Square. And of the Three Little Pigs, the only house left standing was the one made of bricks, which is why Guests can find Christmas decorations only on Practical Pig's house. The Seven Dwarfs, meantime, have decorated a tree with jewels from their mine, and have filled seven tiny stockings with gifts.

And one little piece of trivia—this is where to find the smallest Christmas tree in Disneyland, at just four inches tall!

Storybook Land Canal Boats, Disneyland

H *Practical Pig's house 2018*

I *White Rabbit's house 2018*

J *Toad Hall 2018*

K L *London Park 2018*

M *Geppetto's woodshop 2018*

N *Snow White's cottage 2018*

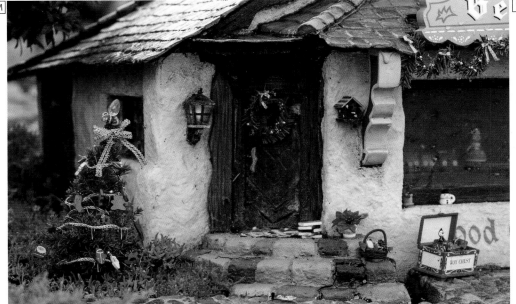

"Sailing with the Yuletide since 1938": The Jungle Cruise skippers of Adventureland look forward, and backward, to celebrating the holiday season with a slew of care packages from their loved ones, to cure a serious case of homesickness. But the eagerly expected holiday cargo has been accidentally jettisoned over the jungle. With a healthy dose of creativity, and tape (lots of tape), the skippers have decorated their boats and the boathouse for the no-snow occasion. It's *jungle* all the way!

The real entertainment of this holiday makeover—presented since 2013 at Walt Disney World and from 2013 through 2016 in Disneyland—comes, of course, in the skippers' spiels: they're a veritable raft of corny jingle jokes and peppermint puns, many of them shared alongside the photographs here.

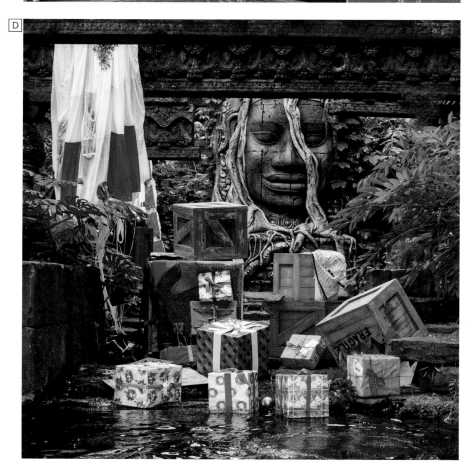

Jingle Cruise

Magic Kingdom

A *"Christmas comes but once every twelve minutes."*
2017

B *"Like any good New Year's resolutions, these will be forgotten in two weeks."*
2015

C *"The chimps are always ape-propriately dressed for the holidays."*
2015

D *"Those wrapped gifts must have washed up with the high Yuletide."*
2015

Disneyland

E *"I'll be your ho-ho-host for twelve days and one silent night."*
2015

F *"Those candy canes are in mint condition."*
2016

G *"Celebrating Piranukkah, the festival of bites."*
2016

H *"This is what happens when you put your heads together, and come up with a bright idea."*
2014

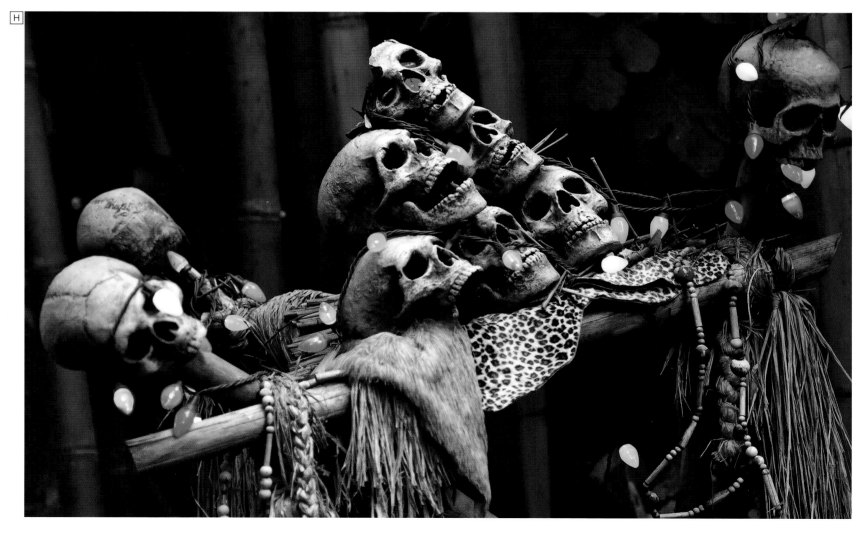

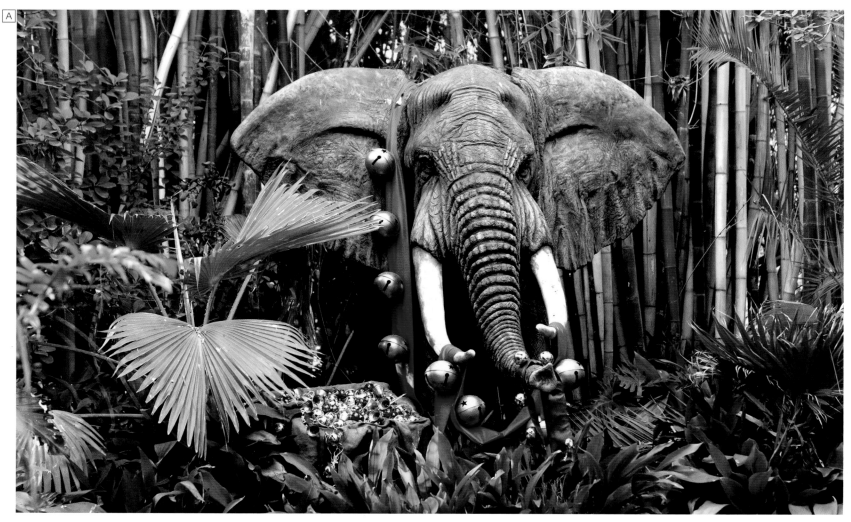

Jingle Cruise, Disneyland

A *"Looks like we discovered a new breed . . . the African Bell-iphant."*
2015

B *"The baboons are going ape over our Santa costumes."*
2014

C *"There's nothing like snow on the side of the hill, and that's nothing like snow on the side of the hill."*
2016

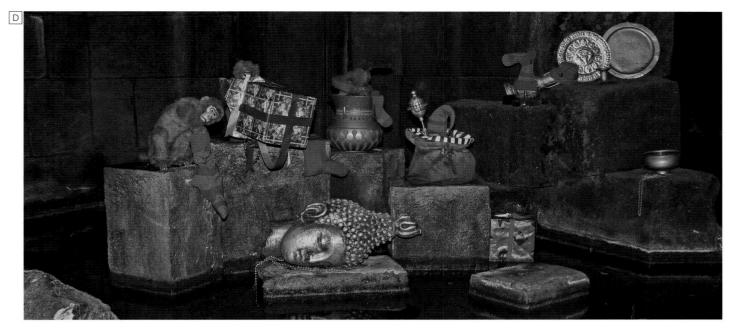

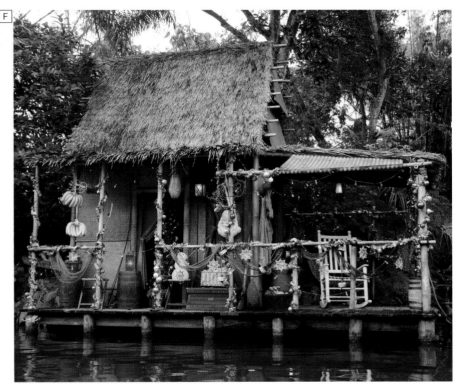

Jingle Cruise, Magic Kingdom

D "Monkeys: the perfect stocking stuffer."
2014

E "Fruitcake, why'd it have to be fruitcake?"
2014

F "I'm dreaming of a tropical Christmas."
2018

G "Wanda is all about preserving the holiday spirit."
2018

H "It's a Lolly Holiday with Yule Log."
2018

Magical Transformations

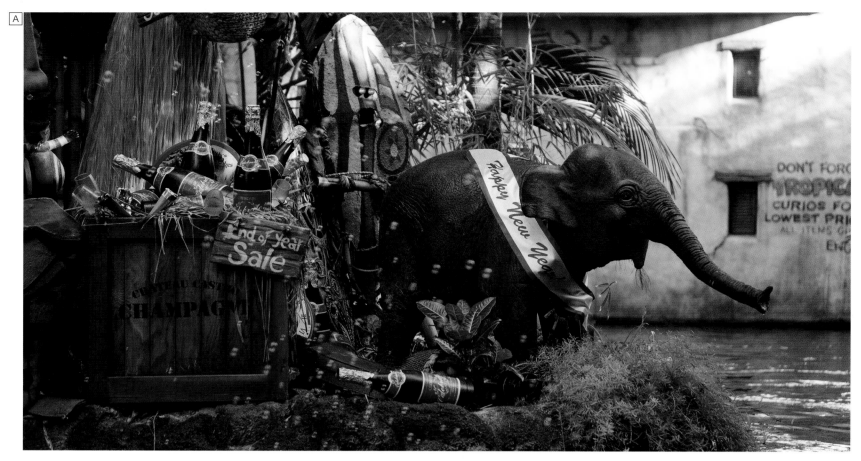

Jingle Cruise

Disneyland

A "Ringing in the New Year always puts Ellie in a bubbly mood."
2014

B "Big Bertha's feeling festive this year."
2014

C "Deck the boat with lights and tinsel."
2018

Magic Kingdom

D "You know why Santa loves the rain forest? Because he loves rain-deer!"
2017

E Attraction poster by Josh Holtsclaw, based on the original design by Bjorn Aronson
2013

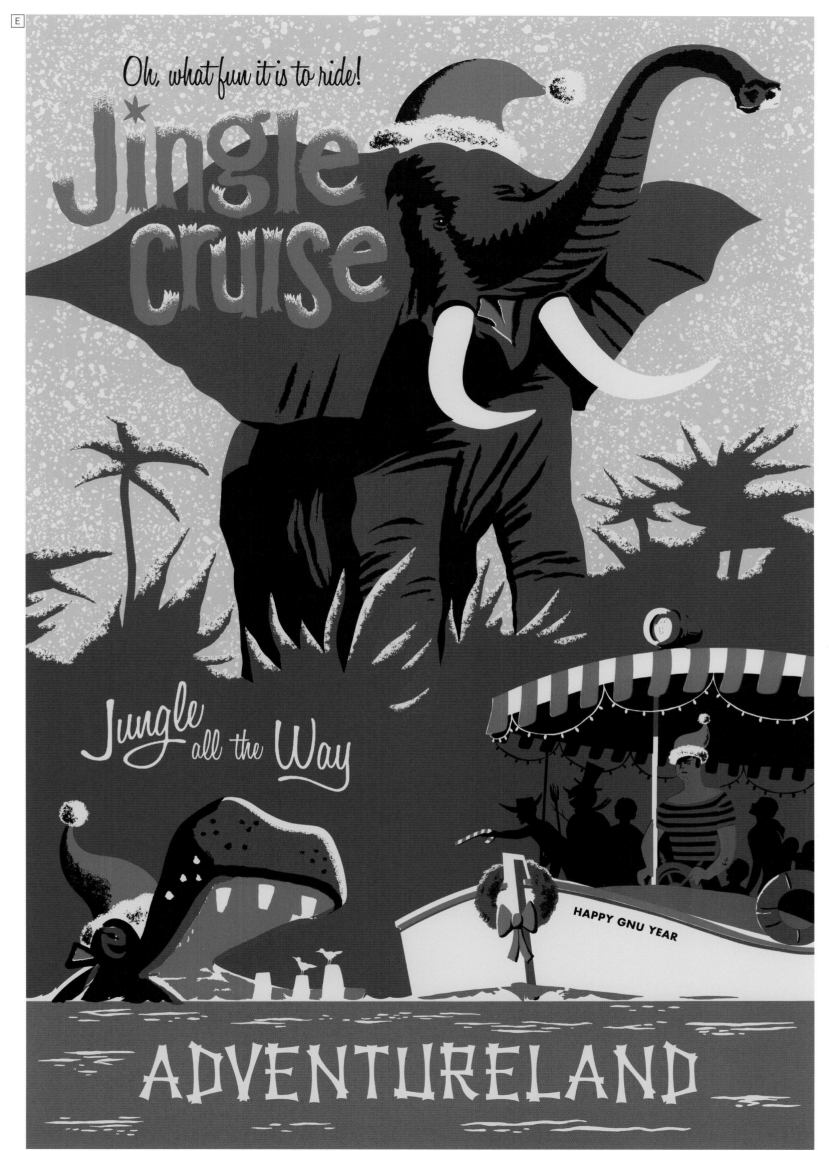

As Mary Blair's original backstory goes, children marooned indoors on a rainy day make a new world for their dolls to play in—fashioning the iconic realm of It's a Small World using boxes, doilies, papier-mâché, and their boundless imaginations. With winter upon us, cold and snowy weather has once again kept these creative youngsters and their craftiness indoors. Ever resourceful, the universe they create for their toys and dolls this time is all about celebrations of the season—thus, It's a Small World Holiday was born.

Disneyland was the first park to make over It's a Small World for the holidays, debuting the reimagined attraction in 1997. And the scale of this seasonal makeover is impressive—even to this day. Each set is decorated or updated, and many new set pieces are added; each doll is enhanced in some way—with holly, props, garlands, or even whole new costume pieces; an entirely new musical soundtrack plays throughout the attraction; scents of pine and peppermint are added; and the exterior dazzles with lights. Lots of lights! There's fifty thousand of them on the building itself—in six colors, peppered with white twinklers—and another 350,000 mini lights in the trees, topiaries, and gardens surrounding the attraction. "We wanted you to come around the corner and see Oz," explains Steven Davison, executive of Parades & Spectaculars and mastermind of the transformation. "That first year we had to put in extra power!" The facade was further brightened with digitally mapped video projection, starting in 2006. Every fifteen minutes, right after the usual clock chimes and the parade of figurines concludes, colorful holiday animation is projected onto the building, accompanied by music. We're definitely not in Kansas anymore!

It is what's behind that iconic Disneyland facade, however, that has Guests queuing for hours. As our boat glides from continent to continent, we are treated to seasonal sights and traditions from all over the world. The particular holiday or wintertime experience depicted in each vignette is culturally relevant to that country, yet always from a child's point of view, starting (appropriately) at the North Pole with a huge, twinkling Father Frost arch overhead and a glimpse into Santa's home as he prepares for the big night ahead.

In the Europe room, the United Kingdom scene is dominated by a *Nutcracker*-inspired tree of giant candles (almost 150 of them). And look nearby for paper chains—a common Christmas garland made by children in the British Isles. Oversized and brightly lit candies drape Italy, while across the waterway the French scene celebrates the New Year. Next comes Asia, with a winter ice festival, and fireworks of all shapes and sizes to ring in the Lunar New Year. (Trivia buffs take heed: the rising fireworks at the back of the display, bursting with streams of twinkling lights, were originally part of the To Honor America finale float in the Main Street Electrical Parade, which was retired in Disneyland the year before It's a Small World Holiday bowed).

Tribal shields spelling out Afi Shia Pa ("Merry Christmas and Happy New Year" in the Akan language of West Africa) welcome us to the Africa room that's decorated in a harvest theme with garlands of grass, along with colorful ethnic fabrics and nods to the continent's rich cultural traditions. Then we bob into the lively world of Latin America, with luminaria lanterns, strings of punched-tin lights, piñatas, and poinsettias—a plant which comes to us from Mexico—and onward through a Royal Hawaiian Holiday in the South Seas room. We float through the American West, where a giant cactus has been decorated as a Christmas tree, and Santa flies high above, signaling our arrival in the final and most impressive room of all. It's a true child's-eye view of peace on earth, a finale that brings all the world's characters and cultures together in a gloriously over-the-top spectacle of holiday icons and lights—the snowman alone (added to the show in 2011) is fourteen feet tall.

Since it was important to retain the core identity of It's a Small World, the ever-so-familiar Sherman brothers' song remains the musical foundation of the attraction's soundtrack. Now, though, Christmas carols are layered onto that theme. "Jingle Bells" and "Deck the Halls" were chosen for their familiarity around the world in many languages, which Guests will hear as they glide through. Instrumental versions play in areas whose cultures do not necessarily celebrate Christmas. Listen for clever twists on the lyrics, too, such as the South Seas mermaids singing "Jingle Shells."

To say that It's a Small World Holiday was an instant hit would be an understatement. Such were the crowds during the first season it ran that the holiday overlay was extended for an extra month . . . through the Lunar New Year. Inspired by the transformation in Disneyland, other parks have created their own versions, too: Tokyo Disneyland decked the halls of It's a Small World Very Merry Holidays from 2003 to 2014, and Hong Kong Disneyland presented a more modest It's a Small World Christmas in 2009 and 2010. In Disneyland Paris, It's a Small World Celebration debuted in 2009 as the park's first attraction-wide holiday overlay. The Paris version brings the Disneyland "Jingle Bells" soundtrack, with a little different twist on the visual style. Here, the emphasis is on the dolls themselves, with particularly elaborate costumes, including a sparkly Santa Claus bidding Guests farewell at the end of the final scene.

More than two decades on from the attraction's first seasonal makeover, It's a Small World Holiday remains immensely popular, drawing significantly more Guests even than those who come on a summer day—the perfect mélange of Disney wonder and holiday magic.

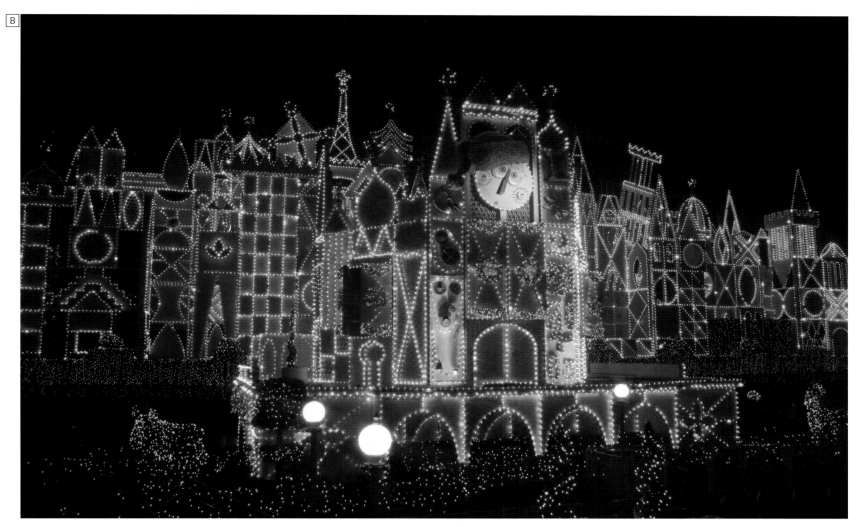

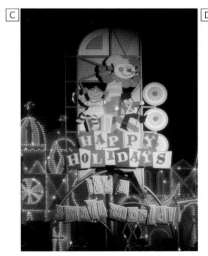

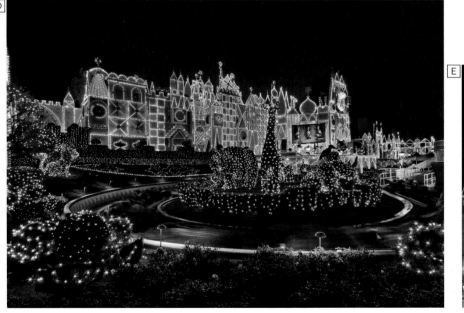

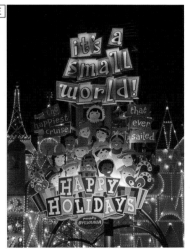

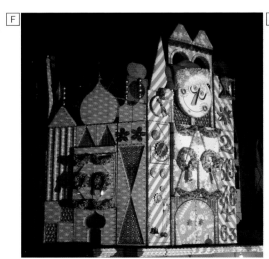

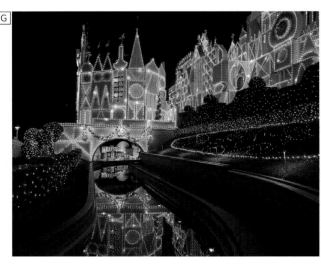

*It's a Small World Holiday,
Disneyland*

A	*2016*		F	*2007*
B	*2008*		G	*2016*
C	*2006*			
D	*2012*			Following pages
E	*2010*			*2016* ▶

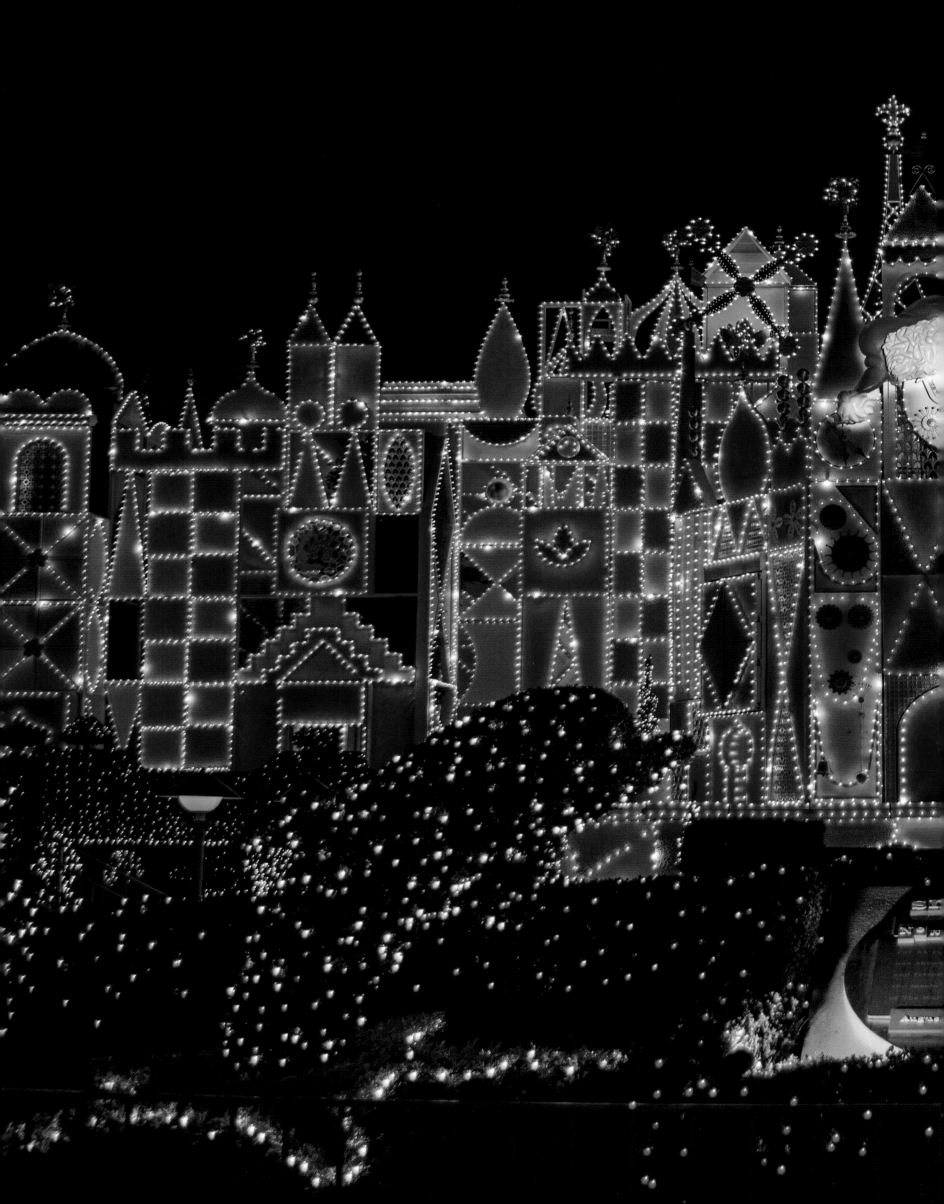

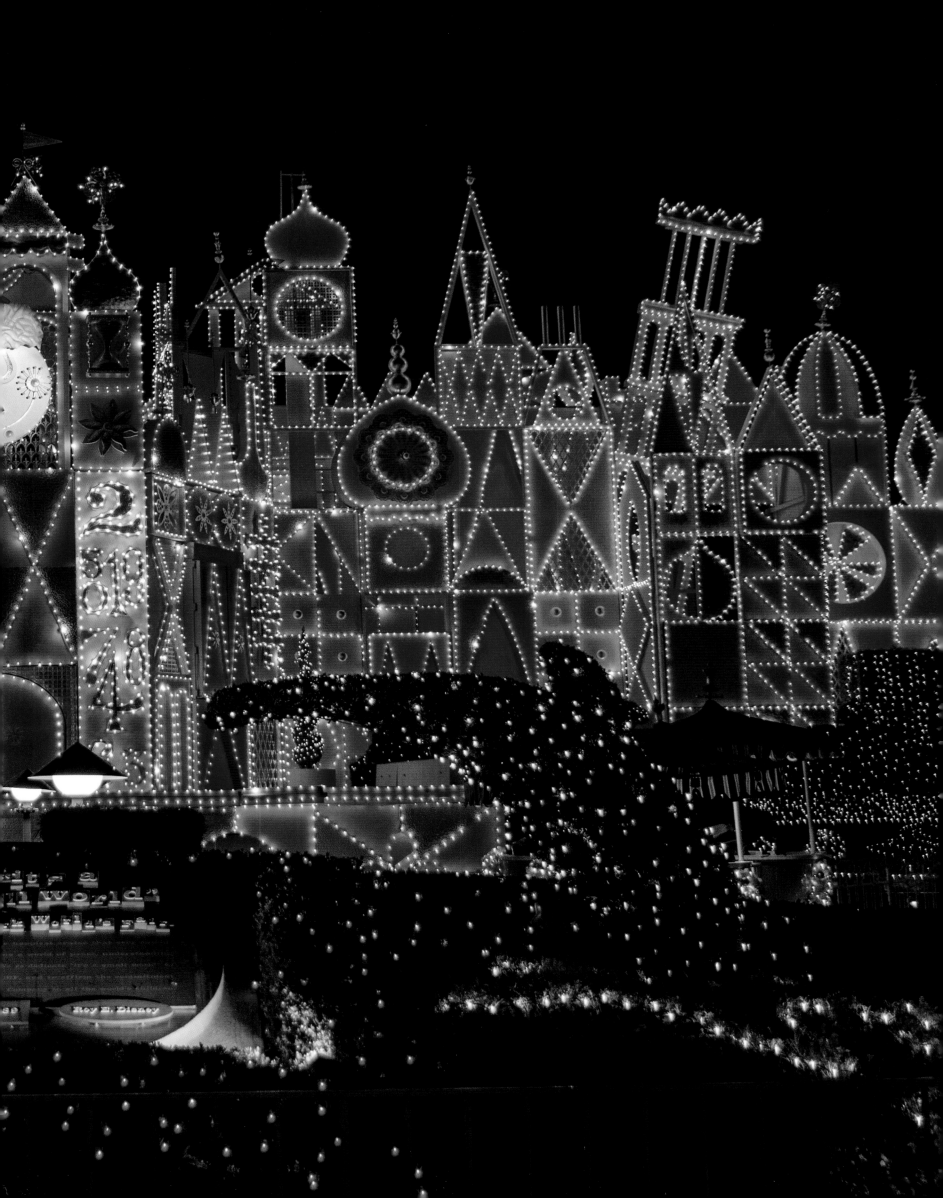

It's a Small World Holiday, Disneyland

Entrance tunnel

[A][B][C] 2016

Northern regions–inspired show scenes

[D][E][F] 2016

European–inspired show scenes

[G] — [L] 2016

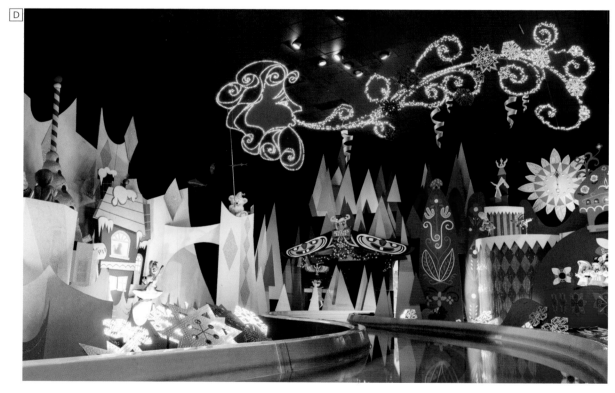

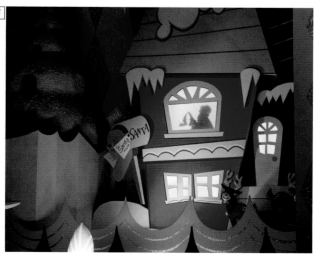

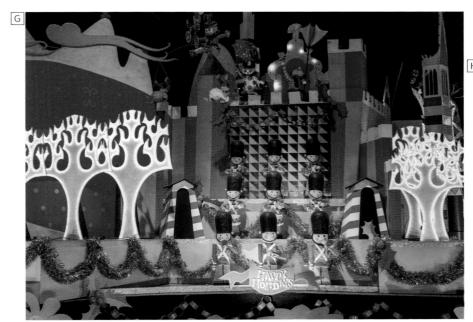

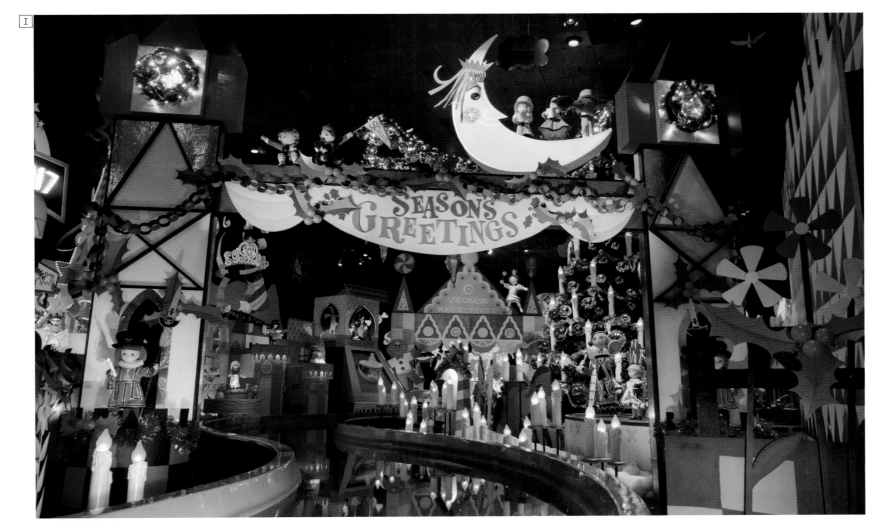

Magical Transformations

It's a Small World Holiday, Disneyland

Asian–inspired show scenes

A 2016

B *One of several "20s" added in 2016 for the twentieth holiday season* 2016

C D E 2016

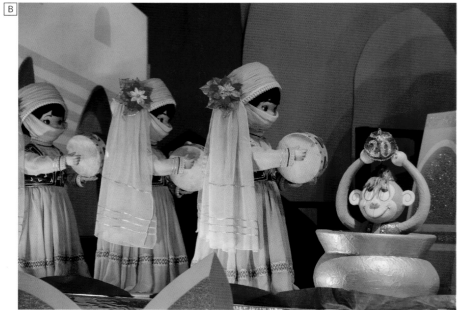

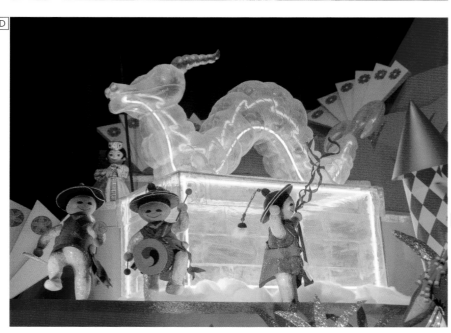

It's a Small World Holiday, Disneyland

African-inspired show scenes

F 2009

G H I 2016

J 2009

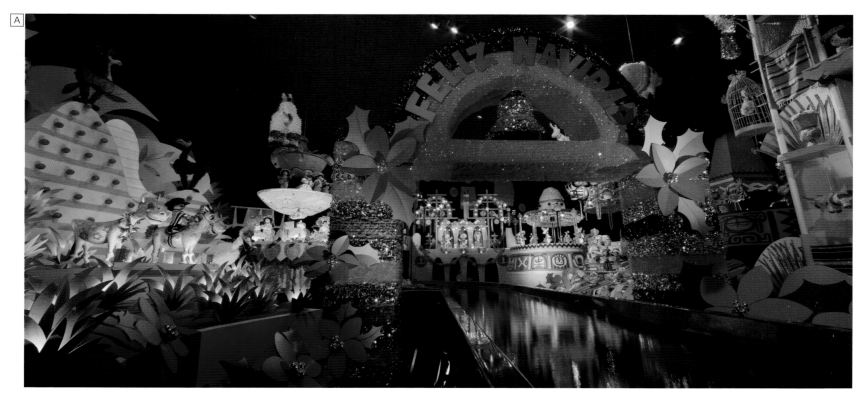

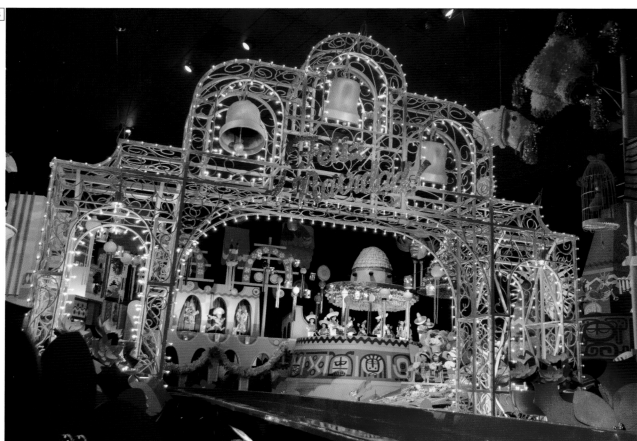

It's a Small World Holiday, Disneyland

Central and South American–inspired show scenes

A 2009

B 2016

C For the twentieth season 2016

D 2007

E 2016

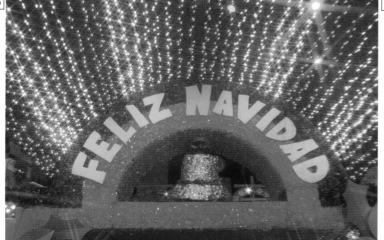

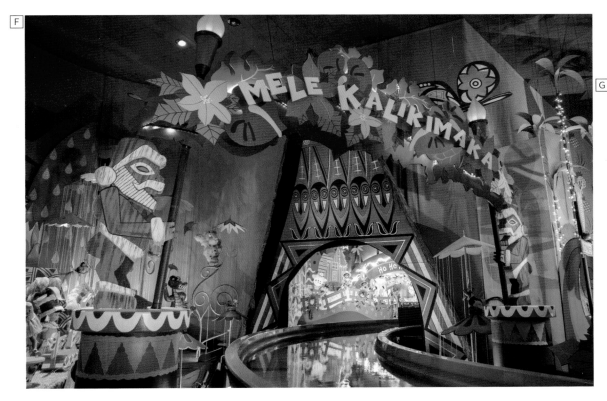

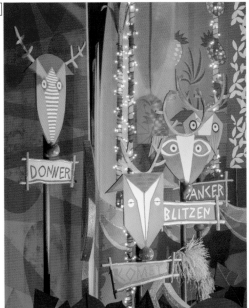

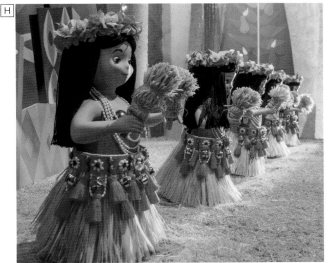

It's a Small World Holiday, Disneyland

Oceania-inspired show scenes

F G H *2016*

North American-inspired show scenes

I *2016*

J *2012*

K *2009*

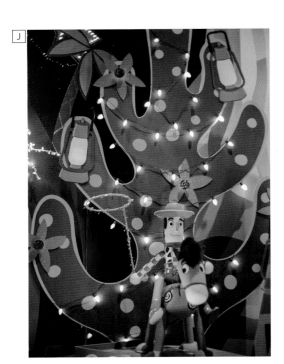

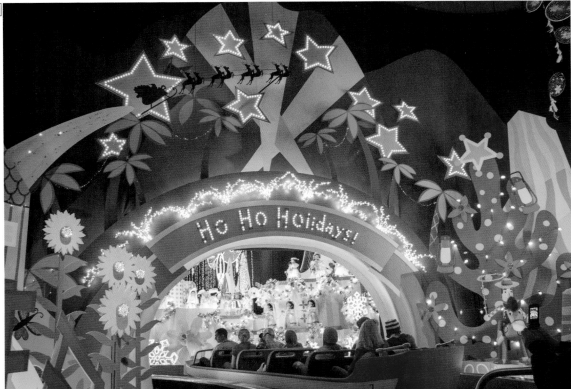

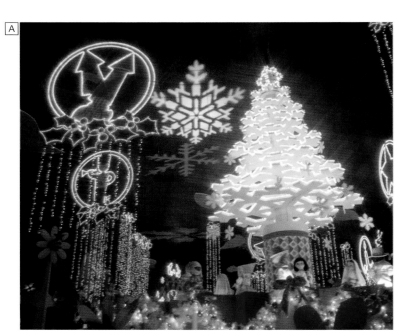

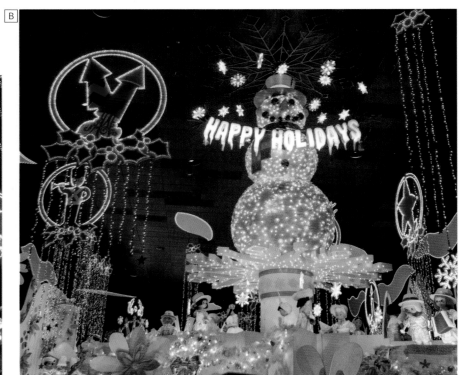

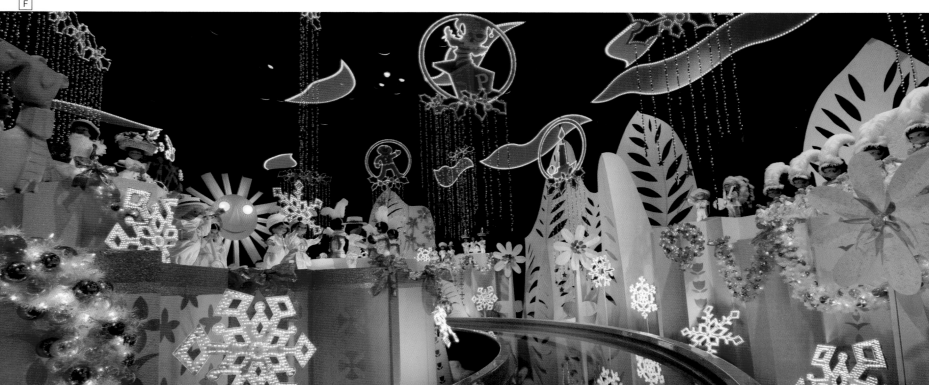

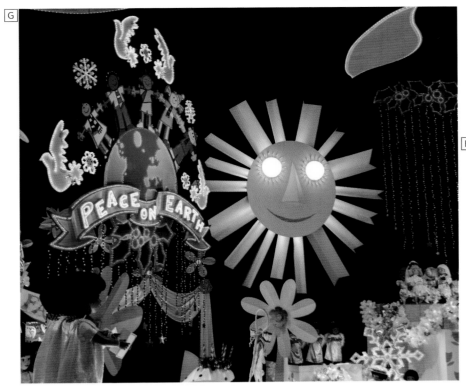

It's a Small World Holiday, Disneyland

Finale show scenes

A 2007

B 2016

C 2009

D E F 2009

G H I 2016

J K 2009

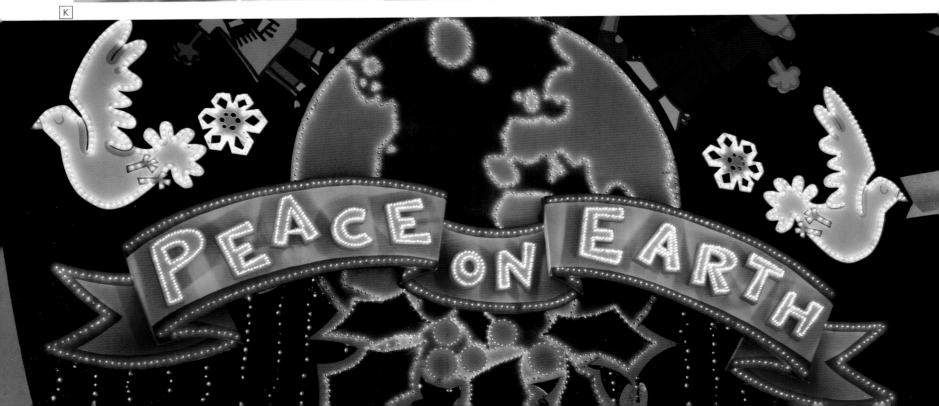

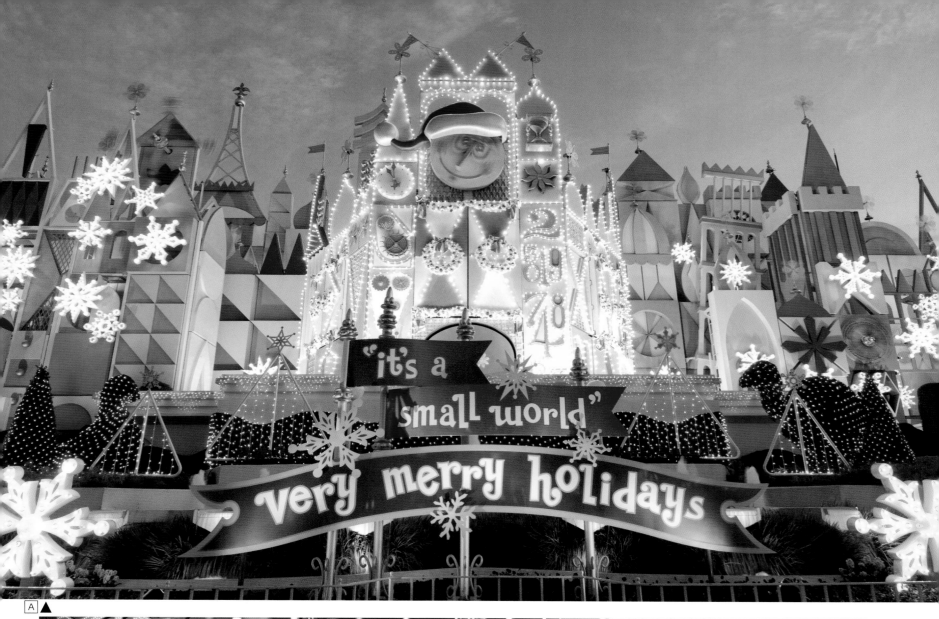

[A] ▲

[B] ▶

[C]

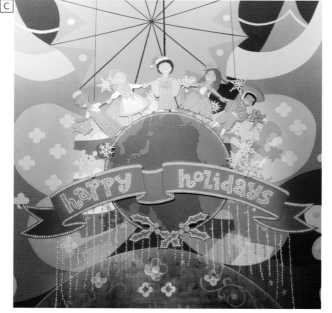

It's a Small World Very Merry Holidays,
Tokyo Disneyland

Exterior	Load/unload area	European–inspired show scenes
[A] 2008	[B] 2012	[E] 2012
	[C] 2008	[F][G] 2003
Entrance tunnel		[H][I] 2012
[D] 2008		

[D]

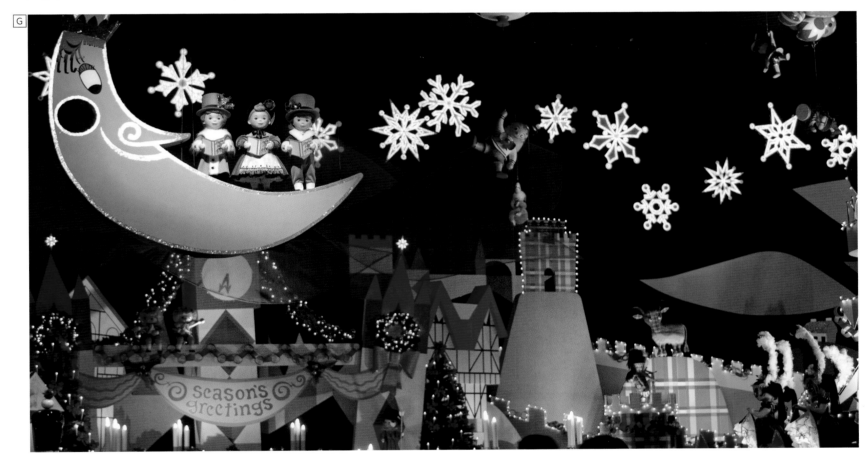

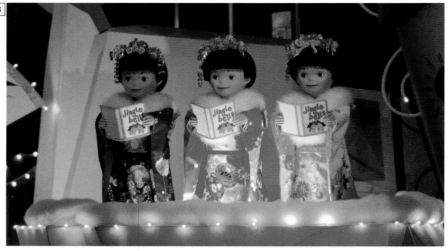

It's a Small World Very Merry Holidays, Tokyo Disneyland

Asian-inspired show scenes

A *2009*

B *2012*

African-inspired show scene

C *2008*

Central and South American-inspired show scene

D *2003*

Oceania-inspired show scene

E *2012*

Finale show scenes

F *2008*

G *2012*

Exterior

H *Christmas Wishes in the Sky fireworks 2007*

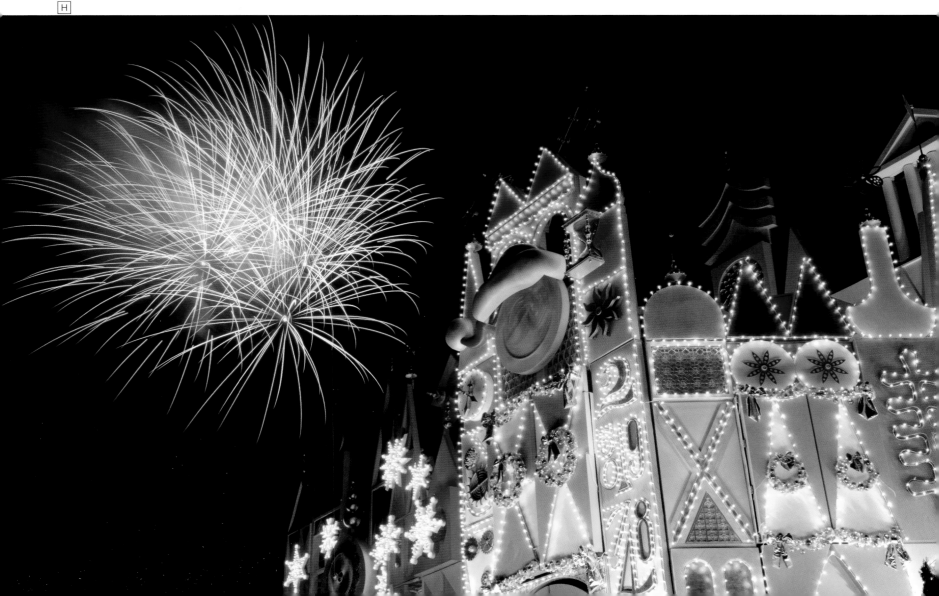

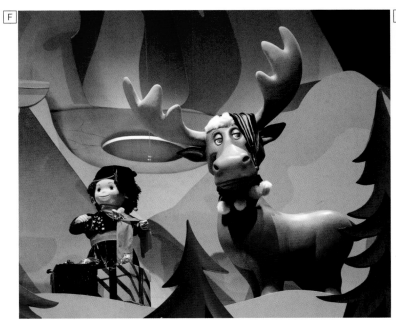

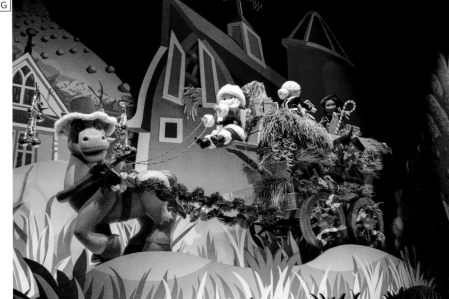

It's a Small World Celebration, Disneyland Paris

A *Scandinavian-inspired show scene 2017*

B *Dutch-inspired show scene 2017*

C *Venetian-inspired show scene 2017*

D *Russian-inspired show scene 2017*

E *Israeli-inspired show scene 2017*

F *Canadian-inspired show scene 2017*

G *U.S.A.-inspired show scene 2017*

H I J *Finale show scenes 2017*

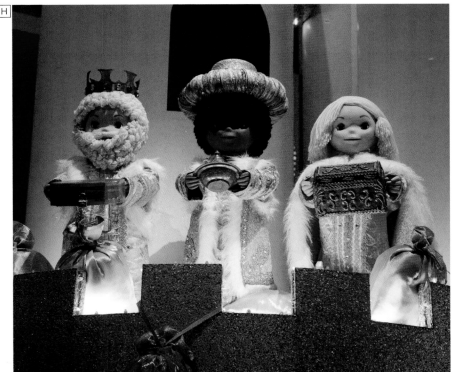

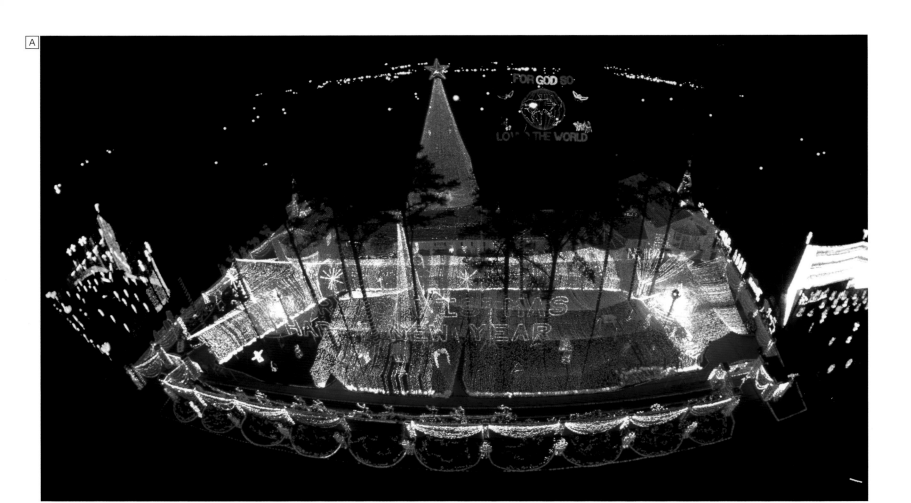

Jennings Osborne was well known in his hometown of Little Rock, Arkansas, as a successful businessman and as a generous philanthropist. He regularly sponsored Fourth of July fireworks, supported underprivileged families in the local community, and hosted legendary charity benefit barbecues in his own backyard. Where he made his name on the world stage, however, was with Christmas lights . . . epic-scale Christmas lights!

In 1986, his then six-year-old daughter, Breezy, asked if their house could be decorated with lights for Christmas. Osborne and his wife, Mitzi, obliged with one thousand red lights—a small beginning for sure, but that was just the start. Each year they added to the display, and when their two-acre estate was no longer large enough, they purchased adjacent properties to allow the show to expand further, reaching over two million lights! "I can't do anything in moderation," he once quipped. The local power company installed special circuits to support the show, commenting that it consumed as much electricity in one month as did an average local home in a whole year, and the lights reportedly burned brightly enough for aircraft to spy the sparkle from eighty miles away.

Inevitably, perhaps, the display outgrew its Little Rock home. With upward of thirty thousand visitors each December, the impact from the huge amount of traffic and congestion was significant; the neighbors' tolerance was tested, so Osborne was eventually obliged to switch it all off in 1994. The story caught the eye of Walt Disney World executives, however, who offered to give the display a new home at what we now know as Disney's Hollywood Studios. He was delighted, and a convoy of eighteen-wheeler trucks transported his amazing display to Florida, where it debuted at the Studios in 1995 as the Osborne Family Spectacle of Lights.

The show was first installed along Residential Street, a series of house fronts used as film and television sets, and on Washington Square at the foot of New York Street. The iconic pieces had all been part of the family's original setup—including one hundred fluttering angels, a seventy-foot-tall tree of lights, the carousels, the canopy of red, and the immense globe with the state of Arkansas and the city of Little Rock highlighted. During the day, Residential Street itself was part of the Backstage Studio Tour. Then, at sunset, the trams retired for the evening, and the street was opened up for Guests to explore on foot for maximum immersion—with the light display bedecking all eight of the residential facades along the full length of the street.

The eye-popping display returned to the Washington Square and back lot areas each year through 2002. The residential street area was removed in 2003 to make way for the Lights, Motors, Action! Extreme Stunt Show, and the Osborne Lights were not presented that year. However, they returned bigger and brighter with the refurbished and renamed Streets of America area in 2004. In fact, the Disney team was quite happy to continue Osborne's tradition of adding more to the show throughout its time at the Studios—with the light count eventually topping out at over five million. Lights were added in all sorts of creative ways—highlighting the architectural elements of the back lot buildings, dressing up otherwise ordinary props (such as bicycles and toys), adding Disney characters (including upward of eighty not-so-hidden Mickeys), or simply layering in more lights and colors.

For the 2006 season, the show was given a major new creative element—sophisticated light patterns synchronized with a musical soundtrack through four hundred individually controllable dimmer circuits. No longer just simply lights, this was now the Osborne Family

Spectacle of *Dancing* Lights! The first dance tracks were "A Mad Russian's Christmas" and "Christmas Eve" by the Trans-Siberian Orchestra, with nine more songs added over the years, including Barbra Streisand's rendition of "Jingle Bells"; Elvis Presley's "Here Comes Santa Claus"; and an arrangement of "Winter Wonderland" created especially for the show by Dan Stamper.

By 2011, the display had been fully converted to modern LED technology, which opened the door to even richer effects. The red lights of the original canopy, for example, now installed over San Francisco Street, were updated to controllable, color-changing LEDs, enabling an almost endless range of patterns and colors. For several years, Guests were provided with special glasses that turned each point of light into a holiday shape, such as a snowflake or an angel. And with or without the glasses, the most eagle-eyed visitors could find an unusual character among the festive cheer—a creepy cat. Hardly festive, the creature was, in actuality, one of the family's Halloween decorations, which had been loaded onto the Disney trucks by mistake. With a twinkle in their eyes, the installation crew would place the cat in a different location each year—sometimes high, sometimes low—as a mini treasure hunt for visitors in on the secret.

The Osborne's Home, Little Rock, Arkansas

Ⓐ Ⓑ *1993*

For anyone who has hung lights for the holidays, the numbers tied to this spectacle are almost beyond comprehension: there were five million lights (at least half of which were being replaced each year), eight hundred thousand watts of power needed, thirty miles of cords and cables, a hundred gallons of "snow mixture" each night, and twenty thousand careful person-hours to install it all (starting each September, to ensure the show was ready for its annual public debut each November).

The Osbornes loved going to Walt Disney World to see their lights and especially to watch Guests experience them. They did continue to decorate their home for the holidays, just on a more modest scale. And they sponsored Christmas displays in many other towns around the United States, even decorating the Plains, Georgia, home of former president Jimmy Carter, and contributing to the lights at Elvis Presley's Graceland in Memphis, Tennessee. Sadly, Jennings Osborne passed away in 2011. A single white angel was added to the display that year, in grateful memory of the great man and his remarkable legacy—a person of warmth, generosity, philanthropy, and a true holiday spirit.

With large-scale construction in the works for *Star Wars*: Galaxy's Edge and Toy Story Land, the Streets of America area would soon disappear. And so, after twenty awe-inspiring seasons, the Osborne Lights twinkled for the last time on January 6, 2016. The final dance track was a special version of the "Mickey Mouse Club March," after which the lights dimmed to black. The Peace on Earth sign stayed lit high above the square for a few extra seconds before it too was extinguished and this amazing spectacle faded into memory.

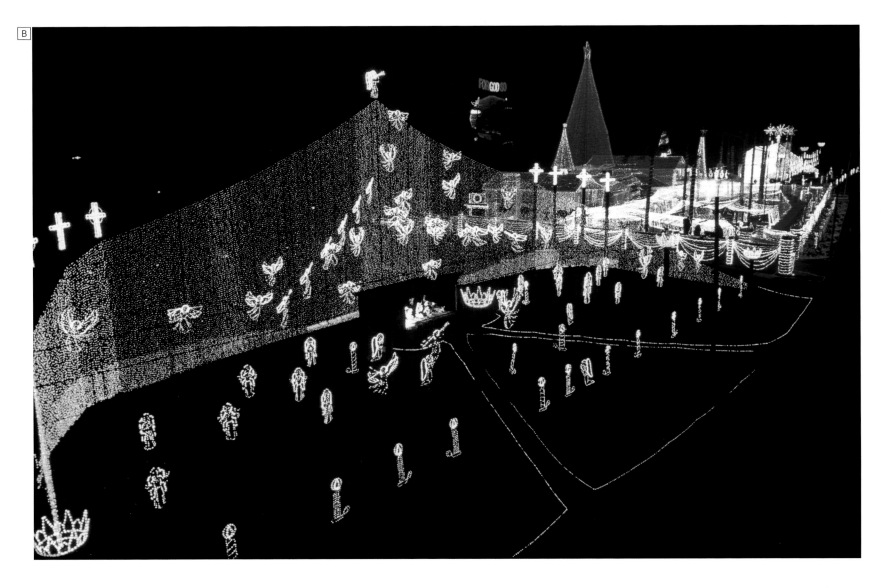

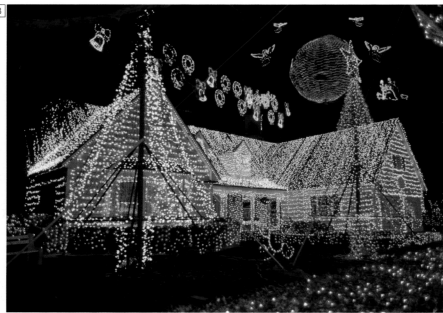

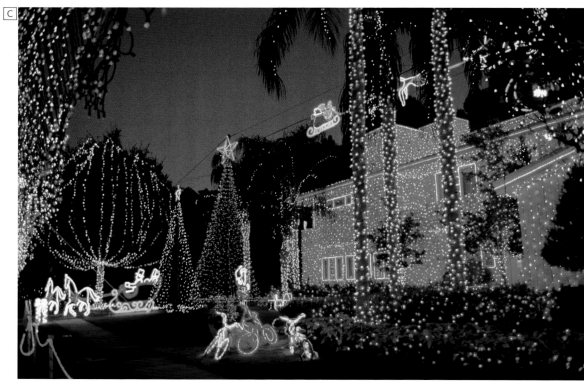

The Osborne Family Spectacle of Lights, Residential Street, Disney's Hollywood Studios

A *1995*

B *1995*

C Empty Nest *house*
 2000

D *2000*

E *2000*

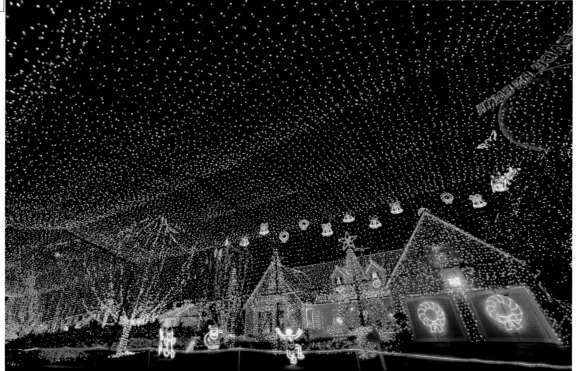

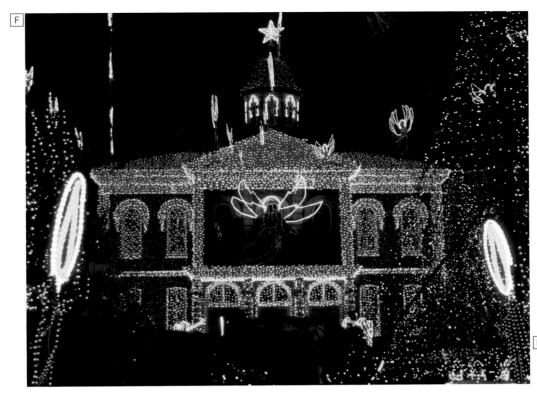

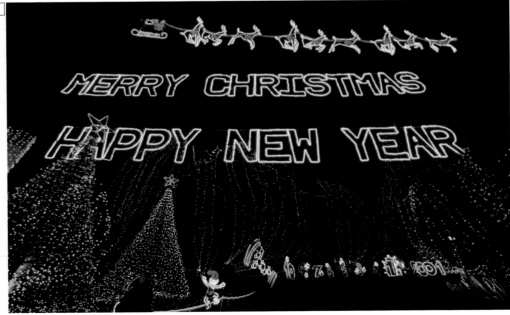

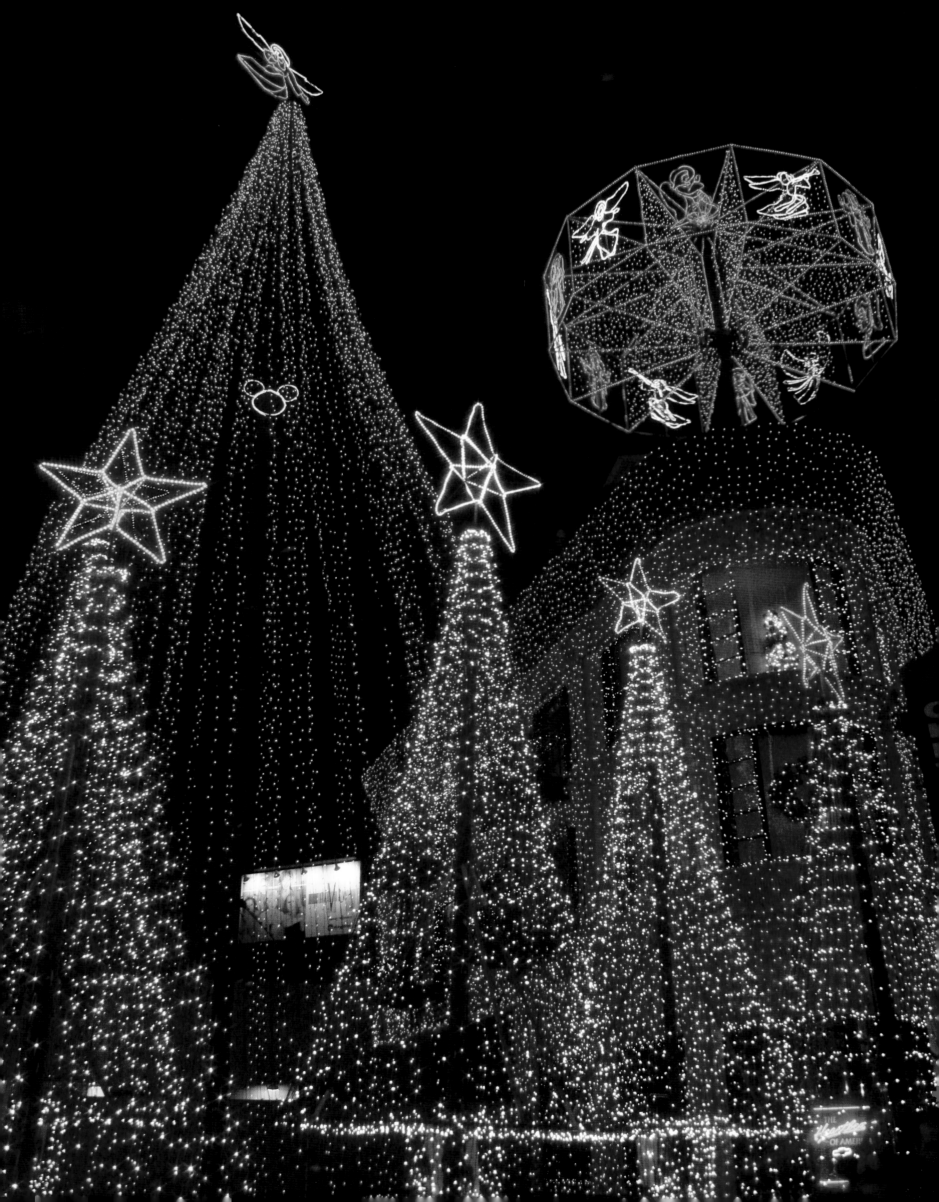

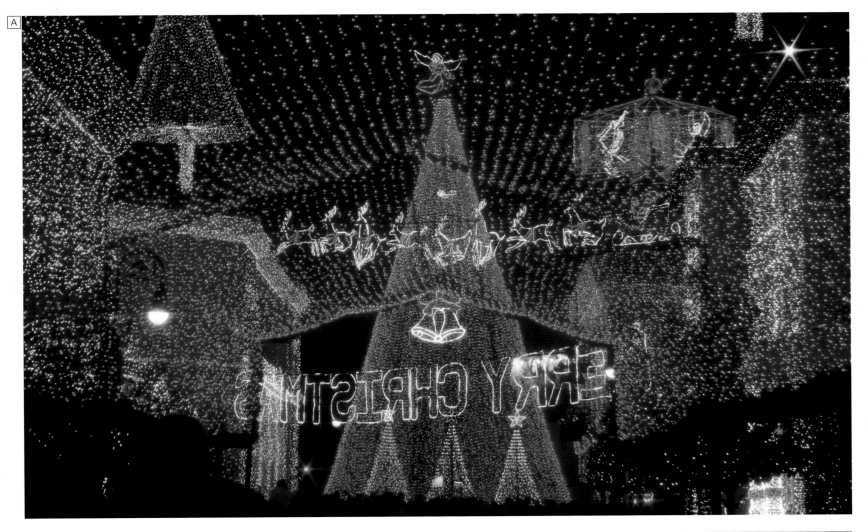

Streets of America, Disney's Hollywood Studios

The Osborne Family Spectacle of Lights

◄ *2005*

The Osborne Family Spectacle of Dancing Lights

A *2006*

B C *2008*

Streets of America,
Disney's Hollywood Studios

The Osborne Family
Spectacle of Dancing Lights

A B C *2008*

D — H *2009*

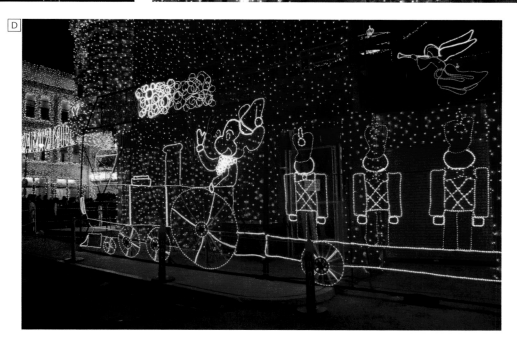

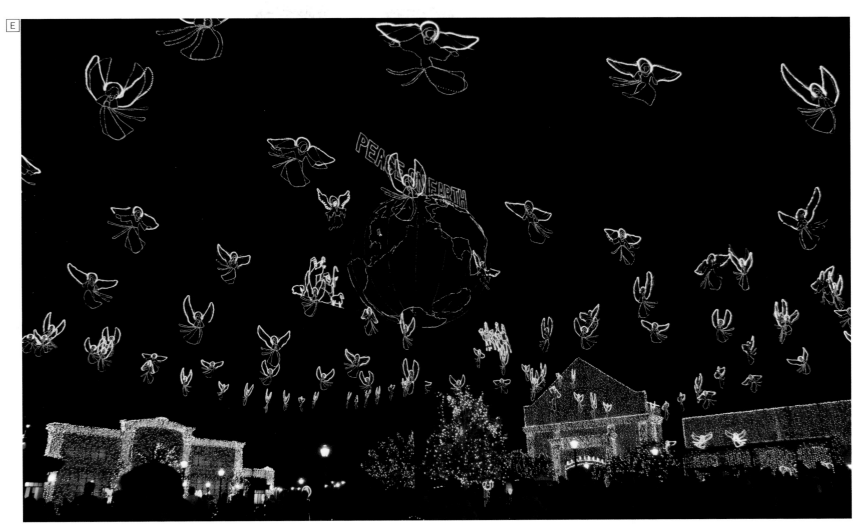

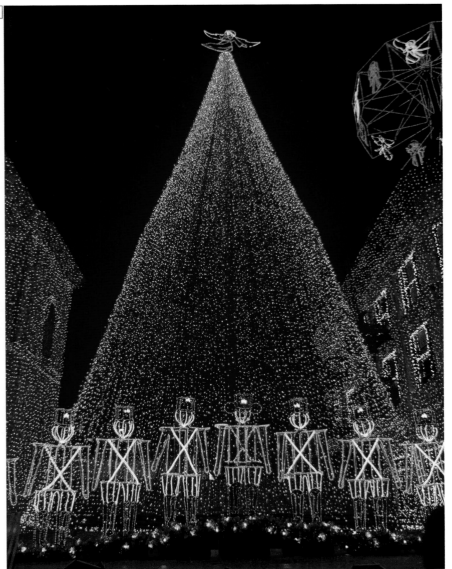

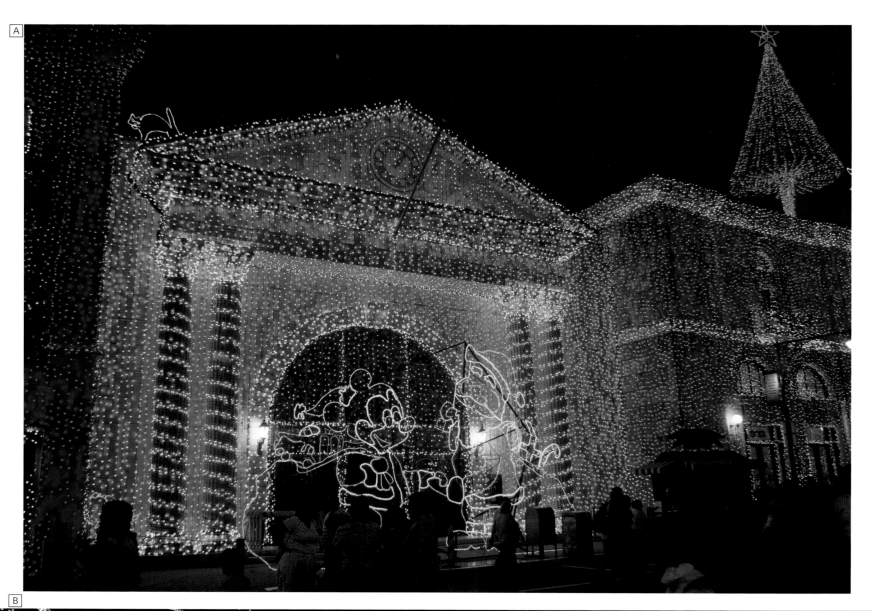

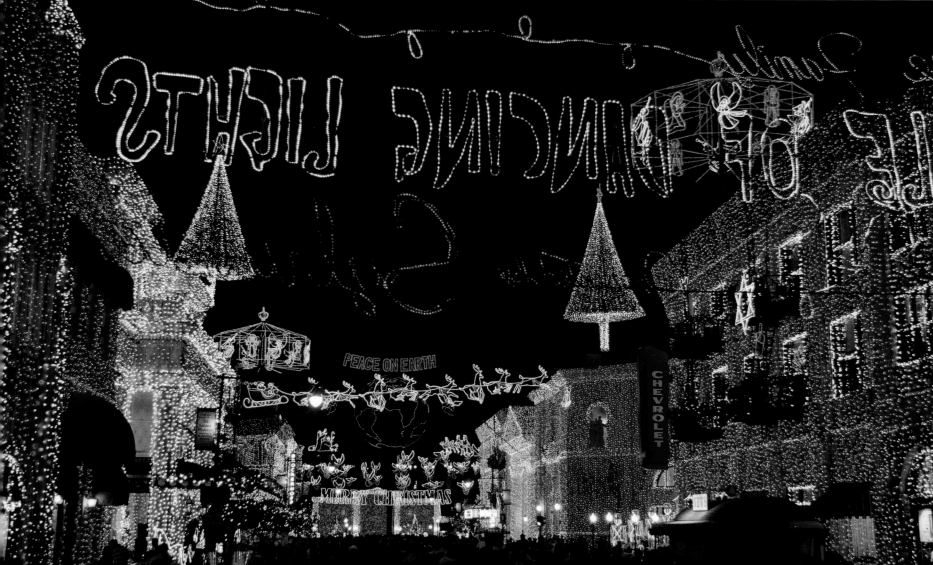

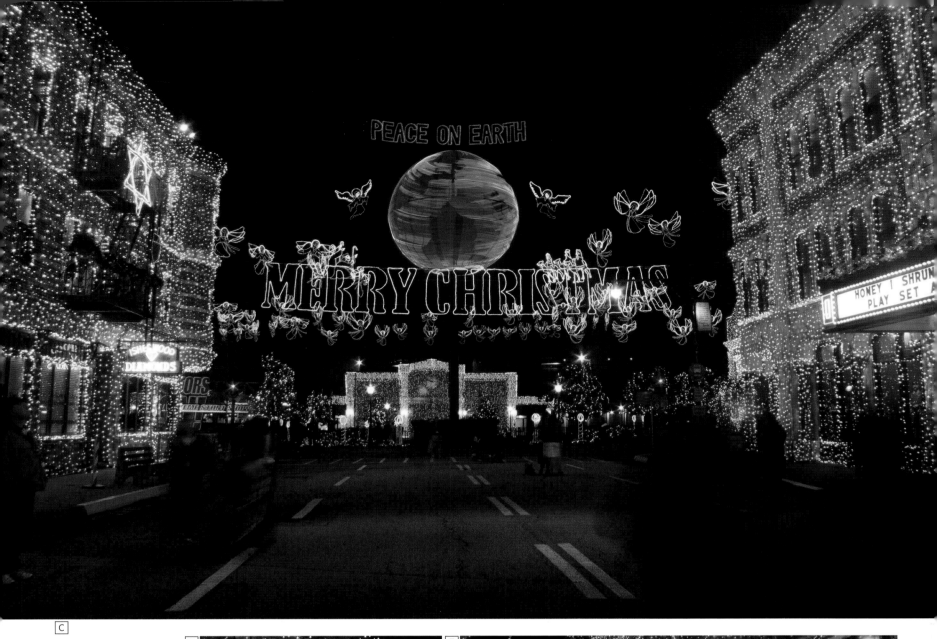

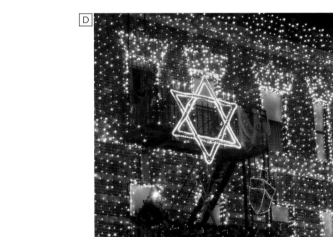

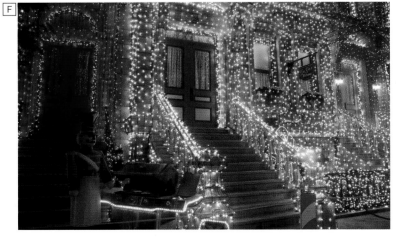

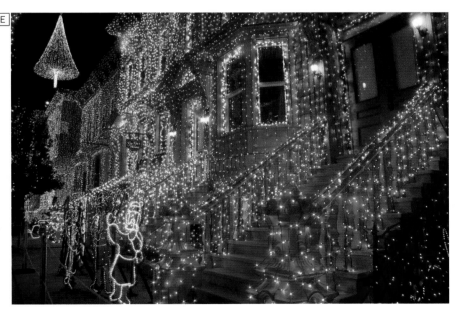

Streets of America, Disney's Hollywood Studios

The Osborne Family Spectacle of Dancing Lights

A *2009*
(Halloween cat visible upper left)

B *2009* Following pages

C — F *2010* *2010* ▶

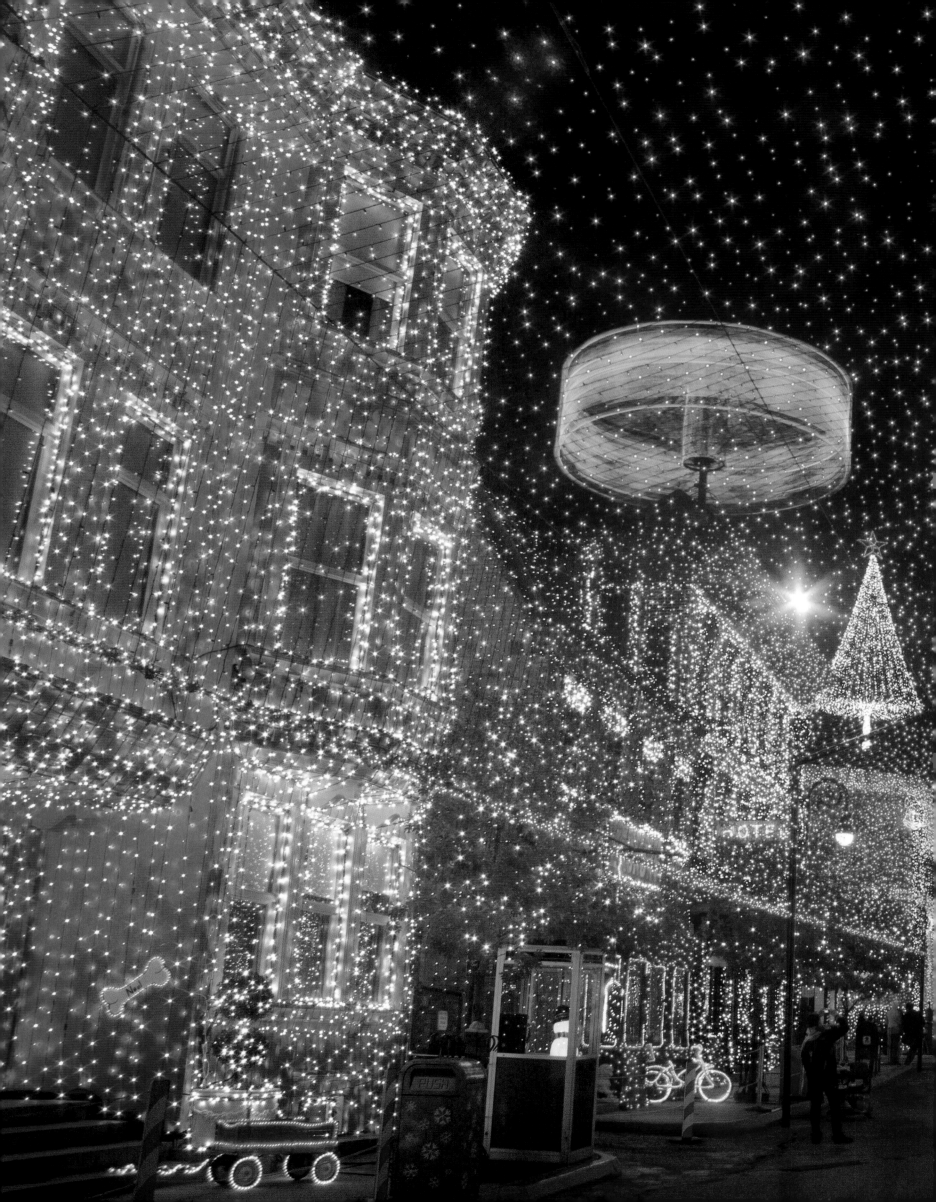

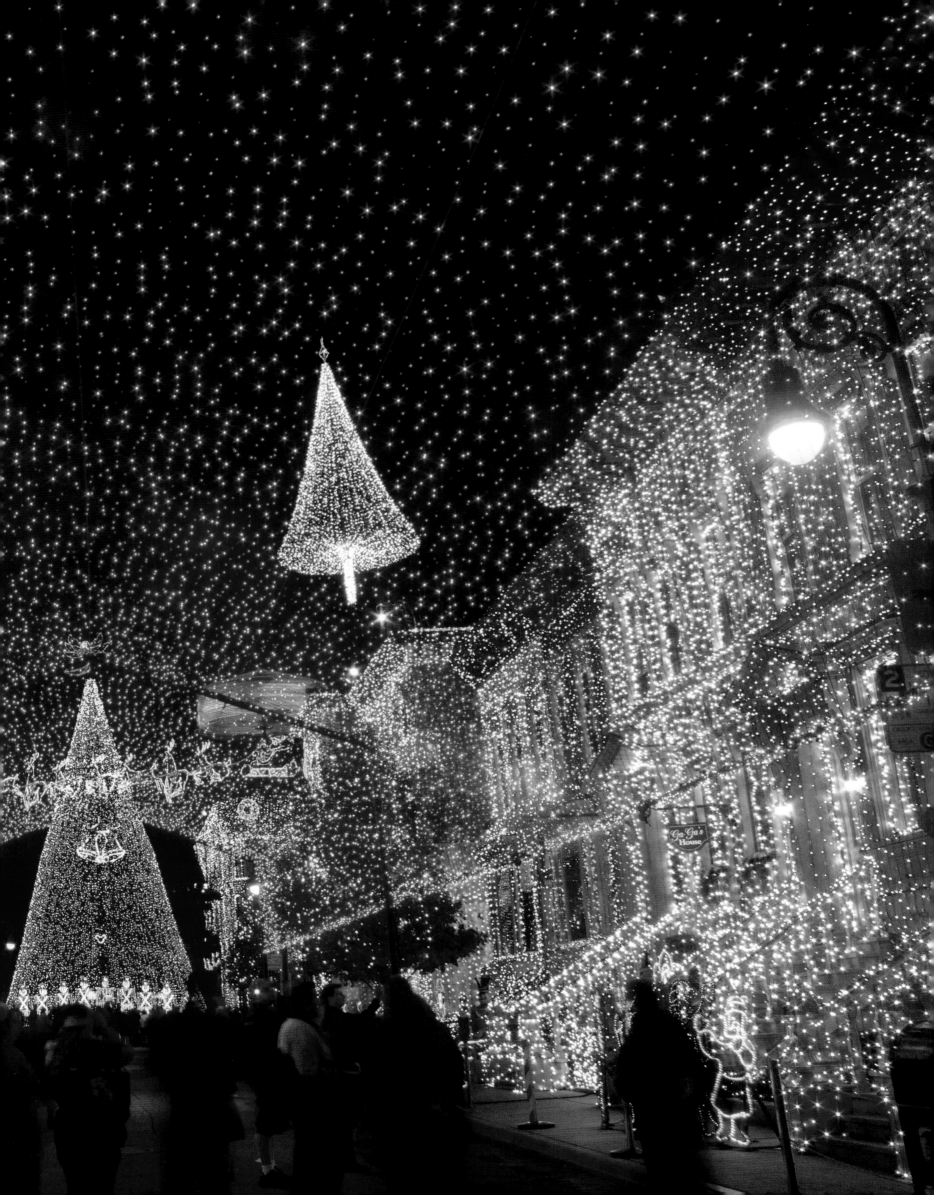

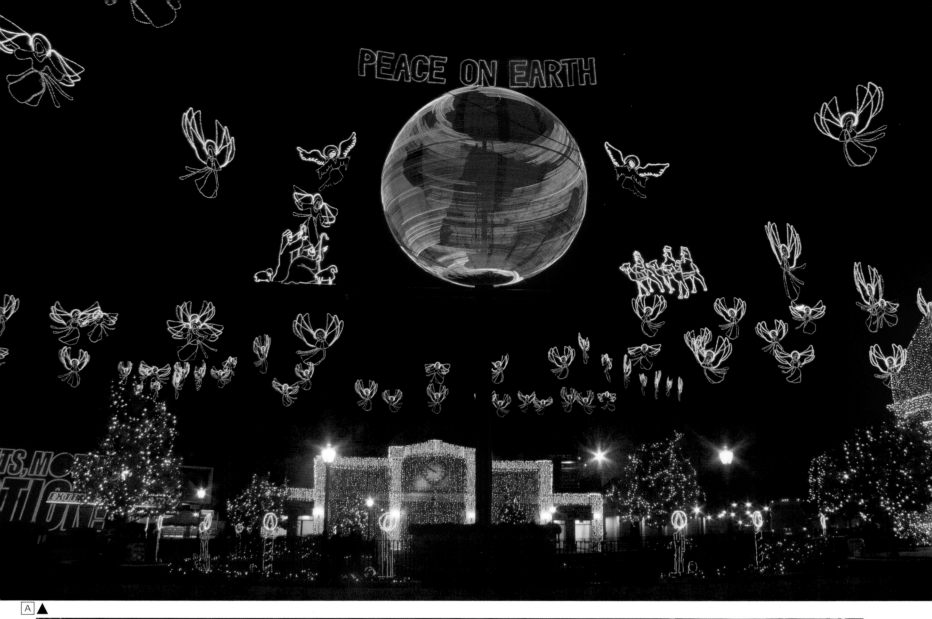

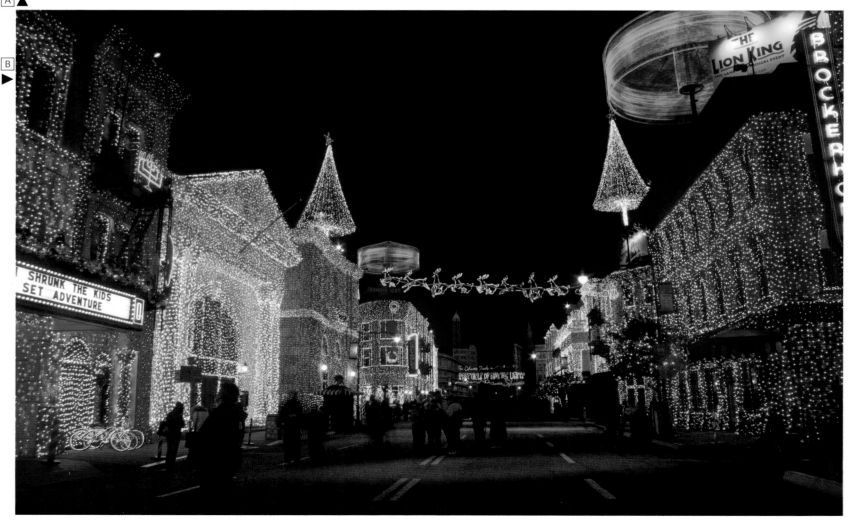

Holiday Magic at the Disney Parks

*Streets of America,
Disney's Hollywood Studios*

*The Osborne Family
Spectacle of Dancing Lights*

A B *2010*

C — F *Farewell season
2015*

Decking the Halls

Sneaking a peek, as stockings are hung by the chimney with care

This book celebrates all of the holiday wonder we experience and enjoy as Disney Guests, and just a little part of what we marvel at is how it all seems to materialize by magic. We never see a ladder or a box of tinsel or anyone dementedly wrestling with a tangle of lights—for the *enchantment* simply appears, pristine and polished. You might imagine that takes some work behind the scenes—and the sheer scale of the operation is quite mind-boggling when you step back to think about it.

At Disneyland, holiday responsibilities are shared across the Resort Enhancement, Entertainment, Walt Disney Imagineering, and Horticulture teams, all coordinating closely in planning and execution. The Christmas season is a year-round project, with Halloween/fall not far behind when it comes to the time applied to creating and setting things up. Residing just a few blocks from Disneyland itself, Resort Enhancement's main Anaheim production and warehouse facility is a hive of holiday activity throughout the year, as each decoration (small or large) is refurbished, cleaned, and prepared for the following season. Within a month of one holiday ending in the parks, some decorations will be ready for their reinstallation nine months ahead. And since one "attic" isn't quite large enough to hold it all, more warehouse space in Anaheim and Ontario, California, is pressed into service. The Southern California teams also look after the holiday splendor at Aulani in Hawaii.

The production warehouse is also where new displays are created. Artists, set dressers, floral arrangers, and technicians work on fresh elements for the coming year—updates to past decor or fresh material for a new space. Main Street, U.S.A. window displays are set up here first, to experiment with colors, placement, and lighting, and to finalize designs well before the pressed-for-time night of installation. Windows are planned so that holiday-specific elements can be removed in January, while the rest of the display remains until spring. By the way, the names Guests see on stockings, parcel tags, and gift lists in the windows are usually the decorators' own family members.

Almost everything is created by hand. In many cases, this means arranging or assembling commercially available decorations to achieve the desired look. (And the warehouse has aisles of boxes containing every type of flower and ornament imaginable—call it the Christmas craft dream store!) More unusual goals might require special attention, such as treating the Haunted Mansion's black garlands with a heat gun to achieve that unique, wizened Halloween look, or fashioning decorations from scratch—period decor for Buena Vista Street or Rushin' River Outfitters, for example, that can't be found in a catalog.

Installation is an adventure! Eagle-eyed Guests may spot some of the subtler Halloween decor appearing in late August (like moss in the trees), while the majority of the fall and Halloween elements are installed in the space of a week, around the Labor Day holiday, and all during the six hours at night when the parks are closed. Then, as soon as Halloween is past, the two-week changeover to Christmas begins, also carried out mostly in the wee, dark hours of the "deserted" night. The Haunted Mansion and It's a Small World each take a little longer, though work inside can take place during the day. Regular patrols throughout the season take care of any burned-out bulbs and damaged or faded decorations.

Once in a while, however, something unexpected will interrupt or disrupt the carefully laid plans. The main Christmas tree in Disneyland was extra special in 2005, smothered with golden ornaments and amber lights in honor of the park's fiftieth anniversary. An equally special custom tree topper was commissioned—a golden Mickey, just like the anniversary icons dotted around the park throughout the celebration. It looked magnificent. Except, when the moment came to place it in position, it turned out to be too heavy for the tree (then still a real fir) to support. Oops! A replacement was fashioned very quickly—that night—using laminated cardboard. Thankfully, from sixty feet below, almost no one noticed!

Disneyland 2018

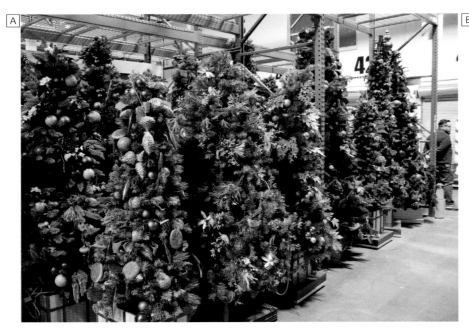

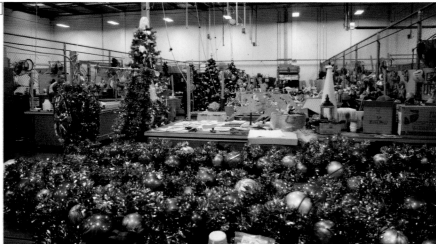

Disneyland Resort Enhancement Production Warehouse, 2018

[A] *Disneyland Hotel trees*

[B][C] *Decorating supplies*

[D] *Grizzly Peak decor*

[E] *Rushin' River Outfitters decor*

[F] *Decorating supplies*

[G] *Cars Land decor*

[H] *Production workshop*

[I][J] *Decorating supplies*

[K] *Main Street, U.S.A. lamppost wreaths*

[L] *Using a heat gun to distress Haunted Mansion decor*

[M] *Disney California Adventure bat decor*

[N][O] *Halloween window display tests for Buena Vista Street*

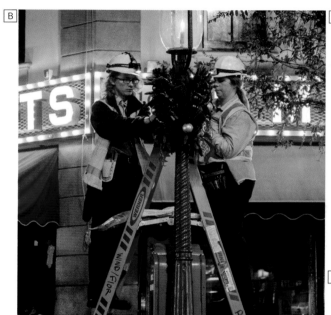

Decorating Disneyland Resort for Christmas 2018

A B *Main Street, U.S.A. decor installation*

C D *Main Street, U.S.A. decor organized, labeled, and staged for installation*

E F *Sleeping Beauty Castle programming and decor installation*

G *Cars Land decor installation*

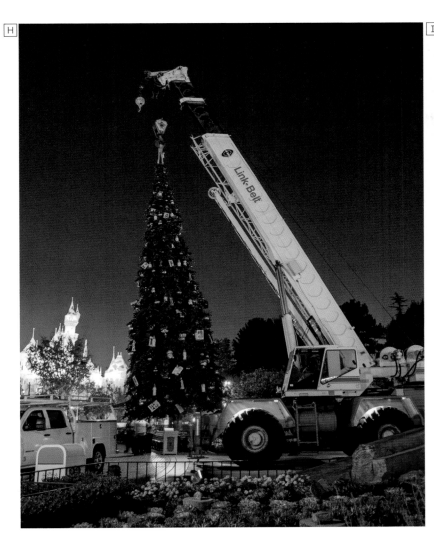

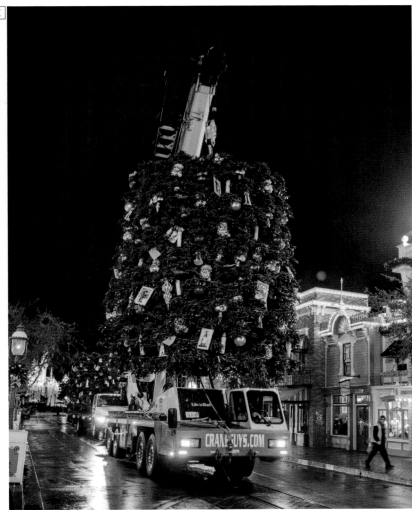

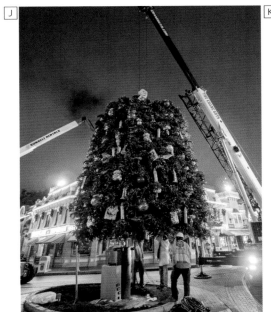

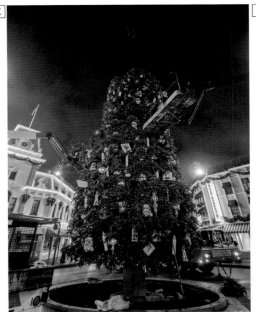

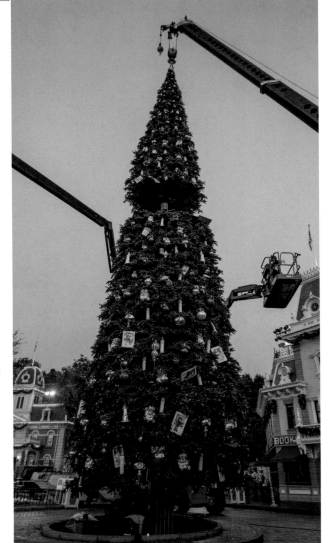

Main Street, U.S.A., Disneyland Tree Install, 2018

H Top section of the tree waits at Central Plaza for the lower sections to pass by.

I Bottom and middle sections proceed down the street to Town Square. (Can you hear music?)

J Bottom section is installed.

K Middle section is lowered into place.

L Finally, the top section is secured.

M Temporary labels help ensure the sections are mated correctly.

With so many parks, resorts, shops, and restaurants to bedeck, the scale of the operation at Walt Disney World is even more eye-popping. There, the Holiday Services team operates from a sixty-eight-thousand-square-foot production facility behind the Magic Kingdom, with two additional warehouses elsewhere on property and a fourth closer to Port Canaveral for the Disney Cruise Line decor. That's over three hundred thousand square feet in total, supporting holiday operations for Walt Disney World itself, all of the cruise ships, and the Vacation Club resorts at Vero Beach and Hilton Head.

Following an annual cycle (that's much the same as the one their California colleagues adhere to), every one of the thirty-three thousand garlands, wreaths, and trees is cleaned and refurbished during the off-season, before being stored and staged for the following year's installation. Of the three hundred thousand handmade bows incorporated into the holiday decor across Walt Disney World, a staggering seventy-five thousand are remade each year in a "magical place" called the Ribbon Room. (It's magical because of the Aladdin's–cave-like trove of ribbon reels stacked from floor to ceiling, and also because it's one of the few air-conditioned spaces in the warehouse!)

Consistency and continuity of the creative vision for holiday decor are an important part of the annual refurbishment process, which poses an interesting challenge for the decorating teams. It is, essentially, impossible to reorder the exact same ribbon, ornaments, garlands, or flowers acquired in previous years. Colors or textures never quite match, or a manufacturer will change a product altogether. So, whenever a good source is found, the largest possible quantity is ordered in hopes that the supply will last for years. One wall of the warehouse is stacked to the roof with crates of classic ball-shaped ornaments in a rainbow of colors and designs—three hundred thousand of them, all told, ready to replace what has become worn or damaged after a season onstage. Innovation in material choices and techniques is also a recurring quest—bows fashioned from patio furniture fabric and ornaments coated with automobile paint have made decorations more resilient to the sometimes-challenging outdoor weather conditions, for instance.

The main production warehouse is also home to twenty-four "icon trees" of Walt Disney World. These are the largest Christmas trees—ranging from fifteen to seventy feet in height—and are usually the holiday focal point for a park or resort. Because of their size, most of these trees are stored and transported in sections, assembled into their full, towering glory only at the final display location. In the warehouse, the branches can be removed for cleaning and refurbishment; each branch has a life of about six years, while the steel structure supporting them all will last for twenty to twenty-five years. Some of the tree decorations have a surprisingly long life, too—the outsized popcorn garlands on the Magic Kingdom tree are at least twenty years old.

Holiday Services, Walt Disney World

A *Main production warehouse*
2017

B C D *Decorating supplies*
2017

E *Vats of glitter*
2017

F *Decorating supplies*
2016

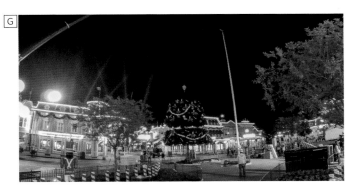

Once assembly, cleaning, primping, and polishing of each decoration are complete, it moves immediately into the staging process—an impressive feat of logistics in itself. Decorations are carefully wrapped in plastic to stop dust from accumulating, placed on pallets, and then loaded into forty-eight-foot-long trailers; twenty-four pallets fit in each one. Finally, the trailers are dispatched to unobtrusive parking locations as close as is feasible to the ultimate location where a display is going to be assembled. All in all, one hundred of these semitrailers are filled with garlands and trees, before being tucked away, out of sight, often many months before they will be opened again to begin the holiday transformation. Only the largest trees stay behind in the warehouse to be delivered at installation time. We visited the production facility in August and found the team busily finishing off the Disney Springs Christmas Tree Trail. Pallets of trees were loaded into a trailer, which tootled off to the Disney Springs area a full three months before Guests would see them.

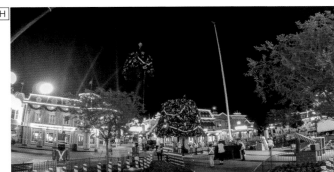

And as that magical moment of transformation approaches, the year-round permanent staff of twenty-eight artists and technicians swells to 120. The changeover from Halloween to Christmas is quite remarkable—a precisely choreographed ballet of people, cranes, trucks, trees, and tinsel, though this performance is mostly out of Guests' sight.

At the Magic Kingdom, there may be only one week between the final Mickey's Not-So-Scary Halloween Party and the first Mickey's Very Merry Christmas Party, so most of the work is completed in just three nights. The first night will see fall and Halloween elements removed and replaced with any winter or Christmas decor destined for the same locations. Then, over the remaining two nights, a squadron of cranes and boom lifts will descend on Main Street, U.S.A. to install the remainder. The Christmas tree arrives in sections on a low loader, pulling in behind the buildings on the west side of Main Street, U.S.A. Each section is lifted over the roofs and lowered carefully into place using a huge crane.

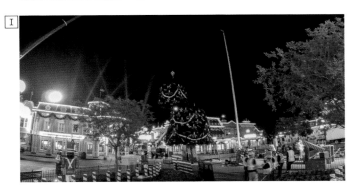

After the Magic Kingdom transformation is completed, each one of the other parks will be transformed over one or two nights; the delivery of each of their icon trees is an interesting undertaking as well. A low loader bearing the tree sections has certainly earned its "oversize load" sign and must be escorted—slowly—by Orange County sheriff's deputies along public roads throughout Walt Disney World. As highways, bridges, and overhead cables are built and rebuilt throughout the whole Disney property, the logistics of tree transportation are a genuine consideration.

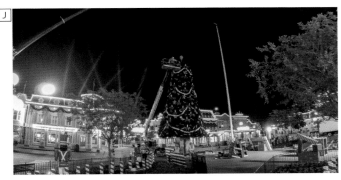

Each resort hotel gets its holiday makeover done in a single night. And each cruise ship goes through the same process during one of the days it spends in port disembarking and later reloading passengers, though this is not always done at Port Canaveral. The Holiday Services crew will transport the decorations and personnel to other locations depending on each ship's fall itineraries.

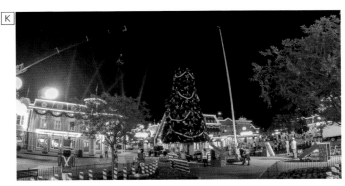

Magic Kingdom

G — L *Main tree installation time-lapse photographs 2017*

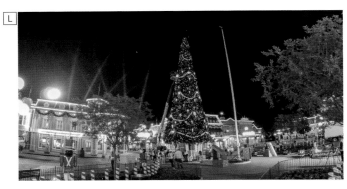

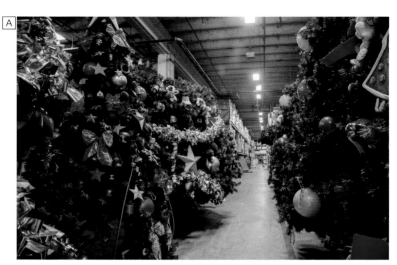

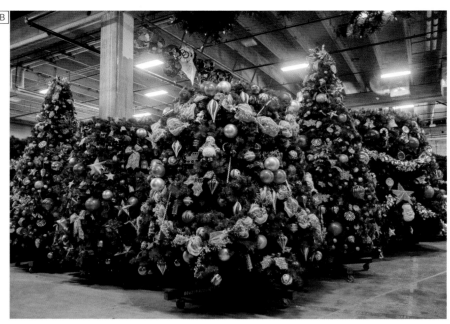

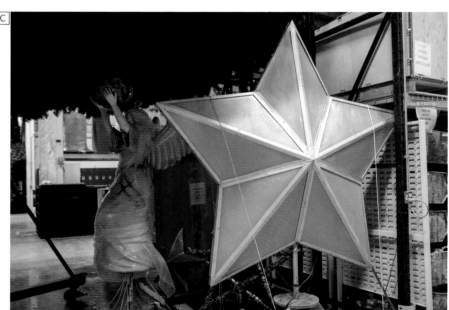

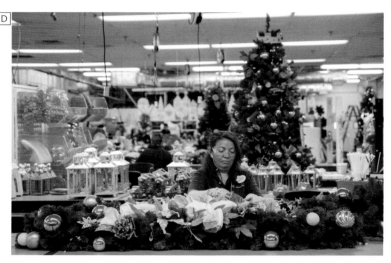

Holiday Services, Walt Disney World
2017

A B Icon tree storage area

C EPCOT and Contemporary
tree toppers, beneath
the bottom section of
the EPCOT main tree

D Production workshop

E Grand Floridian decor
ready for installation

F Ribbon supplies

G H Ribbon Room

Grand Floridian Resort & Spa

I — T Gingerbread house time-
lapse photographs
2017

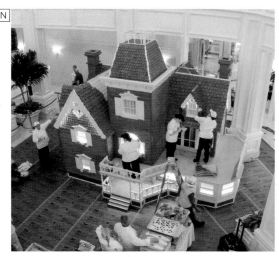

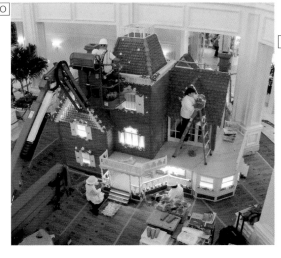

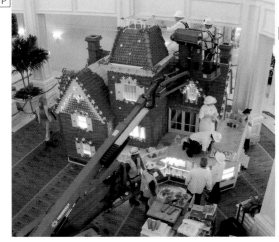

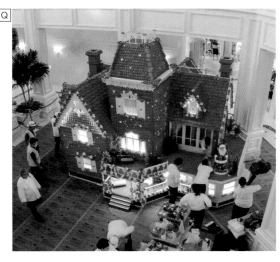

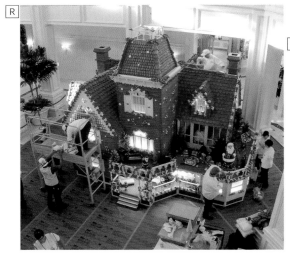

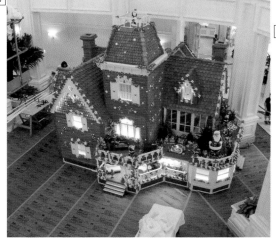

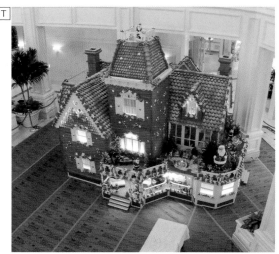

The Horticulture teams are busy all year, keeping the flower beds in the Disney parks' brimming with the colors and scents of every season—truly a never-ending task! The fall and winter periods do get a little-extra attention, though. Planning will begin at least nine months ahead of planting, sometimes longer (whereas most other garden displays are planned six months out). And after the initial planting of the Halloween and Christmas beds, there will be at least two more cycles of replanting—a fall-themed chrysanthemum will last three to three and a half weeks before it must be replaced, and Christmas poinsettias will be changed out after two or three weeks. In this case, "replaced" usually means replanting an entire bed, which the talented gardening crews can do in a magical blur of pulling, tilling, and bedding that takes no more than a few minutes. Where real pumpkins are used—as with the creative squash towers in Downtown Disney in California—these will typically be swapped out once during the two-month fall season.

Surprisingly, perhaps, the floral plans from the past are not simply reused year after year. The Horticulture teams study which plants have thrived (and which have not), they consider what varieties are likely to be available from local nurseries, and (most fun of all) they are always looking for new plants, which will enhance the theme. The darkest possible shade of maroon poinsettia is sought for the Grand Californian Hotel & Spa, and during the 2017 Disneyland Halloween season, the flower beds around Central Plaza were given a new and distinctly "wild" look. Flowerpots are also part of the show—the ornate clay pots used in the Día de los Muertos display in Frontierland were brought specially from Mexico.

As with so much of the holiday decor story, here too the numbers are astounding. Through just one winter holiday season, the Disneyland Resort will plant ten thousand poinsettias of at least ten different varieties, and the same number of cyclamens. One Town Square hanging basket may comprise as many as thirty individual poinsettia plants. The Floral Mickey in front of the train station takes two hundred flats (3,200 plants) for the face and another five hundred individual poinsettias for the floriferous scrolls on either side.

Plant preparation at Walt Disney World begins in July with the two hundred topiaries, timed so that each will reach its full splendor for the holidays. And by New Year's a total of 119,000 poinsettias will have been planted throughout the resort—twenty-five thousand at the Magic Kingdom alone. This surely puts our own home holiday plantings into perspective!

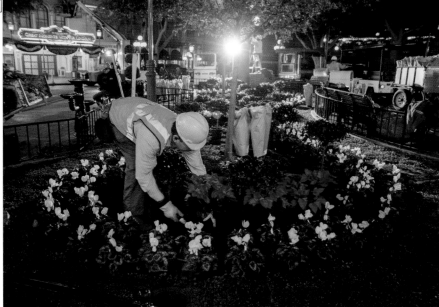

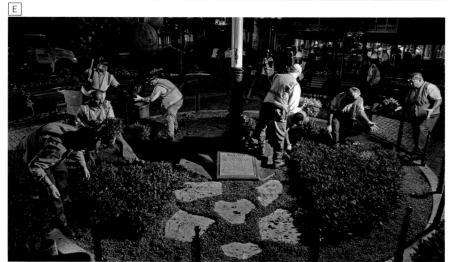

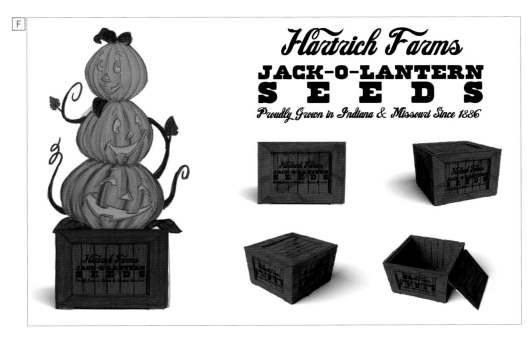

Hartrich Farms
JACK-O-LANTERN SEEDS
Proudly Grown in Indiana & Missouri Since 1886

The story for the parks' specially made decorations starts not in the warehouses backstage but on the artist's pad. Concepts are drafted, reviewed, and tweaked first on paper and on computer screens before anything is actually fabricated, allowing the creative teams to experiment with their vision. Halloween decorations take a special design touch. For example, a Disney Halloween must be fun and funny, not frightening, yet must still feel like the fall season Guests recognize.

A great deal of creative planning goes into achieving that balance, and each one of the resulting whimsical, smile-inducing pumpkins installed on Town Square began that journey on a sketch pad. As shown here, each has a cute name, too!

Horticulture installation, Disneyland, 2018

- [A] *Christmas plant staging*
- [B] *Christmas planting, Town Square*
- [C] *Christmas planting, Floral Mickey*
- [D] *Fall plant staging*
- [E] *Fall planting, Town Square*

Magic Kingdom

- [F] *Concept artwork 2011*
- [G] *Concept artwork 2007*
- [H] [I] *Town Square 2018*
- [J] *Concept artwork 2007*

Disney's Animal Kingdom

- [K] [L] *Winter overlay concept artwork 2019*

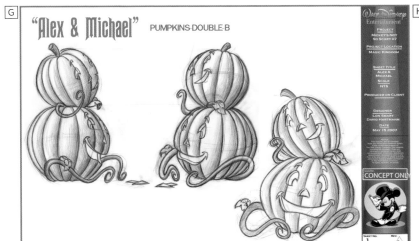

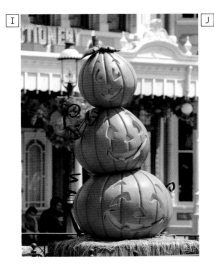

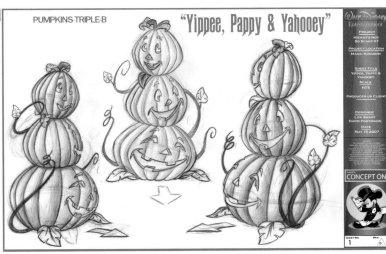

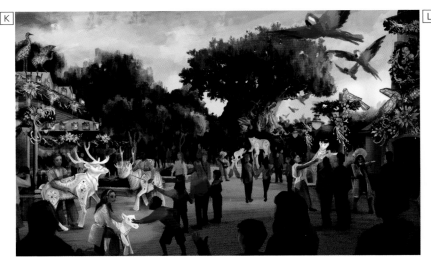

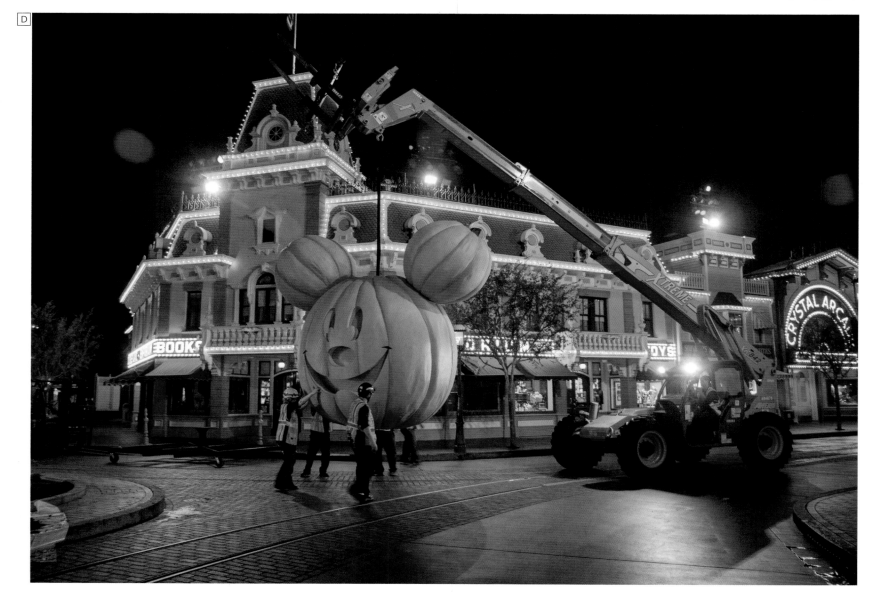

How to install the Town Square pumpkin on Main Street, U.S.A., Disneyland, 2018

A Dig out planter to find hole.

B Suck out water that has accumulated in the hole since the Christmas tree was removed last January.

C Insert bracket B into hole A.

D Lift pumpkin.

E Slide pumpkin C onto bracket B.

F Pause to admire work.

G Tighten bolts, and you're done!

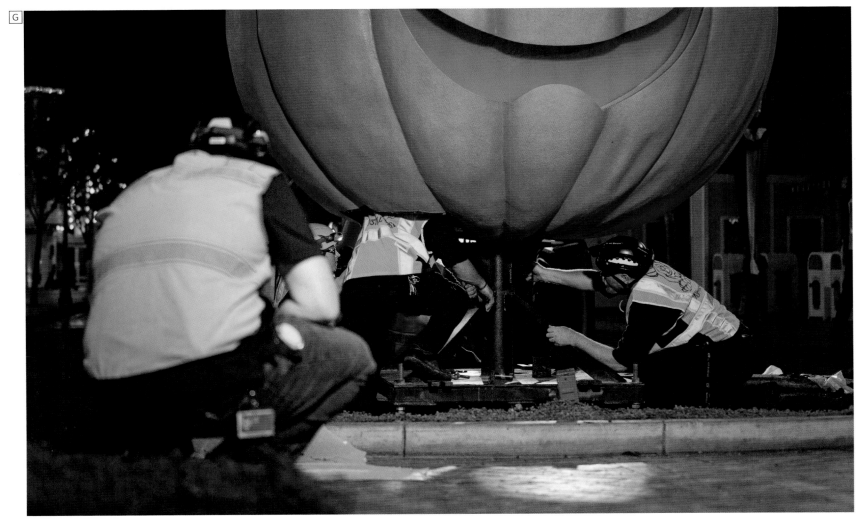

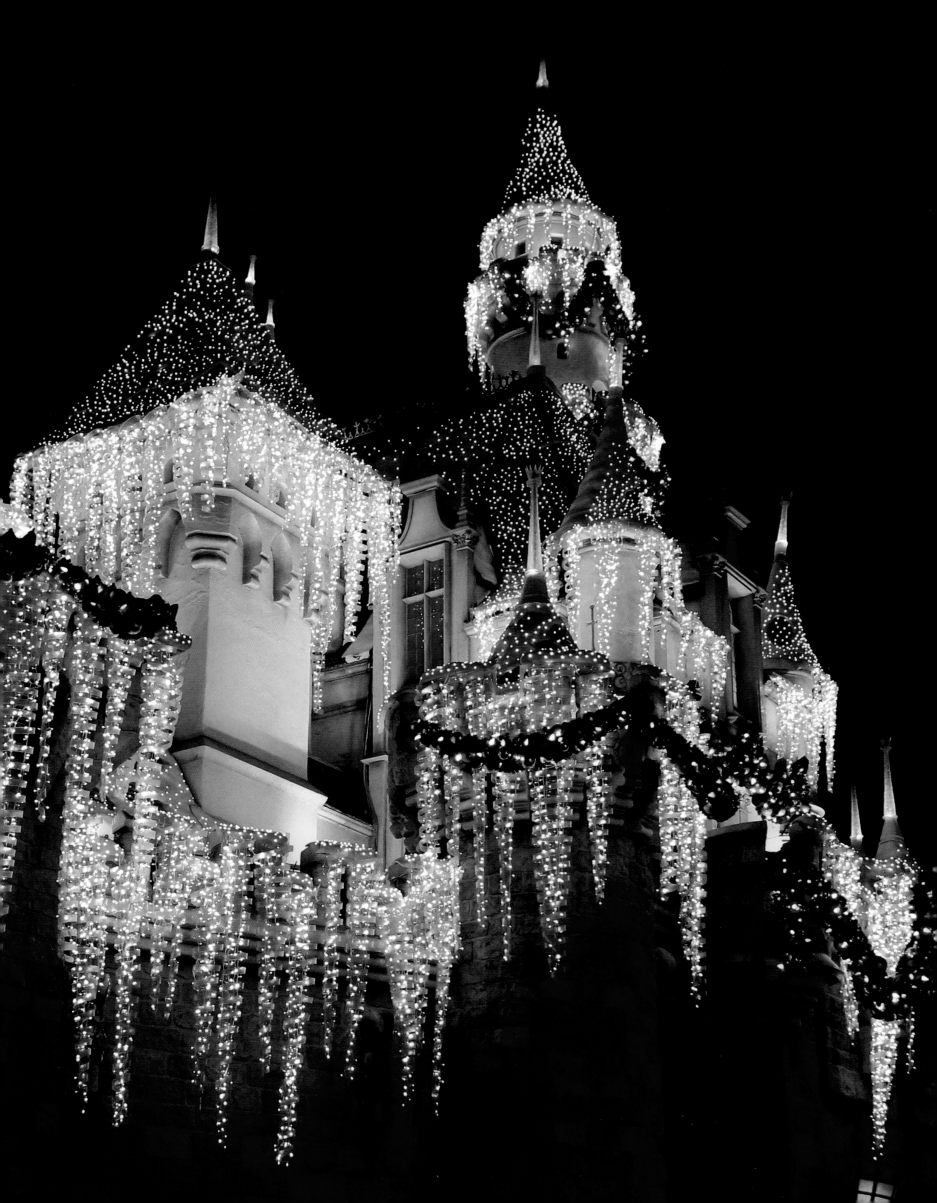

Acknowledgments

Many people from all over The Walt Disney Company have helped us put this story together. Each has a busy life already, yet they found time to share their worlds with us.

Firstly, the Disney Publishing team has been a delight to work with from day one. Jennifer Eastwood led us on the journey with such care and encouragement, along with Lindsay Broderick and Monica Vasquez. And we owe a special thank-you to Ty Popko, one of Disney's corporate photographers, who embraced the project with passion and endless good humor.

The Disney image, film, and video libraries—historical archives and current working collections alike—provided amazing photographs, along with information and research to support them. Thank you Michael Buckhoff and Kelsey Williams at the Walt Disney Archives; George Savvas and Joshua Sudock at Disneyland; Alyce Diamandis, Janice Thomson, Jay Hatcher, Frank Filipo, Paul Clementi, and Japheth Lewis at Walt Disney World; Charles Leatherberry, Denise Brown, and David Stern at Walt Disney Imagineering; and Lewis Lam, Susanna Muk, and Gladys Kong in Hong Kong Disneyland. In Paris and Tokyo, the media teams not only let us roam their vaults but also took care of us when we visited to do our own shooting. Thank you, Shane Hunt, Stephen Barbour, and Miho Tomutsuka at the Tokyo Disney Resort; and Nathalie Raverat, Marie Masseron, Johann Plaza, Typhaine Bazard, and Simon Casa at Disneyland Paris, with a special shout-out there to the incredible Amaury Quinet. We are also grateful to Disney historian Kevin Kidney, who generously shared his personal Anaheim Halloween Parade archive.

We owe Disney's unparalleled cast of artists and designers huge thanks for their time, insights, and art collections: thank yous to Steven Davison, whose talents touch every Disney resort, as well as to David Caranci, Kim Irvine, Tony Baxter, Brad Kaye, Brian Sandahl, Tim Wollweber, Joe Peters, Larry Nikolai, and Marcus Gonzalez in California; David Hartmann, Steven Miller, Larry Kornfehl and Sarah Schmidt in Florida; Mark Huffman and Jerome Picoche in

Paris; the Costuming crew of Leigh Slaughter, David Miller, Trevor Rush, Sue Clements, and Rebecca Carroll-Mulligan; and legendary voice actor Corey Burton.

From the teams of artisans and technicians who fabricate, install, and maintain the decor, our special thanks go to Lisa Borotkanics and Neil Frankenberg at Walt Disney World, and to Phil Rahn, Dawn Keehne, and Colin Roddick at Disneyland, along with Adam Schwerner and the wonderful Candace McIntire in the Disneyland Horticulture Department. This book is so much richer for their wisdom and boundless patience.

Helping us onstage were Chaz Yost, Kate Frankl, Cheryl Hutchinson, Carla Carlile, Scott Auerbach, Gaby Silver, and the amazing Crystal Dancer in Disneyland Entertainment; Disney Ambassadors Allie Kawamoto and Jessica Bernard at Disneyland, and Nathaniel Palma and Caitlin Busscher at Walt Disney World; Roberta Brubaker, orchestrating the intricacies of shooting inside attractions; Diane Lee in Disneyland Guest Relations; and Scott Rench, helming us aboard the cruise ships. Behind the scenes were Jean-Marc Viallet at the enchanting Disneyland Central Bakery (oh, the wonderful smells!), Alyssa Lambert at the Circle D Ranch, and John Van Winkle and Rick Henson in Disneyland Cast Activities.

We thank Max Calne, Jessica Clark, Jeff Fischer, Tyra Harris, Christina Novak, Ryan Potter, Bradley Ross, and Tony Shepherd for navigating our many image clearances, and we are hugely indebted to the staff of the Walt Disney Archives for their support with research, fact-checking, and for keeping all of Disney's incredible legacy neatly preserved, filed, and accessible for projects like ours.

And, of course, we thank all of the Disney Cast Members around the world who touch the parks' holiday splendor in so many ways. We would not have a book without you, but more importantly, we would not have so many cherished memories and treasured experiences. Keep making that magic—we're coming back for more next fall!

Disneyland Sleeping Beauty Castle 2018

Index